July 27, 1988

To Beem

With love, Mom

Hollywood and History

COSTUME DESIGN IN FILM

Essays by

Edward Maeder
Alicia Annas
Satch LaValley
Elois Jenssen

Hollywood and History

COSTUME DESIGN IN FILM

Organized by Edward Maeder

THAMES AND HUDSON

LOS ANGELES COUNTY MUSEUM OF ART

Copublished by
Los Angeles County Museum of Art
5905 Wilshire Boulevard
Los Angeles, California 90036
and
Thames and Hudson Ltd.
30–34 Bloomsbury Street
London WC1B 3QP

**Library of Congress Cataloging-in-
Publication Data**

Hollywood and history.

Catalogue of an exhibition at the Los
Angeles County Museum of Art.
 Includes index.
 1. Costume—Exhibitions. 2. Moving-
pictures—United States—Exhibitions. 1.
Maeder, Edward. II. Los Angeles County
Museum of Art.
PN1995.9.C56H65 1987 791.43′026 87-
17322
ISBN 0-500-01422-1
ISBN 0-87587-139-9 (museum edition)

This exhibition was organized by the Los
Angeles County Museum of Art with the
assistance of the Costume Designers Guild
and the Academy of Motion Picture Arts and
Sciences. It has been made possible by a
grant from the National Endowment for the
Arts.

The original concept for the exhibition and
catalogue is by Edward Maeder and Claire
Polakoff.

Edited by Jonathan Rabinovitz, Los Angeles
County Museum of Art.
Designed by Ian Mackenzie-Kerr, Thames
and Hudson Ltd.

Photography

All costumes and sketches were
photographed by Jeff Conley, Photographic
Services Department, Los Angeles County
Museum of Art, except for images from
Return of the Jedi. Image compositing was by
Peter Green Color Labs.

Typeset in Monophoto *Photina* and *Goudy
Old Style* by Tameside Filmsetting Ltd.
Ashton-under-Lyne, England.
Printed in the United States of America by
R. R. Donnelly & Company

Exhibition Itinerary
Los Angeles County Museum of Art
20 December 1987–6 March 1988

Museum of Fine Arts, Boston
1 June–14 August 1988

Cover: Gown by Adrian (United States,
1903–1959)
Worn by Norma Shearer as Marie
Antoinette in *Marie Antoinette* (M.G.M.,
1938)

Contents

Foreword

POPULAR PERCEPTIONS of the past and the future are strongly influenced by the movies. Larger-than-life screen images provide glimpses of such unfamiliar worlds as Ancient Egypt and the antebellum South, Renaissance Italy and the twenty-third-century Starship Enterprise. In Hollywood films people and cultures outside the audience's everyday experience come to life, and compelling visions of history and times to come are presented. The accuracy of these visions is the subject of this catalogue.

The way human beings view the world—their sense of beauty, glamour, and elegance—is inseparably linked to the times in which they live. Almost everything people create has the imprint of the styles and tastes of their era. In the art of costume design for period films designers strive to transcend these standards. From the simple leather body coverings in *One Million BC* (United Artists, 1940) to the crinolines of Miss Scarlett and Miss Melanie in *Gone with the Wind* (M.G.M., 1939), Hollywood historical costumes have often initially appeared to be authentic re-creations of dress from earlier periods. Contemporary viewers are not aware that the costumes reflect their own standards of style and beauty—that the cave-dwellers' costumes are cut to emphasize the 1940s silhouette, that the antebellum dresses are made with 1930s bias-cut fabrics. It is only with the passage of time that one can see clearly how all-pervasive the designers' contemporary aesthetics have been.

The concept for this exhibition—showing how costume designers present historical dress—originated in a series of meetings with curator Edward Maeder and a committee from the Costume Designers Guild. To transform this unique approach to costume into a show and a catalogue has required more than four years of extensive research and preparation. We are grateful to the National Endowment for the Arts for a grant that helped facilitate the Museum's work. The exhibition and this catalogue are intended to increase our understanding of the aesthetic influences that shape our vision of the past and the future and that, in turn, affect our view of the present.

EARL A. POWELL III
Director

Acknowledgments

I have relied on many people's expertise and assistance while researching and producing this exhibition and catalogue.

Satch LaValley, more than any other individual or group, has been the greatest influence on my understanding and appreciation of Hollywood costumes. He has been studying and collecting film costumes for more than twenty-five years and is one of the most knowledgeable people in the field. On the very first day we met, eight years ago, I was overwhelmed by his infectious enthusiasm for Hollywood wardrobes, and in the ensuing years my conversations and visits with him have fostered a strong conviction that such costumes had to be made available for public viewing. The present exhibition would never have come about without him.

The basic concept for the exhibition—to show the history of the world through the eyes of the film costume designer—came to me after a number of exploratory meetings with representatives of the Costume Designers Guild and a representative of the Academy of Motion Picture Arts and Sciences. This rough concept was transformed into a finished, comprehensive proposal through the able assistance and hard work of Claire Polakoff. Once the general framework for the project was established, the Costume Council, the support group for the Department of Costumes and Textiles, immediately began to search for costumes and sketches, and as can be seen, they proved very successful in their task.

As the show progressed, I continued to work closely with a committee from the Costume Designers Guild, chaired by Renie Conley with members Moss Mabry, Al Nickel, Suzanne Smith Brown, Elois Jenssen, Bill Jobe, Bill Hargate, Bill Thomas, Albert Wolskey, Al Lehman, Robert Fletcher, and Deborah Landis. Their knowledge of costume design and Hollywood was an invaluable resource. Douglas Edwards represented the Academy of Motion Picture Arts and Sciences in the

planning of the exhibition; he gave generously of his time and was extremely helpful.

The staff of the Department of Costumes and Textiles was involved in every aspect of the exhibition. I thank Dale Carolyn Gluckman, assistant curator, and curatorial assistants Louise Coffey, Nola Ewing, Florence Karant, and Sharon Takeda for their tireless work on this project. Alin Millo assisted with the coordination and presentation of the exhibition. Administrative assistants Mary Katherine Aldin, Betty Ditmar, and Audrey M. van der Vorst typed and retyped countless pages and kept the department organized when faced with a deluge of tasks. Volunteers Ed Johnson, May Routh, Charlene Weaver, Amber Wilson, and Lisa Worley gave their time selflessly and contributed an array of professional skills.

Several libraries were used in researching the project. The staff of the Margaret Herrick Library at the Academy of Motion Picture Arts and Sciences—director Linda Mers, Sandra Archer, and Sam Gill—directed me to many fruitful sources and made my months of work there a pleasure. Deidre E. Lawrence, principal librarian at the Brooklyn Museum; Ann Schlosser, librarian at the American Film Institute; and Marjorie Miller, art librarian at the Shirley Goodman Design Laboratory, Fashion Institute of Technology in New York, were also helpful in locating costumes, sketches, stills, and information on various films.

The production of the catalogue involved a number of people. It has been a privilege and honor to work with contributors Alicia M. Annas, Professor of Drama, San Diego State University; Satch LaValley; Elois Jenssen; and David Ehrenstein. Ehrenstein, the research assistant for the book, brought to the project a wealth of knowledge about film and tracked down a multitude of dates and credits. He also coordinated the assembly of illustrations for the catalogue. Mitch Tuchman, managing editor at the Los Angeles County Museum of Art, guided the book through its various administrative and production stages. Deenie Yudell, head graphic designer, reviewed design proposals and layouts and made many helpful suggestions. Jeff Conley of the museum's Photographic Services Department photographed the mannequins and sketches with great sensitivity. But the award for merit above and beyond the call of duty must go to editor Jonathan Rabinovitz, whose total dedication and comprehensive editing made this publication possible.

The conservation and preparation of the objects in this show have taken several years. Victoria Blyth-Hill, senior paper conservator; Catherine McLean, associate textile conservator; Anne Svenson-Perlman, former assistant textile conservator; Pat Reeves, retired head textile conservator; Rosanna Zubiate, assistant textile conservator; and Jim Wilke, a student intern, have worked on the conservation of many fragile costumes and sketches. The Costume Council's Textile Preservation Group carefully reproduced many of the lost or destroyed accessories necessary to complete the costumed figures. Vikki Wood prepared wigs for the mannequins, and Lyndell Otto painted their faces.

The exhibition design, conceptualized by Dino de Girlando of Iris Designs, has been further refined and executed by Bernard Kester with help from the Department of Operations and Technical Services. Information on the exhibition has been disseminated by Pamela Jenkinson and her staff in the museum's Press Office. The concepts addressed in the show have been made more meaningful through the work of William Lillys, head of the museum's Education Department, and Lisa Vihos, museum educator.

Of course all of the work by the museum staff would have been for nought without the great generosity of the individuals and organizations who contributed such beautiful works to the show. Costumes and sketches have been donated or lent by the Academy of Motion Picture Arts and Sciences, Adele Elizabeth Balkan, the Brooklyn Museum, California Mart, Robert Callery, Bob Carlton, the Charles LeMaire estate, Mrs. Leland H. Conley, the Costume Council, Jean-Pierre Dorleac, Tony Duquette, Mr. and Mrs. Albert R. Ekker, Robert Fletcher, Allan J. Gardner, Thomas S. Hartzog, Dorothy Jeakins, Elois Jenssen, Michael Kaplan, Charles Knode, Satch LaValley, Lorimar Studios, Lucasfilm Ltd., Moss Mabry, the Mary Pickford Rogers Bequest, May Routh, Irene Salinger, Michael Tankenson, Bill Thomas, and David Weisz.

Finally I wish to express my deep appreciation to museum director Earl A. Powell III for his encouragement and support of this project.

The exhibition was made possible by a grant from the National Endowment for the Arts.

EDWARD MAEDER

I

The Celluloid Image: *Historical Dress in Film*
EDWARD MAEDER

Every age remakes the visible world to suit itself and so has its own particular way of looking at the clothes which form its daily wear. The eyes of the beholders are so affected by their brains that they see not precisely what is before them, but what they wish to be there.[1]

A particular stamp of the times can be seen on virtually everything that human beings have produced at any given point in history. People in each age create a style that is the acceptable and comfortable aesthetic for their day. Accordingly when we try to re-create historical costumes, a problem arises. Our vision is so influenced by contemporary style that we cannot be objective, and the result is always an interpretation. The remaking of dress from times past is the subject of this essay and accompanying exhibition.

In designing the costumes for *Gone with the Wind* (1939), Walter Plunkett strove for authenticity, a re-creation on film of the way people looked in the American South during the Civil War period. He spent months researching the styles, looking at fashion publications and traveling throughout the South, visiting plantations and interviewing dozens of survivors of the period. He was ushered into homes and proudly shown silk gowns that had belonged to grandmothers and great-grandmothers.

In general the costumes met with critical acclaim. The finished wardrobe was indeed extraordinarily beautiful. Audiences were dazzled by Scarlett O'Hara's barbecue dress. Her wedding gown launched a trend in bridal fashion.[2] Viewers left the theater convinced that they had just seen a true reflection of the past; but almost a half century later, a fashion historian cannot help noticing that many aspects of the film's costume styles are rooted more in the 1930s than in the 1860s. Vivien Leigh's hats, designed by John Frederics, are not of a style used during the Civil War. With silk ribbon bows tied under her right ear, they present an asymmetry that only became acceptable in the 1930s. In all the dresses for the film, bodices were cut to conform to the shape of the bosom; in the 1860s the corset formed the basis for the fashionable shape, and the bosom conformed to it. The crinolines in the film are exaggerated, designed in a dome-shaped style that is larger and wider than that found in surviving examples from the early 1860s. Even the men's suits in the picture reflect the late-1930s cut with broad shoulders, a fullness across the upper rib cage, and a narrower cut over the waist and hips. The style and cut of the lapels are strictly contemporary, although the scale is similar to those worn in 1860.

Similar—and sometimes more flagrant—anachronisms are found in almost every motion picture that portrays another period. While presenting an illusion of an earlier time, these movies rarely replicate the exact look that prevailed; instead the costumes take elements from past styles and combine them with aspects of contemporary fashion.

Hollywood has produced hundreds of period films, with settings from prehistoric Earth to other galaxies millions of years in the future. People are drawn to these movies to see places and times that they could never know. Hollywood usually offers its audience an elaborate and excessive vision of the past, filtering history through rose-colored glasses. Greer Garson, the star of the nineteenth-century period film *Pride and Prejudice* (1940), captured the appeal and the historical approach of these films in an interview about her role:

I think all of us have often thought how interesting it would be to live in a different age and time. Imagination at best is a poor substitute for reality. My role as Miss Bennet was one of the happiest I ever played. In the charming feminine costumes of the period, working on sets authentically re-creating Old English homes, schooled in the modes and manners for the period, and surrounded by the proper atmosphere—gallant gentlemen, candlelight, carriages and pianofortes—it was possible to believe that I was Elizabeth [Bennet] while the cameras turned, and each night after work it was like stepping out of one world into another. I always hated to take off the colorful costumes and put on slacks, feeling something like Cinderella after the ball.[3]

Dress plays a critical role in such movies, establishing the appropriate feeling of another time. Mitchell Leisen, who designed and directed numerous period films, said, "Costume pictures . . . generally become as unconvincing and artificial as fancy-dress balls in a small college gym unless the gowns, hats, shoes, [and] suits . . . are built and tailored exactly as they were in the days of the story."[4] While costumes in these films are not necessarily authentic, Hollywood has worked hard to create the effect of a different time.

The Birth of a Nation (1915) and *Intolerance* (1916), both directed by D. W. Griffith, are among the first films that specifically used costumes to create the illusion of an earlier time. Prior to these films, suggesting period dress was not considered. Actors frequently wore clothing from their personal wardrobes regardless of its accuracy for the period or their characters. In *The Birth of a Nation*, set during and directly after the American Civil War, Griffith required Lillian Gish and others to wear heavy hoop skirts. For *Intolerance*, he used an array of lavish costumes—flowing robes with heavily beaded decoration, fragile lace, and soft velvet as well as outrageous headgear—to evoke ancient Babylon, one of the film's three period settings. Many of its exotic costumes bore little relation to Babylon but involved wild and excessive variations on contemporary styles, adopting the fashionable silhouette and decorations of 1916.

Costumes played an important part in these pictures, but they were still primarily the responsibility of the director and actors. It was not until the 1920s, with the formation of large studios in Hollywood, that costume design became a

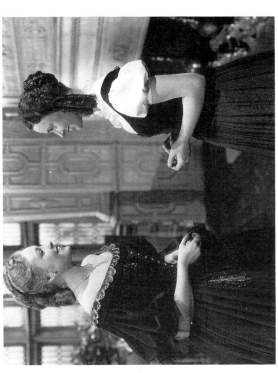

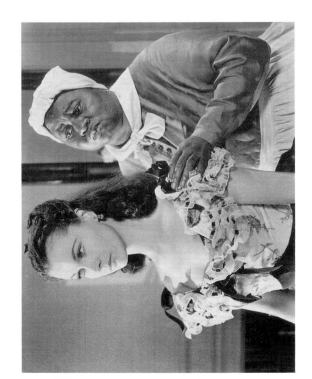

specialized task. Studios began to maintain large costume departments with skilled staffs that worked exclusively on costume pictures. By the end of the decade every major studio had a research department and a library. Lured by large salaries, screen credits, bountiful budgets, and superbly trained workroom staffs, some of the most creative designers in Hollywood history began their tenures in the industry. Edith Head, later the doyenne of movie designers, started as a sketch artist in 1925. That year Plunkett, who eventually designed clothes for more than 250 period films, began his costuming career in Hollywood after graduating from the University of Southern California with a pre-Law degree and working in a few movies as an extra. By 1928 Adrian, Travis Banton, and Howard Greer had already spent several years making wardrobes for movies. The costume designer now began to assume a vital and well-publicized role.[5]

In the ensuing decades wardrobes for period films became more and more elaborate, and accuracy was more assiduously pursued (although there are certainly many exceptions).

A representative example is *Forever Amber* (1947). Linda Darnell wore eighteen evening gowns, twenty daytime dresses, three negligées, and a wedding gown as part of the effort to re-create the seventeenth-century England of King Charles II. According to a press release:

René Hubert designed his costumes exactly as clothes were made during the Restoration era. Each dress averaged 20 yards of material. Each gown had the bodice rigidly boned and laced up the back in the manner of the times. He used thick felt padding pleated into heavy folds to give the voluminous effect to the hips. The gowns averaged 35 pounds; one weighed 58. . . . An average of 10 people worked on each outfit, including cutter, draper, fitter, finishers and embroiderers. The average charge for labor per costume was $850. A French milliner spent five days each on the immense,

plumed hats for the period. The more spectacular cost $750 each, including jewel trims and ostrich plumes. Gloves, hand sewn and embroidered, ran $100 a pair. . . . Willy de Mond, noted Hollywood stocking designer, turned out a $1,100 pair of gold-thread nylon hose for Amber.[6]

Such work is not unusual for a period film, and other productions required similar investments in labor and material.

The Prodigal (1955), which starred Lana Turner and took place in Damascus in the year 70 BC, had more than 4,000 costumes and there were 292 costume changes for the principals alone.[7] The New York Post reported that Turner's costumes, made of gauzes and decorated with gold and precious stones, were as "elaborate and expensive . . . [as were] ever prepared for a Hollywood star."[8] According to M.G.M. authorities, one of her costumes was composed "entirely of seed pearls, thousands of which were handsewn."[9] Another costume she wore in the film was extravagantly decorated with pearls and rhinestones, sewn in complex patterns on pure silk jersey.

The excesses that Hollywood went to are the stuff of legends. When dressing Greta Garbo for Camille (1937) the costume designer, Adrian, had the initials GG embroidered in seed pearls inside the cuffs of her gloves as a personal tribute to the star. According to some sources, all of her underwear was handmade. Rumor had it that the fox trim on a cape worn in the black-and-white film Marie Antoinette (1938) was sent to New York to be dyed blue to match Norma Shearer's eyes. The hundreds of court gowns in this film were decorated with embroidery in many forms, beading, appliqué work, and even painting. Practically every available surface was encrusted with gold or silver sequins, pearls, or ribbons.

Hollywood moviemakers went to great lengths to ensure that their films would be wondrous spectacles and that the actors would look gorgeous. The people who made these costumes had to be wizards of fashion, capable of creating a wardrobe ranging from a riding habit to an elaborate court gown. Many of the costumes shown in this book involved incredible craftsmanship and have a flair, grace, and elegance seen only in the most fashionable haute couture.

A successful period costume, however, must be more than a beautiful work of art. A costume should help a film tell its story, enhance the character, and contribute to the setting. In historical films designers usually try to achieve these objectives by exotica or by authenticity. In the former case the designer communicates the sense of a different time by using fashion devices that are unfamiliar to the contemporary audience but have no basis in the story's period. For example, Pride and Prejudice (1940) is set in the first decade of the nineteenth century, but the costumes are actually in an 1830s style. The designer, Adrian, persuaded the director, Robert Leonard, to place the story out of its time frame for two reasons. He had just finished designing costumes for Conquest (1937), also set in the early nineteenth century, and wanted to design a wardrobe for a different period. He chose an 1830s style so that the costumes

could be more excessive and decorative than the style of the earlier period, the classic revival, best known for the long tubular Empire dress. In this and many other films Adrian frequently used exaggerated forms of decoration, oversized hats, as well as feathers and surface ornamentation which bore only slight resemblance to the past or the present. This hybrid style was successful in convincing the audience that they were viewing an earlier, more romantic period.

While the exotica approach is still used, the second approach—re-creating an exact historical look—is more prevalent. The problem—and the focus of this essay—begins when costume designers try to determine what is authentic.

Many period costumes require extensive research. Charles LeMaire worked with a curator at the Brooklyn Museum for two years, gathering background information for the costumes in *The Egyptian* (1954). For countless films designers have spent months studying illustrations and paintings from the period depicted, as well as using contemporary scholarly works on historical dress. In cases where the period is recent enough for survivors to exist, the designer may visit them or search for existing pieces in thrift shops.

Historical sources, however, can be misleading. For example, *Bride of Vengeance* (1949), the story of Lucretia Borgia, was obviously based on Italian paintings of the late fifteenth century. Although the paintings show several layers in the women's gowns, the full chemise (an undergarment) was meant to puff out through the openings in the seams left at the shoulders and elbows. In the costume these puffs are sewn into the seam as part of the same garment. Superficially this looks correct, but upon careful examination it is apparent that the garment would not move the same way if the various layers were truly independent.

To translate a painting into an exact replica of period dress, a designer must transcend the contemporary aesthetic standard, an impossible task because the designer must also create a wardrobe that will address the contemporary audience in a fashion language that they understand and that is consistent with the movie's tone. Even if there was no audience, the designer could not escape the twentieth-century aesthetic in creating period costume, as it is inherent in the way each one of us, designer and nondesigner alike, thinks about dress. What is socially acceptable, beautiful, risqué, elegant in dress varies dramatically for different periods. Near the end of the eighteenth century in France some dress styles allowed breasts to be exposed. Sometimes the nipples were even rouged. At the same time exposed arms were considered shocking, and long gloves were worn to cover them.

The twentieth century has its own unique standards, and a designer cannot leave these behind when creating costume. We take for granted many aspects of today's fashion which were once significantly different. For centuries clothing forcibly shaped the female body to conform to an ideal figure, which varied with each period. In the twentieth century the natural shape of the female body has had a greater influence on the shape of clothing than in any

other period. By the beginning of the 1920s, the heavy encumbrances of corsets and petticoats, which had haunted the fashionable lady for generations, ceased to be worn. Paul Poiret is credited with liberating women from the corset and replacing it with what would later be known as the brassiere.

This change in the general treatment of the female body was accompanied by a number of other new developments. Each decade in the twentieth century heralded some new fashion that yielded a distinctive look. In the 1930s the newest development was the use of fabric cut on the bias.[10] New methods of prestretching fabric permitted the garments to fit over the curves of the body like a second skin. The 1940s are best known for the widespread use of shoulder pads and well-tailored ladies' suits.[11] With the introduction of Christian Dior's "New Look" in 1947, hips returned, and in the 1950s there was a revival of the mid-nineteenth-century crinolines. As the decade progressed breasts became more prominent, emphasized by such garments as the strapless gown, and the "lifted and separated" look was established.

Costume wardrobe creates the illusion of a past era by including elements from the period fashion but rarely abandons the distinctive traits of twentieth-century dress. When re-creating a period garment—be it a toga or a hoop skirt—the designer, consciously or subconsciously, adapts it to contemporary fashion. One can see a number of trends in the way that period costumes fuse past and present.

Fashion devices that shaped the body in earlier centuries are rarely worn in period films. The silhouette of the figure almost always remains contemporary, with perhaps a few added extensions, such as a bustle or leg-of-mutton sleeves, to make it appear more authentic.

In *Cleopatra* (1963) the average measurements of the one hundred extras playing handmaidens, palace servants, and priestesses were 37-24-36, and the costumes were cut to emphasize their figures. These are measurements popular at the end of the second millennium after Christ and not representative of the more stylized vertical figure of 48 BC. Instead of altering the contemporary silhouette, the film's costumes evoke a sense of ancient times by adopting Egyptian-inspired pleated garments, made of lightweight fabrics, as well as using exotic jewelry and heavy wigs.

Other aspects of period style are seldom reproduced accurately in Hollywood films. The emphasis on breasts and their placement is always consistent with what is fashionable when the film is made. Hats frequently correspond to contemporary fashion instead of historic style. In *Pride and Prejudice*, for example, several of the hats are in the late-1930s mode, with bold stripes and large flat brims. Underpinnings (undergarments) such as crinolines and side hoops are often exaggerated, making them flashier and more noticeable than they were in their time. In *Kitty* (1944), a masterpiece of period costume, the only item that related directly to the 1940s was a small set of side hoops made of ruched satin. In eighteenth-century England structural undergarments such as these were usually made of linen or cotton and were

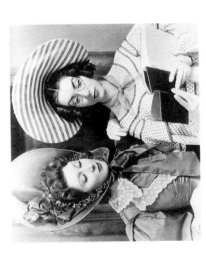

Fig. 3
Greer Garson and Marsha Hunt in *Pride and Prejudice* (M.G.M. 1940).
Costumes by Adrian

merely practical, not beautiful. But drawing attention to such unfamiliar garments heightens the period effect.

Finding authentic fabric and accessories is always a problem, as materials that were available in another time may no longer exist. No amount of work can ever produce a perfect rendition of the garb for a Northern European lord or lady of the Middle Ages. Their cloaks were often lined with a fur called miniver, made from hundreds—sometimes thousands—of pelts from the underbellies of small squirrels. After nearly 200 years as the mainstay of this fashion, the animal became extinct. In *Joan of Arc* (1948) the heroine wears a tunic of soft velvet that hangs loosely over her armor. Five centuries ago the real Joan of Arc would have been wearing a stiffer, less yielding garment of heavy silk velvet, but such material is no longer made. In developing turn-of-the-century costumes for *Hello Frisco Hello* (1942), the film's designer, Helen Rose, could not obtain flexible steel ribs, metal clasps, and other materials needed for constructing an authentic wasp-waisted corset because of wartime restrictions.[12]

In such situations the designer is forced to improvise, to adapt available materials and techniques to imitate historic ones. The designer's judgment about what is an accurate substitute is influenced by the contemporary aesthetic, and there is a tendency toward choosing a replacement that represents the latest development in textiles.

Designers have also compromised authenticity when it clashes with prevailing social mores. While many designers are committed to creating genuine portraits of past fashions, social mores sometimes push them to incorporate the style of their time. Attitudes about socially acceptable dress vary from period to period, and authenticity has often been sacrificed when it clashed with the contemporary view of nudity and the clothing of genitalia and breasts.

While costumes deviate from authenticity in silhouette, fabric, and other aspects, they often include extremely precise reproductions of certain key details. In the 1962 film *Mutiny on the Bounty* designer Moss Mabry was so careful with details that he made sure to clothe a number of the sailors in breeches with a drop front, the predecessor of the modern button and zipper fly fronts. For other sailors in the movie he duplicated the famous striped trousers that were so popular at the time of the French Revolution.

Period films are often meticulous in their reproduction of stitching, patterns, and colors. In *The Egyptian* accordion pleating was used for many of the costumes after research revealed that in 1300 BC women of the upper classes had such folds in nearly all their robes, gowns, and informal clothes.[13] For *Gone with the Wind* Plunkett found a textile mill in Pennsylvania that still made authentic 1860s printed fabrics.[14] *That Forsyte Woman* (1950) used colors, such as "stone" and "ashes of roses," which were considered popular in the late 1870s.

While much energy has been devoted to creating authentic-looking

Figs. 4, 5 and 6
Above left, above right, and opposite:
Norma Shearer in *Marie Antoinette*
(M.G.M. 1938).
Costumes by Adrian

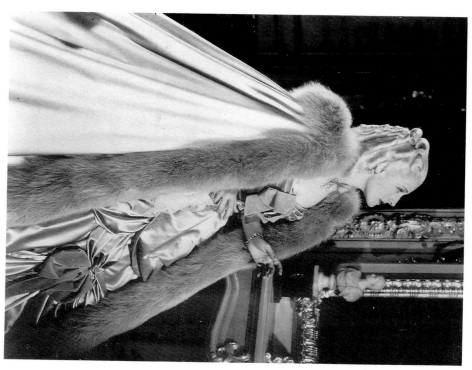

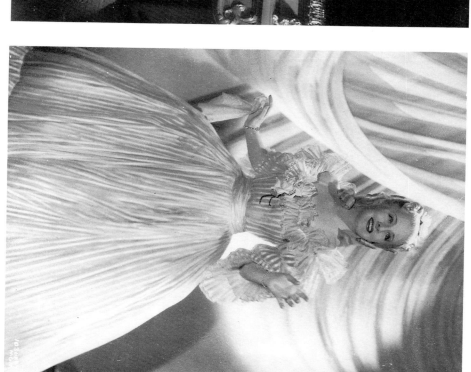

costumes in period films, only occasionally do moviemakers attempt historically accurate hairstyles, and they almost never use authentic makeup. Hollywood films consistently fail to adopt period makeup, even when costumes approach perfection. For example, Molly, a character in the film *Tom Jones* (1963), wears authentic eighteenth-century attire and frosted lipstick—common makeup for the 1960s but not likely to be found at a drugstore two hundred years earlier.

In period films, from the 1920s to the present, hairstyles are a strange combination of exotic effects and contemporary 'dos. In the 1920s the forehead was considered an undesirable feature; so in period films from that decade, such as *Orphans of the Storm* (1922) and *Monsieur Beaucaire* (1924), wigs and hairstyles were developed to conceal it. In period films from the 1950s it is common to see ponytails. (A more thorough discussion of the makeup and hairstyles in period movies is provided in Chapter II.)

A brief review of several period films from each decade reveals how this range of factors—fabric, silhouette, social mores, and others—ensures that costumes always display contemporary influence.

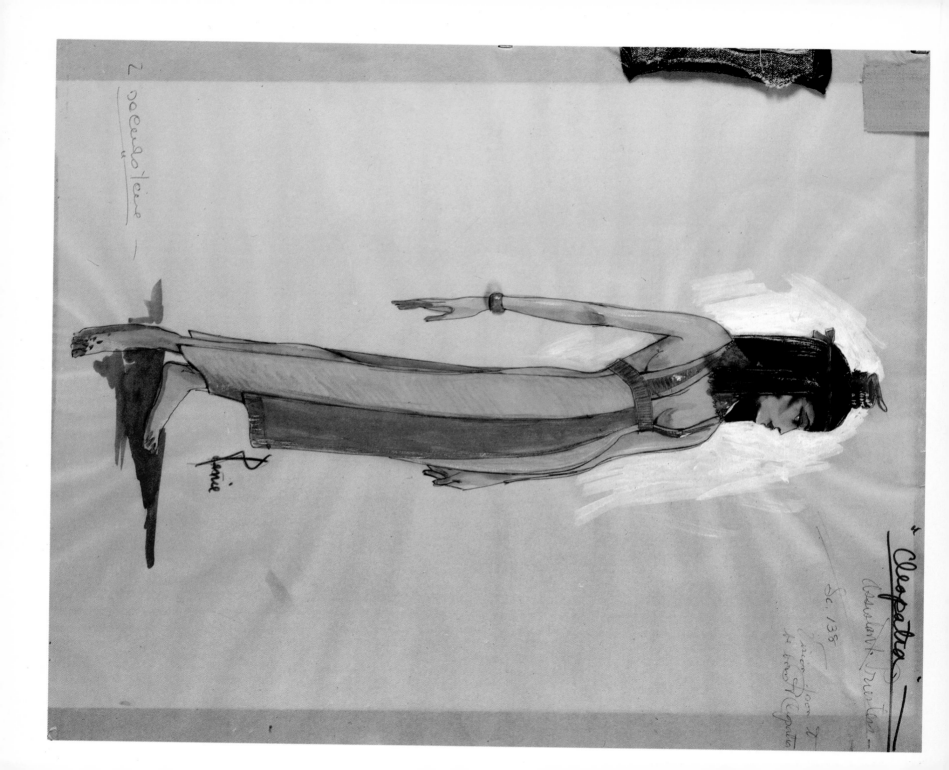

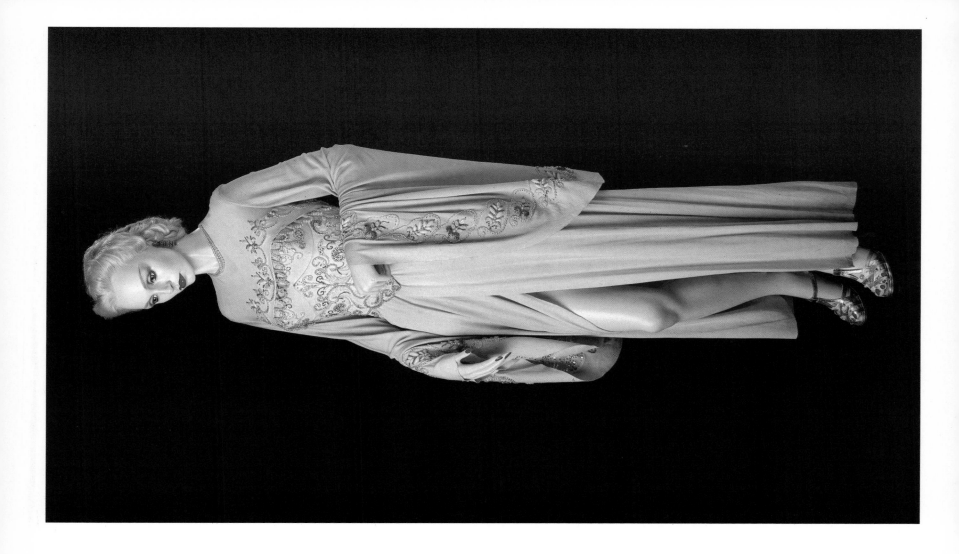

Assistant Priestess
Cleopatra (Twentieth Century-Fox, 1963)
Costume sketch by Renie Conley

Gown with Full Sleeves
Worn by Lana Turner as Samara the High Priestess
The Prodigal (M.G.M., 1955)
Designer: Herschel McCoy

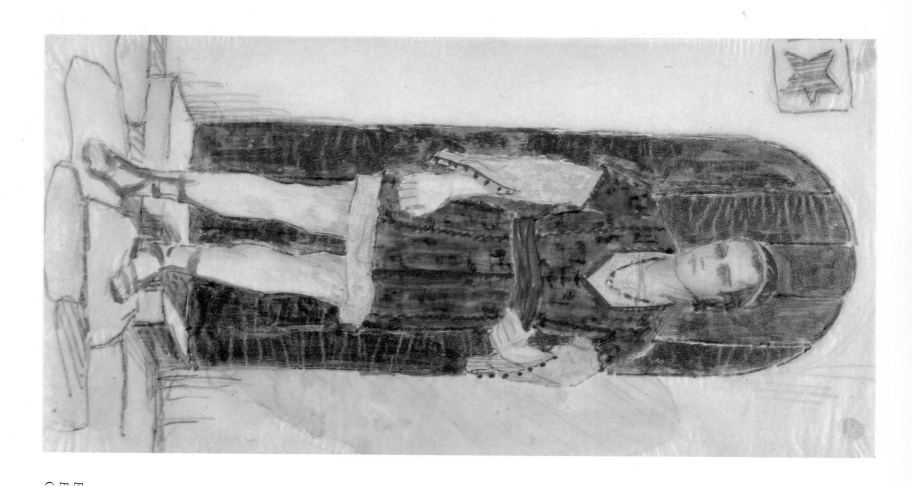

Ben Hur [Ramon Novarro]
Ben Hur (M.G.M., 1926)
Costume sketch by Harold Grieve

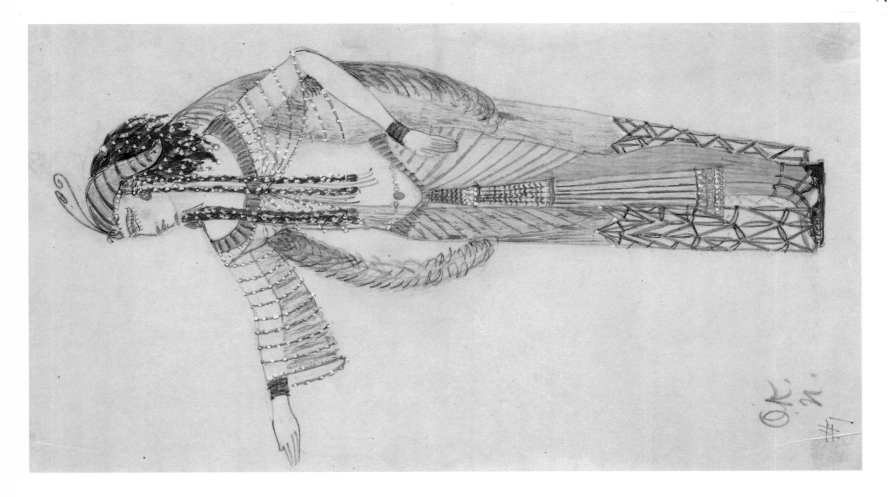

Flavia [Carmel Myers]
Ben Hur (M.G.M., 1926)
Costume sketch by Harold Grieve

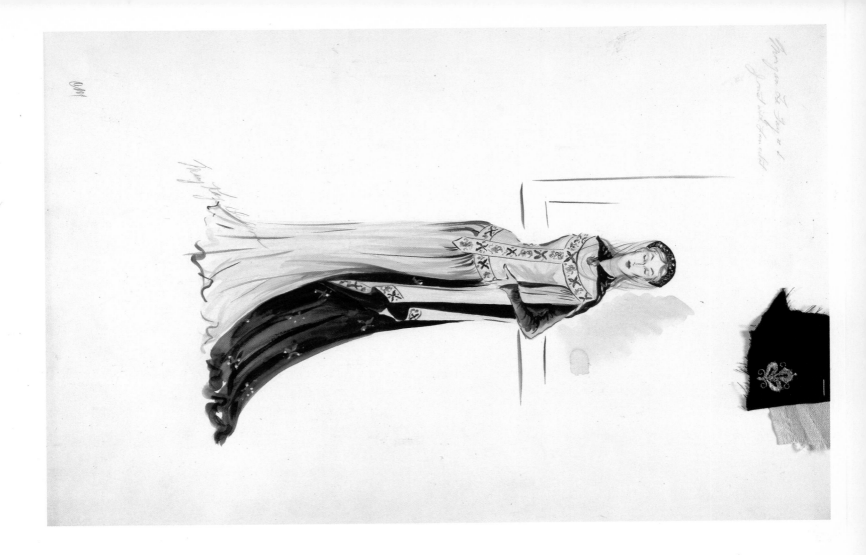

Morgan La Fay [Virginia Field]
A Connecticut Yankee in King Arthur's
Court (Paramount, 1949)
Costume sketch by Mary Kay Dodson

Young Man's Costume
Camelot (Warner Bros., 1967)
Costume sketch by John Truscott

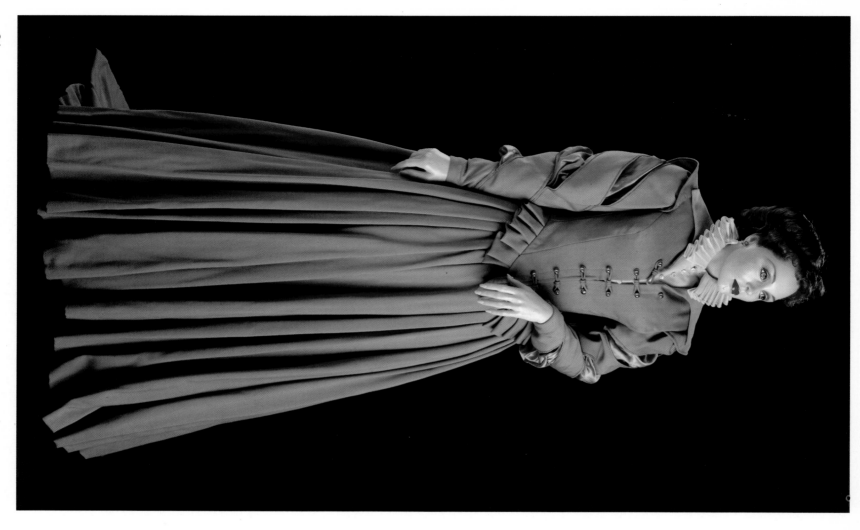

Three-piece Suit with Petticoat
Worn by Joan Collins as Beth
Throckmorton
The Virgin Queen (Twentieth Century-
Fox, 1955)
Designers: Charles LeMaire and Mary
Wills

Gown and Porkpie Hat with Snood
Worn by Lana Turner as Diane de
Poitiers
Diane (M.G.M., 1955)
Designer: Walter Plunkett

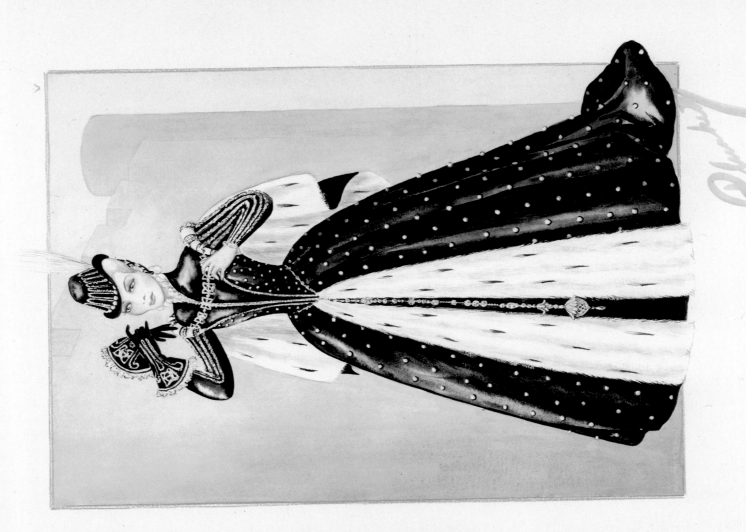

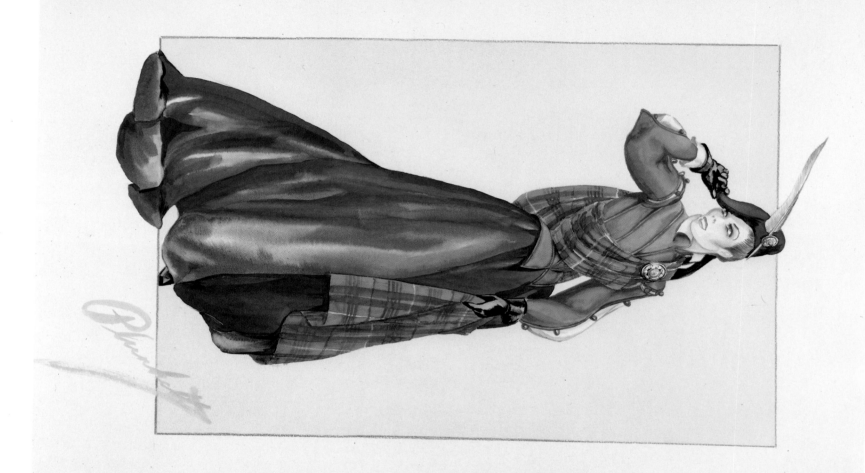

27

Mary [Katharine Hepburn]
Mary of Scotland (R.K.O., 1936)
Costume sketch by Walter Plunkett

Désirée [Jean Simmons] in Paris House
and in Italy
Désirée (Twentieth Century-Fox, 1954)
Costume sketches by René Hubert

CORD VELVET D.B. VEST
WOOL CLOTH COAT

Emma Bovary [Jennifer Jones]
Madame Bovary (M.G.M., 1949)
Costume sketch by Walter Plunkett

Unknown Character #7
A Tale of Two Cities (M.G.M., 1935)
Costume sketch by Valles

Julia [Jeanne Crain]
Centennial Summer (Twentieth
Century-Fox, 1946)
Costume sketch by René Hubert

Lady Flavia [Ann-Margret]
The Last Remake of Beau Geste
(Universal, 1977)
Costume sketch by May Routh

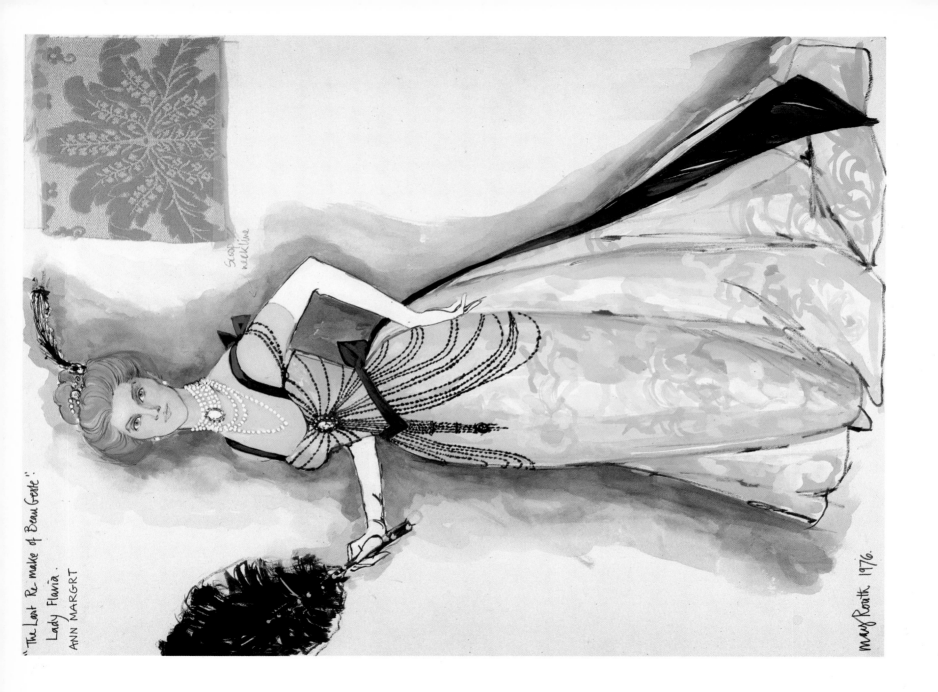

"The Last Re-make of Beau Geste".
Lady Flavia.
ANN MARGRT

Scoop
neckline

Mary Routh 1976.

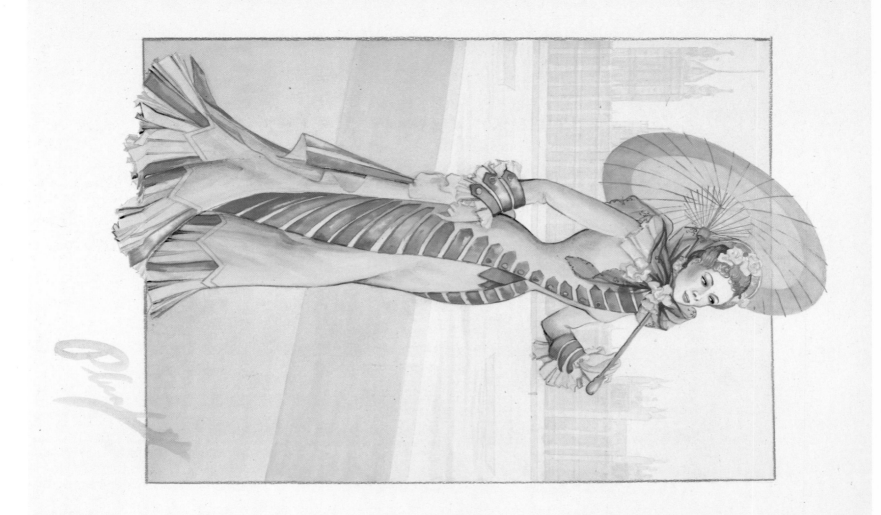

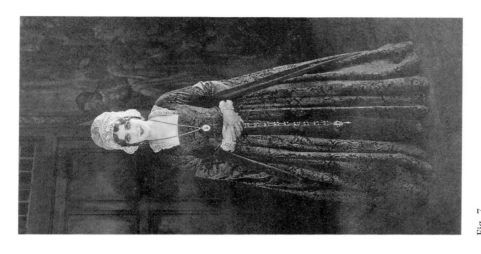

Fig. 7
Mary Pickford in
Dorothy Vernon of Haddon Hall (United
Artists, 1924).
Costumes by Mitchell Leisen

Opposite:
Irene Forsyte [Greer Garson]
That Forsyte Woman (M.G.M., 1950)
Costume sketch by Walter Plunkett

1920s

In period films in the 1920s, such as *Dorothy Vernon of Haddon Hall* (1924), *Orphans of the Storm,* and *Monsieur Beaucaire,* the costumes emphasize the tube-shaped silhouette that prevailed throughout most of the decade.

The elaborate costumes used in the film *Dorothy Vernon of Haddon Hall,* starring Mary Pickford and with costumes by Mitchell Leisen, were based on portraits and paintings of the Tudor period, as well as on descriptions and illustrations such as those found in Max von Boehn's scholarly book, *History of Costume.* As a result many of the details, such as padded pleats at the hips and wired lace collars, are authentic.

Pickford, however, was provided with clothing that was much more lavish than her character would actually have been able to afford. According to Leisen, one of her dresses cost $32,000 and was embroidered with real pearls.[15] Also, despite Leisen's stated concern with authenticity, some elements of the wardrobe had little relation to the film's setting. The small lace cup and cuffs worn with one costume resemble more closely a form of French folk dress than they do anything worn in Tudor England. Other dresses from the film had panes of fabric on the sleeves, imitating the slashed garments worn throughout most of Germany and other parts of northern Europe at the beginning of the sixteenth century.

A major obstacle to achieving an accurate sixteenth-century look was the impossibility of obtaining genuine period silks and brocades, which were largely responsible for the period's fashionable shape. The fabrics used by Leisen were those available to him in the early 1920s. For several dresses he used heavy metallic brocades, which were probably originally intended to be used as furnishing fabrics. The silk brocades and velvets of the Renaissance were both soft and firm, enabling the wearer to appear rigid and formal but still move with grace. Furnishing fabrics are too unyielding to achieve this graceful effect.

Another gown in the film has long, flowing sleeves and is made of a soft silk velvet printed with a modern design based on Renaissance shapes. There is no evidence that any kind of corset or shaped undergarment was worn, and there is no boning in the bodice, though both were essential elements in sixteenth-century England. The dress fits perfectly over the flat-chested, thick-waisted figure of the 1920s belle.

In *Orphans of the Storm* and *Monsieur Beaucaire* also, the typical 1920s tube shape prevails in the costumes for the female characters. In neither film were corsets used.

Set during the French Revolution and starring Lillian and Dorothy Gish, *Orphans of the Storm* attempts a sense of period by adding flimsy little side hoops to the familiar 1920s straight up-and-down look. These "panniers" look like bits of wire hastily stitched into place and extending out about eight inches from just below the hips; they bear little resemblance to the substantial cane or steel structures—sometimes extending several feet—used in eighteenth-century France. In several scenes the viewer can even see them blowing in the wind.

In *Monsieur Beaucaire* too the women are portrayed as having the boyish figures that were the ideal of beauty for women in the 1920s. While the film takes place in mid-eighteenth-century France, when women wore a low-cut decolletage with a slight swelling of the bosom at the top of the corset, Bebe Daniels's breasts are completely obscured through the positioning of the neckline in the ideal place for 1924, several inches higher than the style worn by fashionable women in the mid-1760s. The costumes' scoop necklines, edged with rows of shirred chiffon, are strictly a 1920s fashion device. The neckline in the time of Beaucaire was straight across the front, with the vertical edges of the neck opening creating a trapezoid. The film costumes make no attempt to re-create the V-shaped bodice with the narrow waist, which in the eighteenth-century prototypes was emphasized by the expanded skirts supported by panniers (also called side hoops). In the actual period dress these hoops did not extend from the front or the back but only from the hips. The skirts in the film are bell-shaped and recall the antebellum South more than eighteenth-century France.

Both *Monsieur Beaucaire* and *Dorothy Vernon* reflect an Art Deco style. In *Monsieur Beaucaire* the skirts and dresses are covered with decorations that could only have been created in an atmosphere strongly influenced by the Ballets Russes, George Barbier, and Erté. The decorative devices used are totally unrelated to anything from the eighteenth century, but they looked perfectly acceptable to the moviegoing public in 1924. But no matter how decorative and cluttered a dress might be with trimmings on trimmings, the underlying shape was always the straight up-and-down form that pleased the aesthetic sensibility of people in the 1920s.

1930s

A host of period films was produced during the Depression. Many were set in the antebellum and the American Civil War periods, including *Secrets* (1933), *Little Women* (1933), *Ramona* (1936), *Charge of the Light Brigade* (1936), *In Old Chicago* (1937), *Suez* (1938), *Jezebel* (1938), *Juarez* (1939), and of course *Gone with the Wind*. A number of others, such as *Queen Christina* (1932), *The Barretts of Wimpole Street* (1934), and *Marie Antoinette*, portray noted figures of the remote and seemingly glamorous past, depicting the periods as elegant and luxurious. The moviemakers consciously chose this stylized approach to history; they were offering an imaginary alternative to everyday life, transporting both young and old to the seventeenth- and eighteenth-century courts of Europe and seemingly safe and stable Victorian England. For these films to succeed, it was necessary to re-create the past with as much detail and authenticity as possible.

Marie Antoinette is perhaps the most comprehensive attempt Hollywood has made to show life in the eighteenth-century French court. Press releases touted the extremes to which M.G.M. went in order for everything to be as authentic as possible. Fifty women were brought to Los Angeles from Guadalajara, Mexico, to sew on thousands of sequins and do the elaborate embroidery used on many

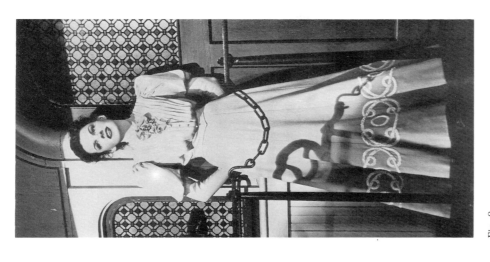

Fig. 8
Judy Garland in *The Harvey Girls*
(M.G.M.. 1946).
Costumes by Helen Rose

of the 2,500 costumes. Scouts were sent to Europe to locate authentic period furniture and fabrics for the production. Costume designer Adrian scoured books on the period and based some of Norma Shearer's costumes on surviving portraits of the queen, including one by the portraitist Elisabeth Vigée-Lebrun.

Never were dresses larger than in the time of Marie Antoinette, sometimes attaining a width of more than six feet. The understructure for Norma Shearer's enormous gowns had to be constructed in the studio's machine shop, and a special dressing room was placed on the sound stage as the heavy, awkward costumes were difficult to maneuver.

Although the costumes captured the physical scope of the period dress, the silhouette was compromised because of the contemporary aesthetic and the image of the star. In the 1930s bare shoulders were considered attractive, and Shearer had a beautiful pair of them. Adrian cut her gowns to emphasize them, ignoring the fact that bared shoulders never appeared in fashionable society in eighteenth-century France. Also, because Shearer was concerned that she was too high-waisted, the designer lengthened the bodice rather unnaturally and expanded the side hoops to an extreme. The exaggerated long waist of Shearer's gowns made the wide hips of the period look even wider. The shape of skirts in the court of Louis XVI tended to be more boxlike than the version seen in the film.

Many of the fabrics used were specially woven in Lyons, France, but contemporary influence still slipped in. In the grand ballroom scene Shearer's dress is adorned with an arrangement of bias-cut swags of silver tissue. Fabrics cut on the bias were not used as dress ornamentation in the eighteenth century; they were an almost obligatory element of fashion in the 1930s. This strange anachronism went largely unnoticed by the adoring public, who were accustomed to its presence and who were probably mesmerized by the excessive display on the screen.

1940s

The restrictions on international trade and the clothing demands imposed by World War II sparked a revolution in textile technology. A multitude of new processes for producing fabrics was developed in this decade. Traditional fabrics continued to be used but in new ways. These changes improved the designers' ability to simulate the past but also increased the potential for error arising from the use of fabrics that had no relation to the period.

Such problems occur in the designs for *The Harvey Girls* (1946) and *Bride of Vengeance*. For the former, costumes were designed by Helen Rose, a designer of retail fashion who also created wardrobes for a number of period films. She sometimes had difficulties in divorcing herself from the kinds of fabrics she used in her commercial fashion line. The shaping of the garments in the film appears quite accurate, and the mandatory leg-of-mutton sleeves are everywhere. However, in several of the dresses the use of thin wool crêpe for this kind of sleeve resulted in the heavy supporting pad, inside at the shoulder, being visible

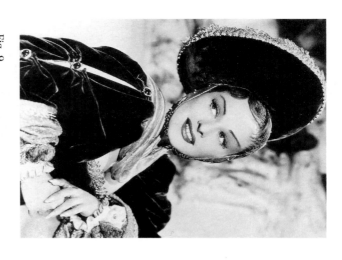

Fig. 9
Paulette Goddard in *Bride of Vengeance*
(Paramount, 1949).
Costumes by Mitchell Leisen and Mary
Grant

when the figure was standing in front of a light source. In the 1890s sleeves of this type were lined with a fabric that rendered them opaque. The point of the style was to form a broad horizontal plane across the shoulders to counterbalance the width at the hem of the skirt. In the film costume the thinness of the arms, visible through the wool crêpe, destroyed the intended period effect.

The misuse of modern material is more obvious in *Bride of Vengeance*, designed by Mitchell Leisen and Mary Grant. Careful attention was paid to the use of "mi-parti" garments, an armorial device indicating family affiliation which was developed in the late Middle Ages and became common throughout Europe. This style required that portions of the garments be cut from cloth of different colors or designs. For example, one leg of a pair of stockings might be blue and the other yellow. The tunic or robe could be similarly divided.

Many of the mi-parti tights seen in *Bride of Vengeance* are made from a fabric developed only two years before the film's release. It combined a stretchy material (Lastex) with an aluminum foil yarn coated with plastic (Lurex), a metallic thread allegedly having "all the richness and allure of the ancient Orient . . . plus adaptability to modern manufacturing."[16] While the tights had an appealing, form-fitting look, the wool stockings worn in the Renaissance were less fitted and baggier.

Costumes in *Bride of Vengeance* reflect the contemporary aesthetic in two other significant ways. Although the men's tights suggest an early Renaissance look, there is no attempt to reproduce any form of a codpiece, a pouch placed over the male genitals. Leisen wanted the actors to wear them, because "that was the period. . . . We made them up and tested that way," he said, "but the studio was not about to allow it and in the end they just wore tights."[17] An even more glaring anachronism is Paulette Goddard's large velvet hat, tied underneath with a scarf. It is set at a rakish, asymmetrical angle and is perfect for the fashion of 1949, but it is wrong for the early sixteenth century.

In spite of these anachronisms Leisen achieved a high degree of authenticity, even reproducing a relatively accurate period silhouette. In other period films of the 1940s, however, one often sees the shoulder pads and narrow hips that typify that decade's fashionable look.

When designing costumes for *Centennial Summer* (1946), Hubert re-created a "princess-line gown," the high fashion of 1876. The shape was a smooth, fitted garment from the shoulders to just above the knees, a form compatible with smart women's clothing of the mid-1940s. In Hubert's version the startling feature is the inclusion of shoulder pads! Of course they were required wear in the 1940s, when even flimsy evening gowns sported them. What they did to the aesthetic of the gowns in *Centennial Summer* was to add a horizontal emphasis at the shoulder.

In *Little Women* (1948) Plunkett, renowned for his attention to detail, avoided the shoulder-pad pitfall. But in spite of all the careful research done by this most talented designer, the cut of the bodices is not that of the late 1860s. In

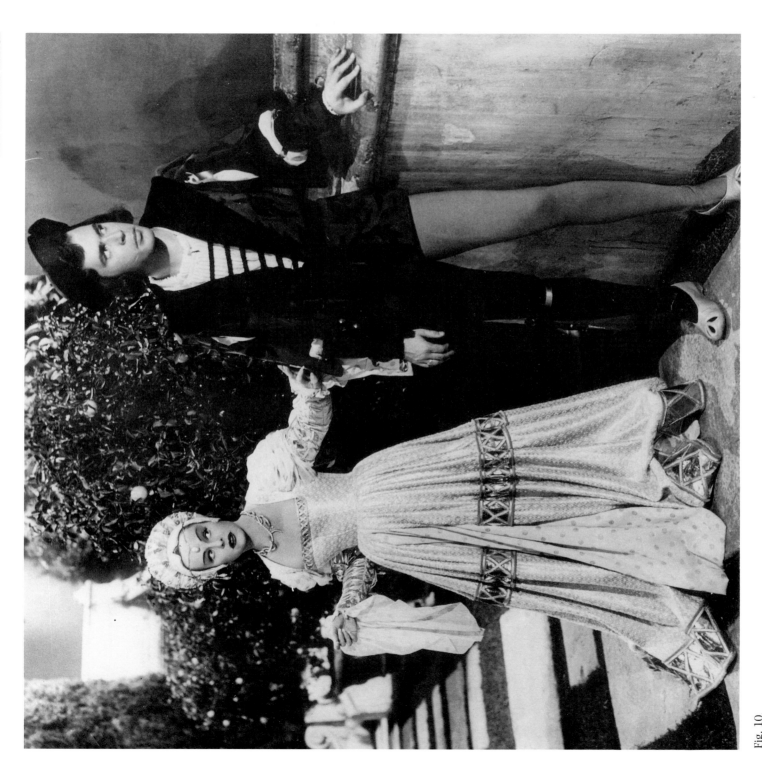

Fig. 10
Still from *Bride of Vengeance*

the late 1940s ladies' garments were cut to conform to the breasts, not for the breasts to conform to the garment. For the film costume a seam was cut from the shoulder to the waist following the shape of the breast. This device began to be used in the late 1930s and was a favorite of Plunkett's. He used a similar treatment in *That Forsyte Woman*, a film set in about 1880. In this case the period silhouette, the long princess-line of the dress with no waist seam and only slight emphasis on the breasts, was compatible with the high fashion of the late 1940s. Even though shoulder pads were not used, the designer could not resist emphasizing that area with shaped velvet appliqués.

1950s

More period films were produced in the 1950s than in any other decade of motion picture history. The search for "authenticity" became an obsession, and no amount of research was considered too extreme. But authenticity rarely involved abandoning contemporary standards.

The conflict between past and present can be seen vividly in the design process for *The President's Lady* (1953), starring Susan Hayward and set in the first decades of the nineteenth century. "The nicest girls would look like hussies today if they wore the flagrant décolletage of the period,"[18] said Renie Conley, the costume designer for the film, so she cheated on the neckline, making it less risqué.

Even with this adjustment the designer's dedication to history had the director, Henry Levin, worried and was a source of controversy. "The nude-look black chiffon over ice blue Empire gown Susan wore during the smoking

Fig. 11
Greer Garson in *That Forsyte Woman* (M.G.M., 1950).
Costumes by Walter Plunkett

scene drew wolf whistles from the cast and crew and admonishment from director Levin about not bending over." While there was some discussion of further alterations, "Miss Hayward, whose natural attributes were set off to advantage in her gowns, impishly murmured, 'but this neckline is authentic!' and won her point."[19]

While in this instance authenticity enabled the costume to emphasize aspects of Hayward's appearance that were considered provocative in 1953, designers frequently compromised authenticity if it did not coincide with the contemporary aesthetic.

Such a compromise can be seen in *Désirée* (1954). The film, a $4,000,000 tribute to Napoleon, took Marlon Brando out of his blue jeans, reported *Time* magazine, and jammed him, literally and aesthetically, into Empire tights.[20] Designer Hubert, brought from Paris to design the Directoire costumes for the film, created tableau after tableau, all based upon the plethora of surviving paintings of the time, including those by Paul Delaroche, Jean-Auguste-Dominique Ingres, and Pierre-Paul Prud'hon.

According to one article, the director, Henry Koster, "has been wary of slavish imitation. At no time does Brando sneak a hand inside his vest. But with built-up nose, exaggerated foam-rubber waistline and extraordinarily accurate uniform, the actor seems more like the Emperor than the Emperor himself."[21] The campaign coat was aged, the buttons cast from originals, and the boots made extra thin so Brando's feet would look as small as Napoleon's.

Fig. 12
Marlon Brando and Jean Simmons in *Désirée* (Twentieth Century-Fox, 1954). Costumes by René Hubert and Charles LeMaire

Fig. 13
Bette Davis and Richard Todd in *The Virgin Queen* (Twentieth Century-Fox, 1955).
Costumes by Mary Wills and Charles LeMaire

But despite this striving for authenticity, the waistlines in the women's costumes are not accurate for the period. The initial costume sketches for the film capture the unusually high waistline of the period, but they were not successfully translated into finished garments. The fashionable waistline in the early 1950s was close to the natural one, very different from the Napoleonic female fashion, which pushed the bosom up under the chin and often had bodices of only an inch or two. The ideal beauty of the day would have looked artificial and distracting to an American audience in 1954.

Among period films *The Virgin Queen* (1955) stands out for its historical accuracy. In Bette Davis's second movie as Queen Elizabeth I her portrayal broke new ground in Hollywood makeup and hairstyle. For the sake of authenticity she wore thick white makeup, and in one scene donned a rubber cap to appear bald. (See Chapter II for a more detailed discussion.)

The film went to great lengths to capture the artificiality of fashionable dress in Elizabethan England. Appearing as the embittered and idiosyncratic queen, an old woman haunted by spinsterhood, Davis was dressed in elaborately wired and starched lace collars, a long-waisted, rigid bodice, and a plate-shaped farthingale. But when the film has to present a portrait of beauty, it shifts back to the 1950s aesthetic. Queen Elizabeth's rival for the heart of Sir Walter Raleigh is the younger and more attractive Beth Throckmorton, played by Joan Collins. Her makeup and hair are basically contemporary. Her costume was of gray wool, a fabric of great popularity in the 1950s. The sleeves and the skirt are accurate, but the shaping over the chest is strictly 1954—the lifted and separated look, the result of the most recently developed bras. The dress lacks the stiffness that is present in Davis's costume.

Throughout the 1950s costume designers' approaches to the female silhouette are remarkably consistent.

The epitome of high style, posture, and shape of the early 1950s can be seen in the costumes for Susan Hayward in *Demetrius and the Gladiators* (1954), which are based on Roman sculptures, mosaics, and other works of art. In the original renderings by sketch artist Adele Balkan the figure appears with the hips jutting forward and the bosom bared. The 1950s aesthetics, which promoted the use of cinch belts and lifted and separated breasts, intruded into the conception of Roman attire. Roman women, in contrast to the earlier Greeks, wore shaped undergarments, which can be detected in a careful examination of surviving sculptures and paintings.

In *King Richard and the Crusaders* (1954) Virginia Mayo wore a form-fitting gown made of a modern synthetic metallic fabric, cut to display her distinctly separated breasts. Clothing in the Middle Ages actually consisted of somewhat shapeless garments for both men and women. Several centuries later the sixteenth-century duchess Diane de Poitiers would have worn a heavy, restricting corset, which would have flattened her bosom and given her a tapering, tubelike shape. But again the Hollywood version, worn by Lana Turner in *Diane* (1955), has the lifted and separated look.

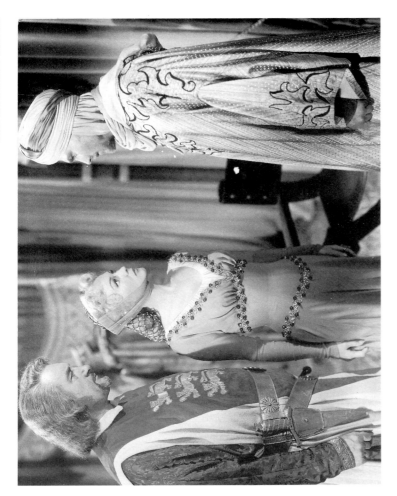

Fig. 14
George Sanders and Virginia Mayo in
King Richard and the Crusaders (Warner
Bros., 1954).
Costumes by Marjorie Best

In the 1960s a vastly different movie industry emerged. With the growing popularity of television, attendance at the movies dropped by millions. Thousands of movie theaters were closed. Skyrocketing costs reduced the number of films produced. As a result there were far fewer period films made, though Hollywood managed to produce several epics—most notably *Cleopatra*—and historical musicals. While costumes for these movies often achieved even greater authenticity than those in previous decades, they remained a mixture of past and present.

Despite inaccuracies in period costuming these films undoubtedly influenced our perception of history. As Scarlett O'Hara, Vivien Leigh still remains the popular archetype of the nineteenth-century Southern belle. Cleopatra and the image of Elizabeth Taylor are inextricably linked in the minds of many Americans. These movies, along with other sources, shape popular notions of historical dress.

In some respects period film is simply another device in humanity's continual effort to discover its past. In the Middle Ages, for example, period plays depicting the lives and miracles of the saints provided people with glimpses of the past. Sculptors and painters in the early Renaissance were inspired by Greek and Roman sculpture and other artifacts; they frequently tried to portray figures from these periods in an authentic fashion. This concern with accuracy in costumes led to scholarly works on the topic. The first publication on the subject of Classical dress appeared in Paris in 1536.[22] Almost thirty years later in Venice Bertelli published the first book of regional costumes,

based on drawings by Aneo Vico. By 1590 Vecellio had published his now-famous costume book, which includes not only foreign dress, but clothing from the past. Renaissance scholars were fascinated with these images, and books such as these allowed artists to create historical paintings for the glory of their patrons. In the ensuing centuries more and more works appeared on the topic, and there are now libraries devoted specifically to the history of dress.

In the twentieth century a new technology and art form—motion pictures—has enabled people to take this re-creation to greater lengths than ever before. Film has inspired people to create exact replicas, striving to re-create stitching, fabrics, and other minute details. Even more importantly this new medium allows the viewer to see how costumes move, how they look surrounded by the proper environment, how they look in living color, how they look close up.

Despite advances in costume reproduction permitted by film technology, the designer, like the sculptor, painter, or even the historian, works within physical, social, and aesthetic limits to make a creation acceptable and comprehensible by contemporary standards. Because of these different factors, a work of art inevitably carries the stamp of its time, the response to the aesthetic of the day. Ultimately a viewer can distinguish between costumes from two *Cleopatra* films, one made in 1934, the other in 1963, just as a scholar of art history can distinguish between a sculpture of a Roman warrior from the first century AD and a sixteenth-century version of the same subject.

The sketches and costumes in this book represent a previously untapped source for understanding how we look at history. Many of these works echo our imaginations, showing costumes and dress that we may have thought to be authentic. By confronting these images and their flaws, we can see the bias in our historical visions and better understand the limitations we have in trying to see the past as it truly was.

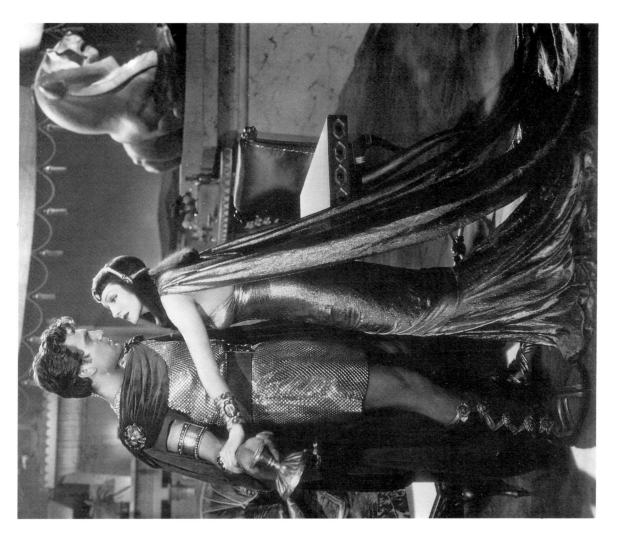

Claudette Colbert and Henry Wilcoxon in *Cleopatra* (Paramount 1934). Costumes by Travis Banton, Ralph Jensen, and Mitchell Leisen.

The Three Faces of Cleopatra

Text based on contributions by Alicia Annas, Satch LaValley, and Edward Maeder

Cleopatra, the Egyptian queen who captured the hearts of Julius Caesar and Marc Antony, has inspired a host of moviemakers to retell her story again and again. Three portrayals of her have left a lasting mark: Theda Bara's in 1917, Claudette Colbert's in 1934, and Elizabeth Taylor's in 1963. All three women shared many of the same exotic costuming devices, but ultimately each one created a portrait that was distinctly a product of her contemporary aesthetic.

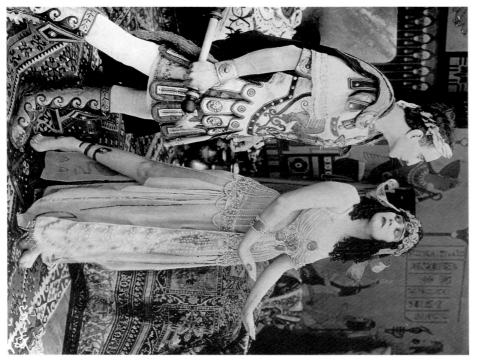

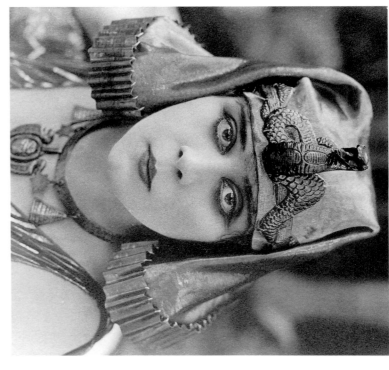

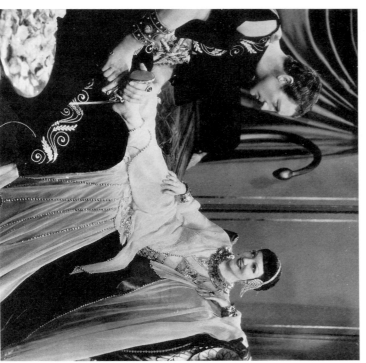

Theda Bara in *Cleopatra* (Fox Film Corporation, 1917). Costume designer unknown

Above: Warren William and Claudette Colbert in *Cleopatra* (Paramount, 1934).

Left: Fritz Leiber and Theda Bara

No prints of the 1917 version of Cleopatra exist today. Based on surviving stills, however, one can see that the costumes, hairstyles, and makeup were more in line with Theda Bara's contemporary screen image than with the dress for a queen of ancient Egypt (left). The next two Cleopatras (Claudette Colbert, right, and Elizabeth Taylor, far right) made more of a fanfare about being true to history, each production touting its sets as being highly authentic; but they were also highly sanitized, band-box fresh versions devoid of any realistic dirt. They had exotic, stylized costumes of varying degrees of accuracy, and the hair and makeup, like the earlier version's, were suited to the stars' images.

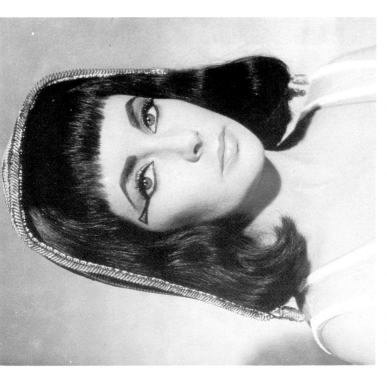

Elizabeth Taylor in *Cleopatra* (Twentieth Century-Fox, 1963). Costumes by Irene Sharaff, Vittorio Nino Novarese, and Renie Conley.

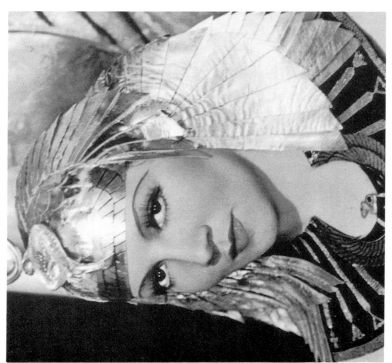

Claudette Colbert

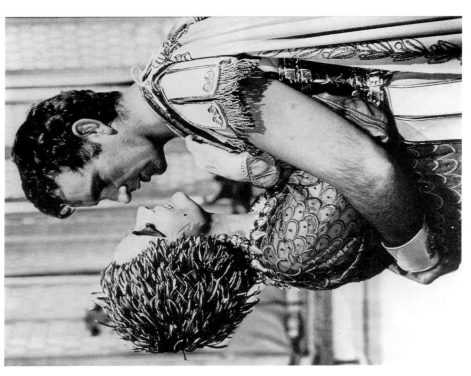

Elizabeth Taylor and Richard Burton

The common denominator in all Cleopatra films is feminine allure. Each of these stars seduces Caesar, Marc Antony, and her audience in her own particular fashion, as one can see in the accompanying photos. Bara's Cleopatra gives her Julius Caesar (Fritz Leiber) the "come hither," as she strikes a classic vamp pose. Colbert by contrast is quite relaxed, playing "footsie" with her Caesar (Warren William). Last, but certainly not least, Elizabeth Taylor plays the Egyptian queen in her characteristically voluptuous style and is taken up by Marc Antony (Richard Burton) in a passionate clinch.

Each of the Cleopatras has a hairstyle typical of the period in which the film was made. As was common in the 1910s and 1920s, Bara's hair completely covers her forehead. In one scene she wears sausage curls (far left). Both Colbert (left) and Taylor (upper right) wore smooth, black, pageboy wigs with straight bangs. Each ignored the historical fact that her wig would have been curled tightly; that beneath the wig her head would have been shaved; and that she would have lathered her scalp with luxurious, perfumed oils to give it a sexy shine. So much for history!

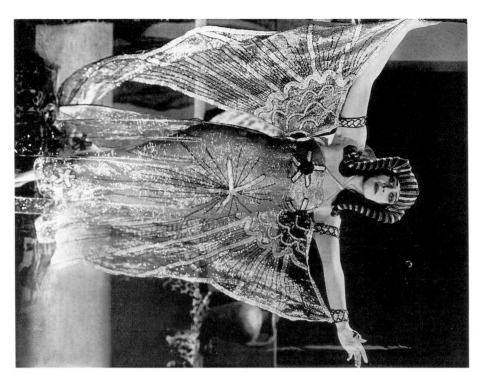

Above and opposite: Theda Bara

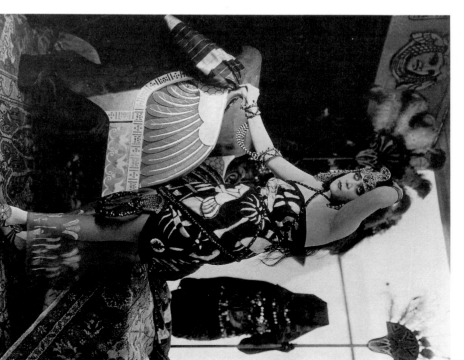

Silent-screen "vamp" Bara was a natural choice for the Queen of the Nile. In the 1910s one of the most important fashion influences was the style of the femme fatale, or vamp, and no one personified it better than she. She wore paste bangles and slave bracelets long before the modern concept of costume jewelry and, indeed, her sequined overskirts, jeweled stomachers, and beaded shawls helped to set the stereotype for a host of exotic screen ladies yet to come.

There is no known costume designer for the 1917 Cleopatra, and much of the costume design, hairstyling, and makeup may have been done by the performers themselves. Bara wore metallic fringes, pearl-embroidered brocades, and rhinestone-encrusted chiffons. Her ideas about such decorative devices undoubtedly came from a variety of sources, including Leon Bakst's designs for the Ballets Russes, Paul Poiret's orientalism, and George Barbier's drawings for the periodical La Gazette du Bon Ton, all initially introduced in Paris.

While these clothes were exciting to see on the screen and certainly did not resemble everyday wear, they did not represent serious attempts to re-create period dress. Many of Bara's costumes were made of lace, even though such material did not exist in Cleopatra's Egypt. (It was first produced in Italy at the end of the sixteenth century.) Large quantities of pearls were used in the film, worn as jewelry and embroidered into her dresses. The Egyptians had developed sophisticated jewelry techniques, using gold and precious stones as well as enamel and ceramics, but pearls were a rarity. They were, however, the vogue in 1917, and during the next few decades continued to be used in costumes for films depicting ancient times. Bara's makeup, typical of the silent era, was heavily applied in contrast to the more subtle styles used for Colbert and Taylor.

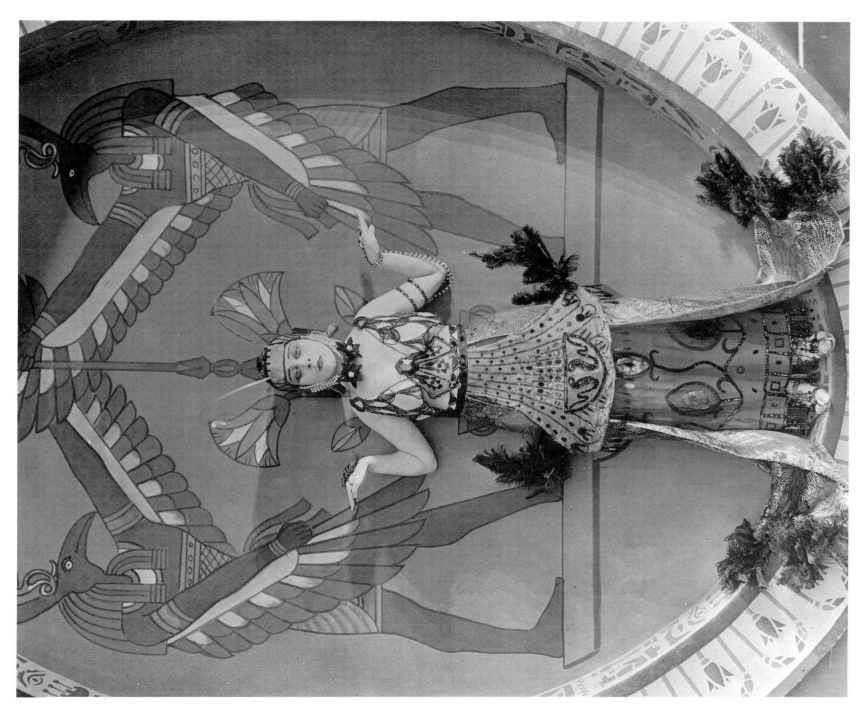

"Handmaiden" and Gertrude Michaels

Claudette Colbert

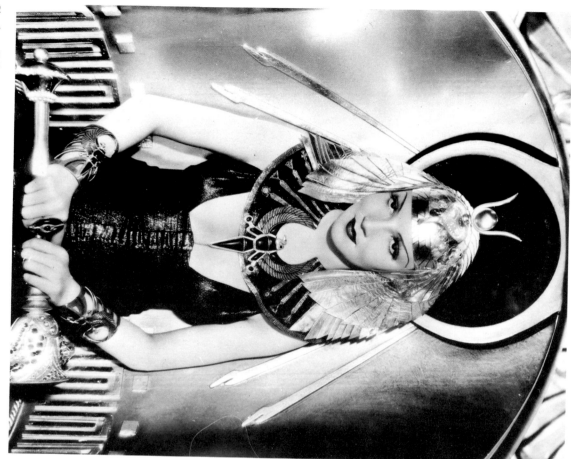

Cecil B. De Mille directed the 1934 production, and he turned the Cleopatra-Marc Antony-Julius Caesar romantic triangle into a fanciful art deco spectacular. He filled the film with the lush exoticism that was his trademark: feathers, gold, glittering jewels, and scantily clad young maidens.

Colbert's Cleopatra makeup was the pure 1930s glamor formula with thin, plucked brows, heavy glamor lashes, dark shadow on the lips, and vividly colored, full, rounded lips. In September 1934 Maybelline cosmetics ran an intriguing ad for "alluring eye makeup" which featured the face of the historic Cleopatra beside a modern woman's face. Although no names were mentioned, it bore a striking resemblance to Claudette Colbert.

Dresses in the 1930s were often cut on the bias, and this smooth, clinging style seemed particularly well suited for this setting and story. The bias-cut gown (below), worn by Gertrude Michaels as Calpurnia, would have been just as appropriate at a Hollywood party in the 1930s. The wavy hairdos of Cleopatra's handmaidens (right) are also quite contemporary. As the true Cleopatra lived in North Africa it is doubtful that her handmaidens were blondes, but this point did not deter De Mille from including several in the movie.

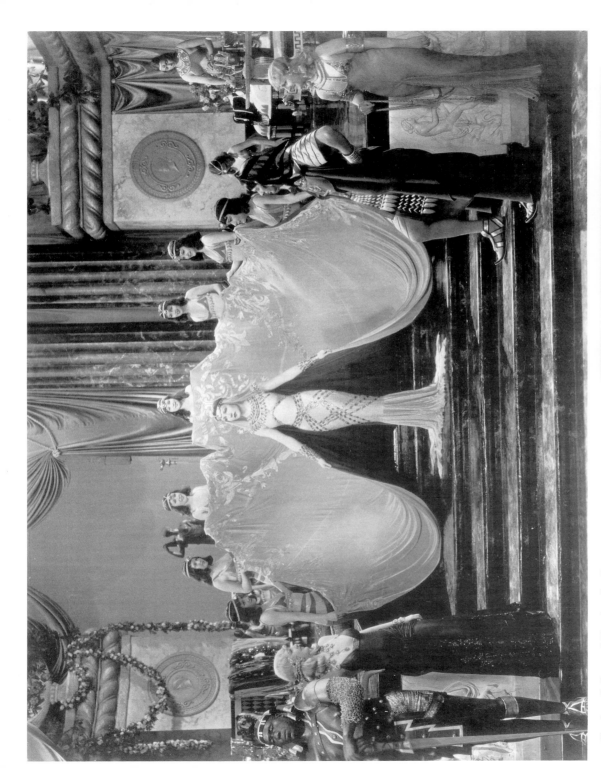

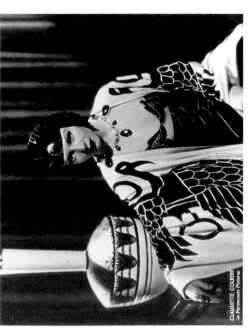

Claudette Colbert and "handmaidens"

Colbert wore at least three wigs in the movie. The one seen most often was a smooth pageboy with ends curled under in 1930s fashion and straight bangs across her entire forehead (see p. 43). One scene showed her in a short, bobbed version of this wig with an art deco winged headdress (right and upper left). In another scene she wore a bird of paradise feather wig (above). Two years earlier Colbert wore an identical version of the longer wig as the wicked Roman Empress Poppaea in The Sign of the Cross. Perhaps this wig influenced her fondness for bangs, because she wore a wig with bangs in It Happened One Night, also 1934, and bangs soon became a trademark of her image in a decade when bangs were not highly fashionable.

Claudette Colbert

Dancers in procession, *Cleopatra* (Twentieth Century-Fox, 1963).

Right: Isabella Cooley

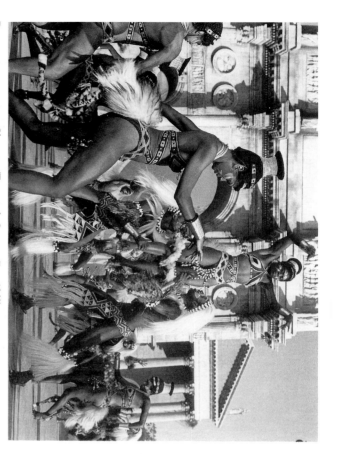

Makeup test for *Cleopatra* (1963)

Woman in banquet scene

The 1963 *Cleopatra*, a gargantuan production directed by Joseph L. Mankiewicz, is one of the most expensive films ever made, and its costumes were a significant part of the budget. Among the outfits that were used were the generic "African" costumes (above), which are representative of the exotic and lavish ensembles that appeared in the film. Taylor alone had sixty-five costume changes (and this does not include forty costumes and headdresses that were not used in the final version.) While the film's wardrobe was based on extensive research, there are a number of elements that clearly reflect the early 1960s aesthetic. For example, the average measurements of the handmaidens were 37-24-36, measurements that bear little resemblance to the stylized vertical figures seen in 48 BC.

Designer Renie Conley created softly wrapped, togalike garments and easy-flowing caftans for the handmaidens (above). The typical costume was, for the most part, a simple rectangular length of fine hand-loomed cotton or semitransparent souffle wrapped or draped on the body. It was perfectly in tune with the 1960s trend toward body-consciousness. Women's Wear Daily considered these outfits the most influential clothes in the picture, and replicas began to appear in leisure wear, beach attire, and evening dress.

Capitalizing on a contemporary trend toward more conspicuous eyes, Taylor's makeup incorporated the historical Egyptian fashion of brows and eyes thickly outlined with black and heavily shadowed lids and sockets, as can be seen in the makeup test left above. This style, in turn, accelerated the popular fashion for exaggerated eye makeup in the second half of the 1960s. It is interesting to note, however, that Taylor's lips, instead of reflecting the bright henna color of ancient Egypt as might be expected, were painted in the fashionably subdued hues of the 1960s, which subordinated the lips to the eyes.

The most noticeable 1960s touch is the combination of hairstyles. Some are based on historic research. Others, however, are not and could have been worn to any society gathering in any major American city. What we now refer to as the Vidal Sassoon look was found throughout. There are even versions of the beehive style (left).

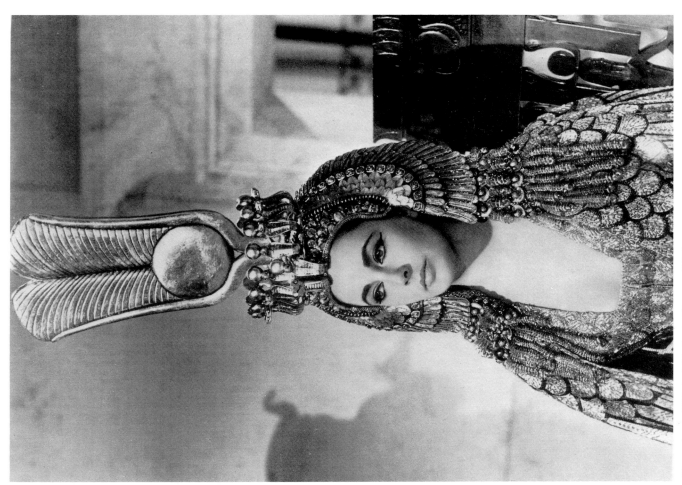

Three views of Elizabeth Taylor in *Cleopatra* (1963)

Taylor's outfits were widely discussed in the press, with some controversy over close-up shots of her breasts. The necklines in many of her costumes were cut to expose her cleavage (see left). Such emphasis is not in keeping with the renderings of clothing seen in ancient art. The waist seam seen in many of Taylor's gowns is similarly contemporary. Despite these digressions from history, audiences found Taylor's portrayal convincing. As with the other two Cleopatras she evoked the ancient past while incorporating the stylistic influences of the day.

Taylor wore a variety of wigs. Besides her black pageboy, which was a little bit fuller on the sides than Colbert's and more accurately accessorized, she wore a version of the Hollywood beauty-queen wig (layered in 1960s fashion below); a chic 1960s chignon piled on top of her head with separated bangs for her bath scene; and an artfully curled postiche for the banquet with Marc Antony on the royal barge.

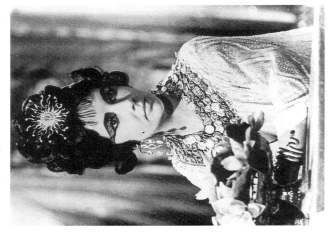

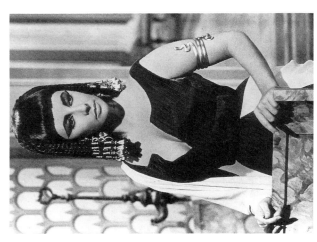

Fig. 15
Rudolph Valentino in *Monsieur Beaucaire* (Paramount, 1924).
Costumes by Natasha Rambova and George Barbier

II
The Photogenic Formula: Hairstyles and Makeup in Historical Films

ALICIA ANNAS

WHEN RUDOLPH VALENTINO exchanged his Latin Lover image for a white marcelled wig and eighteenth-century dandy's heart-shaped beauty mark, the result, *Monsieur Beaucaire* (1924), was a commercial disaster. Audiences during Hollywood's golden years expected a star like Valentino to be true to his established screen image regardless of the historical period of the film.

Hollywood moviemakers' use of makeup and wigs in films, both period and non-period, was usually inspired more by commercial considerations than by a concern for history. In the 1920s performers in movies became more than actors; they were "stars," whose charisma and appearance attracted thousands to the movie theaters. For the next three decades the "star system" functioned as the cornerstone of Hollywood's economic existence; a star's value to a studio was in direct proportion to the receipts that he or she was able to produce at the box office. And box-office appeal depended on the star's ability to project a screen image that audiences could admire, even love. Studio personnel were acutely aware that makeup and hair, those two most personal aspects of adornment, were key elements in creating a successful screen image.

Studios ruthlessly competed for photogenic faces with star potential. When they found one, they immediately tried to improve it by cutting and dyeing the hair and by reshaping the eyebrows, eyes, and lips. "Studio-resident dentists, expert at creating million-dollar smiles, capped teeth or fitted them with braces. Cosmetic surgery was often advised to reshape the nose of a new recruit or tighten [a] sagging chin."[1] Experts experimented with styles of makeup and hair until they found the right combination, the one which would have the maximum impact on fans. "No effort was spared to reinforce that indefinable attraction found in a Garbo, a Dietrich, a Crawford, a Hepburn."[2] The treatment was applied equally to women and men.

In their efforts to perfect stars' images, makeup artists developed a pseudo-scientific corrective makeup technique, based on the classical Greek ideal of beauty. According to this approach the ideal camera face, male or female, should be oval with features balanced symmetrically and arranged according to certain proportions. Vertically the face should be divided into three equal sections, horizontally into five eye widths. The mouth should be beautifully curved, slightly wider than the width of one eye. The upper lip should be a little fuller than the lower. Eyes should be large and open to brighten the expression; they should be an eye's width apart. (One popular way of "opening" the eyes

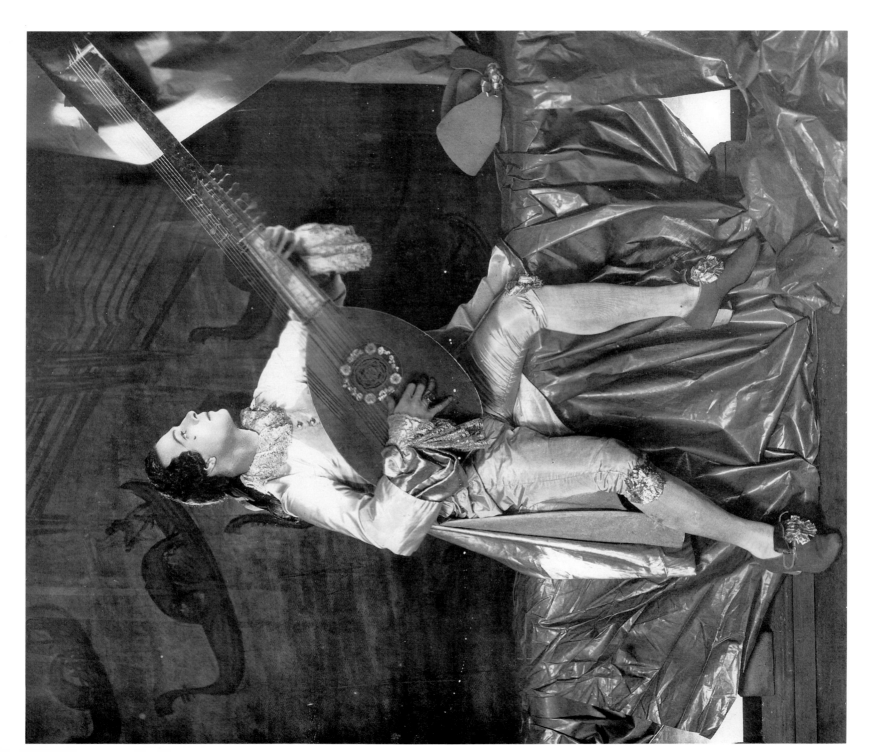

Fig. 16
Unidentified actress in formula makeup,
c. 1938.

was to raise and reshape the eyebrows and add false eyelashes and heavy mascara.) Eyebrows should be slightly arched and extend beyond the outer corner of the eyes.[3]

Not surprisingly very few human beings possess such an ideal camera face. But as *Photoplay* assured its readers, "There is a corrective formula for everything that is wrong with the feminine face. . . . The [makeup] miracle men know what it is. They put it to work. And they transform those who are average and a trifle above average into individuals whose attraction and charm circle the globe."[4] The makeup artists accomplished these transformations by adapting the age-old painting technique of chiaroscuro. They simply applied darker shades of makeup to those parts of the face they wanted to recede on film and added makeup highlights to those areas they wanted to appear more prominent. (This explains why so many female stars had overpainted lips and elaborately treated eyes.) Even today this technique provides the basis for most stage, screen, and fashion makeup, and it indelibly defined the modern screen image of each film star.

Once a star's image was established, it was carefully maintained. Neither studio nor star was willing to tamper with a successful image and risk losing box-office credibility. Particularly unpredictable was the impact of a period film like *Monsieur Beaucaire* in which historically accurate but unfamiliar styles of makeup and hair could so alter a star's image that a barrier would be created between audience and star. When for the sake of authenticity Ronald Colman was persuaded to shave his trademark mustache for the title role of an eighteenth-century diplomat in *Clive of India* (1935), Twentieth Century-Fox executives feared a repetition of Valentino's disaster. To their relief Colman's fans proved less fickle.

Audiences want to identify with the screen performers, even if the film is taking place in an earlier period that is unfamiliar to them. Viewers expect their heroes to look strong and handsome and their heroines beautiful and glamorous—in modern ways, not in historical ones. Thus while period films feature sets that are routinely authentic and costumes that are occasionally authentic, hairstyles and wigs are rarely authentic, and makeup never is. Despite these historical inaccuracies audiences believed that period movies presented true pictures of the past, as film makeup artists and hair stylists masterfully blended modern star images with illusions of historical reality.

The origins of film makeup and hair design have little to do with creating an illusion of history or a beautiful star image so much as preventing severe distortions of performers' faces on the screen and awkward cuts from scene to scene. In the early silent-film days it became clear that actors had to wear makeup and wigs, if they wanted to be filmed effectively. The filming techniques used in these movies exaggerated the actors' facial features, and the process of shooting scenes out of sequence demanded "continuity"—that actors' faces and hairstyles look exactly the same, even when different bits of a scene were filmed weeks apart.

The first filmmakers faced a serious problem: the projection of images onto large screens emphasized every detail of an actor's face and hair. A slight imperfection, which off-screen might give a face character, was magnified to an extraordinary degree. The camera close-up turned dimples into craters, freckles into polka dots, the tiniest blemishes into carbuncles. It made stray hairs stand out like lone trees on a moonscape.

The situation was further complicated by silent movies' reliance on arc lighting and orthochromatic film, a black-and-white film that was highly sensitive to all colors except red. (It turned red to black.) Since red is the base tone of most Caucasian skins and since most film actors were Caucasian, performers had to apply makeup very heavily to "hide the red corpuscles in the face that showed through under the arc lights and . . . caused the face to appear darker in the picture."[5] Arc lighting techniques also distorted the natural highlights and shadows of the face, intensified wrinkles, and made the face look older.

In trying to solve this dilemma, early filmmakers looked for help from the theater, which for centuries had used makeup and wigs. But the heavy greasepaint and thick wig hairlines, which projected so effectively across theatrical footlights, lacked the subtlety film required. Actors made do, applying thick theatrical makeup, but this device obscured facial expressions, making the face look flat and two-dimensional.

The person who single-handedly solved the problem was Max Factor, a young Russian immigrant who had been trained as a theatrical wigmaker and cosmetician and had worked for the Imperial Russian Court Opera of Czar Nicholas II.[6] Factor provided the breakthrough that allowed for a more realistic image on the screen, when in 1914 he created Flexible Grease Paint, the first makeup made specifically for motion pictures and the first natural-looking cosmetic to be used in film production. A thin greasepaint cream in a jar, it was based on existing theatrical products but was compatible with the orthochromatic film and arc lights used in silent film-making—a new makeup thin enough to look subtle on camera yet thick enough to cover the skin's natural red tones. This innovation eliminated the need for crude, heavy, plasterlike makeups and permitted facial flexibility on the silent film screen.

Until his death in 1938 Factor continued to devise and manufacture makeup and wigs that made performers' faces compatible with advances in film technology.

With the advent of talkies in the late 1920s radical changes occurred in both the filming process and film makeup. Arc lights, too noisy for sound stages, were replaced with tungsten lights, which did not sputter and hiss but were less bright. This made it necessary to change to a new type of black-and-white film, which would be sensitive to the softer tungsten lighting This film, called panchromatic, in turn required a new range of makeup colors. Accordingly Factor introduced Pancro makeup, a line of neutral-colored greasepaints, powders, rouges, liners, and pencils, all based on shades of tan or brown.

Pancro could be applied sparingly with subtle highlights and shadows to make the face appear more realistic. It reflected the correct amount of light for the sensitive new film, and it was not affected by the heat of tungsten lights.

When the Technicolor film process was introduced in the mid-1930s, it created a new set of makeup problems. Actors' faces turned green, bright red, or other colors on the screen, as the sheen of their grease makeup, even when powdered heavily, indiscriminately reflected nearby costume and set colors. Again Factor invented a brand-new product: Pan-Cake, a 100-per-cent-mat finish, greaseless, water-soluble makeup that was applied with a damp sponge. When it successfully stabilized skin colors in two 1938 films, *The Goldwyn Follies* and *Vogues of 1938*, makeup artists quickly adopted it as the standard makeup for Technicolor films.

As makeup became increasingly complex, its application developed into a specialized art. In the silent film days actors had followed theatrical tradition and applied their own makeup, but with the advent of talkies and panchromatic film, expert knowledge was needed to balance the colors of skin, makeup, lighting, and film—a skill far beyond the do-it-yourself capabilities of most actors. By the beginning of the 1930s makeup artists were included on every studio's staff.

The work of the makeup artist reinforced Hollywood moviemakers' insistence on using modern makeup in all films, even period ones, an attitude that persists to the present day. With experts on hand to supervise makeup, studio executives were able to take the star system to new heights. Makeup artists were expected to define and enhance the screen images of existing stars and to develop or build the images of potential ones. As the images became increasingly refined, the product of highly specialized corrective makeup techniques, fewer variations could be introduced, whether they were for historical accuracy or some other effect.

The popularity of the star image look limited the makeup artists' freedom to experiment with other cosmetic styles. By the early 1930s film stars were exerting as much influence off-screen as on. Legions of female fans, urged on by fan clubs and fan magazines like *Photoplay, Silver Screen,* and *Modern Screen,* tried to imitate the looks of their favorite stars. Cosmetic sales skyrocketed thanks to the influence of the film stars who made cosmetics socially acceptable for the first time in over a century. While in 1840 no respectable woman wore cosmetics for fear of being labelled a "painted lady," by 1940 no fashionable woman would be caught in public without her makeup. As the commercial demand for makeup increased, new products were manufactured and distributed, stars were used to advertise them, and magazines ran articles with instructions for applying makeup correctly. With access and instruction the average American woman could now make herself up like her favorite star. As screen and fashion makeup styles became more interconnected, both studios and stars ended up locked into a modern makeup image no matter what the period of a film. Anything else ran the risk of alienating the fans.

Film hairstyles, however, differed from makeup in their approach to the past and were not so dependent on the contemporary look.

Until the 1960s almost every film, whether period or modern, was wigged. This technique made sense both aesthetically and economically. Wigs saved the studio time and money by guaranteeing glamor, appropriateness, and continuity. In films it was particularly difficult to re-create exactly the same color, cut, and style of hair when scenes were shot out of sequence, often weeks apart. As soon as the film editor started to match up footage for a scene, any lack of continuity in hairstyle was distractingly apparent. Moreover "a female star [might] be scheduled to wear five or six different hairstyles during a day;" given the star's salary, it was "much more economical for her to slip on a . . . [wig] than . . . to spend a considerable portion of her day with a hairdresser or under a drier."[7]

Additional time was saved by carving balsa wood headblocks to the exact measurements of each actor's head. Whenever a role called for the star to be wigged, the hair department created and styled the wig on the headblock and only called in the performer for a final fitting.

The work of Max Factor & Co. established the standard for the film industry's approach to period hairstyles. Several years after opening his downtown Los Angeles theatrical cosmetics and hairgoods store in 1908, Factor rented the first completely human-hair wig to the film industry for Dustin Farnum in Cecil B. De Mille's first film, The Squaw Man (1913). De Mille was so impressed with the natural-looking result that he insisted that Factor do the wigs for his subsequent films. The excellence of Factor wigs was soon widely known, and for the first four decades that films were made in Hollywood the company "suppl[ied] every wig used in any studio at any time."[8]

The Factor company prided itself on furnishing "wigs that reflect realism . . . wigs that conform with the authenticity of any period . . . wigs with a realistic hairline effect that even the camera cannot betray."[9] The company could produce any type of hairpiece from any period in any degree of authenticity desired. It maintained an extensive research library devoted to period hair, "the most extensive collection of pictured heads and hairdos of all nations and periods of history in the country—perhaps in the world."[10] The most historically authentic wigs were those which created a male historical likeness—Abraham Lincoln, Buffalo Bill, Benjamin Disraeli, Andrew Jackson, and others—because studio, star, and wigmaker all had the same goal: to duplicate an historical portrait. However, in most period films the goal was simply to suggest a period in picturesque style while carefully preserving the star's modern image. Researchers tried to find period hair details that resembled modern styles closely enough to appeal to the fans.

The wigs most extensively researched by Max Factor & Co. were those for Joan of Arc (1948). Researchers spent six months gathering information before work began. The wigs for the male actors, including Jose Ferrer as the Dauphin, displayed authentic fifteenth-century bowl cuts with high-shaved napes. But

when Fred Fredericks cut Ingrid Bergman's wig for the scenes in which she played Joan dressed like a soldier of France, the resulting "Bergman Bob" bore only a nodding resemblance to fifteenth-century hairstyles. The wig, with bangs and sides obviously curled with 1940s curlers and controlled with hair lacquer, looked so chic that it became fashionable nationwide. It was an ingenious cut that successfully merged historical and contemporary styles. It maintained Bergman's natural-looking image; it satisfied her fans; and it blended with the more authentic styles worn by the men in the film.

Bergman's wig, however, would not have worked if the same film were made ten years later. The look produced by merging period elements with contemporary styles for hair, costume, and makeup varies with the time the film was made. Ideals of what make a face appealing are not constant; they change gradually. With hindsight it is easy to distinguish the fashionable look in makeup and hair design that each decade termed modern. (See chart on pp. 60–61.) And it is important to do so because when a potential star was given the standard studio buildup, one of the key steps in creating an appealing image was to have the studio makeup artist and hairstylist "correct" the candidate's face according to the modern style. It was this particular style that not only formed the basis of the star's initial public image but frequently became a career-long trademark.

When a star was cast in a period film, the studio faced a dilemma. While it was desirable that moviegoers believed that the historical image presented on the screen was indeed authentic, it was economically vital that the star's image was not sacrificed to history. In looking at how Hollywood moviemakers reconciled these two conflicting demands, one can see a systematic approach to the way they handled makeup and hair, combining stars' modern images with illusions of historical accuracy. I refer to this approach as the "formula."

For Hollywood male stars the formula for makeup in period films was very simple. It consisted of applying the minimum amount of makeup required by the physics of light and the chemistry of film to enhance an actor's natural features and to reinforce the on-camera impact of his eyes, creating a carefully crafted "no-makeup" look.

The formula for men's hair design consisted of four options. First, modern and period hairstyles could be combined. The period features would be modified so that when viewed from the front, the hairline looked modern with the sides groomed tightly to the head, while in profile, the sides and back assumed a conservative period length. In the second option a completely modern hairstyle could be used which supported the star's glamor hero image with no relation to history. Third, an authentic period style could be reproduced, but this option was rarely used except for character roles or historical likenesses. And fourth, facial hair (mustaches, beards, sideburns) could be added conservatively as befitted star and role.

The formula for female star makeup in period films was also simple. Since makeup was an integral part of the female star's image, modern corrective

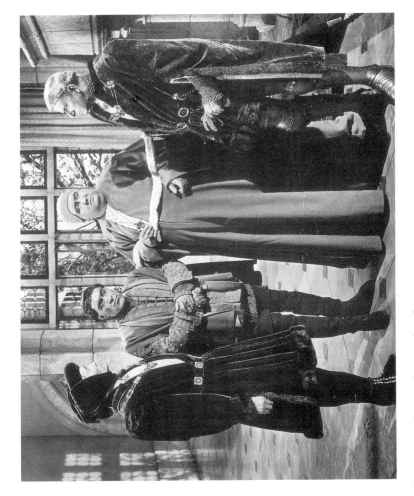

Fig. 17
Four actors in *Joan of Arc* (R.K.O.,
1948).
Costumes by Karinska, Dorothy Jeakins,
and Herschel McCoy

glamor makeup was used in every film, regardless of period. There was absolutely no attempt to make women's film makeup reflect history.

Because women's film makeup was always modern, their hairstyles had to follow suit to a degree. Hairstyles became the key visual component for merging the female star image and its modern glamor makeup with the historical illusion provided by costumes and settings. The formula for women's hairstyles provided three options.

First and most popular, a wig with recognizable period elements could be used as long as any extreme aspects of the period style were modified to reflect modern fashions. At times one period style would be superimposed on another period, if the second period style reflected the modern fashion more closely.

Second, modern and generic period hairstyles could be combined. Starting with a modern base, with the hair either up or down, generic switches, falls, braids, ringlets, chignons, or postiches could be attached in an inventive, glamorous, exotic manner that suggested the past in general rather than a specific period. In this option there developed a generic wig style, the "Hollywood beauty queen." This full-length wig was serviceable for every historical period with its center part, soft, layered crown or temple curls, and soft waves cascading to the shoulder or below. Norma Shearer wore such a wig in *Marie Antoinette* (1938) as did Hedy Lamarr in *Samson and Delilah* (1950), Susan Hayward in *David and Bathsheba* (1951), and Glynis Johns in *The Court Jester* (1956).

'MODERN' FASHIONABLE MAKEUP AND HAIRSTYLES

		1920s	1930s	1940s
WOMEN'S MAKEUP				
	Image/emphasis	Vamp eyes & mouth	Glamor eyes & mouth	Hollywood glamor/the mouth
	Color	Pale powder	Natural powder	Natural foundation & powder Pan-cake
	Eyes	Soulful shadow / Smudge-lined / Heavy, black mascara (no "spiked" lashes)	Lid shadow: light colors / Subtle lining of upper lid only (lifted outer corner of eyes) / Dark-brown mascara	Lid shadow: light colors / Brown socket shadow / By '47: eyeliner ("doe eyes") / Heavy black mascara
	Brows	Long, thin; black pencil drooped down at outer edges (sad-eyed look)	Long, thin; brown pencil / High, round curve (gave eyes "wide open" look) / By '36: brows arch w/ outer edges angled down	Medium thick; dark brown pencil / A "perfect arch" (outer edges angled out & up)
	Cheeks	Soft, high, round rouge	"Healthy"; blended rouge	Natural looking rouge
	Lips	Bright scarlet; narrow / Arched peaks: rosebud or bee-stung shapes	Bright reds: full; rounded & heart-shaped peaks (luscious looking)	Vivid colors; full (generous). / Enlarged & "corrected" with lipstick brush
	Misc.		From '32: beauty spots / Nail polish matches lipstick	Nail polish matches lipstick
WOMEN'S HAIR				
	Color	Brunette	Platinum blonde	War years: 1940-47, Brunette
	Length	Short "bobs"	Lengthens from chin to shoulders	Long—to shoulders / Upsweep
	Hairline	Beetle brows / Center & side parts / Low forehead waves, "naughty bangs", spit curls	Center & side parts / Hair brushed back off forehead / No bangs	Centre & side parts / Forehead curls / Bumper bangs
	Crown	Flat on top / Hair molds crown	To '38: flat crown / '38: upsweep w/ temple curls & tight clusters of curls	High crown: pompadour
	Sides & back	Hair hugs sides & back	To '38: fluffy side volume / '38: side rolls	Temple & side rolls / Smooth back
	Curl & style	Tight, finger-wave (esp. marcelled) / Straight & smooth	Relaxed finger-wave / Smooth page-boy	Fluffy pin-curl waves / Smooth page-boy w/ optional back snood / Top & sides pulled sleekly back to nape w/ gold barette
	Hairpieces	None	'38: curl clusters	Rats, curls, braids on crown
MEN'S HAIR				
	Grooming	Brilliantine	None	Hair lacquer
	Length	Long on top	Medium long on top	Medium long on top
	Hairline	Brushed back smoothly off forehead / Center or high side part	Brushed back smoothly off forehead / Side part	Brushed back smoothly off forehead / Side part
	Crown	Flat crown	Flat crown	Flat crown
	Sides	Medium long	Short sides	Slightly longer sides
	Sideburns	Short, trimmed	Short, trimmed	Short, trimmed
	Back	Medium long / High, trimmed nape	Medium long / High, trimmed nape	Medium long / High, trimmed nape
	Curl/Grooming	Straight: plastered-down "patent leather" look	Straight; natural waves on crown. / "Wet-look" hairdressing	Natural waves on top / "Wet-look" hairdressing
	Facial hair	Clean-shaven	Clean-shaven or thin mustache	Clean-shaven during war / Thin mustaches after war

	(1 9 4 0 s)	1 9 5 0 s	1 9 6 0 s
The eyes		The eyes	Conspicuous eyes
Foundation		Natural foundation & powder	Natural foundation & powder
Eye makeup		Lid shadow blends up into sockets Thin, black eyeliner extends "doe-eyes" at outer corners Heavy, black mascara concentrated on outer lashes	Lid shadow: multicolored. Extends up to brows Heavy, black eyeliner extends eyes at outer corners Heavy, black mascara False eyelashes
Brows		Thick; dark brown pencil Arched upward	Thick; black pencil; arched
Rouge		Natural rouge	Rouge high on cheekbone
Lips		Bright and soft pink colors Natural shape	Very pale colors, even white Natural shape
Nails		Nail polish matches lipstick	Nail polish
Hair color	New Look: 1947–9. Brunette/Redhead	Redhead/Blonde	All colors
Length	Short—to nose or chin Long—pulled tightly back and up	Short—to nose or chin Long—pulled tightly back and up	Very long
Part/bangs	Side parts Temple waves Side bangs	Side part or no part Natural lifted hairline w/ temple waves Early: short "mamie" bangs Late: layered bangs	Side part or no part Layered bangs & no bangs
Crown	Flat, smooth crown	Early: flat crown Late: beehive	High crown: back-combed Hairpiece added
Sides/back	Hair hugs sides Smooth back Long hair secured in chignon, French twist, or bun	Early: fitted cap look Late: long hair secured in chignon, French twist, or bun	Smooth
Styling	Smooth pin-curl waves "Polished look"	Early: pin-curls for soft wave Late: rollers for volume Early: poodle cut Late: smooth flip. Italian layered cut	Loose, roller curls Bouffant Gibson revival Geometric cuts
Hairpieces	None	None	Falls, switches, braids, postiches, chignons, etc.
Product	Hair lacquer	Hairspray	Hairspray
Men		Older conservative men—same as 1940s Younger men—new styles: Crew-cut Dutch-cut Flat-top The Elvis, D.A., pompadour, & long sideburns	Long hair all over Brushed forward w/ bangs '63: Beatles' Caesar or Mod cut Low side part or no part Blow-dry crown volume Long, covers ears Long Long, covers nape "Dry" look Hairspray
Facial hair		From '54: mustaches	Mustaches, beards: all kinds

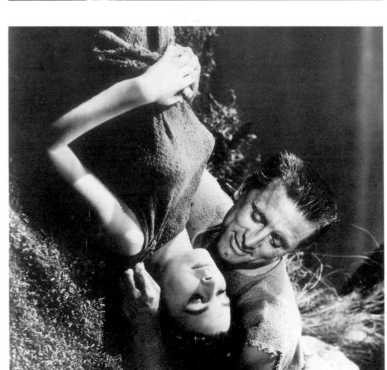

Fig. 18
Left: Ramon Novarro and May McAvoy in *Ben Hur* (M.G.M., 1926). Costumes by Camillo Innocente, Erté, and Harold Grieve

Fig. 19
Right: Jean Simmons and Kirk Douglas in *Spartacus* (Universal, 1960). Costumes by Valles, costumes for Jean Simmons by Bill Thomas, and wardrobe by Peruzzi

The third option was to use a completely modern hairstyle, pure star image, with no relation to history. Women rarely elected to use this option.

The persistence and versatility of the formula for appropriately adapting modern faces and hairstyles to the period film can be witnessed in films of almost any period from antiquity to the recent past.

Roman Empire

The 1926 silent epic *Ben Hur* required Max Factor & Co. to fill one of the greatest single makeup orders of all time: more than 600 gallons of body makeup were needed to be sprayed on the thundering Roman hordes and lords. This classic orthochromatic film pitted Francis X. Bushman as the evil Messala, with black lips and character eyebrows arched villainously over vampish, heavily shadowed eye sockets, against Ramon Novarro as the virtuous Ben Hur, with thick, horizontally curved brows and softly accented lids and lips. By their makeup alone, the film's outcome should have been obvious.

Virginia Mayo, cast as the sorceress Helena in *The Silver Chalice* (1955), wore a range of predictably formula hairstyles from Hollywood beauty queen, with 1950s temple curls, to various long, chic combinations of generic ponytails, chignons, and postiches. Her eye makeup was particularly arresting as she allowed herself to be painted with stylized character eyebrows arching diagonally upward over exotic metallic eyeshadow. This unusual departure from her glamorous star image added an interesting dimension to her

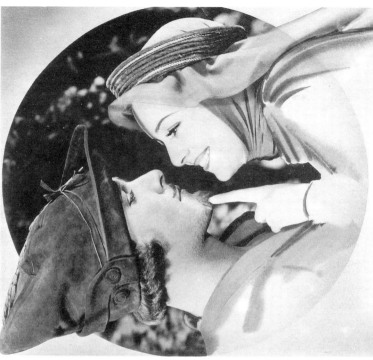

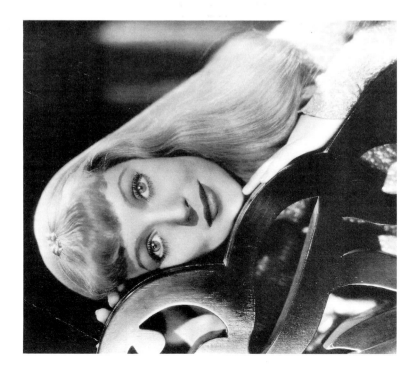

Fig. 20
Left: Loretta Young in *The Crusades* (Paramount, 1935).
Costumes by Travis Banton, Natalie Visart, Al Nickel, Renie Conley, and Ralph Jester

Fig. 21
Right: Errol Flynn and Olivia de Havilland in *The Adventures of Robin Hood* (Warner Bros, 1938).
Costumes by Milo Anderson

characterization. By contrast Pier Angeli as the ingenue, Deborah, wore straight 1950s formula makeup and a modern, fashionable, shoulder-flip wig, bearing no resemblance to anything historic.

Spartacus (1960) was quite simply a film about brown eyeshadow. The eye sockets and lids of performers, both men and women, were dramatically sunken with brown paint. But it was Kirk Douglas in the title role whose hair deserves special note. As the Roman slave Spartacus he sported an ultra-fashionable, distinctly non-Roman, tough-guy flat-top, almost identical to the one he wore earlier that year in the modern film *Strangers When We Meet*. In *Spartacus* the sides of his hair were slicked back, while one small section of the back crown was drawn into a token gladiator's ponytail. Period authenticity in this film was adjusted to the male lead's star image, although one could argue that Spartacus's position as both a rebel and a member of the élite corps of gladiators merited a hairstyle that set him apart from his fellows.

Middle Ages

Filmmakers have succumbed frequently to the lure of the Middle Ages. One of the first was Cecil B. De Mille, who in 1935 presented the epic *The Crusades*, which required among other things "several thousand wigs, 2,500 pounds of crêpe hair . . . [and] fifty gallons of imitation blood."[11] It starred Loretta Young as Berengaria of Navarre, later queen to England's King Richard the Lionheart, wearing 1930s glamor formula makeup and a set of blonde wigs all based on the

Fig. 22
Richard Harris in *Camelot* (Warner
Bros., 1967).
Costumes by John Truscott

waist-length fashions of 1187 but with non-historic straight-cut bangs. The wigs, particularly her first one as Princess of Navarre, were dressed to echo familiar styles of the 1930s. The smooth long hair of this first wig was all drawn to the front of her body and gracefully eased into two hanks, which were tied with ribbons below each shoulder. This caused the hair around her face to puff softly like a 1930s pageboy, while the hair below the ribbons hung loosely to her waist. After she became queen, the long hair was braided and coiled by the studio hairdresser with amazing non-historic inventiveness. De Mille's daughter Katherine as the scheming rival princess Alice of France wore late-1920s vampish makeup and a dark wig with modern 1930s finger-waved crown and sides and a token historic waist-length braid attached below her right ear.

One of the most popular medieval tales to reach the screen was the rousing 1938 version of *Robin Hood*, starring Errol Flynn, Olivia de Havilland, and Basil Rathbone. Flynn was one of the few male Hollywood stars whose image was not locked into a single hairstyle. His dashing air transcended the particular constraints of medieval, Elizabethan, Restoration, or Victorian hairstyles with equal aplomb. As Robin he seemed perfectly at home in a nose-length, finger-waved, bobbed wig, narrow chin beard, and thin mustache. Rathbone, in a slightly longer, smoother wig looked as if he had stepped out of a medieval painting, and de Havilland as Marian wore a wig that evoked the long, braided Norman style but in reality was a 1930s finger-waved cap with center part and braids attached at the sides. Her makeup was pure 1930s formula.

The 1960s contributed *Camelot* (1967) to the library of medieval film lore. Stars Richard Harris (King Arthur), Franco Nero (Lancelot), and David Hemmings (Mordred) all wore variations of the Beatles' blow-dried Caesar cut. Hemmings added a thick, neo-Edwardian, contemporary mustache. Vanessa Redgrave (Guinevere) modeled a variety of long wigs all echoing 1960s fashions. They ranged from below-the-shoulders, tousled curls and fashionable bangs to a teased version of the Beatles' style, which she wore when she was about to be burned at the stake. The actors sported a highly made-up "no makeup" look with soft, brown eye accents and pale, almost colorless lips. Much publicity was devoted to the special mirrored contact lenses created for Laurence Naismith as the sorcerer Merlin.

Renaissance

Shakespeare and the Italian Renaissance went hand in hand on the screen. Douglas Fairbanks and Mary Pickford produced and starred in Shakespeare's *Taming of the Shrew* in 1929. Fairbanks as Petruchio wore his stock swashbuckling mustache and slicked-back hair. Pickford as Kate wore formula makeup and a clochelike, finger-waved wig, which curled low on her forehead and had a cluster of curls at the nape for period effect.

In *Romeo and Juliet* (1936) Leslie Howard's makeup and hair were pure formula glamor hero. Norma Shearer's makeup was also formula, but her wig was an ingenious blend of 1930s fashion and the styles worn by young *men* in Renaissance Florence.

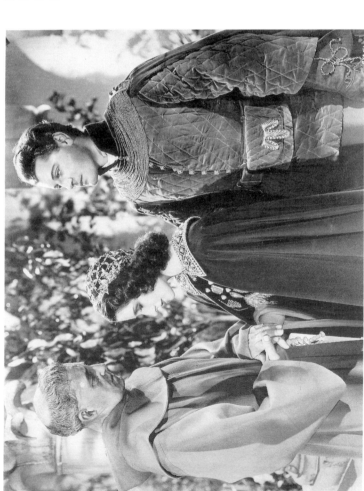

Fig. 23
Norma Shearer in *Romeo and Juliet* (M.G.M., 1936).
Costumes by Oliver Messel and Adrian

Key episodes in the life of Diane de Poitiers, the mistress of the French King Henri II (1519–1559), formed the basis of the 1955 film *Diane* starring Lana Turner. While Pedro Armendariz looked authentic as Henri's father, Francis I, in a nose-length wig and square beard derived from well-known contemporary portraits, a youthful Roger Moore as the young Henri opted for the 1950s male glamor formula with short, wavy hair, pompadour top, side part, short nape, and slicked-back sides. Upon his coronation he added a somewhat incongruous mustache to indicate his maturity.

Turner wore full formula makeup throughout, along with a series of blonde wigs that ranged from Hollywood beauty queen in her boudoir to a series of generic period styles based on a 1950s hairline, soft forehead pompadour, temple waves, and sides pulled back tightly under a series of back and top hairpieces including chignons, postiches, and French twists, all obviously lacquered into place. These generic styles suggested the past in that they were too elaborate for street wear, although they were contemporary enough to be compatible with her modern makeup. As a result her fans undoubtedly left the theatre convinced that what they had seen was an accurate re-creation of the styles of the French court in the sixteenth century.

Between 1939 and 1955 the Hollywood studios released three films about England's Queen Elizabeth I: *The Private Lives of Elizabeth and Essex* (1939), *The Sea Hawk* (1940), and *The Virgin Queen* (1955). Bette Davis played Elizabeth in 1939 and 1955; Flora Robson, in 1940. It is Davis's interpretation that made film history.

Davis was Warner Bros.'s top female star at the time *Elizabeth and Essex*

Fig. 24
Lana Turner in *Diane* (M.G.M., 1956).
Costumes by Walter Plunket

went into production. She was thirty years old, at the peak of her career, and known to be fearless in her approach to any role. She had wanted to play Elizabeth for some time, and the studio chose this role for her Technicolor debut.

Davis viewed Elizabeth as a character, not a glamor, role and insisted on appearing as authentic as possible. She suggested that makeup artist Perc Westmore shave off her eyebrows and shave back her hairline several inches in order to make her look more exactly like the aged, bald queen, who was in her mid-sixties and wore red wigs and heavy white lead makeup at the time of the events depicted.

Producer Hall Wallis "was horrified; no actress had ever appeared bald in a movie before, and Warner Bros.'s top star would not be the first!"[12]

They compromised. Davis did not appear bald on film, but she did shave her hairline and brows and thus became the first major female star to allow her glamor image to be sacrificed totally for the sake of character.

Her theatrically daring gamble paid off. Audiences and critics alike praised her astonishing interpretation.

There were, however, a few minor deviations from history in her appearance. Diaries of Elizabeth's contemporaries refer to the sixty-five-year-old queen's face as being heavily wrinkled. Davis's face was youthfully smooth with only a few, pale wrinkles artfully drawn on her forehead. Her wigs had soft, 1930s pin curls and not the tiny, frizzed curls of history which were produced with tongs. The real Elizabeth lost her eyelashes to illness at an early age. Davis kept hers.

Seventeen years later Davis re-created the role of Elizabeth in *The Virgin Queen*. She asked that Perc Westmore again be brought in to do her makeup and wigs. "Every morning he shaved her hair back two inches, as he had when she played Elizabeth the first time." This time, however, she went a step further and insisted on revealing her baldness on screen as a contrast to Joan Collins's beautiful, young Beth Throckmorton, the object of Walter Raleigh's genuine affections. For the confrontation between the two, the "bald scene," Westmore, taking advantage of numerous advances in makeup and wig technologies, devised a thin rubber "bald cap" with white hairs only at the back of the crown.[13] Collins as Elizabeth's rival wore 1950s formula glamor makeup and a wig with pseudo-Elizabethan temple rolls combined with 1950s wispy hairline curls and spit-curl bangs, all firmly anchored with copious amounts of hair spray. Thus the incongruity between the two women was startlingly intense. The DeLuxe Color process used in this film added to the vividness of Davis's carrot-red wigs (which also reflected the popularity of red hair in the 1950s). The curls on these wigs were less rigid than those in the 1939 film.

Flora Robson, who was blessed with a naturally high forehead, declined to shave either her hairline or her brows when she played Elizabeth in *The Sea Hawk*. Her wig looked very much like one worn by Davis the previous year but was tilted forward to cover her hairline and ears. Hers was a much less extreme portrait but an effective one nevertheless.

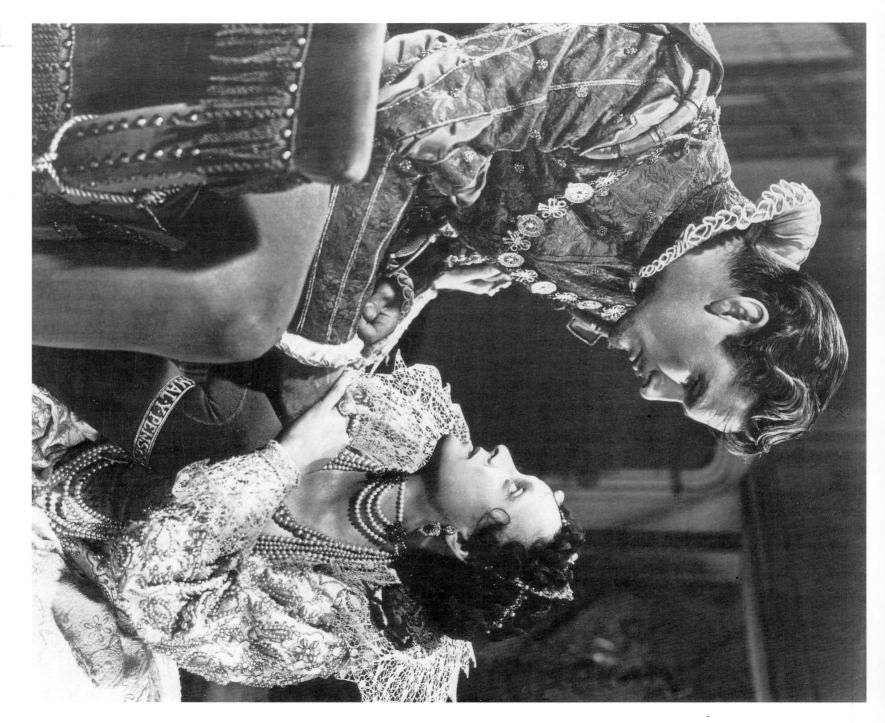

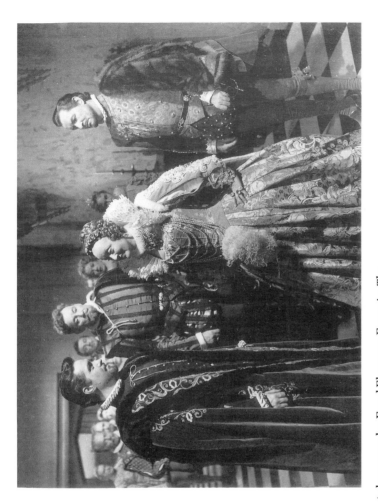

Fig. 25
Errol Flynn and Bette Davis in *The Private Lives of Elizabeth and Essex* (Warner Bros., 1939).
Costumes by Orry-Kelly.

Fig. 26
Bette Davis and Richard Todd in *The Virgin Queen* (Twentieth Century-Fox, 1955).
Costumes by Mary Wills and Charles LeMaire

It is interesting to compare the hairstyles worn by Errol Flynn as Essex in *The Private Lives of Elizabeth and Essex* and as the fictional sea captain, Geoffrey Thorpe, in *The Sea Hawk*. Uncharacteristically, opposite Davis he made no attempt to assume a period hairstyle but stuck to his leading-man glamor image. His only concession to period was a very thin chin beard. Perhaps he saw this as one way to hold his own against the overpowering image of his co-star. The very next year opposite Robson, however, he returned to his swashbuckling image, complete with longer wig: a cross between his Captain Blood and Robin Hood styles. Only his mustache remained the same in both films.

Seventeenth Century

One of the largest wig orders ever filled for a film was for the 1947 costume melodrama *Forever Amber*, set in England in the 1660s. Max Factor supplied Twentieth Century-Fox with 4,402 period wigs "authentic to the last curl."[14] Most of the men, especially John Russell as Black Jack the Highwayman, did appear to be authentically wigged in the film. "When Fred Fredericks, Max Factor Makeup Studio Hair Stylist, was given the job of making a wig for George Sanders to wear as Charles II in *Forever Amber* he aimed for real authenticity by styling it after a portrait of the ruler on a gold 'broad' or 20 shilling piece of the seventeenth century."[15] And while the female court servants could have stepped out of a seventeenth-century engraving by Abraham Bosse, Linda Darnell as Amber was coiffed in an imaginatively eclectic manner, mixing styles from both the eighteenth and the nineteenth centuries with those from

Fig. 27
Linda Darnell and Cornel Wilde in
Forever Amber (Twentieth Century-Fox,
1947). Costumes by René Hubert
and Charles LeMaire

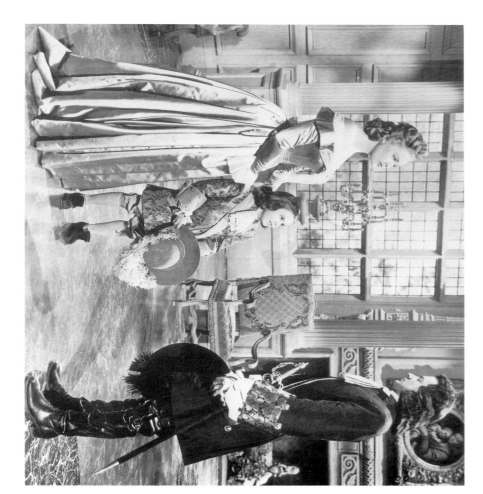

the 1940s. Predictably her Hollywood beauty-queen prison wig remained neat and her makeup intact throughout her incarceration, as is only appropriate for a heroine in the Hollywood view of history.

M.G.M.'s 1948 Technicolor version of *The Three Musketeers* epitomized the Hollywood approach to wigs and makeup. Set in France in 1625, it provided a number of authentic wigs for the character roles. Vincent Price as Cardinal Richelieu wore a carefully groomed, shoulder-length wig and Keenan Wynn as D'Artagnan's servant wore a generic peasant mop. Frank Morgan as King Louis XIII wore a wig that would have been more appropriate for Charles II of England thirty-five years later. The musketeers themselves—Van Heflin as Athos, Gig Young as Porthos, and Robert Coote as Aramis—were coiffed in chin-length Van Dyke wigs with side hair lacquered much more tightly to their heads than the bushy, free-flowing styles of their seventeenth-century counterparts. They also wore pointed goatees and thin mustaches. Gene Kelly as D'Artagnan wore an identical wig and mustache but no beard. His mustache continuity was a bit uneven, varying in width from shot to shot.

The wigs of the two leading ladies, June Allyson and Lana Turner, posed some problems. French ladies of 1625 wore their hair flat on top, brushed back

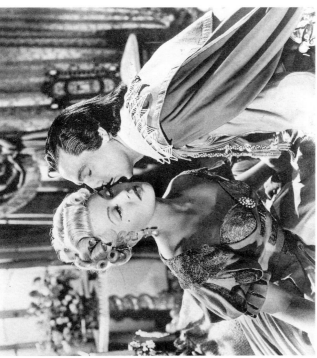

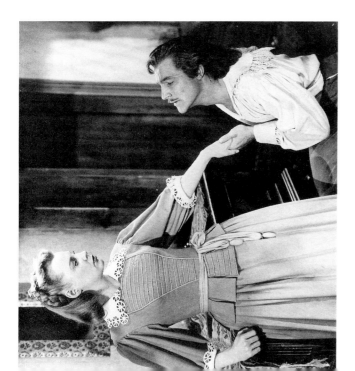

Fig. 28
Left: June Allyson and Gene Kelly in
The Three Musketeers (M.G.M., 1948).
Costumes by Walter Plunkett

Fig. 29
Right: Lana Turner and Gene Kelly in
The Three Musketeers (M.G.M., 1948).
Costumes by Walter Plunkett

from the forehead except for a thin, uneven fringe of bangs. From two high parts, the side hair was frizzed with tongs and fluffed out in a freewheeling moon shape around the cheeks to just below the chin. (In certain ways it was similar to many of the finger-dried, moussed styles popular today.) Back hair was coiled into a flat bun. To the smoothly coiffed, fashionable world of 1948 it was not a hairstyle calculated to look glamorous on the stars or attractive to their fans.

Allyson, cast as Constance, the basic seventeenth-century "girl next door," wore her side and crown hair pulled back softly from her hairline and hidden under a long, smooth 1940s pageboy fall straight out of the pages of *Harper's Bazaar*. The join on the crown was disguised with a braided coronet. We first see Constance's hair early in the film as she's undressing. Close-ups reveal two flat pink 1940s bows that match the trim on her underwear. The bows are nestled in front of the crown braid and help to disguise it. Interrupted by kidnappers, then rescued by D'Artagnan, she climbs back into her clothing, and—*voilà*—her two little pink bows have become two little blue bows that match exactly the color of her dress. From that point the story turns serious, and the bows vanish, never to be seen again. For the duration of the film, Allyson looks distinctly uncomfortable with her eclectically styled wig.

As the femme fatale, Milady de Winter, Turner wore a series of generic blonde wigs with the same inventive mixture of periods that was shown in Twentieth Century-Fox's treatment of *Forever Amber* the year before. Generally Turner's wigs looked more eighteenth than seventeenth century, though several appeared to have been concocted simply to accommodate the sensational hats designed for her by Walter Plunkett. In all but her prison wig,

her hair was up, usually with considerable non-period height on the crown and variations on a French twist in back. In most cases the hair was brushed back from her forehead in soft, flattering pompadours with temple waves, though in one scene her wig incorporated a version of the popular 1940s "bumper bangs" and in another a back cluster of nineteenth-century sausage curls. Despite the fact that her wigs moved all over the historical map, they were rooted in a recognizably 1940s base, which made her look appropriately glamorous.

Toward the end of the film, when imprisoned and trying to trick Constance into believing she is dying, Milady did change into an interesting character makeup and wig. The wig, a waist-length, tousled Hollywood beauty-queen style, was in startling contrast to her previous ones. Combined with makeup that gave her a sallow, colorless complexion, sunken eyes, and soft brows, it effectively elicited the sympathy of both Constance and the audience. Once freed, however, Milady returned to her glamor image and went off to be beheaded in great style with a preposterously heavy, twisted chignon low on her neck. Pity the poor executioner trying to take aim with his ax.

Eighteenth Century

The eighteenth century and white wigs: the two are linked inseparably in our minds. But is this perception historically accurate?

Until the French Revolution the majority of fashionable eighteenth-century men wore wigs and women wore elaborate hairpieces. It is true that most of these were powdered white. But when hair is powdered white, it does not look white—it looks gray. Examine most eighteenth-century portraits, and you will see that the hair indeed is gray. Where then did the penchant for pure-white eighteenth-century wigs come from? Actually it arose in the mid-nineteenth century, when a mania for fancy-dress parties and *masquerade poudré* balls revived interest in eighteenth-century fashions, especially wigs. Victorian theatrical costume houses hired out their pure-white versions of eighteenth-century wigs made of yak hair, wool, or cotton, with uniform, stylized curls. Hollywood wigmakers, starting with Max Factor, perpetuated the style in films. An authentic eighteenth-century wig, powdered and liberally greased with pomatum, would have looked dirty, unglamorous, and completely unsuitable for a star on screen. Hence, the ubiquitous eighteenth-century white wig.

Both versions of *Monsieur Beaucaire*—Valentino's unpopular 1924 romantic version and Bob Hope's far more successful comedy version in 1946—offer good examples of this style. Valentino's pure-white wig remains a fascinating reflection of the 1920s notion of eighteenth-century styles. In silhouette it correctly followed the shape of the historical tied-back wig. But in place of authentic curls, the entire crown and sides were a series of fashionably marcelled finger waves. The two leading ladies, Bebe Daniels and Doris Kenyon, wore wigs that were pure figments of designer George Barbier's imagination, with 1920s flat cloche crowns, marcelled curls, and "beetle brow" foreheads in which hairline and eyebrows merged. They had absolutely nothing to do with

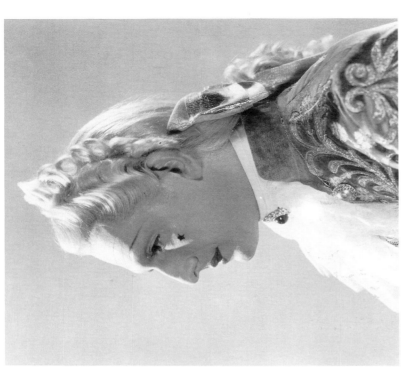

Figs. 30, 31
Wig and makeup test for Norma Shearer (*left*) and Joseph Shildkraut (*right*) in *Marie Antoinette* (M.G.M.. 1938).
Costumes by Adrian

the eighteenth century, but aesthetically they were exotic and highly appealing to the mid-1920s film fan.

Bob Hope's white, tied-back wig looks remarkably 1940s with its flat crown brushed smoothly back off the hairline and its neatly lacquered sides. To the back he added an extension, like a ponytail, tied in a traditional black bag at the nape of his neck.

One of the most elaborate eighteenth-century period films ever made was *Marie Antoinette* (1938). Max Factor & Co. made 903 ornate white wigs and another 1,200 more restrained wigs for the extras. Norma Shearer in the title role wore 18 extravagant wigs designed for her by M.G.M.'s chief hairstylist, Sydney Guilaroff. As the Dauphine her wigs conveyed a youthful quality, with fanciful curls suggesting some remote relationship with the eighteenth century, though nothing that could be documented. Her wedding-night Hollywood beauty-queen wig adopted the 1930s formula complete with satin ribbon tied in a bow on top of her head. Her court wigs, befitting a queen of France, were, however, another story. Obviously a product of painstaking research, they incorporated authentic height and curls, although they lacked correct period width on the sides (which probably would have overpowered Shearer's face). They were also Hollywood-hairdresser smooth with no sign of period teasing or frizzed curls. Occasionally her wig accessories were proportioned incorrectly for the period—some plumes were too large; a birdcage headdress was absurdly

Fig. 32
Charlton Heston in *The President's Lady*
(Twentieth Century-Fox, 1953).
Costumes by Renie Conley

small—but these details were minor. Overall Shearer's wigs were masterpieces of the Hollywood hairdresser's art and proved to be amazingly compatible with her elaborate 1930s formula makeup, including spiked lashes, heart-shaped beauty mark, and colored nail polish.

Authentic men's wigs ranged from the ornate foppishness of Joseph Schildkraut's crafty Duke of Orleans to the more restrained style of Robert Morley's King Louis XVI, looking as if he had stepped out of the portrait by Joseph-Silfrède Duplessis (although Morley's curls were much more contrived and heavily lacquered than the relaxed natural curls of the original). Tyrone Power as the handsome Swedish count Axel de Fersen wore a conservative, unpowdered wig, another of those ingenious formula styles that look modern from the front, but in profile reveal long sides plastered tightly to the head and tied back at the nape of the neck.

Nineteenth Century

Films set in the nineteenth century sustained the formula for makeup and hair design.

The President's Lady (1953) chronicled Andrew Jackson's rise to the American presidency in the 1820s. As the young Jackson, Charlton Heston wore a wig styled in the 1950s conservative men's star image formula, but as "Old Hickory," the distinguished politician, he wore a character wig authentically reproduced from contemporary portraits of the president.

The 1830s were depicted delightfully in *Pride and Prejudice* (1940). With his strong theatrical background Laurence Olivier as Mr. Darcy had long, period sideburns and a wig with temple and side curls, although carefully groomed so as not to "fluff" in historical fashion. The five Bennet sisters wore late-1930s formula makeup and wigs that more or less echoed the romantic fashions of the 1830s. The wig worn by Marsha Hunt as the plainest sister, Mary, was the most accurate with center part, flat top, and ear coils. Maureen O'Sullivan, Heather Angel, and Ann Rutherford all wore charming variations of the late-1930s upsweep with tight clusters of curls suggesting the 1830s topknot, though much shorter on top and lacking the curly side volume of the originals. The least historical wig was worn by leading lady Greer Garson as Elizabeth. It was a 1930s star image formula style, which could have been worn equally well on the street as on the screen.

Green Dolphin Street (1947), which is set during the years from 1837 to 1855, starred Lana Turner as the assertive, worldly Marianne Pataurel and Donna Reed as her more spiritually inclined sister, Marguerite. Turner wore a series of upsweeps with assorted generic buns, switches, and braids. Three of the wigs she wore may have been inspired by a modern style advertised three years earlier in the December 1944 issue of *Harper's Bazaar*. (In 1945 Virginia Mayo wore this same style in the modern comedy *Wonder Man*.) The final sequence in *Green Dolphin Street* shows Reed taking her vows as a cloistered nun, wearing full corrective glamor formula makeup.

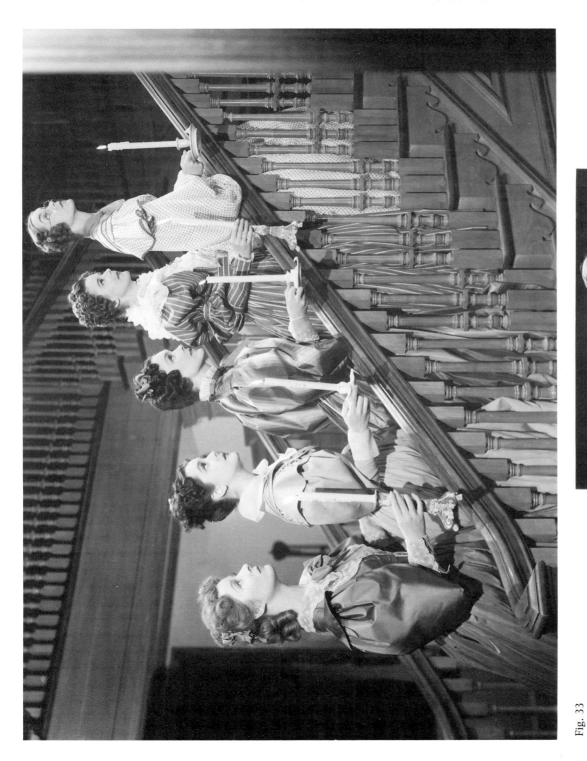

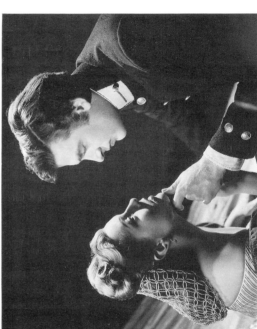

Fig. 33
Above: Greer Garson, Ann Rutherford,
Maureen O'Sullivan, Heather Angel,
and Marsha Hunt in *Pride and Prejudice*
(M.G.M., 1940).
Costumes by Adrian

Fig. 34
Right: Lana Turner and Richard Hart
in *Green Dolphin Street* (M.G.M., 1947).
Costumes by Walter Plunkett

One of the more effective film re-creations of the mid-nineteenth century was *The Heiress* (1949), starring Olivia de Havilland as the plain, introverted Catherine Sloper. De Havilland approached the role as a character part, deliberately de-emphasizing her natural beauty. Carefully applied makeup made her complexion dark and sallow, her eyes sunken and undefined, her brows heavy and harsh, her lips barely visible. Her wigs were simple and severe. Both makeup and hair reinforced the dignity, resolve, and poignancy of the character, and she won an Oscar for the role.

By contrast Katharine Hepburn in *Song of Love* (1947), set in the same period as *The Heiress*, wore distractingly modern, New Look formula makeup and hair pulled up tightly in a bun on top of her head for her role as Clara Schumann. There was absolutely no attempt to reconcile this star's image with historical reality.

The 1860s have inspired a rash of Hollywood films: *Secrets* (1933) with Mary Pickford (in her last film) coiffed in a pure 1930s star image formula style; *The Barretts of Wimpole Street* (1934) with notably effective period wigs on Norma Shearer, Fredric March, and Charles Laughton; *Suez* (1938), in which Loretta Young as the Empress Eugénie launched the snood on its way to 1940s fame and fashion; *Jezebel* (1938); *Juarez* (1939); and of course, the incomparable *Gone with the Wind* (1939). From the first costume sketches for Rhett Butler to his final moments in the film, Clark Gable's star image was not altered. The length, style, and grooming of his hair was pure formula. His only concession to historical style was a pair of slight sideburns. The women too all wore formula makeup. Their hairstyles were clearly based on late-1930s fashion. Even Vivien Leigh's wigs, which most people remember as authentic, were seventy years out of date, truer to the 1930s than the 1860s with pageboys, temple rolls, bumper bangs, upsweeps, and clusters of curls.

Twentieth Century

We end our discussion with two examples of films set in the 1920s which perpetuated the formula.

Some Like It Hot (1959) looked back thirty years to the Chicago of 1929 only to discover how remarkably it resembled the 1950s. In this comedy Jack Lemmon and Tony Curtis disguised themselves as flappers in an all-girl band whose lead singer was Marilyn Monroe. The two leading men wore female makeup disguises that combined rounded 1950s lips and thick 1950s brows angled like those of the 1920s. They also wore the heavy lashes and smudged eyeshadow of the 1920s. Their wigs likewise were a clever cross between periods. But Marilyn was pure Marilyn with 1950s formula makeup and hairstyle. She clung to her star image and made absolutely no attempt to look 1920s. The film's approach to authenticity was summed up by one character who brags that she just got her hair marcelled when what she is wearing is a short, fluffy, layered 1950s wig.

Fig. 35
Marilyn Monroe in *Some Like It Hot*
(United Artists, 1959).
Costumes by Orry-Kelly and Bert
Henrikson

Thoroughly Modern Millie (1966) provides a tongue-in-cheek view of the year 1922. Under the opening credits Julie Andrews arrives in the big city, looking terribly innocent in Mary Pickford curls and "no makeup," then emerges from a hairdresser's shop "bobbed" and wearing Clara Bow vamp makeup with 1960s full lips. She soon befriends an innocent Southern orphan (Mary Tyler Moore), who refuses even to consider cutting her Pickford curls. Moore's curls were actually accurate, but unable to reconcile her 1960s image with the flat-crowned fashions of the 1920s, she added modern bangs to her wig and gently teased the top and sides into a modern bouffant style. It was an eclectic mixture but looked wonderful. The impeccably groomed John Gavin, with off-center part and neatly trimmed sides and nape, looked as if he had just stepped out of a 1920s Sta-Comb hairdressing ad. James Fox succumbed to modern, blow-dry bangs, but when the story calls for him to disguise himself as a woman, his wig and makeup are classic 1920s right down to his heavily outlined bee-stung lips.

Thus the Hollywood dream factory filtered history through its unique lens. We have seen how from the beginning the technical demands of film required actors to wear makeup and wigs. When existing theatrical products proved unsuitable for the new medium, new products were developed which helped to define and heighten the stars' images. Because studios banked so heavily on the box-office appeal of their stars, few were willing to jeopardize a star's image and risk the rejection of the fans just for the sake of historical accuracy in a period film. For actors in period roles, makeup artists and hairstylists devised a formula for treating makeup and hair, those two most intimate aspects of a star's image. This formula blended the look of the present with selected elements of the past.

From 1920 till 1970, a fifty-year span that included the heyday of both the studio star system and the period film, Hollywood repeated the formula over and over again with great box-office success. What amazes us today is how effectively the makeup artists and hairstylists made it work. For nearly fifty years they superimposed the present on the past, reinventing and glamorizing history the way audiences wanted it to have looked. Perhaps, in retrospect, we feel a bit chagrined at how many of our own perceptions of history have been influenced by the myths the formula introduced or how easily in the darkness of a movie theater, confronted with those larger-than-life faces, we still find ourselves seduced by it.

III

Hollywood and Seventh Avenue: The Impact of Period Films on Fashion

SATCH LAVALLEY

Fig. 36
Unidentified actress with costumed mannequin. c. 1948

MOTION PICTURES have had a major influence on the way people dress. For decades men and women have tried to appear like their favorite stars, to wear clothing that looked just like what they saw in the latest movie. These film wardrobes were often exquisite, innovative works of fashion, the work of highly talented designers. According the New York garment district and the Parisian fashion houses, influenced by the clothing demand the movies created as well as by the designs Hollywood produced, often adopted ideas and patterns from movie costumes for the retail market.

Among the many films that Hollywood has produced, period films have had a specially significant influence on contemporary fashion. "It cannot be denied that clothes in period pictures do affect the modes of the moment," observed fashion reporter Lillian Churchill in the *New York Times Magazine*. "The dress in modern films may be of little importance, but costume pictures add notes, bars, and passages to the symphony of dress."[1]

In films set in the present, costumes mirror the prevailing mode, adapted to the image of particular stars and characters; but while historic films may also reflect contemporary fashion, they bring to life dress from another era and introduce concepts that are not in current circulation. Thus while period film costumes may be influenced by the contemporary aesthetic, the unfamiliar period elements in these costumes ironically often become a source for innovative designs and new ideas in retail trade.

A classic example of Hollywood period costume contributing new elements to contemporary fashion is the wardrobe of Mae West, who dazzled movie audiences with her frank sexuality and her Mauve Decade (1890s) *poitrine*. Her films customarily had fin-de-siècle settings, and her costume designers expended upon the popular star all the extravagant furbelows of an earlier age. She reintroduced the tightly laced corset, long feather boas, princess-line gowns, large feather-laden picture hats, leg-of-mutton sleeves, and a feeling of luxury not seen in years. According to an article in *Vogue*, West's wardrobe in *She Done Him Wrong* (1933) helped inspire "the return of the corseted silhouette."[2] Paris couturière Elsa Schiaparelli frankly admitted she was enchanted by the star's glittery Hollywood finery and paid homage in a collection based on "the Mae West look."[3] In 1938 West engaged Schiaparelli to design her wardrobe for *Every Day's a Holiday*. Other Paris designers also took notice. For the first time in many seasons shoulders were bared at the houses of

Fig. 37
Mae West and Cary Grant in *She Done Him Wrong* (Paramount, 1933). Costumes by Edith Head

Chanel and Molyneux. Mainbocher and Lelong emphasized the bosom with ruffles and sprays of osprey.

In response to West's style *Collier's* magazine proclaimed, "Curves Ahead." The article suggests that West's hourglass silhouette was not her only contribution to the current fashion:

More than the silhouette is being revived with beer and bicycles. . . . Hats are being brought back . . . of black velvet and drenched with feathers—ostrich, osprey, crosse, burnt peacock. . . . Not only that—feather capes are back, delicious, soda-watery things. . . . These are the kind that stick in men's eyes and tickle their noses—stiff affairs of heron standing out around the neck like an electric spray. . . . Many quaint trifles called pelisses, dolmans, tunics, and peplums are coming back. . . . Long gloves? Everywhere. Rhinestone jewelry? Quarts of it, even to the most elaborate sunbursts, shooting-star necklaces, dripping earrings. . . . Pearls by the yard are back again. . . . Ye olde time furs and fabrics are coming back—golden Alaska seal, skunk, Persian lamb . . . stiff taffeta, ottoman silk, brocades, tinsel embroidery, sateen, slipper satin—ah, me!—ah, me!— what a rummaging in old trunks.[4]

The resemblance between movie period costume and the next season's fashion, however, is not necessarily a case of cause and effect. Obviously designers in fashion and film frequently arrive at a similar approach, completely unaware of what the other is doing. But retail fashion designers in New York and Paris have openly acknowledged the importance of film costumes.

To determine whether such famous designers as Captain Molyneux, Jeanne Lanvin, Charles Frederick Worth, Lucien Lelong, Marcel Rochas, and Jean Patou were directly influenced by *Little Women* (1933), *The Barretts of Wimpole Street* (1934), and other Hollywood period films, movie correspondent Laura Blayney covered the 1935 Paris collections:

What do I see? Everywhere the billowy-skirted silhouette. What do I hear? The steady swish-swish of crisp taffetas and alpacas.

Wherefore all these feminine fripperies? Ruffled parasols . . . gold-handled glass fans or fans matching the dress . . . poke bonnets at Schiaparelli. Little ruffled tulle capes with hoods, and hoops are in, at least the trailly part of the skirt, at Mainbocher. Balloon sleeves at Rochas. Bows, ribbons, embroidery everywhere.[5]

Blayney spotted plumed Tudor hats, Russian tunics, and Cossack hats, seemingly derived from current films, and then went to interview the distinguished fashion creators. Molyneux confirmed that his new skirts had been inspired by *The Barretts of Wimpole Street* (costume design by Adrian). Lelong agreed with Molyneux: "We all take inspiration from the same sources. . . . We, the couturiers, can no longer live without the cinema any more than the cinema can live without us. We corroborate each other's instinct."[6] Marcel Rochas concluded: "In *Little Women* [costume design by Walter Plunkett], Katharine Hepburn was so charming in those old-fashioned clothes that her charm naturally drew our eyes to them as well. So pleasing were they, and so apropos, at a time when everyone was feeling the need for something 'new' that these types of clothes offered the solution."[7]

A few years later Edith Head, destined to become the chief designer at Paramount, cabled enthusiastically from Paris that the city "is all agog about *Zaza* clothes, giving full credit to Hollywood and Claudette Colbert."[8] Head was thrilled that her costumes for the movie (released in 1939) "had inspired"[9] Paris to renew its fascination with the 1900 to 1904 mode. In the United States the trade publication *Women's Wear Daily* featured sketches of the Colbert costumes on the front page, predicting another rash of copies from Seventh Avenue.

In 1940 one thousand American buyers voted on their favorite designers. Three of the top nine names selected were designers from motion pictures: Adrian, Travis Banton, and Howard Greer.[10]

Despite this success it was not the primary objective of film costume designers to produce garments that would sell well in department stores. A successful film costume has different requirements from a successful retail product: it has to fit the technical needs of the movie and complement the story

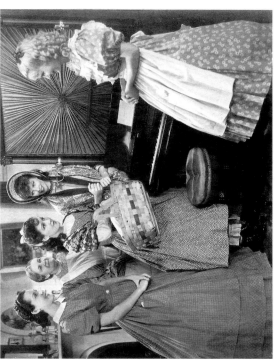

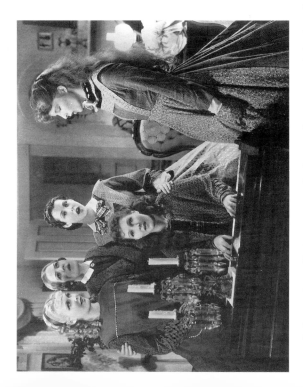

Figs. 38, 39
Two stills from *Little Women* (R.K.O., 1933).
Costumes by Walter Plunkett

and characters. But costume designers have to anticipate what the fashion will be when the film is released and make sure that their costumes look attractive to the audience. As a result their designs often provided the basis for a real-life version. While the costume designers did not concentrate on retail fashion, many had received their training in the clothing industry, working at salons in New York and Paris. So it is not surprising that their designs had an excellent sense of contemporary fashion and were so easily adapted from the screen to the street.

If one looks at the work of two of the best-known designers, Adrian and Walter Plunkett, it becomes clear that their films were a constant source of ideas for the retail establishment.

Adrian, at M.G.M. from 1928 to 1942, is perhaps the most famous costume designer in Hollywood's history. During his tenure at the studio he was treated like a star, and he was so well known that press releases would often trumpet his work as a special—sometimes the most important—element in a film. His work for Greta Garbo in the 1930s had an impact on commercial fashion that could be said to be unequaled by any other designer.

Garbo appeared in a number of historical films: *Romance* (1930), *Mata Hari* (1931), *Queen Christina* (1933), *Anna Karenina* (1935), and *Camille* (1936). Under Adrian's astute guidance she projected an image of unattainable allure, yet thousands of women aspired to look and dress like the star. Her historical costumes, often unfaithful to the period in which the film was set, did not comply with contemporary fashion either. They were quaint, eccentric, yet strangely becoming on the screen, and many of her garments became widely popular as retail products.

While designing for *Romance*, Adrian foresaw the demise of the ubiquitous cloche of the 1920s, and he devised for Garbo a little velvet hat, trimmed with ostrich feathers and worn tilted becomingly over one eye. The vogue for the

Empress Eugénie hat was born. Universally copied in a wide price range, it influenced how women wore their hats for the rest of the decade. His designs for *Romance* may also have revived the trend for less décolleté necklines in evening dress. The costumes for *Mata Hari* also caused a sensation and were sent on tour around the country. Several years after the film's release Garbo's double-breasted, broad-shouldered sable coat was still a royalty-free bestseller.

The retail popularity of Adrian's designs continued. The fine cartridge pleating, the large, face-framing, linen collars, the heavy velvet doublets, and the leather jerkins of *Queen Christina* were adapted for retail and sold at Macy's, Gimbel's, and Saks Fifth Avenue.

Adrian designed for many other leading stars as well as Garbo, creating costumes that yielded numerous commercial spin-offs. The quattrocento apparel from *Romeo and Juliet* (1936) inspired long velvet evening dresses, full-skirted and virginal, trimmed with touches of white, and with *moyen âge* waistlines. The star of the film, Norma Shearer, was pictured in *Vogue* wearing her beaded skullcap; Adrian told readers that it was based on the head of an angel in Fra Angelico's *Annunciation* but could be easily adopted by contemporary women of fashion. His work on *Marie Antoinette* (1938), the most elaborate costume film up until that time, inspired numerous retail designs. Hattie Carnegie, a celebrated New York designer, promised her clientele that she would borrow some elements from the film: ''modest little hoops'' (suitable for dismounting from taxis but flirtatious enough for a debutante at a ball) and lots of pleats.[11]

Along with Adrian, Walter Plunkett was one of the best-known designers of period films. Whereas Adrian did not worry about authenticity, often evincing a period feeling by using exotic and lavish effects, Plunkett was greatly concerned with historical accuracy. Despite this difference between the two, Plunkett's work, like that of his colleague, was frequently a source of ideas and designs for the fashion industry.

Cimarron (1931), which featured a series of 1890s costumes complete with oversized leg-of-mutton sleeves, was Plunkett's first period film. ''The costumes were so magnificent that the script was altered to mention their appearance.''[12] Irene Dunne's dresses helped to launch the broad-shouldered look and garment manufacturers began to watch the Plunkett historical films with a keen eye.

Little Women (1933), set in the 1860s, proved to be a treasure house of marketable ideas. Plunkett had pored over *Godey's Ladies' Book* and *Petersen's Magazine*, fashion publications from the period portrayed, and the resulting costumes were delightful. He had resurrected old-fashioned fabrics such as dimities, lawn, and soft muslins, and the film popularized gingham pinafores, calicoes printed in dainty Victorian patterns, and demure organdy party frocks. Bouffants in evening wear were directly attributable to Plunkett's costumes. Exact copies of the gowns were made for the retail market, with Plunkett himself supervising the copies and directing the operation.

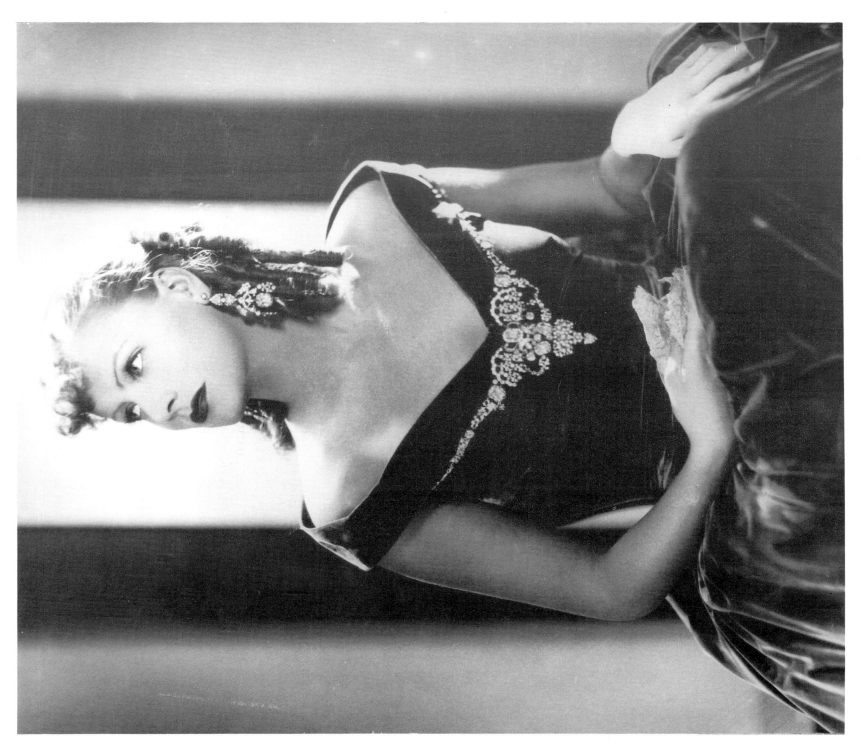

Fig. 41
Katharine Hepburn in *Mary of Scotland*
(R.K.O., 1936). Costumes by Walter
Plunkett

With the possible exception of Adrian's costumes for Garbo, Plunkett's masterful designs for *Mary of Scotland* (1936) received more publicity than those of any other period film prior to that time. *Photoplay* ("The World's Leading Moving Picture Magazine") forecast the new fashion influences for the season, presenting pictures of a pair of gold-buckled scarlet satin slippers, a pair of embroidered scarlet suede gloves, and a copy of Mary's gold filigree rosary, all with appropriate suggestions on how to adapt them for contemporary wear.[13] Katharine Hepburn as the ill-fated queen wore stately court gowns of thick velvets in royal fuchsia, midnight blue, or plum, and created a trend for the use of velvet for formal dresses with matching cloaks. A velvet tam with a matching snood and a suede sports jacket were adapted from Hepburn's hunting costume. Quilted yokes, padded sleeves, white ruffs trimmed with tiny pearls, and gold medallions were attractive ideas for designers. Plunkett, wise to the ways of Seventh Avenue, again guided the manufacture of the copies, exercising quality control.

Surely no period costumes have drawn more attention than Plunkett's wardrobe for *Gone with the Wind* (1939). Lillian Churchill, writing in the *New York Times*, commented, "As an influence on screen entertainment, *Gone with the Wind* is causing a magnificent splash in the cinema sea, and as an influence on women's dress it has created a great stir in the pool of fashion. . . . [The] bouffants, girdles, minute waistlines, and ostrich-feather trimmings . . . are sure to have an influence on the creations of Paris and New York."[14] Plunkett correctly predicted that Vivien Leigh's attire would help establish a new style for sleeves as well as encouraging a return to lace ruffles, appliqué, and braid.[15]

The unprecedented success of *Gone with the Wind* produced a merchandising blitz unequaled in the history of period film publicity tie-ins. Brassieres and corsets, dress patterns, hats and veils, snoods, scarves, jewelry, even wrist watches, were marketed as "inspired" by the film.

No dress in the 1930s was as copied as the barbecue dress (with the exception of Wallis Simpson's Mainbocher dress for her marriage to the abdicated Edward VII). It was produced in dozens of variations, many of which bore little or no resemblance to the original costume. Manufactured in a wide price range, the dress was copied in rayon, seersucker, and flocked organdy. A dress needed only to have a green velvet ribbon around the waist or a dotted Swiss ruffle at the hem or around the shoulders to be promoted as "Scarlett O'Hara's barbecue dress." "Dress patterns, ostensibly based on the original, were produced, and movie stars obligingly posed in these street-length, hoopless versions, which used less than one-tenth of the yardage of the screen costume.

According to *Vogue* the film also introduced the "Scarlett O'Hara look" into bridal fashion. "With a rustle of petticoats."[16] While wedding gowns of the early 1930s were often made from bias-cut, crêpe-backed satin that clings to the figure, the wedding gown in the film presented an exaggerated feminine silhouette, achieved with padding and cinching devices. For wedding gowns in the years immediately after the film, "waists were nipped in still further,

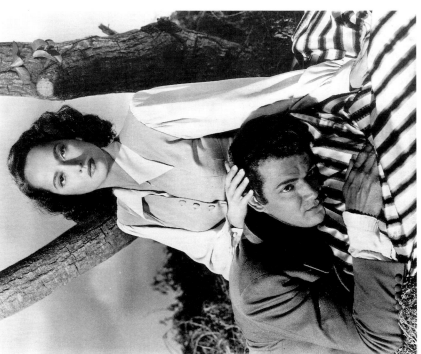

Fig. 42
Left: Vivien Leigh in *Gone with the Wind* (M.G.M./Selznick, 1939).
Costumes by Walter Plunkett

Fig. 43
Right: Merle Oberon and Cornel Wilde in *A Song to Remember* (Columbia, 1945).

Costumes by Walter Plunkett and Travis Banton (for Merle Oberon)

petticoats were worn over crinolines, and some designs even had additional panniers and bustles."[17]

Vivien Leigh's hats were designed by John Frederics, a commercial milliner as well as a costume designer, and his 1940 line was influenced by the film's designs. Like the film's hats and like hats from the period, many of his retail adaptations included a "veil, draped low and caught up with a piece of period jewelry."[18]

While most of Adrian's period costume work ceased after 1940, Plunkett continued designing such films for the next three decades, and his designs continued to be used for everyday wear. For example, he worked with Travis Banton on the costumes for *A Song to Remember* (1945), a popular film based on the life of Frédéric Chopin, and once again his work was made available to consumers:

One of America's leading designers, Jo Copeland, used men's coats of the period of Liszt and George Sand as inspiration for the smart double-breasted reefer of checked fabric. The velvet contrast at collar and pockets was suggested by the costume worn by Liszt [in *A Song to Remember*]. . . . Because this picture was a major production and received great publicity, the large stores were delighted to be in with the advertising, and gave window display of these reefers and the clothes and the costume from which they were adapted.[19]

Eight years later stores were carrying the Plunkett-inspired *Young Bess* collection of sleeveless, full-skirted summer frocks, inspired by the M.G.M. film released in 1953. In 1960 he was again providing ideas for commercial fashion with his costumes for the Walt Disney film *Pollyanna* (1960), a nostalgic look at small-town America at the beginning of the twentieth century. Hayley Mills re-created the role of the cheer-spreading orphan in a series of dropped-waist dresses executed in dark plaids, crisp chambrays, and wool serge that recaptured the Elsie Dinsmore look of the early 1900s. Plunkett used sailor collars, pleated skirts, wide ribbon sashes, lace ruffles, braid-trimmed capes, and straw boaters for the child star's costumes, which were widely featured in women's magazines and just as widely copied by manufacturers. The movie also helped to revive long dark hosiery or tights for young girls and the tweed Norfolk jacket for boys.

The popularity of these designs by Adrian and Plunkett reflects a dramatic change from film costume's early roots. Prior to 1920 the wardrobe for a period film was more likely to have come from a noted fashion designer than to include designs that would launch a new style. The fastidious actress would not leave her costumes to the whims or desperate invention of well-meaning but untutored wardrobe laborers. Sarah Bernhardt, for example, commissioned the French couturier Paul Poiret to design her costumes for *Queen Elizabeth* (1912). Lillian Gish shopped at chic New York salons like Madame Frances and Henri Bendel, and the latter supplied her gowns for *Way Down East* (1920).

There were some signs in those early days, however, that Hollywood period costumes were eventually to have a great impact. D. W. Griffith's film *Intolerance* (1916) with three of its four interwoven stories set in the remote historical past, namely the fall of Babylon, the Crucifixion, and the St. Bartholomew's Day Massacre of 1572, was one of the first films to use lavish period costumes and provides one of the first examples of period costume/current fashion crossover. *Photoplay* predicted in its April 1917 issue in an article entitled "Back to Babylon for New Fashions" that the Babylonian costumes worn in *Intolerance* would immediately influence fashion and published sketches of dresses from the film for adept home seamstresses to copy. (As the movies' influence continued to grow, adapting period costume to dress patterns for home sewing became extremely popular.) In another issue that year the magazine discussed Beverly Bayne's historically accurate costumes for *Romeo and Juliet* (1916), claiming that new adaptations for modern fashions could be made. Faithful fans were urged to study the costumes on the screen as a potentially rich source of inspiration for summer wardrobes.[20]

By the early 1920s the studios were placing a greater emphasis on costume, and these clothes in turn were attracting greater interest from viewers. The largest studios began to maintain enormous costume departments; the costume designer, heretofore anonymous for the most part, now began to assume a vital and well-publicized role in the production of period films. The

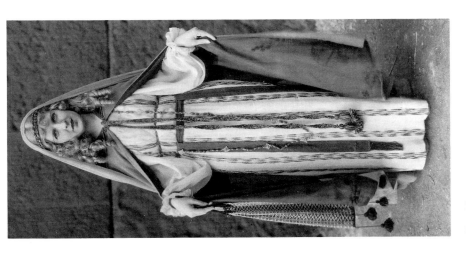

Fig. 44
May McAvoy in *Ben Hur* (M.G.M., 1926).
Costumes by Camillo Innocente, Erté, and Harold Grieve

increased attention to wardrobe brought to Hollywood many new designers who had backgrounds rich in design experience, including apprenticeships with important fashion houses in New York, study in Paris, illustrating for the leading glossies of the day, and work on Broadway for George White, Irving Berlin, and Florenz Ziegfeld.

The British fashion historian Elizabeth Ewing points out:

A new and potent influence came into fashion at this time. It was American films, and it remained at its peak for nearly two decades. To look like their favorite film star was the aim of the new young women, for films were the chief entertainment of the public everywhere in these pre-television days. It was universal as no previous influence could have been and, as cinemas sprang up everywhere, weekly or twice-weekly visits to the latest films became part of life.[21]

Starting in the 1920s, a host of fan magazines was founded, and major newspapers hired Hollywood correspondents. To take advantage of this development, the studios established publicity departments, with press agents and photographers, to handle the task of selling motion pictures. They quickly learned that epics such as *The Ten Commandments* (1923), *Ben Hur* (1926), and *The King of Kings* (1927), could be promoted successfully in part by publicity based on the ornate costumes.

Magazines and newspapers, greedy for an endless supply of fresh material about the stars, printed hundreds of fashion articles, chiefly slanted to young female readers. A shrewd publicist could always place copy on historical costumes, especially if the designs could be modified to the current style. Often young contract players were obliged to perform these publicity chores and were required to pose in all manner of costumes. Rotogravure sections of newspapers frequently featured starlets in eighteenth-century panniers, Louis Philippe pantalets, or some other period garment, suggesting that such items could provide followers of fashion with fillips for tired twentieth-century wardrobes. "Sixteenth-century gowns with long sleeves, for example, could easily be adapted for modern wardrobes as 'batwing' sleeves," advised Sophie Wachner, designer for *The Dust Flower* (1922).[22]

With the onset of the Depression movies increasingly became the vehicle for the newest fashions. It was during the 1930s that period film costume had its greatest impact on the garment industry.

Costume dramas, with heavy emphasis on glamor, became known in the trade as "women's pictures." "One of the most important attractions in women's pictures, from the depths of the Depression until Pearl Harbor, were the clothes worn by the female stars," wrote Paul Michael in his encyclopedia of American movies. "A string of actresses drew tremendous audiences from the members of their sex because of the jewelry, costumes, and fashions they displayed. Some of the clothes were merely exotic, such as those worn by Carlotta King in *The Desert Song* (1929) or Dolores Del Rio in *Resurrection* (1931)," but others, such as the costumes in *Becky Sharp* (1935), had more of a period motif.[23]

This demand for seeing costumes on the screen was increasingly translated into a supply of screen-inspired clothes in the stores. "The film fashions of today," commented Schiaparelli at the start of the decade, "are your fashions of tomorrow."[24]

Aware of the growing interest in film costumes, moviemakers consciously sought to use retail adaptations of these items to promote their primary product: films. In 1930 the Modern Merchandising Bureau was founded in New York for the express purpose of manufacturing and merchandising styles adapted from the movies. The bureau, taking a modest commission, supplied exclusive reproductions of hats and dresses (selected from production stills) to more than 1,400 shops across the nation. The first store to install a so-called cinema shop was the R. H. Macy Company in New York. The garments were moderately priced, and their promotion and sale proved to be a publicity bonanza for the cinema companies, who decided to waive their percentage of the sales.[25]

To an impoverished nation caught in the throes of the Depression, handsome yet simplified clothes from the movies were thus made more affordable. With the development of inexpensive and washable synthetic fabrics, such as rayon, the most glamorous and expressive creations for a period picture, for example the costumes designed by Orry-Kelly for Anita Louise and Olivia de Havilland in *Anthony Adverse* (1936), could easily be translated into cheaper, more practical fabrics, retaining only the most vestigial features of the original dress, yet keeping the panache of a Hollywood garment.

With large audiences admiring Hollywood costumes and the stars who wore them, with studios actively publicizing the films' wardrobes, and with talented designers who produced innovative clothing, *Vogue* and *Harper's Bazaar*, prime arbiters of the mode, made sure to report on the costume scene from the movie studios, including period designs. *Vogue* printed Adrian's sketches for *Camille* (1936) and *Marie Antoinette* (1938). Luise Rainer primped for photos in a room full of spectacularly plumed hats from *The Great Ziegfeld* (1936). Marlene Dietrich appeared in layouts in splendid Russian sables and brocades designed by Travis Banton for *The Scarlet Empress* (1934). *Harper's Bazaar* suggested that its readers borrow the Spanish parasols, lace scarves, and net hoop skirts as worn by Dietrich in *The Devil Is a Woman* (1935). The smartest women in London, reported *Vogue*, were copying the long black taffeta cloak designed by Oliver Messel for Merle Oberon in *The Scarlet Pimpernel* (1935) and wearing it to the season's best parties.

By the time the 1930s had drawn to a close, the fashion world had borrowed from Hollywood period films again and again. *The Crusades* (1935) popularized long, flowing lines, particularly long evening capes fastened at the shoulder with large clips. Gwen Wakeling, designing at Twentieth Century-Fox, had alerted fashion followers to the fact that label watches and beaded handbags, rediscovered for Alice Faye in *Alexander's Ragtime Band* (1938), would make a smart impression on the accessory scene. Promoters sold everything from

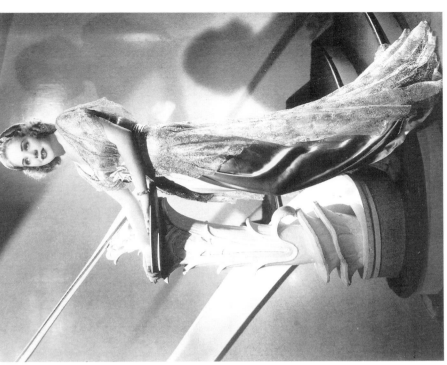

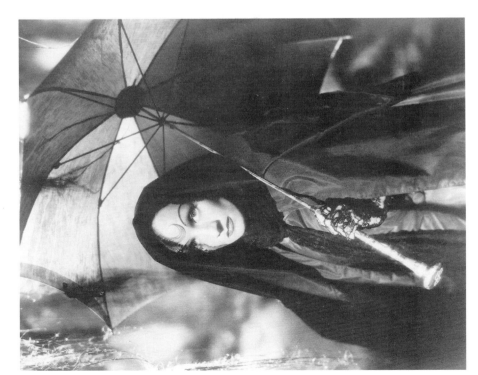

Fig. 45
Left: Marlene Dietrich in *The Devil Is a Woman* (Paramount, 1935). Costumes by Travis Banton

Fig. 46
Right: Alice Faye in *Alexander's Ragtime Band* (Twentieth Century-Fox, 1938). Costumes by Gwen Wakeling

copies of William Powell's sapphire cuff-links in the 1931 film *Man of the World* (women wore them with tailored dinner clothes) to replicas of Merle Oberon's wedding gown from *Wuthering Heights* (1939). Natalie Visart, designing *Union Pacific* (1939) at Paramount, adapted Joel McCrea's flannel frontierman's shirt and metal belt buckle for female wear. The "Snow White afternoon dress," executed in a silk crêpe with piquant "Gallic spirit" at $39.95, was offered to shoppers on Fifth Avenue who had been enchanted with Walt Disney's *Snow White and the Seven Dwarfs* (1938).[26] The "Dopey hat," a retail adaptation inspired by the dwarf's cap, was displayed in Manhattan's smartest salons.

As the 1940s began, it appeared that the Hollywood influence on dress would continue and possibly grow. When France fell in Autumn 1940 the entire fashion world "was thrown into a frenzy. . . . Without Paris, other major cosmopolitan cities vied for the title [of fashion capital]. . . . Most commentators on the fashion scene expected the movie designers to influence greatly the retail market during this period."[27] Several films indicated that these hopes might be realized. Vivien Leigh and Laurence Olivier were costumed beautifully by René Hubert for *That Hamilton Woman* (1941). Leigh's attractive Regency fashions helped to popularize fichu dresses. Her "Lady Hamilton hat," a large, velvet

HOLLYWOOD AND SEVENTH AVENUE

90

Fig. 47
Costume sketch by Leah Rhodes for
Saratoga Trunk (Warner Bros. 1946).

picture hat, was adapted for general sale throughout America. The American lace industry went on record to thank Hubert for Dietrich's gowns in *Flame of New Orleans* (1941), as his prodigal use of lace and lace appliqués was sure to promise more profits.

Retail fashion designers' use of Hollywood costume, however, declined significantly during World War II as the government imposed limitations, known as L–85, on the use of fabrics and other materials needed for period costume. Good fabrics became rare, then nonexistent. Through ingenuity creditable costumes were produced for many period pictures; a manufacturer, however, might admire handsome costumes such as those designed by Irene and Madame Karinska for *Gaslight* (1944) or Greer Garson's wardrobe by Irene Sharaff for *Madame Curie* (1943), but find that government regulations and the wartime economy prevented all but the barest elements of the original design from being translated into a marketable dress. Yardage had to be reduced, pleats and cuffs eliminated, and lapels narrowed.

For the purposes of publicity the designer might on occasion furnish sketches derived from the screen costume, as a way of suggesting ideas to manufacturers. For example, New York designer Nettie Rosenstein used historical film costume as the inspiration for several of her creations. Because male costume generally used less yardage, she chose to adapt for female dress an 1840s costume in the movie *Jane Eyre* (1944), designed by Hubert and worn by Orson Welles as Mr. Rochester. Borrowing the black wool fabric, the wide-winged lapels, and a white shirt cut like an early Victorian nightshirt, Rosenstein produced the Jane Eyre suit. Its skimpy jacket, very narrow skirt, and lack of trimming were perfectly in tune with L–85's dictum for meager chic. Other clothes worn by Joan Fontaine in the title role were adapted by Rosenstein, who months later also presented a line of dresses inspired by Hubert's costumes for Woodrow Wilson's wife and daughters in the film *Wilson* (1944).

But even during these years of restrictions the influence of period design did not disappear. For example, Leah Rhodes, the designer of Ingrid Bergman's 1880 gowns for *Saratoga Trunk* (1945), would simplify her period reconstructions, adapting the cut of a sleeve, a neckline, or the shape of a bonnet. These sketches made for an effective publicity layout in the fan magazines, but they seemed to have a minimal effect on the trade.

Towards the end of the war there was extensive promotion of the costumes (termed "The Miracle of Mauve" by the fashion press) from *Meet Me in St. Louis* (1944), *Experiment Perilous* (1944), *The Belle of the Yukon* (1944), *Miss Susie Slagle's* (1945), and *Nob Hill* (1945). The *California Stylist* reported, "The Miracle of Mauve [is] . . . a matter of amazement. . . . Every major studio in Hollywood has in production or release during this month a motion picture laid in [or close to] the Mauve Decade [the 1890s]. . . . Each one is a treasure trove of fashion ideas for any designer of dresses, suits, coats, or blouses."[28] The "treasure trove" included braid and ball fringe trim, back peplums, chatelaines, tucked

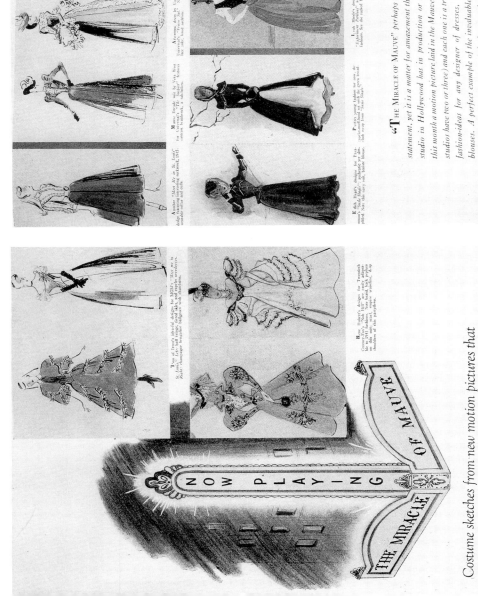

Costume sketches from new motion pictures that will make your customers mauve-decade conscious.

"THE MIRACLE OF MAUVE" *perhaps a fashion over-statement, yet it is a matter for amazement that every major studio in Hollywood has in production or release during this month a motion picture laid in the Mauve Decade (some studios have two or three) and each one is a treasure-trove of fashion-ideas for any designer of dresses, suits, coats or blouses. A perfect example of the invaluable design-source the California market has ready for use right on its door-step, in motion pictures.*

CALIFORNIA STYLIST, February, 1945

Fig. 48
Double spread from *California Stylist,* February 1945.

blouses, fur capelets, and lace *gilets.* Judy Garland's knit stocking cap worn with a tennis costume in *Meet Me in St. Louis* was adapted and became a bestseller in the junior market.

After the war fashion designers were no longer so strongly influenced by Hollywood as they had been in the 1930s—even though more historical films were produced in the 1950s than in any other period. With the proliferation of television and increases in advertising, movies had more competition in the dissemination of fashion. Paris re-emerged from the war as a more independent fashion capital. European films became popular, introducing a new type of female star—earthy, more realistic—to whom elaborate costuming seemed to be less important. Mature screen types, given to wearing expensive couture with authority and emphasizing a well-groomed appearance, became outmoded. The youth market had developed and with it increased casualness in dress. Legs and heads were bare. The young now formed the largest part of the movie-going audience, and films reflected their tastes.

91

Fig. 49

Maurice Chevalier, Leslie Caron, and Louis Jourdan in *Gigi* (M.G.M. 1958). Costumes by Cecil Beaton

One of the few designers who had a noticeable impact in this environment was Cecil Beaton. Although Beaton was British and worked on a number of English productions, he did considerable work for the American studios and is generally considered part of the Hollywood design community. His period costumes for Vivien Leigh in *Anna Karenina* (1948), a British film, were heralded as a major influence in Paris, reviving velvet throat ribbons, jeweled dog collars, velvets, and sables. The House of Dior was motivated by the pre-Revolutionary clothes to design an ankle-length Anna Karenina coat, lavishly trimmed with fur, accessorized with a fur hat and muff.[29] That same year his elaborate gowns and hats for *An Ideal Husband* were a *succès d'estime*. As it was produced in war-weary England, Beaton noted, "It was not easy to find among our utility materials, docketed cretonnes or nylon household goods [which had to]

simulate thick brocades, cumbrous satins, and quilted damasks.''[30] His liberal use of sumptuous-looking fabrics, his iconoclastic use of color (borrowed from the ballet designs of Christian Bérard), and his use of opulent furs, feathers, and ribbons made a vivid impression on American designers and helped to stabilize a growing postwar revival of Romanticism.

In the 1950s, however, it became even rarer for Hollywood to influence fashion trends. For example, *Gigi* (1958) presented an impressive array of Cecil Beaton's Belle Epoque costumes. He designed clothes in ravishing color for a world of extravagant demimondaines, for a period ''when fashion was daring and eloquent, and when women loved the big effect; their hats, none alike, gloriously exuberant.''[31] It was a major movie costuming effort, but for all its success at the box office and for all the awards it won, *Gigi* made little impression on the garment industry; all that emerged was a line of *Gigi*-inspired children's dresses, reproduced in economical fabrics, which bore only a vague resemblance to the Beaton designs.

There were a few merchandising tie-ins from time to time during this decade, aided in great part by the studio's publicity departments and confined as a rule to the fashion glossies or fan magazines. Clever promoters introduced a line of dresses, publicized as though they were derived from the film *Ivanhoe* (1952), but bearing no similarities to Roger Furse's costumes for the M.G.M. epic. A new color, ''Black Rose,'' was introduced to publicize Twentieth Century-Fox's film *Black Rose* (1950), but it was forgotten in a season. M.G.M. designer Helen Rose adapted for daily dress a Roman cape from *Quo Vadis* (1951): the ''Quo Vadis raincoat'' was a street-length coat with hood interpreted in a new fabric woven of acetate, rayon, and Dupont Orlon, lined in a rayon print, and selling for $40. Rose also cooperated with studio publicists and freely adapted her sketches for Lana Turner's period gowns in *The Merry Widow* (1952) and Eleanor Parker's clothes in *Escape from Fort Bravo* (1953), but there is no evidence that the simplified adaptations were ever reproduced by the studio or by a manufacturer.

The most significant movie influence of the decade came from an unlikely source and reached epidemic proportions before it faded with other quickly abandoned fads of the 1950s. Walt Disney promoted the film *Davy Crockett* (1955) with a barrage of publicity and merchandising. ''The frontier hero became the new teenage idol, creating a rage for trapper-style dress. Moccasins, fringed jackets and trousers, and above all the fur hat with a tail at the back were seen in all parts of the world, and were especially popular with children.''[32]

The film industry changed dramatically during the 1960s. European films and films produced in Europe were more important than they had ever been before. Skyrocketing costs reduced the number of films produced in the United States. But the movies became more outspoken than ever before; the cautious censorship of the past had all but vanished. With these changes costume film began again to exert some significant influences on fashion.

Fig. 50
Left: Susannah York and Albert Finney in *Tom Jones* (United Artists, 1963). Costumes by John McCorry

Fig. 51
Right: Tom Courtenay and Julie Christie in *Doctor Zhivago* (M.G.M., 1965). Costumes by Phyllis Dalton

The fashion industry borrowed ideas from *Tom Jones* (1963) and its costumed re-creation of eighteenth-century England. Dior showed a navy-blue Tom Jones dress in his spring collection. The Tom Jones shirt was adapted for women and sold in major department stores. *Vogue* described it effusively: "We have a thousand delicious memories of the movie, but what we came away with was a really insatiable craving for: the Tom Jones shirt . . . the thinnest handkerchief linen . . . the long stock tie, the yoked top; those marvelously full sleeves, tight and ruffled around the wrists . . . entrancingly in character."[33]

Two years later garment manufacturers were again inspired by a period picture, *Doctor Zhivago* (1965), with costumes by British designer Phyllis Dalton. The "Doctor Zhivago coat," fur-trimmed, usually worn with boots, a fur hat and muff, was introduced in New York for the winter season of 1965/66. "Marc Bohan, designer for the House of Dior in Paris, [presented] a collection featuring mid-calf coats to capitalize on the so-called Russian influence of the Zhivago look."[34] Other designers showed coats that were furless and trimmed with frog closures, braid, and military-looking buttons, to create a vague approximation of the pre-Revolutionary Russian mode. Abe Schrader, an American garment manufacturer, marketed a "Caviar Collection," consisting of over-blouses and turtleneck sweaters loosely derived from styles in the film. The Persian lamb hat worn by Omar Sharif was copied by a number of manufacturers and was widely worn.

Without question the most pervasive influence on late-1960s and early-1970s fashion was the style of the 1930s. Hollywood played a key role in establishing and disseminating this look. Much attention was paid to a remarkable group of films, different in content and style, yet all set during the Depression: *Bonnie and Clyde* (1967), *The Prime of Miss Jean Brodie* (1968), *They Shoot Horses Don't They?* (1969) and *The Damned* (1969). Other films such as *Star!* (1968) and *Funny Girl* (1968) included costumes from the post-World War I era.

The first of these films, *Bonnie and Clyde*, was a formidable triumph. Several years after the film's release *Show* magazine observed:

Probably no one imagined at the time that the most far-reaching contribution *Bonnie and Clyde* would leave to our acid-rock-pop generation was its influence on fashion. Nor that Theadora Van Runkle, who designed the clothes for Faye Dunaway and cast, would become responsible for the midis and braless bosoms that are the trademark of the early seventies. But that's just what happened. The Van Runkle look . . . is unmistakably 1930s. The free-flowing calf-skimming skirts. Deep V-necked shirts and sweaters. Shortly bobbed hair with a close fitting cloche.[35]

Bonnie and Clyde relaunched soft sweaters, the cardigan, and the fagoted silk blouse—the classic sportswear look of the 1930s, which was also the look presented by Elizabeth Haffenden in her dresses for *The Prime of Miss Jean Brodie*. Berets, like the one Faye Dunaway wore as Bonnie Parker, became available for $1.99 at discount stores across the country, restoring a hatted look to a hatless generation.

Fig. 52
Above: *Florinda Bolkan in The Damned* (Warner Bros.. 1969). Costumes by Piero Tosi

Fig. 53
Left: *Warren Beatty and Faye Dunaway in Bonnie and Clyde* (Warner Bros.. 1967).
Costumes by Theadora van Runkle

Donfeld's costumes for Jane Fonda, Susannah York, and others in *They Shoot Horses Don't They?* presented another carefully researched look at the Depression. Although the movie gives a grim view of a dance marathon, the garments with halter tops and sleeveless, striped pullovers, worn with nautical-looking trousers, were thought adaptable by mass-market retailers.

The image presented by Piero Tosi's costumes in *The Damned* was more sophisticated, invoking the haute couture of the 1930s, with expensive evening gowns by Vionnet and tailored suits by Chanel. "[Tosi] had assembled [the costumes] from secondhand shops, private collections, or re-created from fashions at the time of the Third Reich." He presented "women in mannish suits with wide lapels and 1930s side-tilted hats—crimped hair and deep vermilion lips . . . at night their bodies sheathed in silver lamé or bias-cut silk." [36] The next season revealed the extent of Tosi's influence as almost every New York designer included garments with a 1930s feeling.

The film industry's influence on fashion continues today. While this influence reached its height in the 1930s, in every decade period movies have made important contributions to dress. The impact of these costumes is partly the result of their aesthetic strength and originality and partly the result of the power of film as a mass medium. Millions of people have gone to the movies and been entranced by the beauty of the stars and the clothes they have seen on the screen. Well aware of this audience, Hollywood moviemakers and garment manufacturers have marketed film-related clothes, capitalizing on the public's love for the movies. But the costumes copied and the clothes produced are not necessarily examples of crass commercialism. Although studio executives were always looking to increase profits, they often did this by supporting the creation of beautiful and innovative works of art. The period costumes in this book fall into this category; they provided the basis for many designs and new trends that have been so popular in retail fashion.

Imperial Guard in *Return of the Jedi*
(Twentieth Century-Fox, 1983). Designers:
Aggie Guerard Rodgers and Nilo Rodis.

Visions of the Future:
Costume in Science-Fiction Films

ELOIS JENSSEN

When re-creating costumes of the past, designers have historical precedents to turn to; but what do designers do when looking to the future? The costumes they create must reflect the social structure and values of the new society; dress must complement the vision of the future being produced by the movie-makers. Depending on the story and style of the film, designers may make a conscientious effort to predict how styles may change, or they may simply let their imaginations run wild. The possibilities appear to be limitless, but curiously, certain motifs occur again and again in costume design for science-fiction and fantasy film. For example, broad-shouldered, Neo-classical drapery, as seen above in the costume for an imperial guard in The Return of the Jedi *(1983), is a common costume device for films set in the future. Perhaps costume elements from the ancient past create a sense of timelessness.*

The Hollywood clothes of the future almost always reflect historic influences and can usually be placed into one of several stylistic categories. The heroes and heroines may be on other planets, millions of years into the future, but the costumes in the films often recall the dress of the Ancient Greeks and Romans, harem girls and sheiks, samurai and geisha, or medieval knights and maidens.

Buster Crabbe and Charles Middleton in *Flash Gordon* (Universal, 1936). Costumes uncredited.

Draconian Warrior. Buck Rogers in the Twenty-fifth Century (Universal, 1979). Costume sketch by Jean-Pierre Dorleac.

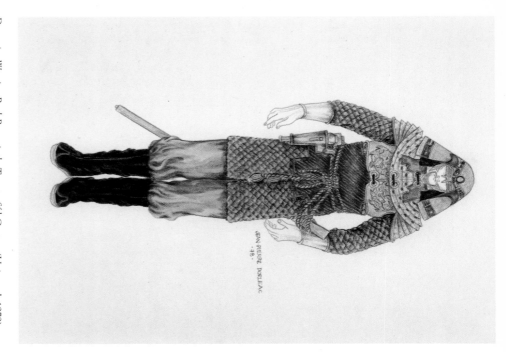

Dressed for Space

The prospect of going into outer space would suggest protective equipment and utilitarian clothing, but in most science-fiction films realism is not the deciding factor in costume design. Usually the films' wardrobes incorporate fashion elements of the past. As Flash Gordon, Buster Crabbe (below left) wears medieval armored forms with studded belt and collar. In another photo from the film (below), it looks as if Flash has walked into a production of Wagner's Die Walküre, set in the Middle Ages, with Prince Baron and his men clothed in mail coats and winged, metal helmets.

Buster Crabbe and Jean Rogers in *Flash Gordon* (Universal, 1936). Costumes uncredited.

Jean-Pierre Dorleac's design for a "Draconian" warrior (above left) in Buck Rogers in the Twenty-fifth Century (1979) was inspired by directions in the script and by the producer's decision that Buck's adversaries come from a technically advanced civilization influenced by opulent barbarian dress. Dorleac borrowed these styles from these ancient oriental cultures and gave the costumes a "high tech" feeling, using only natural-looking fabrics that were both real and synthetic.

The teenage space pilot Luke Skywalker, played by Mark Hamill (opposite, above left) in Return of the Jedi, is dressed like a serf in fourteenth-century Europe. His upper garment is a simple T-shape of fabric, extending to the hips.

In Star Trek II: The Wrath of Khan (1982) the woman's uniform, worn by Bibi Besch (opposite, below left), shows a Greco-Roman influence once removed: this cowl-necked outfit was in fashion in the 1980s and was based on the 1930s version of Ancient Greek designs. The man's uniform is asymmetrical, a common device in futuristic design.

Admiral Kirk (William Shatner). Star Trek II: The Wrath of Khan *(Paramount, 1982). Costume sketch by Robert Fletcher.*

The costume design for Admiral James Kirk (above) is an adaptation of twentieth-century military dress. Robert Fletcher designed a series of uniforms for the Federation space force which reflect the wearer's rank and department. In this case the denotation of rank — admiral — is on the sleeve rather than the shoulder (as is usually the style in military wear). The sketch is particularly interesting for the way the costume projects a mixture of authority and informality in keeping with Kirk's character, played by William Shatner. The coat is of a military design, but instead of a tailored collar, Fletcher has put in a turtleneck, an informal touch. The pants are baggy rather than straight, also evincing a more casual feeling.

In his work for Star Trek II and the two sequels, Fletcher evoked a futuristic feeling through his use of color. In an interview he said: "The colors I wanted for the film were what I called 'corrupt colors', a shade off from a pure color. In other words, the uniform jackets aren't quite red. . . . Spock's Vulcan robe isn't a pure black. I call them 'ish colors', maroonish red, brownish green, purplish black. They're not colors you see today, so in that subtle way, they indicate another time."

Mark Hamill in Return of the Jedi *(Twentieth Century-Fox, 1983). Designers: Aggie Guerard Rodgers and Nilo Rodis.*

Bibi Bensch in Star Trek II: The Wrath of Khan *(Paramount, 1982). Designer: Robert Fletcher.*

Above and below: Two stills from 2001: A Space Odyssey (M.G.M., 1968). Designer: Hardy Amies.

Stanley Kubrick's 2001: A Space Odyssey was released in 1968, a year before man first walked on the moon. One of the most influential science-fiction films ever made, it revived a genre that had been thought dead. A number of scientific and technical concerns contributed to the film's overall design scheme, which attempted a serious prediction of what outer-space travel might be like in the near future. Designer Hardy Amies, known for his line of men's suits, designed space suits for the film which appeared at the time to be completely utilitarian. Today, however, in comparison with the suits used for the space shuttle and moon walks, the 2001 outfits appear sleek and streamlined. In contrast to the drabness of the suits worn by real astronauts, those in the film were brightly colored. The helmet worn by Keir Dullea as David Bowman is similar to the helmet worn by Raymond Massey in the British film Things to Come (1939).

Part of Kubrick's imaginative plan for the film was suggesting how space travel in the future might take the form of everyday transportation. The photo above shows two stewardesses eating lunch; their outfits are fairly simple pantsuits, similar in cut to 1960s fashions designed by André Courrèges. The collars are modified boatnecks, commonly seen in women's attire in the 1960s. Their padded headgear is designed for the rigors of interplanetary weightlessness, but suggests that underneath it, their hair is worn in a beehive. The fabric is a stretch material similar to the double-knit wools popular at the time.

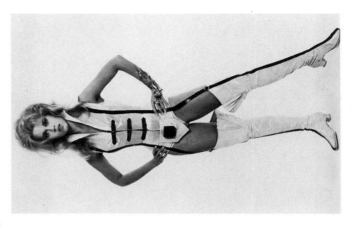

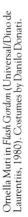

Princess Ardala [Pamela Hensley]. Buck Rogers in the Twenty-fifth Century *(Universal, 1979). Costume sketch by Jean-Pierre Dorleac.*

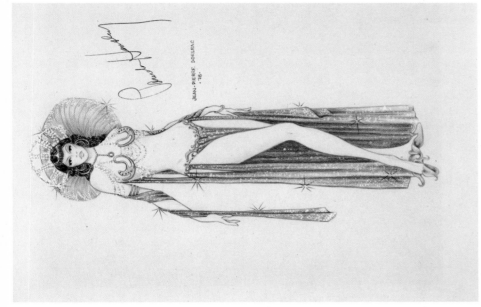

Jean Rogers in *Flash Gordon* (Universal, 1936). Costumes uncredited.

Harem Girls

While intergalactic menswear often means suiting up from head to toe, women in outer-space adventure films invariably seem to have wandered in from a sultan's palace. As Dale Arden in the 1936 Flash Gordon, *Jean Rogers (above) appears in a bias-cut, flared, hip-hugging skirt, typical of the 1930s. Her top flattens her breasts according to the style of the day. In the 1980 version of* Flash Gordon, *Ornella Muti (Princess Aura) wears an attractive Folies Bergère ensemble (below left). The costume and pose are strikingly similar to the dance outfit worn by Lana Turner in* The Prodigal *(see p. 19). Pamela Hensley (Princess Ardala) also wears a "harem girl" outfit (above right) in* Buck Rogers in the Twenty-fifth Century *(1979), but the costume is given a unique futuristic flare with its displaced Mongolian-inspired ceremonial collar and ornate breastplate and loin piece. In a "high tech" adaptation of the odalisque outfit, Jane Fonda (below right) in* Barbarella *(1968) is suited and booted in a 1960s chic, Courrèges-style ensemble, notable for its shiny vinyl and tight body-fit.*

Ornella Muti in *Flash Gordon* (Universal/Dino de Laurentiis, 1980). Costumes by Danilo Donati.

Jane Fonda in *Barbarella* (Paramount/Dino de Laurentiis, 1968). Costumes by Jacques Fonteray.

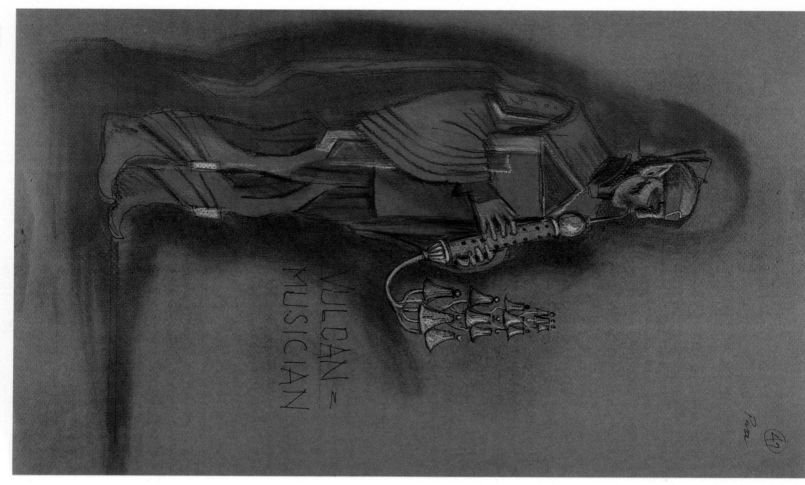

VULCAN MUSICIAN

Star Trek

Although the Star Trek stories take place in outer space in the twenty-third century, one aspect of them is decidedly earthbound: religious mysticism. Whenever the stories are set on the planet Vulcan, home of Mr. Spock (below), futuristic designs include a neo-medieval atmosphere. With his short tunic, boots, and draped sleeves, the Vulcan musician (left) would hardly be out of place in the court of King Arthur, although his ears might raise a few eyebrows.

Leonard Nimoy in Star Trek II: The Wrath of Khan (Paramount, 1982). Costumes by Robert Fletcher.

Vulcan Musician with Pipes, Star Trek III: The Search for Spock (Paramount, 1984). Costume sketch by Robert Fletcher.

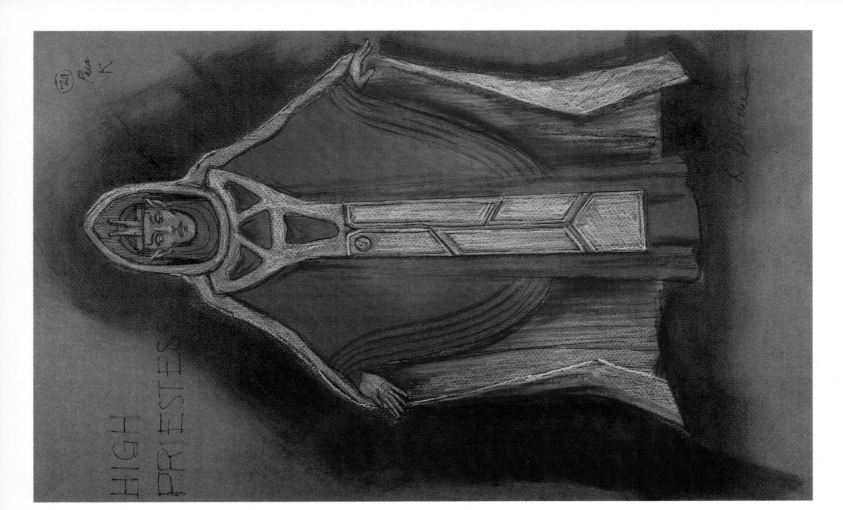

HIGH PRIESTESS

Above and right: Priestess in Star Trek III: The Search for Spock (Paramount, 1984). Costumes by Robert Fletcher.

The Vulcan priestess, played by Dame Judith Anderson in Star Trek III: The Search for Spock (1984), is wearing a robe (right) derived from a fourteenth-century chasuble, an ecclesiastical garment worn by Roman Catholic priests. Her head-dress (above) is of an Egyptian design and has pseudo-hieroglyphic inscriptions on its band. The costume of the president of the Federation (see p. 189) for Star Trek IV: The Voyage Home (1986) is a futuristic adaptation of a Henry VIII-style, Tudor costume. It even includes a stylized version of a late-fifteenth-century metal collar/ necklace worn by members of a knightly order. In the costumes for both the priestess and the president the embroidered decorations are asymmetrical and abstract unlike their historic counterparts, removing the costumes from their period context and giving them a futuristic feeling.

Two hairstyles for Carrie Fisher in Return of the Jedi (Twentieth Century-Fox, 1983). Designers: Aggie Guerard Rodgers and Nilo Rodis.

104

Return of the Jedi

In making the Star Wars series, George Lucas envisioned a fairy-tale universe of knights and wizards, princesses and monsters. The costumes in the three films contribute to the story's setting, a faraway galaxy thousands of years from today, by mixing medieval and oriental motifs. The tunics, flowing capes, swords, and helmets (see p. 97) reflect historic earth fashions. The two motifs are also apparent in Princess Leia's hairstyles designed by Paul LeBlanc, for The Return of the Jedi. The single braid (above left) is worn in the Arabian Nights sequence at Jabba the Hutt's palace, where the princess is part of the creature's harem. The curled free-flowing locks (above right and right) are seen elsewhere in the film and are reminiscent of medieval romanticism as viewed by the nineteenth-century Pre-Raphaelites (particularly William Morris and Dante Gabriel Rossetti).

Carrie Fisher in Return of the Jedi.

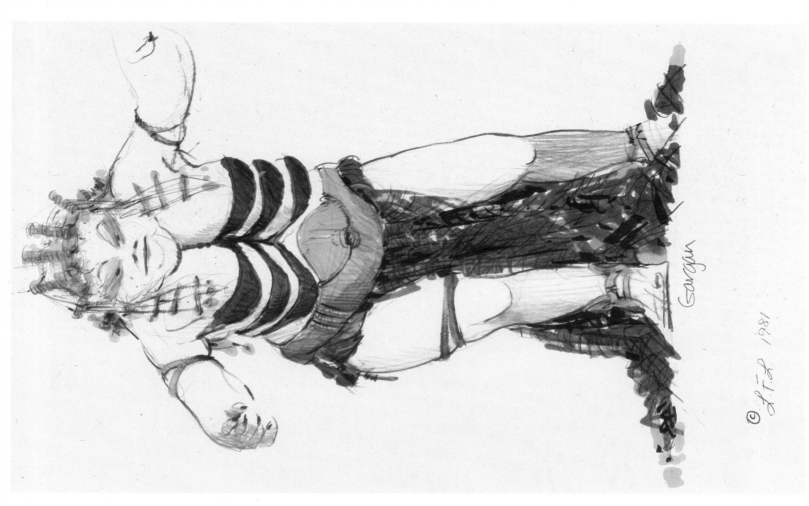

Gargan: Multibreasted Dancing Figure from Jabba the Hutt's Palace. Return of the Jedi. Costume sketch by Nilo Rodis.

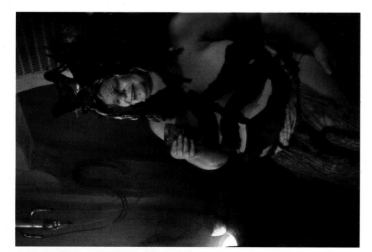

Gargan in Return of the Jedi.

This multibreasted member (above and left) of Jabba's harem is a parody of Princess Leia and the "harem girl" tradition as a whole. Precedents for such a character can be found in turn-of-the-century illustrations by Aubrey Beardsley. This and other sketches for the film were drawn by Nilo Rodis, but the design and execution of the costumes was by Aggie Guerard Rodgers. Whether the film is modern, period, or set in the future, Rodgers looks for inspiration by consulting Japanese fashion magazines and other sources of modern and period oriental design. With Return of the Jedi, she also evoked a futuristic feeling by using items not associated with everyday wear: ski clothes and hockey equipment.

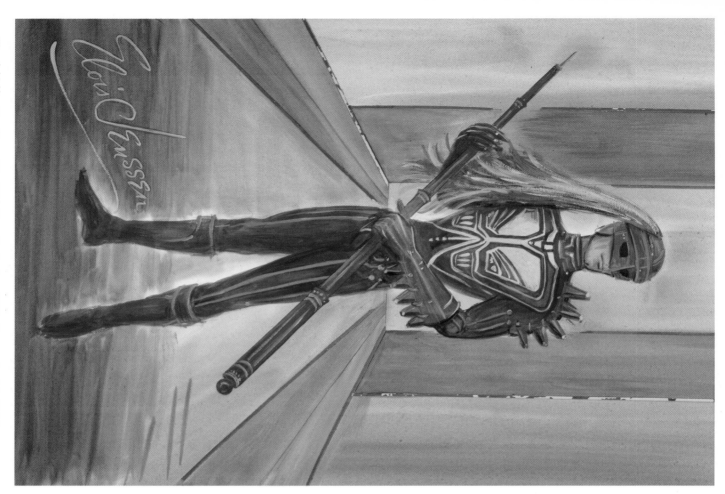

Wounded Soldier, Tron (Buena Vista/Walt Disney Productions, 1982). Costume sketch by Elois Jensen.

Bruce Boxleitner and Jeff Bridges in Tron.

Tron

Tron (1982) is a futuristic adventure, predominantly set inside a computer with actors portraying different computer programs. The film had originally been planned to be entirely animated, but the animation of human figures was not considered satisfactory. Instead, the producers decided to use actors, set against backgrounds created entirely by computer imaging. Sophisticated optical techniques create an electronic fantasy world, using state-of-the-art computer graphics. Quite different from other films set in the future, the costume designs for Tron were most significantly influenced by the requirements of having the dress mesh perfectly with the special graphic effects.

The costumes for Tron were body-suits made of four-way stretch nylon in off-white (above and opposite, above left), and the different patterns representing computer programs were silk-screened in black. The patterns were also taped, painted, and glued on the helmets, arm bands, and other parts of the costume. The computer sequence was shot in black-and-white, and the actors worked against a black background. A negative was then made, and where the program lines had been black, they were now white, making it possible for special effects workers to add colors for the different characters: blue for the heroes and red for the villains.

The sketch of Yori (far right) was intended for a love scene and represents the concept of a nude computer program. Given its subject matter, the proposed costume was the softest design for the film but was not used in the final cut. The Wounded Warrior (left) has a more hard-edged look, with the dangling wires denoting a fatal head wound.

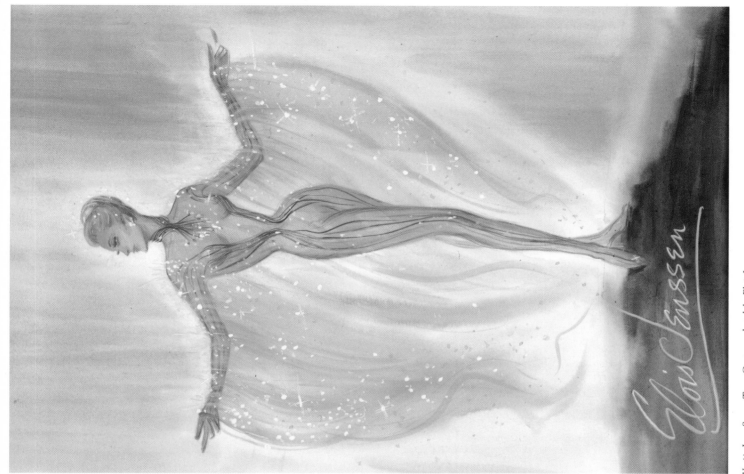

Yori in Love Scene. Tron. Costume sketch by Elois Jenssen.

Still from *Tron.*

Costume design for *Tron.*

Man's Maroon Costume (left) and Jessica [Jenny Agutter] (right). Logan's Run (M.G.M., 1976). Costume sketches by Bill Thomas.

Michael York and Jenny Agutter in *Logan's Run*.

Logan's Run

Logan's Run (1976) is set in the twenty-third century in a world of full employment, zero population growth, food for all, and free sex. There is, however, one catch: life is automatically terminated at age thirty to make room for new citizens.

Bill Thomas's costumes had to be logical extensions of this imaginary society in which the social structure was based rigidly on age. The colors of the clothing denoted the citizen's stage in life: white for seven and under; yellow for eight to fifteen; green for fifteen to twenty-two; and red or pink for twenty-two to thirty. Black uniforms with bands of quilted gray across the chest to relieve the starkness, were worn by the "sandmen," armed police officers who enforced the mandatory death sentence on those who did not accept it willingly.

Since the story takes place inside a hermetically sealed dome, a world devoted to sensual pleasure,

Thomas felt that the clothes should be lightweight and function as decorative rather than essential, protective garments. He compared the culture of the "City of Domes" with those of Pompeii and ancient Rome and created costumes (left) that were basically thigh-length tunics tied around the waist with a sash or gold belt; they featured either high collars or V-necks. Because the clothes were to reflect the prevailing sexual freedom, he wanted the women to appear nude under the short tunics, and in the film they wore no bras. Hose and dance sandals were dyed to match the various shades of the costumes. He would have preferred a bare-legged, barefoot look, but budgetry considerations ruled out the added expense of body makeup for more than five hundred extras. Likewise, he originally envisioned some of the men going shirtless with elaborate jewelry as a substitute (above left), but this costume was not adopted for the film.

Blade Runner

Ridley Scott, director of Blade Runner (1982), was determined to avoid "shiny buildings, under-populated streets, and silver suits with diagonal zippers" in this film, set in Los Angeles, 2019. Its futuristic, urban landscape of crowded, dirty streets is supplemented by costumes that are not exotic but that compellingly suggest the dress of the near future, styles that include a range of fashion influences from the recent past.

As part of the overall design scheme for the film, Blade Runner sought to predict in a scientific manner what life would be like in the future, given the development of certain social, cultural, and scientific trends. Fashion played an important part in this predictive framework; it was felt that certain styles would remain fairly constant, certain ones would disappear, and others of past decades would come back into favor. This approach led to the incorporation of 1940s fashion designs as a prime influence in the wardrobe, along with traditional 1980s men's suits and punk clothing.

Two costume designers, Charles Knode and Michael Kaplan, were responsible for the film's clothing. They knew that Scott's vision of Blade Runner was a 1940s film noir detective story, like Humphrey Bogart's portrayal of Philip Marlowe in The Big Sleep. Using Art Deco influences as well as other period devices, Knode and Kaplan created a number of costumes with 1940s-style silhouettes.

The most obvious 1940s touches in the wardrobe are Harrison Ford's Bogart-esque trenchcoat (above) and Sean Young's broad-shouldered business suit (next page). A 1980s influence can be seen in the unlikely juxtaposition of patterns in Ford's shirt and tie (below). The use of unrelated patterns, forbidden for the fashionable only a few years before, became acceptable and chic in the early 1980s.

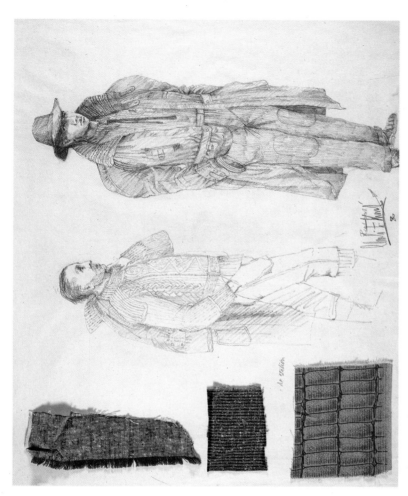

Deckard [Harrison Ford]. Blade Runner (Ladd Company/Run Run Shaw, 1982). Designers: Charles Knode and Michael Kaplan.

Harrison Ford in Blade Runner.

Above and opposite: Sean Young in Blade Runner (Ladd Company/Run Run Shaw, 1982). Designers: Charles Knode and Michael Kaplan.

The costume for Sean Young (left) looks like a 1940s women's suit by Adrian in the collection of the Los Angeles County Museum of Art. The period design of the 1940s was adapted, to make it more appropriate for the twenty-first century. By changing the padded shoulders to a more rounded shape, the outfit looked both familiar and unfamiliar. The designers also juxtaposed extremes — a nipped-in waist and overly extended shoulders — which had not previously been seen together and which became fashionable in the 1980s.

Other costumes in the film, such as Rutger Hauer's black leather coat and Joanna Cassidy's transparent plastic raincoat, were more contemporary in origin. Perhaps the most intriguing ones are the punk or "new wave" outfits worn by extras on the Los Angeles street set and the character Pris, played by Daryl Hannah.

All of the film's costumes provide subtle clues as to the nature of society in 2019. Since the world of Blade Runner was a very depressed one, everything was over-dyed and aged. Knode and Kaplan dressed many of the oriental extras in tatters to denote their working-class status, while the well-to-do wore lavish furs, an obvious status symbol, because there were no fur-bearing animals left on the planet. The fur-decorated coat worn by Sean Young (below and opposite) could have been inspired by a late-1920s gold lace coat with mink trim by Jean Patou, formerly owned by Edna St. Vincent Millay and now in the collection of the Los Angeles County Museum of Art.

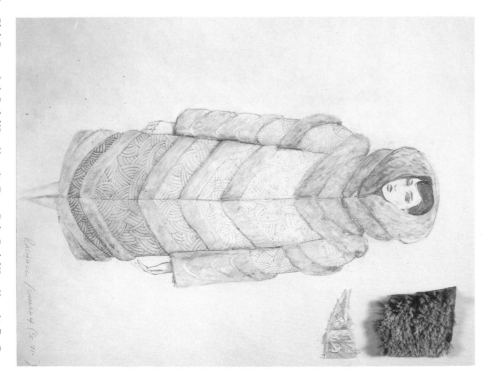

Two costume sketches from Blade Runner. Left: Rachel [Sean Young] in Dress; Right: Rachel [Sean Young] in Fur Coat.

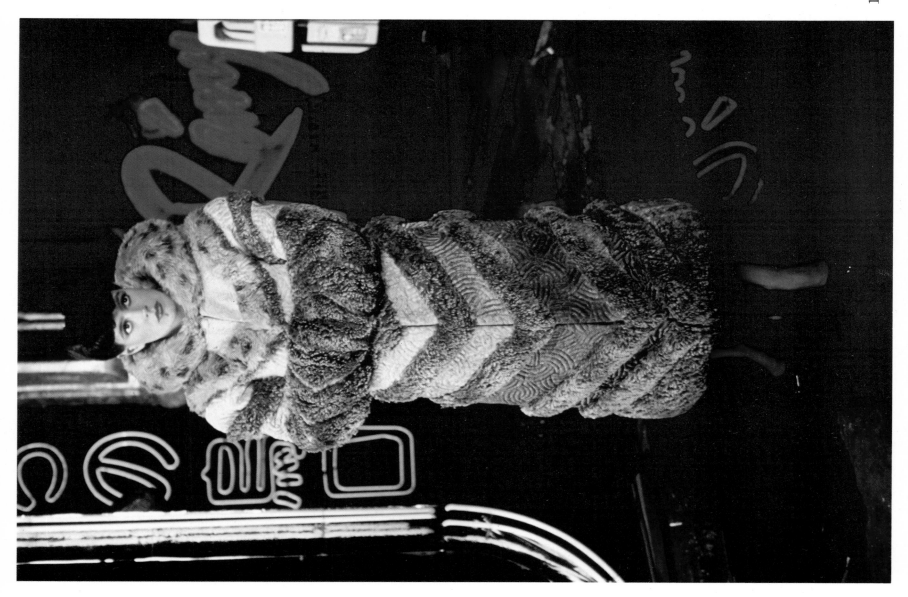

Cityscape from *Blade Runner* (Ladd Company/Run Run Shaw, 1982). Designers: Charles Knode and Michael Kaplan.

Cityscape from *Metropolis*, made in Germany, 1927.

These cityscapes of the near future were created fifty-five years apart. The Los Angeles skyscraper (*above*) is seen in Blade Runner (1982), while the other building (*below*) is part of the skyline of the fictional city in Metropolis (1927), one of the first science-fiction films made. Their striking similarity indicates that even in the world of the imaginary future, the more things change, the more they remain the same. Just as these sets bear an uncanny resemblance, so do costumes in different science-fiction films. Certain images seem to recur in the attempts by film-makers to portray the future.

As the history of film continues, new designers will offer their visions of what the world might be like years from now. There is no telling exactly what they may come up with, but one thing is certain: their designs will inevitably reflect influences of both the historic past and contemporary aesthetics.

Exhibition Checklist

This checklist presents a selection of the costumes and sketches included in the exhibition *Hollywood and History.* They are arranged chronologically by the films' time settings.

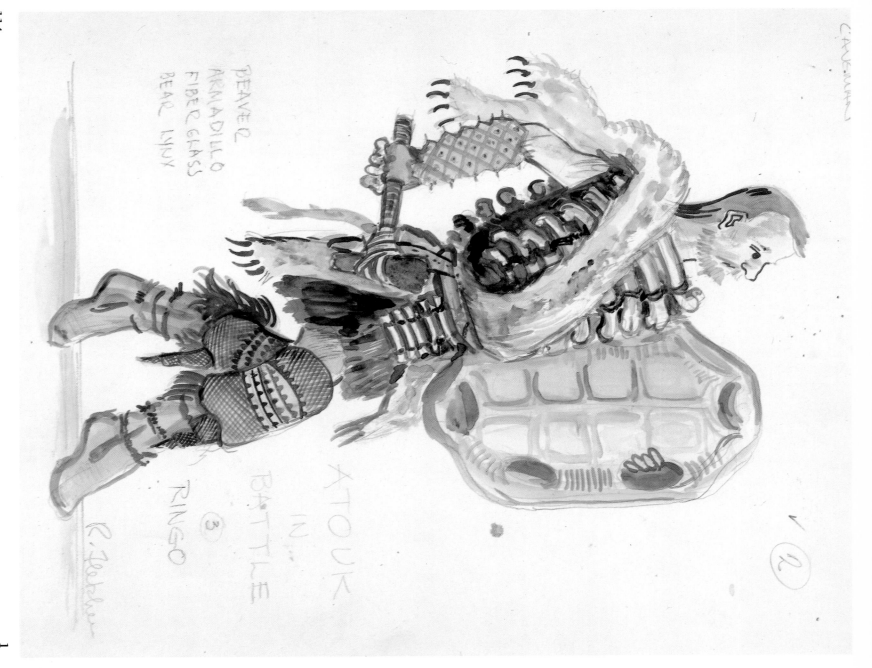

CAVEMAN

BEAVER
ARMADILLO
FIBER GLASS
BEAR LYNX

ATOUK IN... BATTLE

③ RINGO

R. Peckler

2

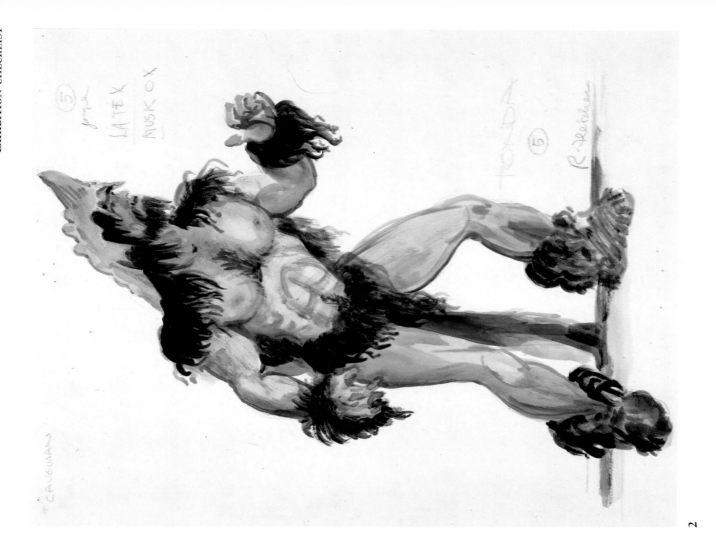

rehistory

Caveman

(United Artists, 1981)
Designer: Robert Fletcher (United
States, born 1924)

1 *Atouk [Ringo Starr] in Battle*
Costume sketch
Gouache and pencil
$14\frac{1}{2} \times 11\frac{1}{2}$ in.
Los Angeles County Museum of Art
Gift of Robert Fletcher
M.86.262.5

2 *Tonda [John Matuszak]*
Costume sketch
Gouache and pencil
$14\frac{1}{2} \times 11$ in.
Los Angeles County Museum of Art
Gift of Robert Fletcher
M.86.262.6

2

Early Egyptian/Biblical

The Egyptian

(Twentieth Century-Fox, 1954)
Designer: Charles LeMaire (United States, 1897–1985)

Baketamon [Gene Tierney]
Costume sketch by Adele Elizabeth Balkan (United States, born 1947)
Gouache and pencil
20 × 16 in.
Academy of Motion Picture Arts and Sciences
Adele Elizabeth Balkan collection

Dancer in Nefer's House
Costume sketch
Colored pencil
14 × 10 in.
Charles LeMaire estate

Egyptian Soldier
Costume sketch by Adele Elizabeth Balkan (United States, born 1947)
Gouache and pencil
20 × 16 in.
Academy of Motion Picture Arts and Sciences
Adele Elizabeth Balkan collection

Lady in Waiting
Costume sketch
Colored pencil
14 × 10 in.
Charles LeMaire estate

Princesses: Aknaton's Daughters
Costume sketch by Adele Elizabeth Balkan (United States, born 1947)
Gouache and pencil
20 × 16 in.
Academy of Motion Picture Arts and Sciences
Adele Elizabeth Balkan collection

Sinuhe [Edmund Purdom]
Costume sketch by Adele Elizabeth Balkan (United States, born 1947)
Gouache and pencil
20 × 16 in.
Academy of Motion Picture Arts and Sciences
Adele Elizabeth Balkan collection

Woman Carrying Bowls of Flowers
Costume sketch
Colored pencil
14 × 10 in.
Charles LeMaire estate

Woman in Nefer's House
Costume sketch
Colored pencil
14 × 10 in.
Charles LeMaire estate

The Ten Commandments

(Paramount, 1956)
Designers: Edith Head (United States, 1907–1982), Ralph Jester (United States, born 1901), John Jensen, Dorothy Jeakins (United States, born 1914), and Arnold Friberg

3

Abraham
Costume sketch by John Jensen
Gouache and pencil
20 × 15 in.
Los Angeles County Museum of Art
Gift of the Costume Council
M.86.262.1

Egyptian Fan
Costume sketch
Gouache and pencil
19 × 14 in.
Academy of Motion Picture Arts and Sciences
Edith Head collection

Lilia [Yvonne de Carlo]
Costume sketch
Gouache and pencil
20 × 15 in.
Academy of Motion Picture Arts and Sciences
Edith Head collection

Lilia [Yvonne de Carlo]: Lamp on Sinai Slope
Costume sketch by Dorothy Jeakins
Gouache and pencil
20½ × 15 in.
Academy of Motion Picture Arts and Sciences
Edith Head collection

Nefertiti [Anne Baxter] in Robe
Costume sketch
Gouache and pencil
20 × 15 in.
Academy of Motion Picture Arts and Sciences
Edith Head collection

Nefertiti [Anne Baxter]: Litter and Barge
Costume sketch
Gouache and pencil
20 × 15 in.
Academy of Motion Picture Arts and Sciences
Edith Head collection

Nefertiti [Anne Baxter]: Room and Balcony
Costume sketch
Gouache and pencil
20 × 15 in.
Academy of Motion Picture Arts and Sciences
Edith Head collection

Nefertiti [Anne Baxter]: Shrine of Sokor
Costume sketch
Gouache, pencil, and silver metallic materials
20 × 15 in.
Academy of Motion Picture Arts and Sciences
Edith Head collection

Sephora [Deborah Piaget]
Costume sketch by Dorothy Jeakins
Gouache and pencil
20 × 15 in.
Academy of Motion Picture Arts and Sciences
Edith Head collection

ABRAM

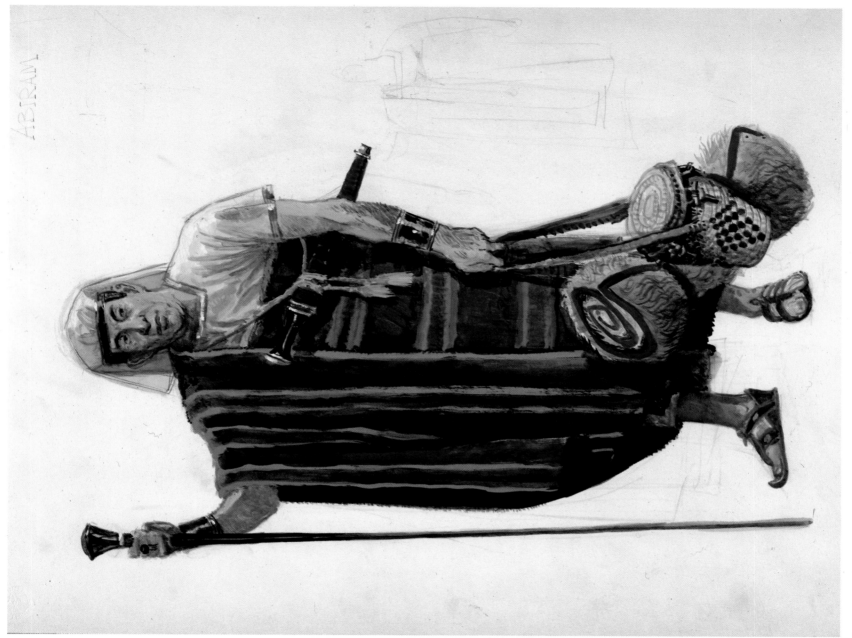

Samson and Delilah

(Paramount, 1950)
Designers: Edith Head (United States,
1907–1982), Gile Steele (United
States, 1908–1952), Dorothy Jeakins
(United States, born 1914), Gwen
Wakeling (United States, born 1901),
and Elois Jenssen (United States,
active since 1947)

Delilah [Hedy Lamarr]
Costume sketch by Dorothy Jeakins
Gouache and pencil
15 1/2 × 7 3/4 in.
Collection of Dorothy Jeakins

An Idea for DeMille
Costume sketch by Dorothy Jeakins
Gouache and pencil
15 1/4 × 4 1/2 in.
Collection of Dorothy Jeakins

4

Greek/Early Roman

A Night in Paradise

(R.K.O., 1946)
Designer: Travis Banton (United
States, 1894–1958)

4 *Persian Princess in Blue Gown*
Costume sketch
Pencil and watercolor
23 × 14½ in.
Los Angeles County Museum of Art
Gift of Tony Duquette
M.86.385.127

Persian Princess in Green Gown
Costume sketch
Pencil and watercolor
23 × 14½ in.
Los Angeles County Museum of Art
Gift of Tony Duquette
M.86.385.121

5 *Persian Princess in Orange Gown*
Costume sketch
Pencil and watercolor
23 × 14½ in.
Los Angeles County Museum of Art
Gift of Tony Duquette
M.86.385.122

6

Spartacus

(Universal, 1960)
Designers: Bill Thomas (United States,
born 1921), Valles (United States,
1885–1970); and Peruzzi

6 *Livia [Jean Simmons]*
Costume sketch by Bill Thomas
Pencil and watercolor
15 × 5¼ in.
Los Angeles County Museum of Art
Gift of the Costume Council
M.87.86.3

Late Egyptian/Biblical
The Prodigal

(M.G.M., 1955)
Designer: Herschel McCoy (United
States, 1913–1956)

Dance Costume
Multicolored cabochon-cut paste
jewels and pressed metallic silver
squares joined by metallic silver
chain link
Worn by Lana Turner as Samara
the High Priestess
Los Angeles County Museum of Art
Gift of David Weisz
M.70.61.12

Gown with Full Sleeves
Cream silk jersey with embroidered
and beaded bodice
Worn by Lana Turner as Samara
the High Priestess
Los Angeles County Museum of Art
Gift of Thomas S. Hartzog
M.87.25.4

7 *Samara the High Priestess [Lana
Turner]*
Costume sketch
Pencil, ink, gouache, and glitter
22 × 15 in.
Los Angeles County Museum of Art
Gift of Thomas S. Hartzog
M.87.25.6

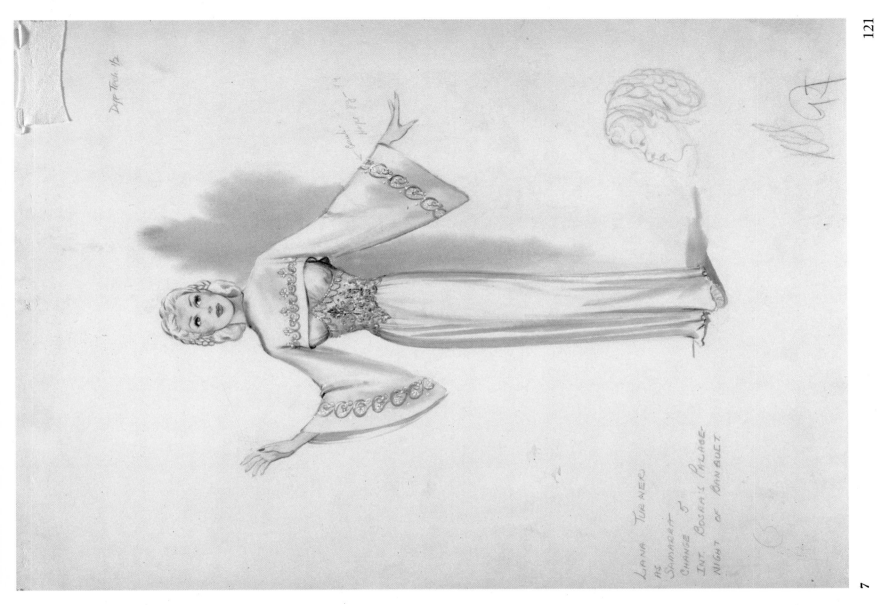

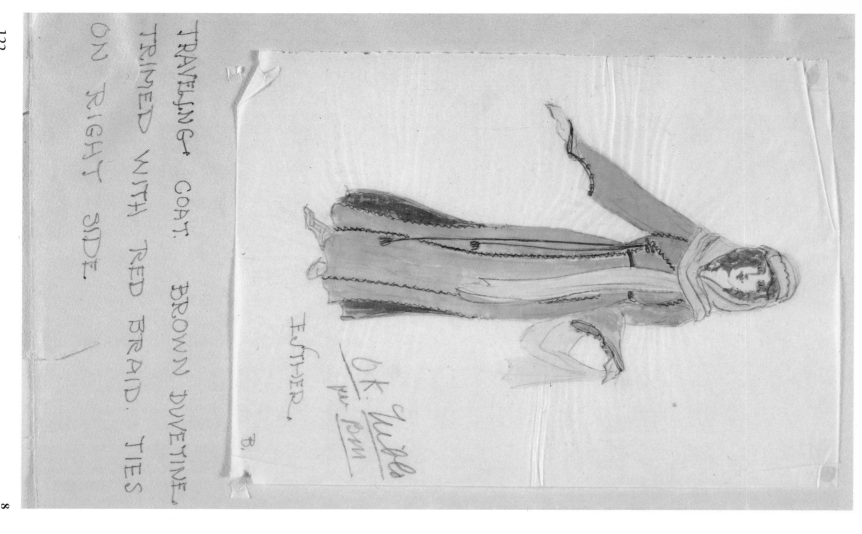

TRAVELING COAT. BROWN DUVETINE.
TRIMED WITH RED BRAID. TIES
ON RIGHT SIDE.

O.K. Irene
per bm

Esther.

B.

8

Cleopatra

(Twentieth Century-Fox, 1963)
Designers: Irene Sharaff (United
States, active 1932–77), Vittorio
Nino Novarese (Italy, 1907–1983),
and Renie Conley (United States,
active 1936–68)

Assistant Priestess
Costume sketch by Renie Conley
Colored pencil
20 × 15 in.
Los Angeles County Museum of Art
Gift of the Costume Council
M.86.305.2

Charmain-Barge at Tarsus-Banquet
Costume sketch by Renie Conley
Colored pencil
20 × 15 in.
Los Angeles County Museum of Art
Gift of the Costume Council
M.86.305.1

Ben Hur

(M.G.M. 1926)
Designers: Camillo Innocente (Italy,
1871–1961), Erté (Russia, born
1892) and Harold Grieve (United
States, born 1901)

Tunic with Horizontal Straps
Brown leather
Worn by Ramon Novarro as Ben
Hur
Los Angeles County Museum of Art
Gift of the Costume Council
M.87.4.6

Ben Hur [Ramon Novarro]
Costume sketch by Harold Grieve
Pencil and watercolor
13¾ × 6¼ in.
Los Angeles County Museum of Art
Gift of the Costume Council
M.86.302.4

*Ben Hur [Ramon Novarro] in Chariot
Race Scene*
Costume sketch by Harold Grieve
Pencil and watercolor
10¼ × 6 in.
Academy of Motion Picture Arts and
Sciences
Harold Grieve collection

9

Esther [May McAvoy]
Costume sketch by Harold Grieve
Pencil and watercolor
11⅝ × 7¼ in.
Los Angeles County Museum of Art
Gift of the Costume Council
M.86.302.7

Flavia [Carmel Myers]
Costume sketch by Harold Grieve
Pencil and watercolor
13½ × 7 in.
Los Angeles County Museum of Art
Gift of the Costume Council
M.86.302.2

Three Handmaidens
Costume sketch by Harold Grieve
Pencil and watercolor
8¾ × 3⅝ in.
Los Angeles County Museum of Art
Gift of the Costume Council
M.86.302.10

Ben Hur

(M.G.M., 1959)
Designer: Elizabeth Haffenden
(United States, 1906–1976)

Tunic Trimmed with Key-Fret Pattern
Wool
Worn by Charlton Heston as Ben
Hur
Los Angeles County Museum of Art
Gift of the Costume Council
M.87.4.7

9 *Eli*
Costume sketch
Pencil and watercolor
22 × 15 in.
Collection of Robert Callery

Tirzah #2 [Cathy O'Donnell]
Costume sketch
Watercolor
18 × 11 in.
Collection of Robert Callery

Valerius Gratus #1
Costume sketch
Watercolor
18 × 11 in.
Collection of Robert Callery

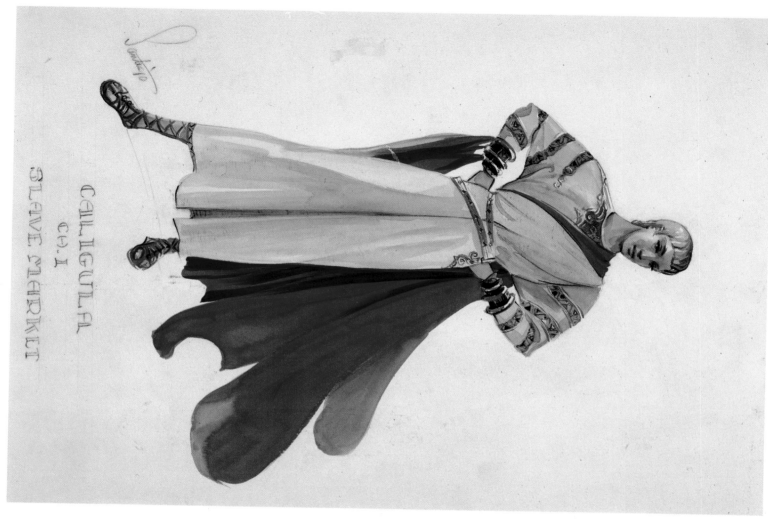

10

Young Aretis in Roman Toga
Costume sketch
Watercolor
18 × 11 in.
Collection of Robert Callery

The Robe

(Twentieth Century-Fox, 1953)
Designers: Charles LeMaire (United
States, 1897–1985) and Emile
Santiago (United States, active
1950–58)

10
Caligula [Jay Robinson]
Costume sketch by Emile Santiago
Watercolor
20 × 15 in.
Los Angeles County Museum of Art
Gift of the Costume Council
M.85.144.16

Dancer
Costume sketch by Charles LeMaire
Pencil and watercolor
12 × 10 in.
Charles LeMaire estate

Ruth
Costume sketch by Charles LeMaire
Pencil and watercolor
12 × 10 in.
Charles LeMaire estate

Slave Girl
Costume sketch by Charles LeMaire
Pencil and watercolor
12 × 10 in.
Charles LeMaire estate

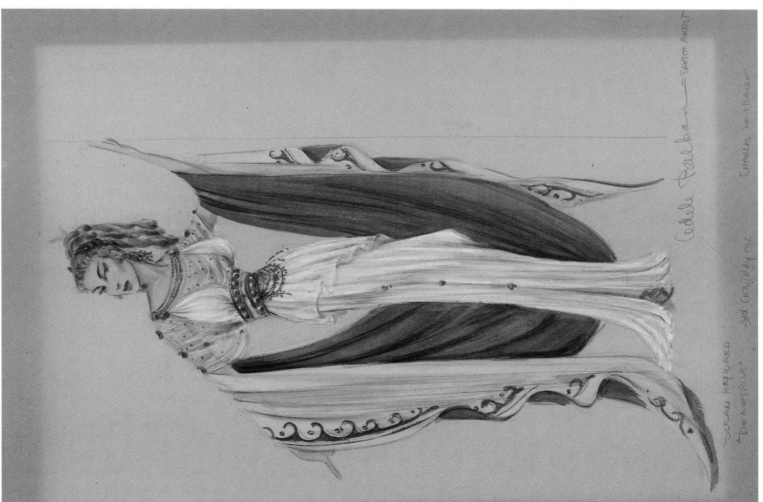

11

Demetrius and the Gladiators

(Twentieth Century-Fox, 1954)
Designers: Charles LeMaire (United
States, 1897–1985) and Adele
Elizabeth Balkan (United States, born
1947)

Messalina [Susan Hayward]
Costume sketch by Adele Elizabeth
Balkan
Gouache
20 × 15¾ in.
Los Angeles County Museum of Art
Gift of Adele Elizabeth Balkan
M.84.142.4

*Messalina [Susan Hayward] by the
Pool at Moonlight*
Costume sketch by Charles LeMaire
Pencil and watercolor
12 × 10 in.
Charles LeMaire estate

*Messalina [Susan Hayward] in the
Arena*
Costume sketch by Charles LeMaire
Pencil and watercolor
12 × 10 in.
Charles LeMaire estate

*Messalina [Susan Hayward] in the
Summer Palace*
Costume sketch by Charles LeMaire
Pencil and watercolor
12 × 10 in.
Charles LeMaire estate

*Messalina [Susan Hayward] in the
Temple*
Costume sketch by Charles LeMaire
Pencil and watercolor with fabric
swatch
12 × 10 in.
Charles LeMaire estate

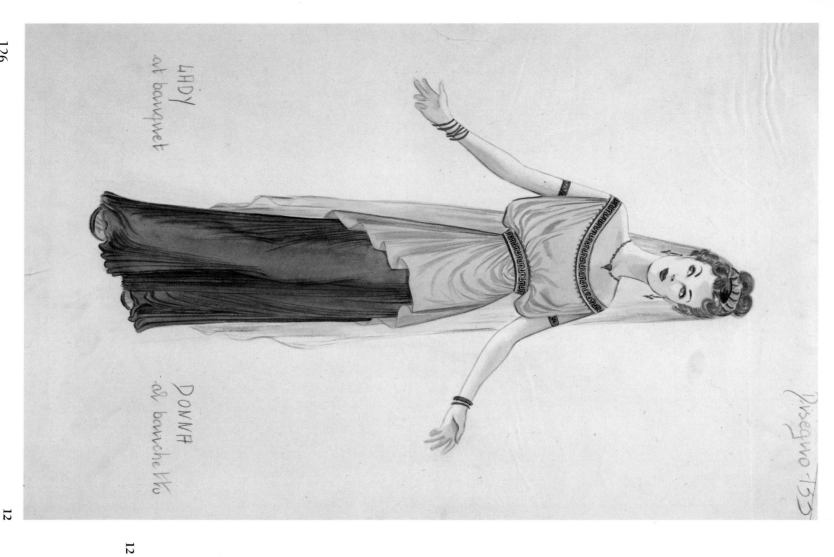

LADY
at banquet

DONNA
al banchetto

Disegno 135

Quo Vadis

(M.G.M., 1951)
Designer: Herschel McCoy (United
States, 1913–1956)

12

*Donna al Banchetto (Lady at the
Banquet)*
Costume sketch
Watercolor
19 × 12 in.
Los Angeles County Museum of Art
Gift of the Costume Council
M.85.144.14

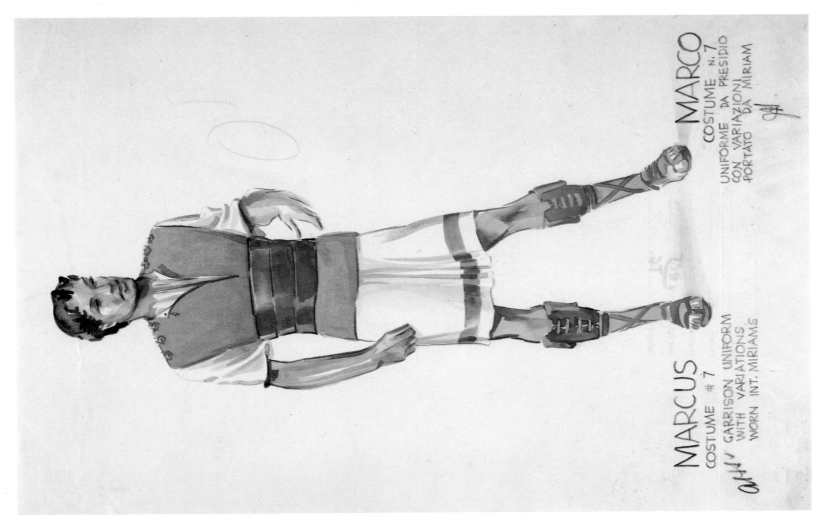

MARCUS
COSTUME #7
ONLY GARRISON UNIFORM
WITH VARIATIONS
WORN INT. MIRIAMS

MARCO
COSTUME N. 7
UNIFORME DA PRESIDIO
CON VARIAZIONI
PORTATO DA MIRIAM

Marcus #7 [Robert Taylor]
Costume sketch
Watercolor
$18\frac{7}{8} \times 12\frac{1}{8}$ in.
Los Angeles County Museum of Art
Gift of the Costume Council
M.86.297.9

13

Medieval

A Connecticut Yankee in King Arthur's Court

(Paramount, 1949)
Designers: Mary Kay Dodson (United
States, 1908–1976) and Gile Steele
(United States, 1908–1952)

Morgan La Fay [Virginia Field]
Costume sketch by Mary Kay
Dodson
Gouache and pencil with fabric
swatch
22 × 15 in.
Los Angeles County Museum of Art
Gift of the Costume Council
M.85.114.15

Camelot

(Warner Bros., 1967)
Designer: John Truscott (Great
Britain, born 1937)

Three Blacksmiths
Costume sketch
Pencil
17½ × 13 in.
Los Angeles County Museum of Art
Gift of the Costume Council
M.85.144.17

Young Man's Costume
Costume sketch
Pencil and watercolor
21 × 16 in.
Los Angeles County Museum of Art
Gift of the Costume Council
M.85.114.18

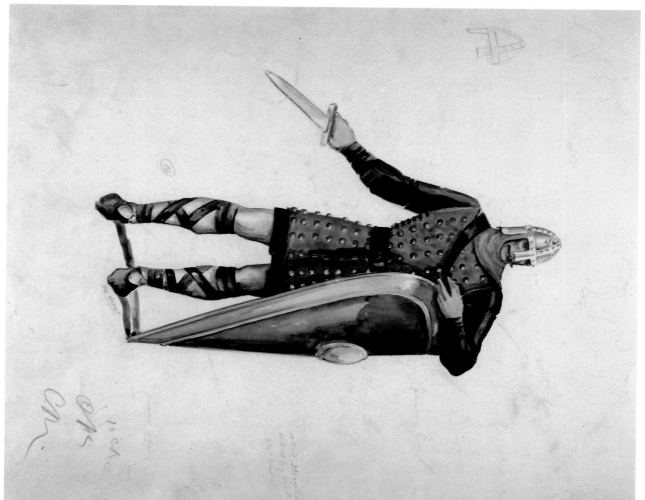

14

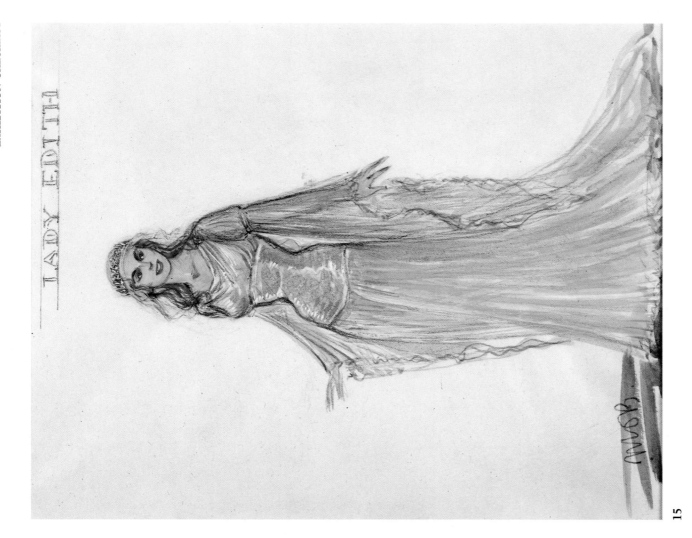

LADY EDITH

15

The Crusades

(Paramount, 1935)
Designers: Travis Banton (United
States, 1894–1958), Natalie Visart
(United States, active 1936–46), Al
Nickel (United States, born 1905),
Renie Conley (United States, active
1936–68), and Ralph Jester (United
States, born 1901)

Soldier
Costume sketch by Al Nickel
Pencil and watercolor
22 × 15 in.
Los Angeles County Museum of Art
Gift of the Costume Council
M.85.114.10

King Richard and the Crusaders

(Warner Bros., 1954)
Designer: Marjorie Best (United
States, active 1943–65)

Lady Edith [Virginia Mayo]
Costume sketch
Pencil and watercolor
11 × 8½ in.
Los Angeles County Museum of Art
Gift of the Costume Council
M.85.144.3

The Adventures of Robin Hood

(Warner Bros., 1938)
Designer: Milo Anderson (United
States, active 1932–55)

Maid Marian [Olivia de Havilland]
Costume sketch
Pencil and gouache
20 × 15 in.
Academy of Motion Picture Arts and
Sciences
Antoinette Cronjager collection

Joan of Arc

(R.K.O., 1948)
Designers: Dorothy Jeakins (United
States, born 1914), Herschel McCoy
(United States, 1913–1956) and
Karinska

16 *Joan of Arc [Ingrid Bergman] in*
 Dauphin's Chambers
 Costume sketch by Dorothy Jeakins
 Pencil and watercolor
 14¼ × 8¼ in.
 Collection of Dorothy Jeakins

16

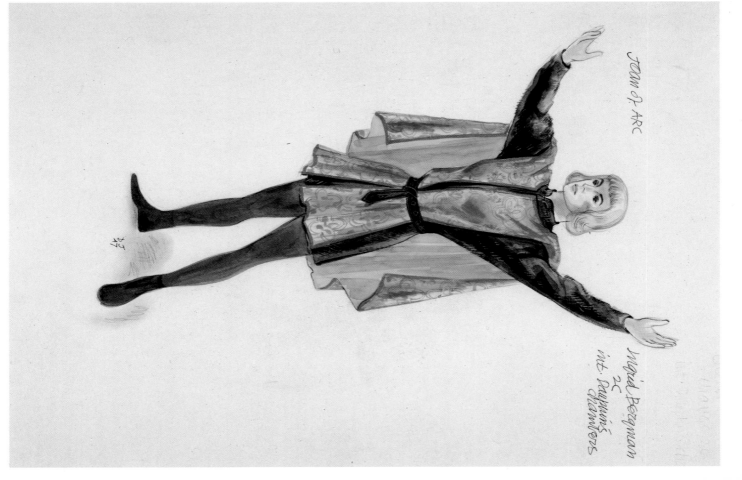

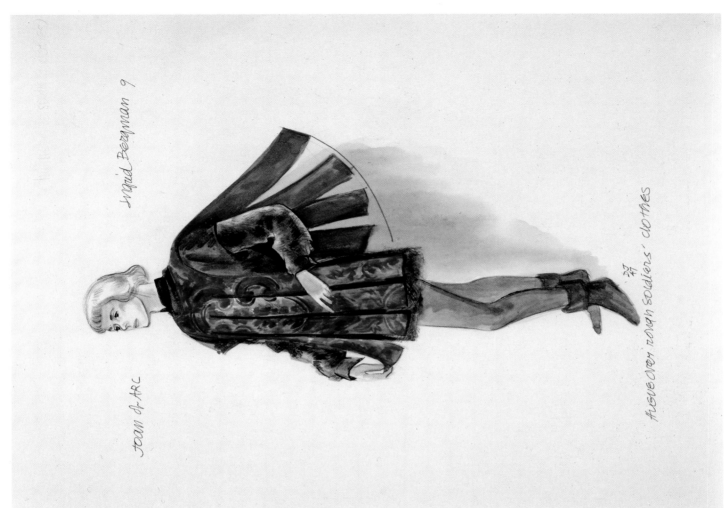

17 *Joan of Arc [Ingrid Bergman] in
Soldier's Clothes*
Costume sketch by Dorothy Jeakins
Pencil and watercolor
$13\frac{1}{2} \times 6\frac{3}{4}$ in.
Collection of Dorothy Jeakins

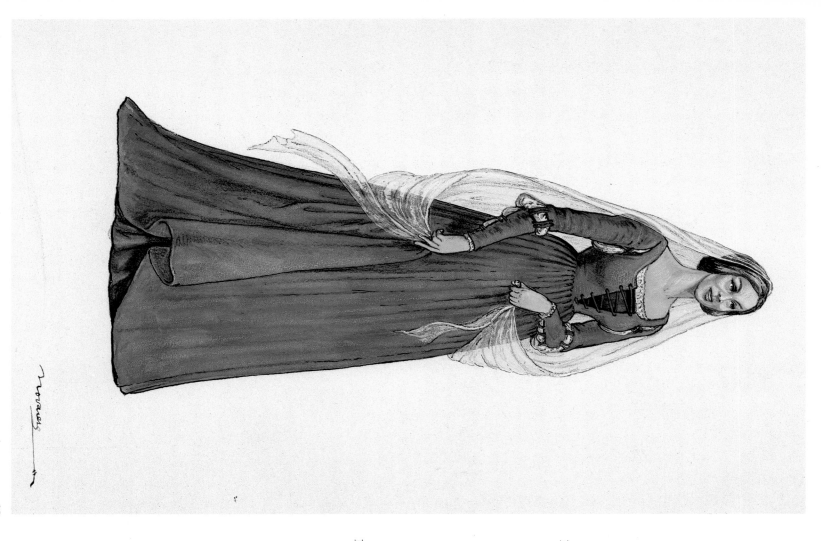

Renaissance

The Agony and the Ecstasy

18 (Twentieth Century-Fox, 1965)
Designer: Vittorio Nino Novarese
(Italy, 1907–1983)
Contessina de Medici [Diane Cilento]
Costume sketch
Ink and watercolor
15 × 10 in.
Los Angeles County Museum of Art
Gift of Robert Fletcher
M.86.262.3

Captain from Castille

(Twentieth Century-Fox, 1947)
Designer: Charles LeMaire (United
States, 1897–1985)

19 *Gown*
Silver metallic fabric with floral
design, green velvet ribbons, and
pearls
Worn by Barbara Lawrence as Luisa
Los Angeles County Museum of Art
Gift of the Costume Council
M.85.4.5

Catana [Jean Peters]
Costume sketch
Pencil and watercolor
13½ × 9 in.
Charles LeMaire estate

Peasant Woman in Brown
Costume sketch
Pencil and watercolor
13½ × 9 in.
Charles LeMaire estate

Peasant Woman in Gray
Costume sketch
Pencil and watercolor
13½ × 9 in.
Charles LeMaire estate

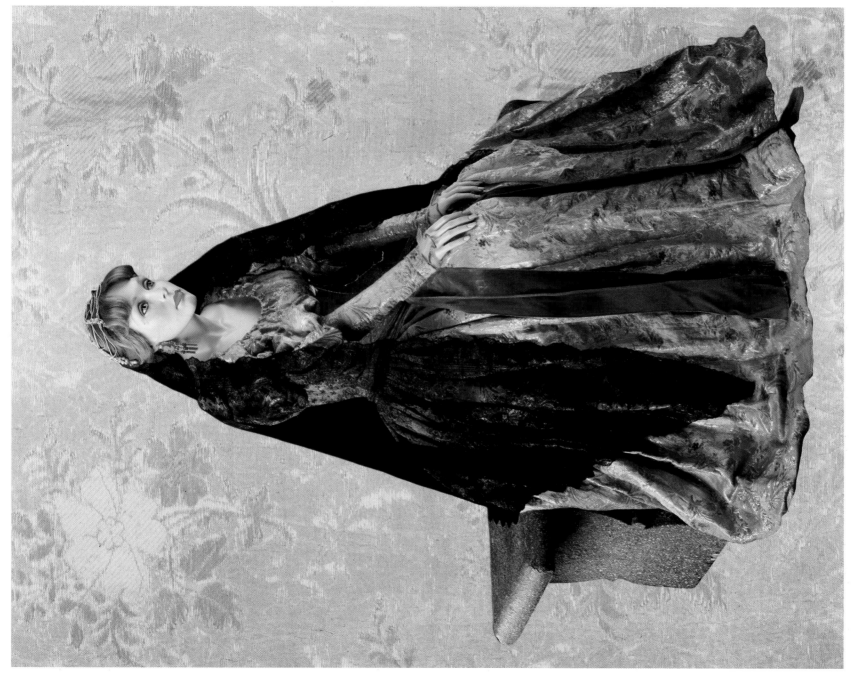

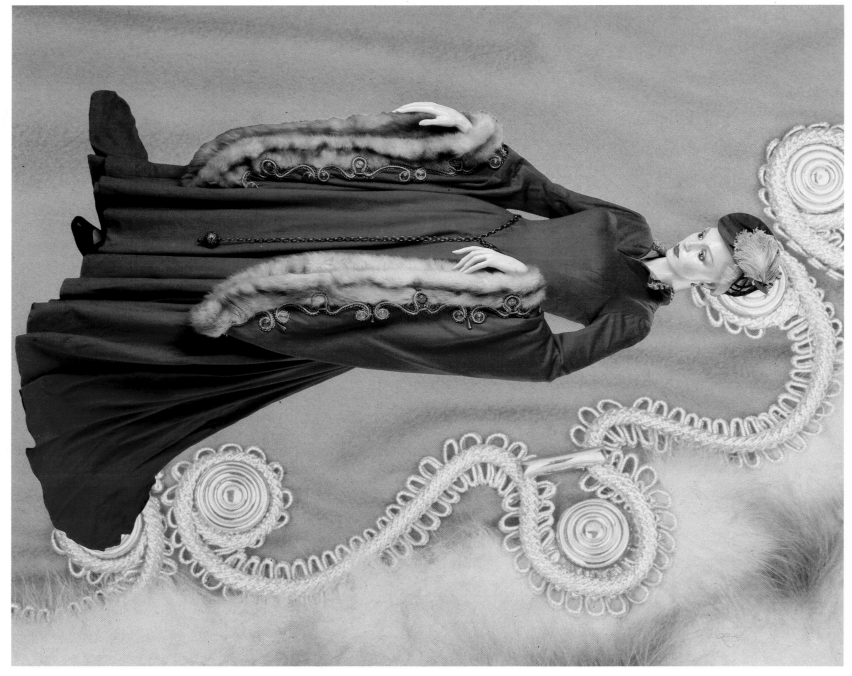

Diane

20
(M.G.M., 1956)
Designer: Walter Plunkett (United
States, 1902–1982)

Gown and Porkpie Hat with Snood
Magenta wool gown: trumpet-
shaped sleeves edged with fur and
gold braid; stomacher trimmed with
chatelaine chain and ornamental
ball; hat and snood of wool and
metallic braid with ostrich feather
Worn by Lana Turner as Diane de
Poitiers
California Mart

21
*Gown with Long Trumpet-shaped
Sleeves*
Black satin trimmed with beading
Worn by Lana Turner as Diane de
Poitiers
California Mart

Diane de Poitiers [Lana Turner]
Costume sketch
Gouache and pencil
21 × 15½ in.
Los Angeles County Museum of Art
Gift of the Costume Council
M.87.79.2

Elizabethan
Mary of Scotland

(R.K.O., 1936)
Designer: Walter Plunkett (United
States, 1902–1982)

Mary [Katharine Hepburn]
Costume sketch
Gouache and pencil
21 × 15½ in.
Los Angeles County Museum of Art
Gift of the Costume Council
M.87.79.1

22

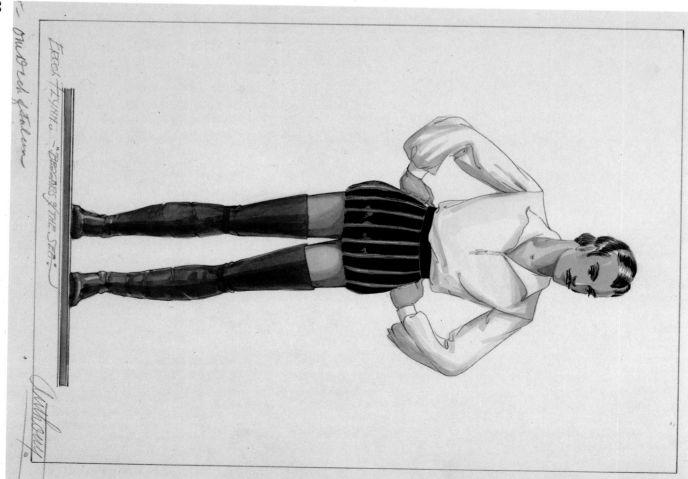

Seventeenth Century

The Sea Hawk

(Warner Bros., 1940)
Designer: Orry-Kelly (United States, 1897–1964)

Geoffrey Thorpe [Errol Flynn]
Costume sketch by Anthony
Pencil and watercolor
20 × 15 in.
Los Angeles County Museum of Art
Gift of the Costume Council
M.85.144.13

The Virgin Queen

(Twentieth Century-Fox, 1955)
Designers: Charles LeMaire (United States, 1897–1985) and Mary Wills (United States, active 1948–62)

Two-piece Gown
Pale gray wool gaberdine
Worn by Joan Collins as Beth
Throckmorton
Los Angeles County Museum of Art
Gift of Mary Pickford Rogers Bequest
M.81.168.2

Dorothy Vernon of Haddon Hall

(United Artists, 1924)
Designer: Mitchell Leisen (United States, active 1919–57)

Gown with Hanging Sleeves
Gold, blue, and magenta printed silk
velvet with lace trim
Worn by Mary Pickford as Dorothy
Vernon
Los Angeles County Museum of Art
Gift of Mary Pickford Rogers Bequest
M.81.168.2

The Adventures of Don Juan

(Warner Bros., 1949)
Designers: Leah Rhodes (United States, active 1939–68) and William Travilla (United States, active 1941–69)

Elena [Ann Rutherford]
Costume sketch by Leah Rhodes
Gouache and pencil with fabric
swatch
22 × 15 in.
Academy of Motion Picture Arts and
Sciences
Leah Rhodes collection

Lady Diana [Helen Westcott]
Costume sketch by Leah Rhodes
Gouache and pencil
22 × 15 in.
Academy of Motion Picture Arts and
Sciences
Leah Rhodes collection

Queen Margaret [Viveca Lindfors]
Costume sketch by Leah Rhodes
Gouache and pencil
22 × 15 in.
Academy of Motion Picture Arts and
Sciences
Leah Rhodes collection

The Three Musketeers

(Twentieth Century-Fox, 1974)
Costume designers: Yvonne Blake
(Great Britain) and Ron Talsky
(United States, born 1934) for
Raquel Welch

Buckingham [Simon Ward]
Costume sketch by Yvonne Blake
Gouache and ink
21½ × 15 in.
Academy of Motion Picture Arts and
Sciences

Milady [Faye Dunaway]
Costume sketch by Yvonne Blake
Gouache and ink
21½ × 15 in.
Academy of Motion Picture Arts and
Sciences

*Milady [Faye Dunaway] in
Buckingham's Room*
Costume sketch by Yvonne Blake
Gouache and ink
21½ × 15 in.
Academy of Motion Picture Arts and
Sciences

Forever Amber

(Twentieth Century-Fox, 1947)
Designers: René Hubert (France, born 1899) and Charles LeMaire (United States, 1897–1985)

23 *Skirt and Bodice*
Black silk watered faille trimmed
with satin and beading
Worn by Linda Darnell as Amber
Los Angeles County Museum of Art
Gift of the Costume Council
M.85.4.2a–d

24 *Peasant Dress with White Cuffs and
Fichu*
Pale blue-gray striped cotton
Worn by Linda Darnell as Amber
Los Angeles County Museum of Art
Gift of the Costume Council
M.85.4.1

The Spanish Main

(R.K.O., 1945)
Designer: Edward Stevenson (United States, 1906–1960)

Francesca [Maureen O'Hara]
Costume sketch
Pencil and watercolor
17⅞ × 13 in.
Brooklyn Museum

Eighteenth Century
Du Barry Was a Lady

(M.G.M., 1943)
Designers: Irene (United States, 1901–1962), Howard Shoup (United States, active 1936–67), and Gile Steele (United States, 1908–1952)

Traveling Costume: Jacket and Skirt
Blue-green silk velvet with blue silk corded trim; peach net undersleeves
Worn by Lucille Ball as Madame Du Barry
Los Angeles County Museum of Art
Gift of the Costume Council
M.87.4.5a–b

The Howards of Virginia

(Columbia, 1940)
Designer: Irene Saltern (United States, active 1937–41)

Woman in Nightgown
Costume sketch
Pencil and watercolor
20 × 15 in.
Gift of Irene Salinger (Saltern) in honor of Martha Scott in *The Howards of Virginia*
M.86.407.2

Marie Antoinette

(M.G.M., 1938)
Designer: Adrian (United States, 1903–1959)

Gown
Cream organza over metallic silver lamé trimmed with silver passementerie, sequins, beading, and paste stones
Worn by Norma Shearer as Marie Antoinette
Los Angeles County Museum of Art
Gift of Bob Carlton
M.86.237a–b

25

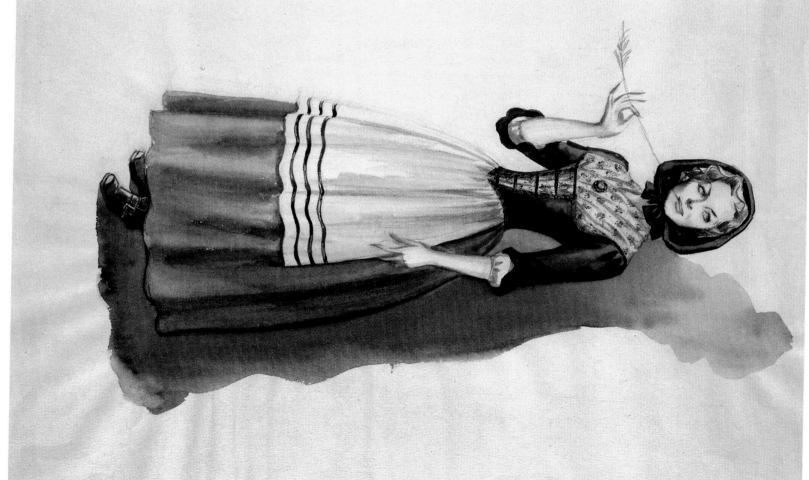

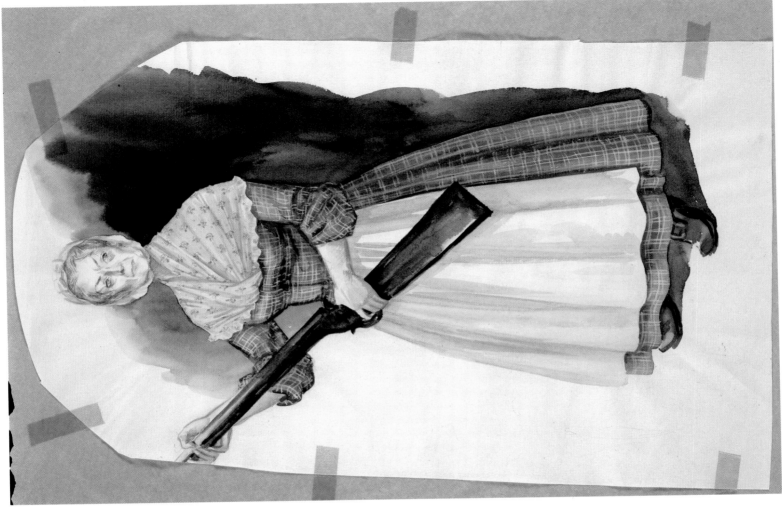

26

Drums along the Mohawk

(Twentieth Century-Fox, 1939)
Designer: Gwen Wakeling (United
States, born 1901)

5 *Lana Martin [Claudette Colbert]*
Costume sketch by Royer (United
States, born 1904)
Pencil and watercolor
16½ × 12½ in.
Los Angeles County Museum of Art
Gift of Michael Tankenson
M.86.270.14

6 *Mrs. Weaver [Jessie Ralph]*
Costume sketch by Royer (United
States, born 1904)
Pencil and watercolor
16½ × 10 in.
Los Angeles County Museum of Art
Gift of Michael Tankenson
M.86.270.22

French Revolution/Directoire

A Tale of Two Cities

(M.G.M., 1935)
Designers: Dolly Tree (United States, active 1930–42) and Valles (United States, 1885–1970)

Man in Wool Cloth Coat
Costume sketch by Valles
Pencil and watercolor
20 × 13 in.
Los Angeles County Museum of Art
Gift of the Costume Council
M.85.144.2

Unknown Character #7
Costume sketch by Valles
Ink and watercolor
20¼ × 13 in.
Los Angeles County Museum of Art
Gift of the Costume Council
M.85.144.2

Désirée

(Twentieth Century-Fox, 1954)
Designers: René Hubert (France, born 1899) and Charles LeMaire (United States, 1897–1985)

Trained Gown I
Cream-colored silk crêpe embroidered with iridescent paillettes in a feather pattern
Worn by Jean Simmons as Désirée
Los Angeles County Museum of Art
Gift of Thomas S. Hartzog
M.87.25.1

Trained Gown II
Sheer white nylon trimmed with red velvet and red jewels
Worn by Merle Oberon as Paulette
Los Angeles County Museum of Art
Gift of the Costume Council
M.87.55.2

Désirée [Jean Simmons] in Italy
Costume sketch by René Hubert
Watercolor
11 × 7 in.
Los Angeles County Museum of Art
Gift of Mr. and Mrs. Albert R. Ekker
M.81.167.14

142

27

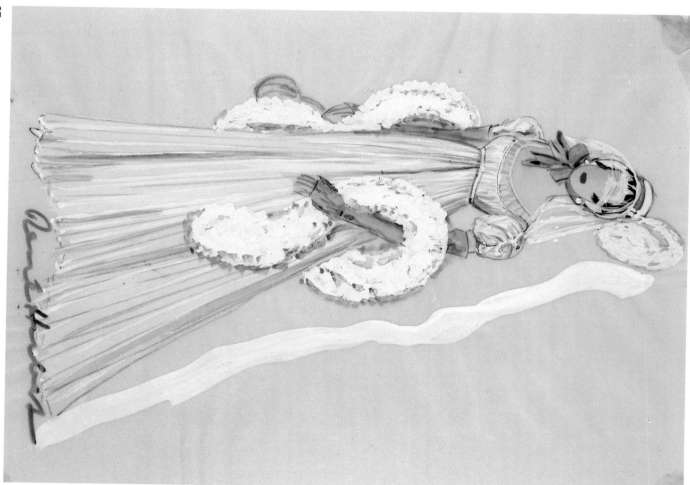

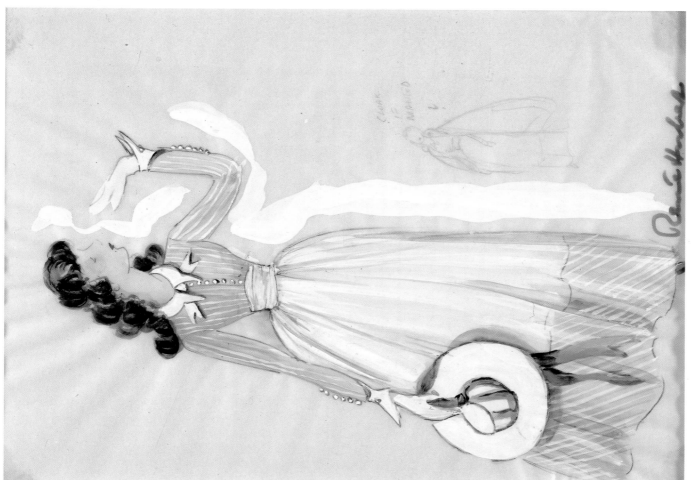

28

Désirée [Jean Simmons] in Paris House
Costume sketch by René Hubert
Watercolor
11 × 7¼ in.
Los Angeles County Museum of Art
Gift of Mr. and Mrs. Albert R. Ekker
M.81.167.10

27 *Julie #7 [Jean Simmons]*
Costume sketch by René Hubert
Watercolor
11 × 7 in.
Los Angeles County Museum of Art
Gift of Mr. and Mrs. Albert R. Ekker
M.81.167.8

28 *Paulette [Merle Oberon] in Brown,
Striped Dress*
Costume sketch by René Hubert
Gouache
19½ × 14¼ in.
Los Angeles County Museum of Art
Gift of Mr. and Mrs. Albert R. Ekker
M.81.167.11

29 Paulette [Merle Oberon] in Velvet and
Brocade Dress
Costume sketch by René Hubert
Watercolor
11 × 7 in.
Los Angeles County Museum of Art
Gift of Mr. and Mrs. Albert R. Ekker
M.81.167.7

29

30

rly Nineteenth Century
Little Old New York

(Twentieth Century-Fox, 1940)
Designer: Royer (United States, born
1904)

Pat O'Day [Alice Faye] in Gown
Costume sketch
Pencil and watercolor
16 × 8 in.
Los Angeles County Museum of Art
Gift of Michael Tankenson
M.86.270.25

Pat O'Day [Alice Faye] in Shawl
Costume sketch
Pencil and watercolor
14 × 9 in.
Los Angeles County Museum of Art
Gift of Michael Tankenson
M.86.270.26

The Magnificent Doll

(Universal, 1946)
Designers: Travis Banton (United
States, 1894–1958) and Vera West
(United States, active 1928–47)

31
*Dolley Madison [Ginger Rogers] in
Green Dress*
Costume sketch by Travis Banton
Colored pencil and gouache
23 × 14½ in.
Los Angeles County Museum of Art
Gift of Tony Duquette
M.86.385.217

*Dolley Madison [Ginger Rogers] in
Riding Costume*
Costume sketch by Travis Banton
Colored pencil and gouache
23 × 14½ in.
Los Angeles County Museum of Art
Gift of Tony Duquette
M.86.385.211

*Dolley Madison [Ginger Rogers] with
Fur Muff*
Costume sketch by Travis Banton
Colored pencil and gouache
23 × 14½ in.
Los Angeles County Museum of Art
Gift of Tony Duquette
M.86.385.218

Becky Sharp

(Paramount, 1935)
Designers: Howard Greer (United
States, 1896–1974) and Robert
Edmond Jones (United States,
1887–1954)

Amelia [Frances Dee]
Costume sketch by Robert Edmond
Jones
Pencil and watercolor
20 × 13 in.
Los Angeles County Museum of Art
Gift of Robert Fletcher
M.86.262.2

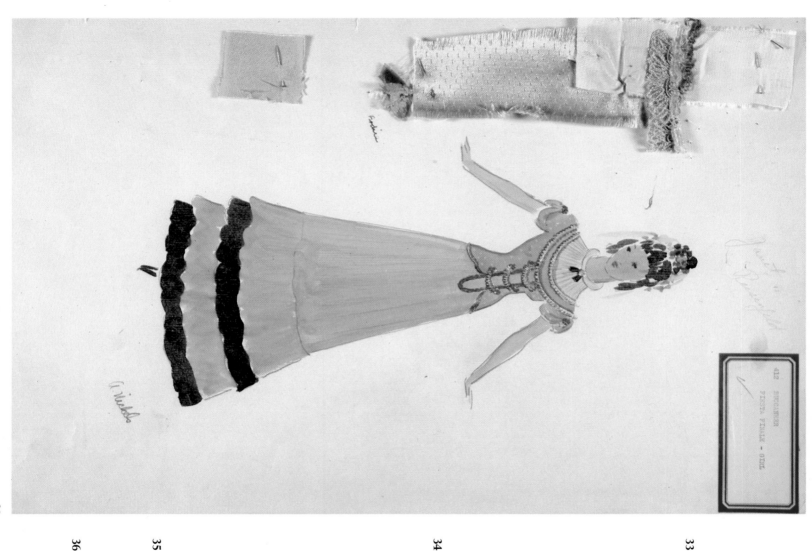

33

The Buccaneer

(Paramount, 1938)
Designers: Natalie Visart (United States, active 1936–46) and Dwight Franklin (United States, active 1926–47)

33
Girl in Fiesta Finale
Costume sketch by Al Nickel (United States, born 1905)
Pencil and watercolor with fabric swatch
20 × 13 in.
Los Angeles County Museum of Art
Gift of the Costume Council
M.85.144.9

The Buccaneer

(Paramount, 1958)
Designers: Edith Head (United States, 1907–1982), Ralph Jester (United States, born 1901), and John Jensen

34
Flowsy Wench
Costume sketch by Ralph Jester
Pencil and watercolor
14¼ × 9¼ in.
Los Angeles County Museum of Art
Gift of the Costume Council
M.87.86.7

Hawaii

(Twentieth Century-Fox, 1966)
Designer: Dorothy Jeakins (United States, born 1914)

35
Abner Hale [Max Von Sydow]
Costume sketch
Pencil and watercolor
16½ × 6 in.
Collection of Dorothy Jeakins

36
Jerusha [Julie Andrews]
Costume sketch
Pencil and watercolor
20 × 15 in.
Collection of Dorothy Jeakins

EXISTING
HAT
(ADD FEATHERS)

EXISTING
DRESS
(TO BE DYED)

RALPH
VESTER
O.A

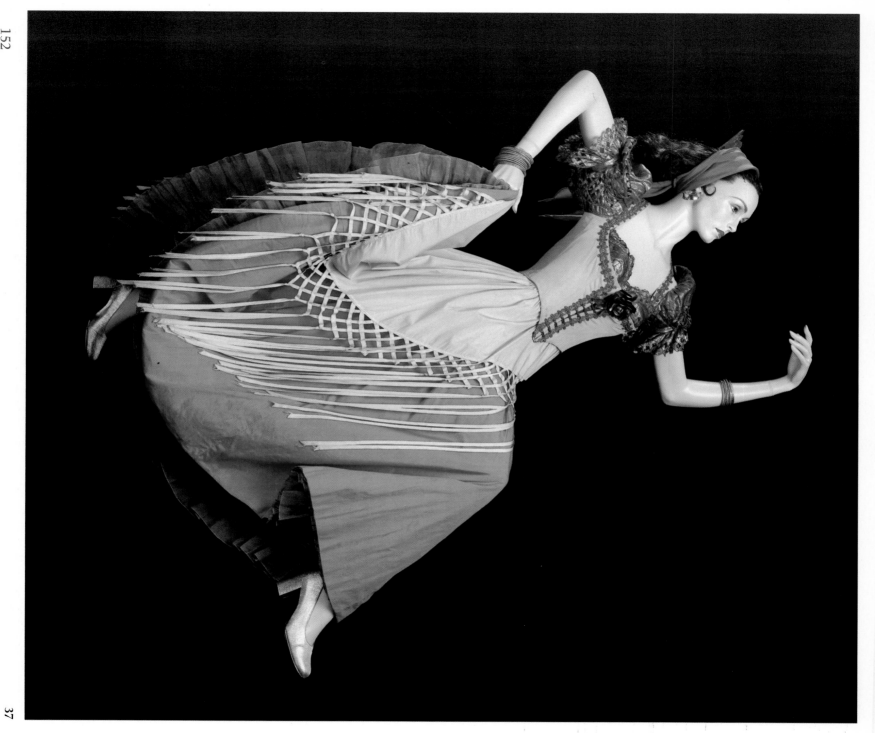

38

id Nineteenth Century

Green Dolphin Street

(M.G.M., 1947)
Designer: Walter Plunkett (United States, 1902–1982)

Gown with Yoke and Full Sleeves
Pink self-patterned silk with ecru gauze collar
Worn by Donna Reed as Marguerite Patourel
Los Angeles County Museum of Art
Gift of the Costume Council
M.87.55.1

Marianne Patourel [Lana Turner] in Dressing Gown
Costume sketch
Pencil and watercolor
$20\frac{1}{16} \times 14\frac{5}{16}$ in.
Brooklyn Museum

Marianne Patourel [Lana Turner] in Green Dress
Costume sketch
Pencil and watercolor
$22\frac{1}{16} \times 16\frac{1}{8}$ in.
Brooklyn Museum

The Kissing Bandit

(M.G.M., 1947)
Designer: Walter Plunkett (United States, 1902–1982)

Two-Piece Dress: Overdress and Underskirt
Overdress of yellow cotton with ribbon lattice trim; latticework sleeves of gold lamé; underskirt of salmon cotton with green ruffled organdy lining
Worn by Cyd Charisse as a dancer
California Mart

Dancer [Cyd Charisse]
Costume sketch
Gouache and pencil
$21 \times 15\frac{1}{2}$ in.
Los Angeles County Museum of Art
Gift of the Costume Council
M.87.79.4

THE OLD MAID.

Oak Thorn Coat -

slightly darker

darker

39

The Old Maid

(Warner Bros., 1939)
Designer: Orry-Kelly (United States, 1899–1964)

Lt. Clem Spenser [*George Brent*]
Costume sketch
Gouache and pencil
20 × 15 in.
Los Angeles County Museum of Art
Gift of the Costume Council
M.86.297.5

A Song to Remember

(Columbia, 1945)
Designers: Walter Plunkett (United States, 1902–1982) and Travis Banton (United States, 1894–1958) for Merle Oberon

George Sand [*Merle Oberon*] *in Black Dress*
Costume sketch by Travis Banton
Pencil and watercolor
$23\frac{5}{8} \times 14\frac{5}{16}$ in.
Brooklyn Museum

George Sand [*Merle Oberon*] *in Black Lace Dress*
Costume sketch by Travis Banton
Pencil and watercolor
$23\frac{7}{8} \times 14\frac{5}{16}$ in.
Brooklyn Museum

George Sand [*Merle Oberon*] *in Green Dress*
Costume sketch by Travis Banton
Pencil and watercolor
$21\frac{1}{4} \times 14\frac{5}{16}$ in.
Brooklyn Museum

Jezebel

(Warner Bros., 1938)
Designer: Orry-Kelly (United States, 1897–1964)

Buck Winston [*George Brent*]
Costume sketch by Anthony
Pencil and watercolor
20 × 15 in.
Los Angeles County Museum of Art
Gift of the Costume Council
M.86.297.8

39

Madame Bovary

(M.G.M., 1949)
Designers: Walter Plunkett (United
States, 1902–1982)
and Valles (United States,
1885–1970) for the men

40 *Two-Piece Dress*
Bodice of dark brown velvet and rust
silk taffeta; skirt of rust taffeta
appliquéd with stripes of dark
brown velvet
Worn by Jennifer Jones as Madame
Bovary
California Mart

Madame Bovary [*Jennifer Jones*]
Costume sketch by Walter Plunkett
Pencil and watercolor
20 × 15 in.
Los Angeles County Museum of Art
Gift of the Costume Council
M.87.79.3

155

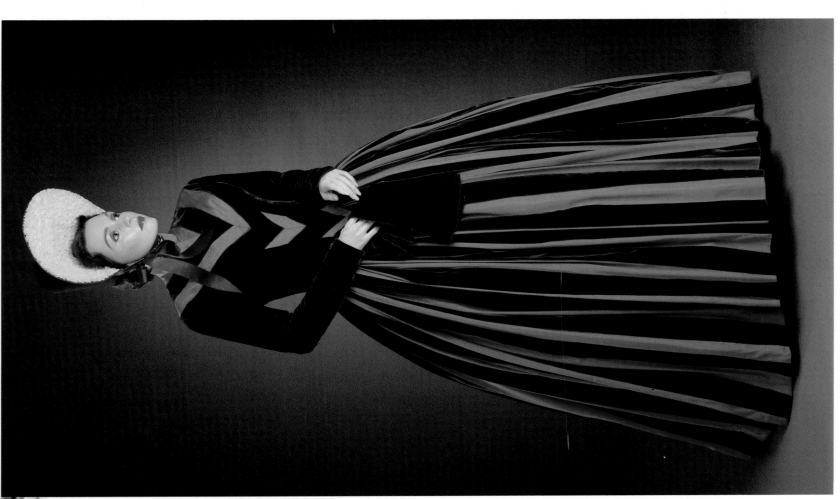

40

Bitter Sweet
(M.G.M. 1940)
Designer: Adrian (United States, 1903–1959)

41 *Three-Piece Suit*
Claret silk velvet fitted jacket with ecru lace engageantes; matching floor-length draped skirt; beige silk, tucked-front, sleeveless blouse with claret velvet bow
Worn by Jeanette MacDonald as Sarah Millick
Los Angeles County Museum of Art
Gift of Thomas S. Hartzog
M.87.3a–c

156

41

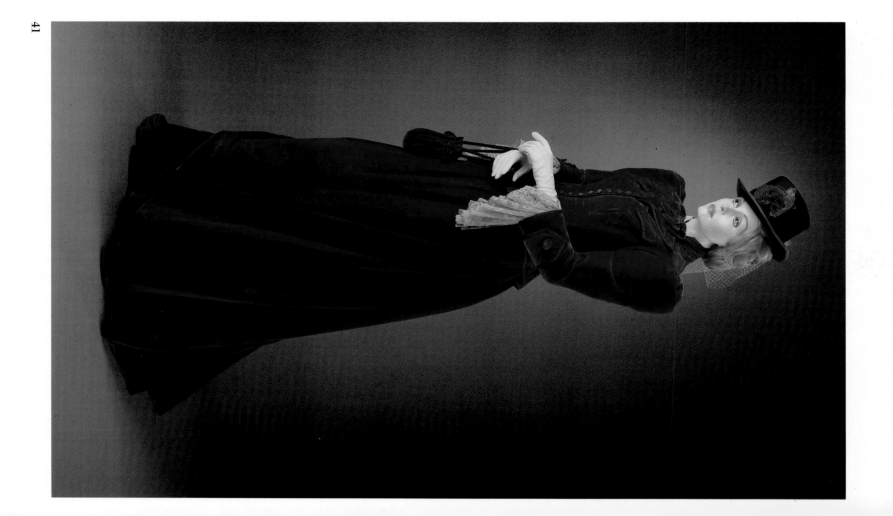

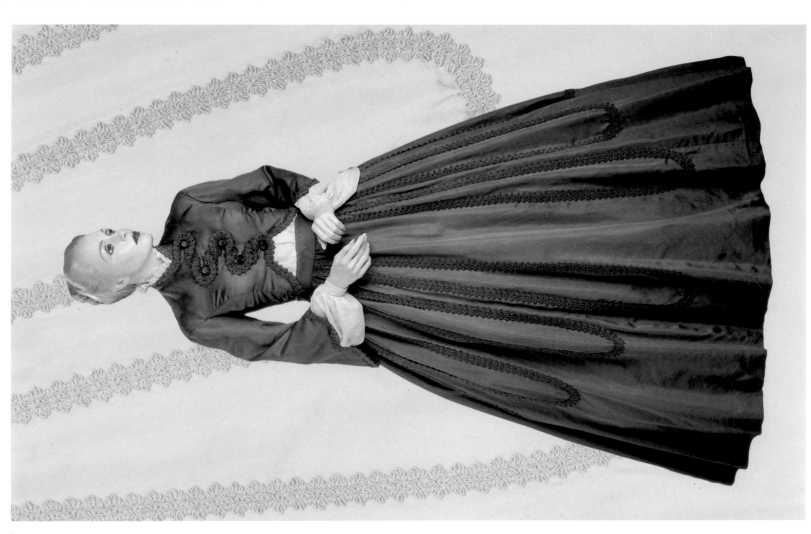

42

The Men in Her Life

(Columbia, 1941)
Designers: Bridgehouse and Charles
LeMaire (United States, 1897–1985)

*Lina Varasavina [Loretta Young] in
Black Velvet*
Costume sketch by Charles LeMaire
Ink and watercolor
24 × 17½ in.
Charles LeMaire estate

*Lina Varasavina [Loretta Young] in
Blue Flower Dress*
Costume sketch by Charles LeMaire
Ink and watercolor
24 × 17 in.
Charles LeMaire estate

*Lina Varasavina [Loretta Young] in
Brown Dress with Lilies*
Costume sketch by Charles LeMaire
Ink and watercolor
23 × 17½ in.
Charles LeMaire estate

*Lina Varasavina [Loretta Young] in
Cotton Gingham Dress*
Costume sketch by Charles LeMaire
Ink and watercolor
24 × 17½ in.
Charles LeMaire estate

*Lina Varasavina [Loretta Young] in
Gray Chiffon Dress with Velvet Ribbon*
Costume sketch by Charles LeMaire
Ink and watercolor
24 × 17½ in.
Charles LeMaire estate

Raintree County

(M.G.M., 1958)
Designer: Walter Plunkett (United
States, 1902–1982)

Two-Piece Dress
Two shades of gray silk faille
Worn by Eva Marie Saint as Nell
Gaither
California Mart

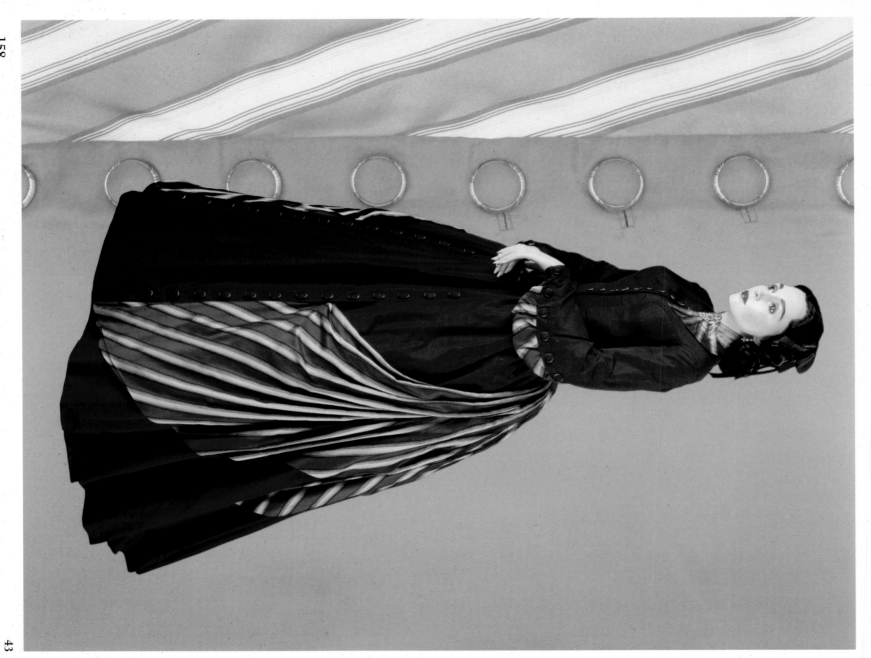

44

Two-Piece Gown
Burgundy silk with striped covered
buttons and matching striped fabric
draped on skirt
Worn by Elizabeth Taylor as
Susanna Drake
California Mart

That Lady in Ermine

(Twentieth Century-Fox, 1948)
Designer: René Hubert (France, born
1899)

Angelica [Betty Grable] in Ruffle Dress
Costume sketch
Gouache and pencil
11 × 7½ in.
Los Angeles County Museum of Art
Gift of Mr. and Mrs. Albert R. Ekker
M.81.167.1

Traveling Costume
Costume sketch
Gouache and pencil
11 × 7½ in.
Los Angeles County Museum of Art
Gift of Mr. and Mrs. Albert R. Ekker
M.81.167.2

Anna and the King of Siam

(Twentieth Century-Fox, 1946)
Designer: Bonnie Cashin (United
States, active 1943–49)

King's Wife
Costume sketch
Gouache and pencil
20 × 11 in.
Los Angeles County Museum of Art
Gift of anonymous donor
M.87.85

Juarez

(Warner Bros., 1939)
Designer: Orry-Kelly (United States,
1899–1964)

*Maximilian von Hapsburg [Brian
Aherne]*
Costume sketch by Anthony
Pencil and watercolor
20 × 15 in.
Los Angeles County Museum of Art
Gift of the Costume Council
M.86.297.7

Napoleon III [Claude Rains]
Costume sketch by Anthony
Pencil and watercolor
20 × 15 in.
Los Angeles County Museum of Art
Gift of the Costume Council
M.86.297.6

Little Women

(Unrealized Selznick production,
c. 1940)
Designers: Walter Plunkett (United
States, 1902–1982) and Robert
Kalloch (United States, active
1932–47)

Brown Dress
Costume sketch by Robert Kalloch
Pencil and watercolor
23 × 14½ in.
Los Angeles County Museum of Art
Gift of Tony Duquette
M.86.385.109

Jo
Costume sketch by Robert Kalloch
Pencil and watercolor
23 × 14½ in.
Los Angeles County Museum of Art
Gift of Tony Duquette
M.86.385.115

Jo Play-acting
Costume sketch by Robert Kalloch
Pencil and watercolor
23 × 14½ in.
Los Angeles County Museum of Art
Gift of Tony Duquette
M.86.385.114

46

Marmee
Costume sketch by Robert Kalloch
Pencil and watercolor
23 × 14½ in.
Los Angeles County Museum of Art
Gift of Tony Duquette
M.86.385.117

te Nineteenth Century

Ramona

(Twentieth Century-Fox, 1936)
Designer: Gwen Wakeling (United
States, born 1901)

*Ramona [Loretta Young] in Calico
Dress*
Costume sketch by Royer (United
States, born 1904)
Pencil and watercolor
14 × 13 in.
Los Angeles County Museum of Art
Gift of Tony Duquette
M.86.270.21

Ramona [Loretta Young] in Lace Dress
Costume sketch by Royer (United
States, born 1904)
Pencil and watercolor
13 × 9 in.
Los Angeles County Museum of Art
Gift of Tony Duquette
M.86.270.12

47

The Hawaiians

(United Artists, 1970)
Designer: Bill Thomas (United States,
born 1921)

47 *Queen Liliuokalani*
Costume sketch
Gouache and pencil
20 × 15 in.
Los Angeles County Museum of Art
Gift of Bill Thomas
M.86.412.8

Carousel

(Twentieth Century-Fox, 1956)
Designer: Dorothy Jeakins (United
States, born 1914)

Prologue Character
Costume sketch
Pencil
15 × 11 in.
Los Angeles County Museum of Art
Gift of the Costume Council
M.85.144.7

48 *Town Girl*
Costume sketch
Pencil
15 × 11 in.
Los Angeles County Museum of Art
Gift of the Costume Council
M.85.144.6

Saratoga Trunk

(Warner Bros. 1946)
Designer: Leah Rhodes (United
States, active 1939–68)

*Clio Dulaine [Ingrid Bergman] in Blue
Plaid Dress*
Costume sketch
Gouache and pencil with fabric
swatch
19⅞ × 13 in.
Academy of Motion Picture Arts and
Sciences
Leah Rhodes collection

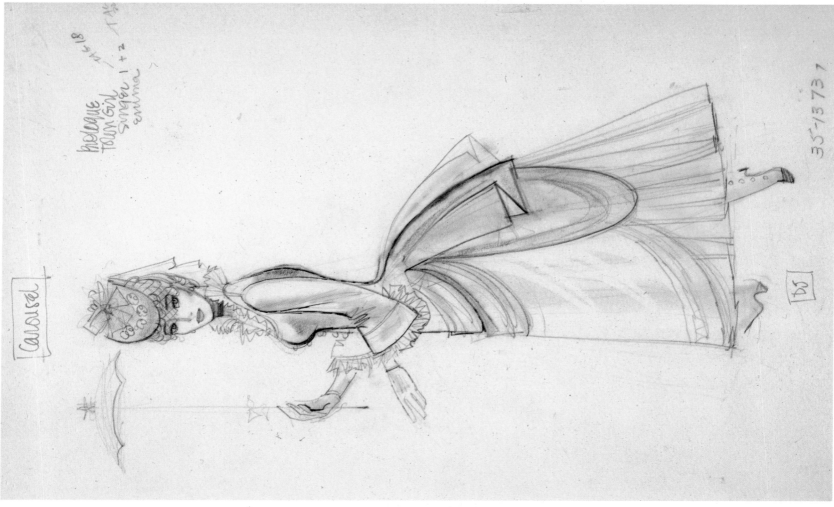

Clio Dulaine [Ingrid Bergman] in Navy Blue Dress
Costume sketch
Gouache and pencil with fabric swatch
$19\frac{7}{8} \times 13$ in.
Academy of Motion Picture Arts and Sciences
Leah Rhodes collection

Clio Dulaine [Ingrid Bergman] in Peach and Gold Striped Dress
Costume sketch
Gouache and pencil with fabric swatch
$19\frac{7}{8} \times 13$ in.
Academy of Motion Picture Arts and Sciences
Leah Rhodes collection

Centennial Summer

(Twentieth Century-Fox, 1946)
Designer: René Hubert (France, born 1899)

Julia [Jeanne Crain]
Costume sketch
Ink and wash
$11\frac{1}{4} \times 8\frac{1}{8}$ in.
Los Angeles County Museum of Art
Gift of the Costume Council
M.83.161.26

Sea of Grass

(M.G.M., 1947)
Designers: Walter Plunkett (United States, 1902–1982) and Valles (United States, 1885–1970) for the men

Lutie Cameron [Katharine Hepburn] in Blue Dress
Costume sketch by Walter Plunkett
Pencil and watercolor
$21\frac{1}{8} \times 14\frac{5}{16}$ in.
Brooklyn Museum

Lutie Cameron [Katharine Hepburn] in Striped Dress
Costume sketch by Walter Plunkett
Pencil and watercolor
$19\frac{5}{16} \times 13\frac{3}{4}$ in.
Brooklyn Museum

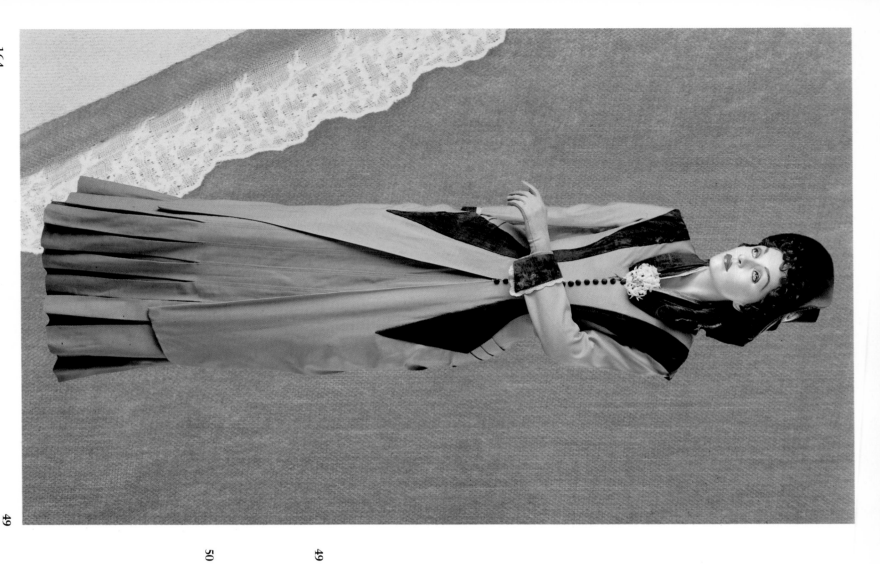

49

That Forsyte Woman

49
(M.G.M., 1950)
Designer: Walter Plunkett (United States, 1902–1982)

Two-Piece Gown 1
Gray wool trimmed with blue velveteen and embroidered white organdy
Worn by Greer Garson as Irene Forsyte
Collection of Satch LaValley

50
Two-Piece Gown II
Gray-beige wool gaberdine trimmed with matching velveteen
Worn by Greer Garson as Irene Forsyte
Collection of Satch LaValley

Irene Forsyte [Greer Garson]
Costume sketch
Gouache and pencil
21 × 15½ in.
Los Angeles County Museum of Art
Gift of the Costume Council
M.87.79.5

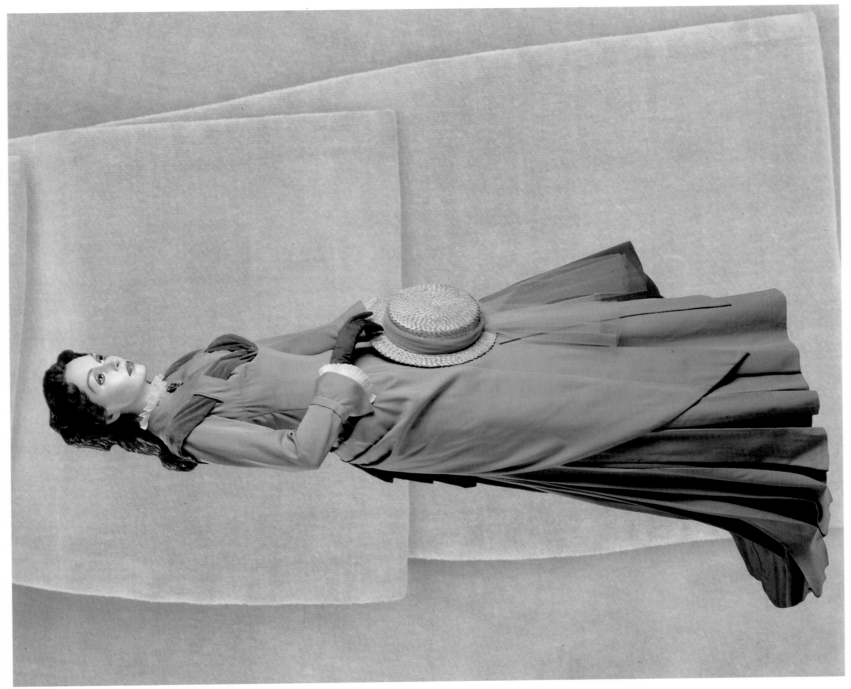

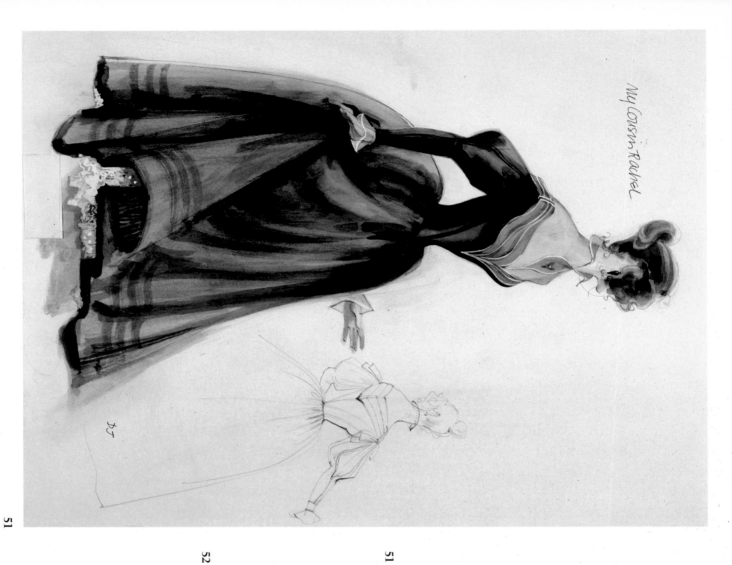

51

My Cousin Rachel

(Twentieth Century-Fox, 1952)
Designer: Dorothy Jeakins (United
States, born 1914)

Rachel [Olivia de Havilland]
Costume sketch
Pencil and watercolor
18 × 14¼ in.
Collection of Dorothy Jeakins

51

Mrs. Parkington

(M.G.M., 1944)
Designers: Irene (United States,
1901–1962) and Valles (United
States, 1885–1970) for the men

Dress
Black crêpe and chiffon
Worn by Greer Garson as Susie
Parkington
California Mart

52

The Last Remake of Beau Geste

(Universal, 1977)
Designer: May Routh (Great Britain,
born 1934)

Lady Flavia [Ann-Margret]
Costume sketch
Gouache and pencil with fabric
swatch
20 × 15 in.
Los Angeles County Museum of Art
Gift of May Routh
M.86.406.8

53

The Belle of New York

(M.G.M., 1952)
Designers: Helen Rose (United States,
1904–1985) and Gile Steele (United
States, 1908–1952)

*Dancer [Jean Cobett] in Boardwalk
Scene*
Costume sketch by Donna Peterson
Gouache with fabric swatches
22 × 15 in.
Los Angeles County Museum of Art
Gift of the Costume Council
M.86.302.19

Early Twentieth Century

Lady L

53

(M.G.M., 1961)
Designer: Orry-Kelly (United States,
1899–1964)
Trained Evening Gown: Dress and Cape
Peach silk brocade; cape of peach
silk tulle; floral, velvet trim
To be worn by Gina Lollobrigida as
Lady L.
California Mart

54

*Bridal Gown: Fitted Bodice and Skirt
with Bouquet*
Cream satin and ecru cotton crochet
trimmed with seed pearl and clear
glass beading
To be worn by Gina Lollobrigida as
Lady L.
California Mart

This project was cancelled before
completed. It was taken up again
several years later with a different
designer, director, and cast.

Lady L [Gina Lollobrigida]
Costume sketch
Gouache and pencil with fabric
swatch
22 × 18 in.
Los Angeles County Museum of Art
Gift of the Costume Council
M.83.161.20

Mrs. Soffel

(M.G.M., 1984)
Designer: Shay Cunliffe (Great
Britain)

Ensemble: Jacket, Blouse, and Skirt
Jacket and skirt of emerald-green
silk faille with black soutache trim;
blouse of black polyester-net over
green silk satin, black bias-cut
polyester ribbon, and black
passementerie trim; black polyester-
covered buttons
Worn by Diane Keaton as Mrs. Soffel
Lorimar Studios

The Reivers

(National General, 1969)
Designer: Theadora van Runkle
(United States, active since 1967)

56
Boon [Steve McQueen]
Costume sketch
Pencil and watercolor
19 × 7 in.
Los Angeles County Museum of Art
Gift of the Costume Council
M.87.86.13

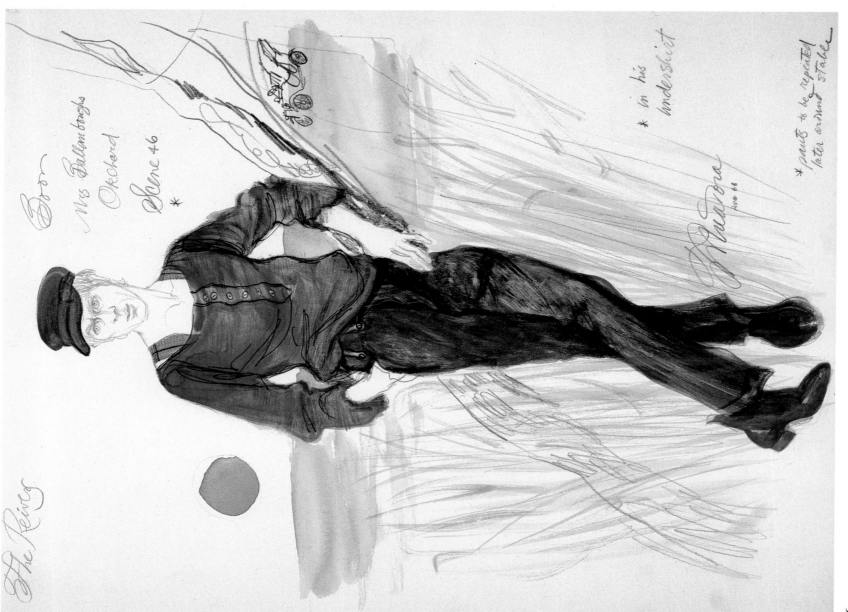

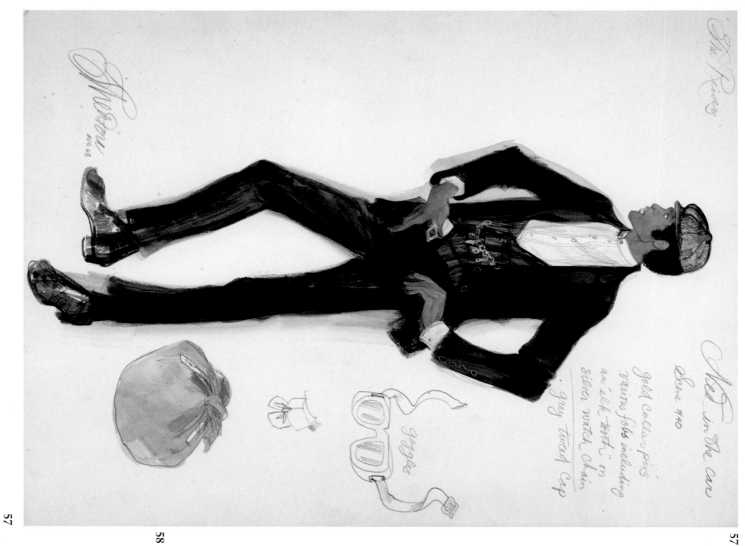

57

57

Ned [Rupert Crosse]
Costume sketch
Pencil and watercolor
$19\frac{1}{4} \times 7\frac{3}{4}$ in.
Los Angeles County Museum of Art
Gift of the Costume Council
M.87.86.12

Wilson

(Twentieth Century-Fox, 1944)
Designer: René Hubert (France, born 1899)

Edith Wilson [Geraldine Fitzgerald]
Costume sketch
Watercolor
$19\frac{5}{16} \times 12\frac{9}{16}$ in.
Brooklyn Museum

Easter Parade

(M.G.M. 1948)
Designer: Irene (United States, 1901–1962)

58

Walking Dress, Jacket, and Bow
Jacket of yellow wool; dress bodice
and bow of gray and white striped
rayon taffeta; dress skirt of taupe
wool crêpe
Wearer unknown
Collection of Satch LaValley

Nadine Hale [Ann Miller] in Leopard Skin Outfit
Costume sketch
Pastel and wash
$19 \times 12\frac{3}{8}$ in.
Los Angeles County Museum of Art
Gift of Allan J. Gardner
M.80.172.4

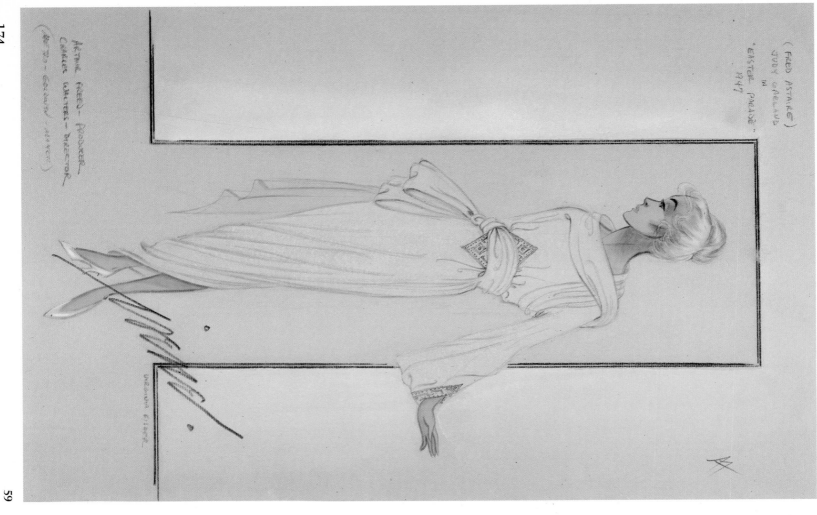

(FRED ASTAIRE)
JUDY GARLAND
in
"EASTER PARADE"
1947

ARTHUR FREED - PRODUCER
CHARLES WALTERS - DIRECTOR
(METRO - GOLDWYN - MAYER)

59 *Nadine Hale [Ann Miller] in Pale Blue*
Dress
Costume sketch
Pastel and wash
19 × 12¾ in.
Los Angeles County Museum of Art
Gift of Allan J. Gardner
M.80.172.1

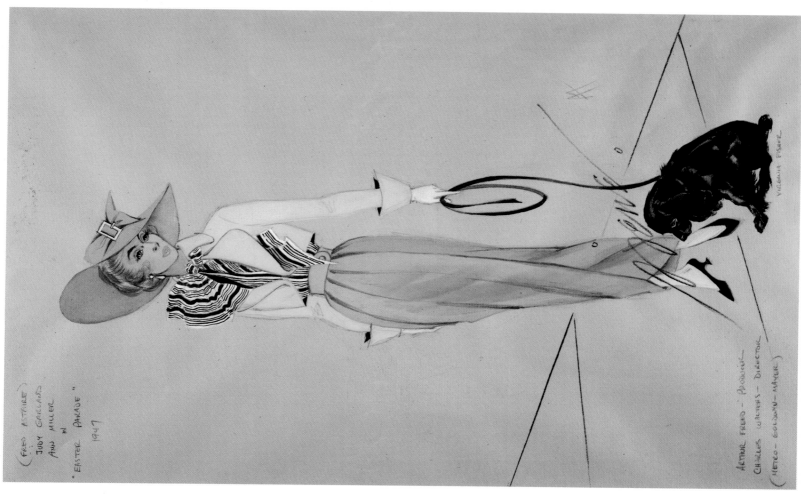

60

Walking Dress, Jacket, and Bow
Costume sketch
Gouache
18½ × 11½ in.
Collection of Satch LaValley

61

The Music Man

(Warner Bros., 1962)
Designer: Dorothy Jeakins (United
States, born 1914)

61 *Child [Patti Lee Hilka]*
Costume sketch
Gouache and pencil
15 × 11 in.
Los Angeles County Museum of Art
Gift of the Costume Council
M.85.114.8

62 *Marian Paroo [Shirley Jones]*
Costume sketch
Pencil and watercolor
20 × 15 in.
Collection of Dorothy Jeakins

Music Man
Shirley Jones
Marian, the librarian

63

The "I Don't Care" Girl

63

Eva Tanguay [Mitzi Gaynor]
Costume sketch by Renie Conley
Gouache and pencil
16½ × 12½ in.
Los Angeles County Museum of Art
Gift of Mrs. Leland H. Conley
M.86.207

(Twentieth Century-Fox, 1953)
Designers: Renie Conley (United
States, active 1936–68) and Charles
LeMaire (United States, 1897–1985)

Somewhere in Time

(Universal, 1980)
Designer: Jean-Pierre Dorléac
(France, born 1943)

64

*Ensemble: Dress, Blouse, Hat, Shoes,
Mitts, Handbag, and Jewelry*
Dress of pale pink shantung with
ecru lace trim; matching hat of light
tan silk chiffon over wire with ecru
net and flower trim; shoes of pink
and tan leather; mitts and handbag
of ecru cotton Irish crochet; earrings
and necklace of crystal faux pearls
Worn by Jane Seymour as Elise
McKenna
Collection of Jean-Pierre Dorléac

Elise McKenna [Jane Seymour]
Costume sketch
Colored pencil
16 × 12 in.
Los Angeles County Museum of Art
Gift of Jean-Pierre Dorléac
M.86.384

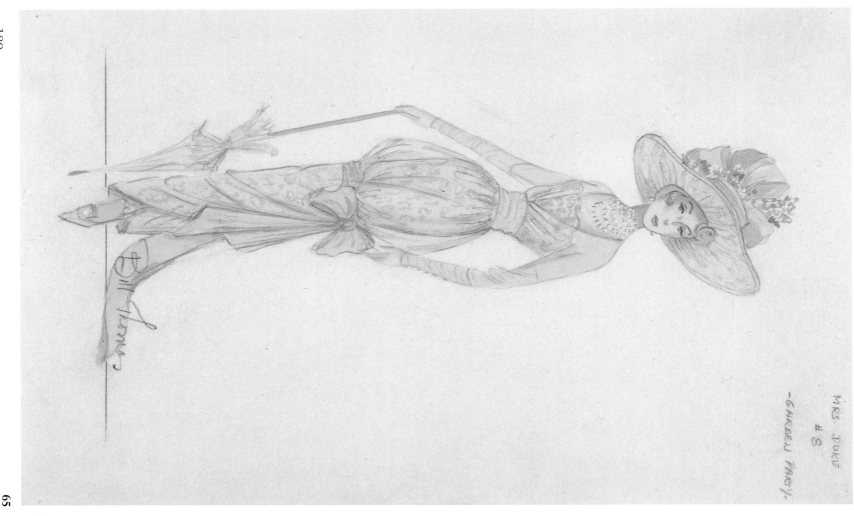

MRS. DUKE
#8
—GARDEN PARTY/-

Bill Thomas

The Happiest Millionaire

(Buena Vista/Walt Disney
Productions, 1967)
Designer: Bill Thomas (United States,
born 1921)

65

*Mrs. Duke [Geraldine Page] at the
Garden Party*
Costume sketch
Pencil and watercolor
15 × 11 in.
Los Angeles County Museum of Art
Gift of Bill Thomas
M.86.215.1

Cheaper by the Dozen

(Twentieth Century-Fox, 1950)
Designers: Edward Stevenson (United
States, 1906–1960) and Charles
LeMaire (United States, 1897–1985)

*Ann Gilbreth [Jeanne Crain] in Black
Shirt with Sailor Top*
Costume sketch by Edward
Stevenson
Pencil and watercolor
$20\frac{1}{16}$ × 13 in.
Brooklyn Museum

*Ann Gilbreth [Jeanne Crain] in Plaid
Dress*
Costume sketch by Edward
Stevenson
Pencil and watercolor
$20\frac{1}{16}$ × 13 in.
Brooklyn Museum

*Lillian Gilbreth [Myrna Loy] in Black
Dress*
Costume sketch by Edward
Stevenson
Pencil and watercolor
$20\frac{1}{16}$ × 13 in.
Brooklyn Museum

*Lillian Gilbreth [Myrna Loy] in Brown
Dress*
Costume sketch by Edward
Stevenson
Pencil and watercolor
$20\frac{1}{16}$ × 13 in.
Brooklyn Museum

66

Lillian Gilbreth [Myrna Loy] in Brown Suit
Costume sketch by Edward Stevenson
Pencil and watercolor
$20\frac{1}{16} \times 13$ in.
Brooklyn Museum

Thoroughly Modern Millie

(Universal, 1966)
Designer: Jean Louis (France, born 1907)

Woman's Costume
Costume sketch
Pencil and watercolor
$14 \times 6\frac{1}{2}$ in.
Los Angeles County Museum of Art
Gift of the Costume Council
M.87.86.9

67

Elmer Gantry

(United Artists, 1960)
Designer: Dorothy Jeakins (United
States, born 1914)

*Sister Sharon [Jean Simmons] in
Cream Dress*
Costume sketch
Gouache and pencil
15½ × 5½ in.
Collection of Dorothy Jeakins

*Sister Sharon [Jean Simmons] in White
Robe*
Costume sketch
Gouache and pencil
20 × 15 in.
Los Angeles County Museum of Art
Gift of the Costume Council
M.86.193.4

Tender Is the Night

(Twentieth Century-Fox, 1962)
Designers: Pierre Balmain (France,
1914–1982) Marjorie Best (United
States, active 1943–65), and Charles
LeMaire (United States, 1897–1985)

Nicole Diver [Jennifer Jones]
Costume sketch by Adele Elizabeth
Balkan (United States, born 1947)
Gouache
20¼ × 15⅛ in.
Los Angeles County Museum of Art
Gift of Adele Elizabeth Balkan
M.84.142.5

Some Like It Hot

(United Artists, 1959)
Designers: Orry-Kelly (United States,
1899–1964) and Bert Henrikson

Sugar Kane [Marilyn Monroe]
Costume sketch by Orry-Kelly
Gouache and pencil
22 × 18 in.
Los Angeles County Museum of Art
Gift of the Costume Council
M.83.161.25

68

Auntie Mame

(Warner Bros., 1958)
Designer: Orry-Kelly (United States,
1899–1964)

*Mame [Rosalind Russell] in Brown
Traveling Costume*
Costume sketch
Pen and pencil
23 × 14½ in.
Los Angeles County Museum of Art
Gift of Tony Duquette
M.86.385.194

*Mame [Rosalind Russell] in
Embroidered Robe*
Costume sketch
Gouache
23 × 14½ in.
Los Angeles County Museum of Art
Gift of Tony Duquette
M.86.385.197

*Mame [Rosalind Russell] in Gray
Traveling Costume*
Costume sketch
Gouache
15 × 10 in.
Los Angeles County Museum of Art
Gift of Tony Duquette
M.86.385.186

69

Giant

(Warner Bros., 1956)
Designer: Moss Mabry (United
States, active since 1951) and
Marjorie Best (United States,
active 1943–65)

Leslie Benedict [Elizabeth Taylor]
Costume sketch by Moss Mabry
Pencil and watercolor
20 × 15 in.
Los Angeles County Museum of Art
Gift of Moss Mabry
M.87.92.1

69

*Leslie Benedict [Elizabeth Taylor]:
Arrival in Texas, 1926*
Costume sketch by Marjorie Best
Gouache and pencil
9 × 7 in.
Los Angeles County Museum of Art
Gift of the Costume Council
M.85.144.5

1930s

The Sound of Music

(Twentieth Century-Fox, 1965)
Designer: Dorothy Jeakins (United
States, born 1914)

70 *Maria [Julie Andrews]*
Costume sketch
Pencil and watercolor
15¾ × 8¼ in.
Collection of Dorothy Jeakins

Pennies from Heaven

(M.G.M., 1981)
Designer: Bob Mackie (United States,
active since 1972)

Evening Gown
Off-white silk chiffon with
translucent, silver-colored, plastic
sequins, paste stones, and caviar
beading; shoes of silver leather
Worn by Bernadette Peters as Eileen
Lorimar Studios

Sound of Music

Maria MISS JULIE ANDREWS
2nd DO RE ME

Bodice & Sketch x

R 30½

DJT
64

Pastinella or
BLOUSE

SLEEVES: JOFA WHITE ↑
SKIRT: GREEN
BODICE: HERMAN MILLER MEX.
OLIVE SOUTACHE
APRON Natural
TRISSAN #079 FE
49/50 • 6.50
SCARF BEIGE KHADI FE

The Sting

(Universal, 1973)
Designer: Edith Head (United States, 1907–1982)

Doyle Lonnegan [Robert Shaw]
Costume sketch
Colored pencil and gouache with fabric swatch
20 × 15 in.
Academy of Motion Picture Arts and Sciences
Edith Head collection

Henry Gondorff [Paul Newman] and Johnny Hooker [Robert Redford]
Costume sketch
Colored pencil and gouache
20 × 15 in.
Academy of Motion Picture Arts and Sciences
Edith Head collection

1950s

My Favorite Year

(M.G.M. 1982)
Designer: May Routh (Great Britain, born 1934)

Alan Swann [Peter O'Toole]
Costume sketch
Felt marker and gouache with fabric swatch
20¼ × 14¼ in.
Los Angeles County Museum of Art
Gift of May Routh
M.86.406.9

71 *K. C. Downing [Jessica Harper]*
Costume sketch
Felt marker and gouache with fabric swatch
20⅛ × 16⅛ in.
Los Angeles County Museum of Art
Gift of May Routh
M.86.406.10

71

K.C. DOWING.

MY FAVOURITE YEAR.

e Future

Tron

(Buena Vista/Walt Disney
Productions, 1982)
Designers: Elois Jenssen (United
States, active since 1947) and
Rosanna Norton (United States, born
1944)

Wounded Soldier
Costume sketch by Elois Jenssen
Gouache and watercolor
$23\frac{3}{4} \times 17\frac{3}{4}$ in.
Los Angeles County Museum of Art
Gift of Elois Jenssen
M.86.239.2

Yori in Love Scene
Costume sketch by Elois Jenssen
Gouache and watercolor
$22\frac{1}{2} \times 13\frac{1}{2}$ in.
Los Angeles County Museum of Art
Gift of Elois Jenssen
M.86.239.1

Blade Runner

(Ladd Company/Run Run Shaw,
1982)
Designers: Charles Knode (Great
Britain, born 1942) and Michael
Kaplan

Deckard [Harrison Ford]
Costume sketch
Pencil
30 × 20 in.
Collection of Charles Knode and
Michael Kaplan

Rachel [Sean Young] in Dress
Costume sketch
Pencil
25 × 20 in.
Collection of Charles Knode and
Michael Kaplan

Rachel [Sean Young] in Fur Coat
Costume sketch
Pencil
25 × 20 in.
Collection of Charles Knode and
Michael Kaplan

Logan's Run

(M.G.M., 1976)
Designer: Bill Thomas (United States,
born 1921)

Jessica [Jenny Agutter]
Costume sketch
Gouache and pencil
15 × 11 in.
Los Angeles County Museum of Art
Gift of Bill Thomas
M.86.412.9

Man's Maroon Costume
Costume sketch
Gouache and pencil
15 × 11 in.
Los Angeles County Museum of Art
Gift of Bill Thomas
M.86.412.8

Man's Red Costume
Costume sketch
Gouache and pencil
15 × 11 in.
Los Angeles County Museum of Art
Gift of Bill Thomas
M.86.412.1

Star Trek II: The Wrath of Khan

(Paramount, 1982)
Designer: Robert Fletcher (United
States, born 1924)

Admiral Kirk [William Shatner]
Costume sketch
Gouache
20 × 15 in.
Los Angeles County Museum of Art
Gift of the Costume Council
M.86.262.115

Star Trek III: The Search for Spock

(Paramount, 1984)
Designer: Robert Fletcher (United
States, born 1924)

Mr. Spock [Leonard Nimoy]
Costume sketch
Ink and pastel with fabric swatch
$20 \times 12\frac{1}{2}$ in.
Los Angeles County Museum of Art
Gift of Robert Fletcher
M.86.262.99

Priestess
Costume sketch
Ink and pastel
$19\frac{3}{4} \times 12\frac{3}{4}$ in.
Los Angeles County Museum of Art
Gift of Robert Fletcher
M.86.262.114

Vulcan Musician with Lute
Costume sketch
Ink and pastel
$19\frac{3}{4} \times 12\frac{3}{4}$ in.
Los Angeles County Museum of Art
Gift of Robert Fletcher
M.86.262.113a

72 *Vulcan Musician with Pipes*
Costume sketch
Ink and pastel
19¾ × 12¾ in.
Los Angeles County Museum of Art
Gift of Robert Fletcher
M.86.262.113b

Star Trek IV: The Voyage Home

(Paramount, 1986)
Designer: Robert Fletcher (United
States, born 1924)

73 *President of the Federation*
Costume sketch
Ink, pencil, and watercolor
17 × 14 in.
Los Angeles County Museum of Art
Gift of Robert Fletcher
M.86.262.116

Battlestar Galactica

(Universal, 1979)
Designer: Jean-Pierre Dorleac
(France, born 1943)

Adama [Lorne Greene]
Costume sketch
Colored pencil
16 × 12 in.
Collection of Jean-Pierre Dorleac

Serina [Jane Seymour]
Costume sketch
Colored pencil
16 × 12 in.
Collection of Jean-Pierre Dorleac

President of the Federation Council

C. Fletcher '86

Star Trek IV

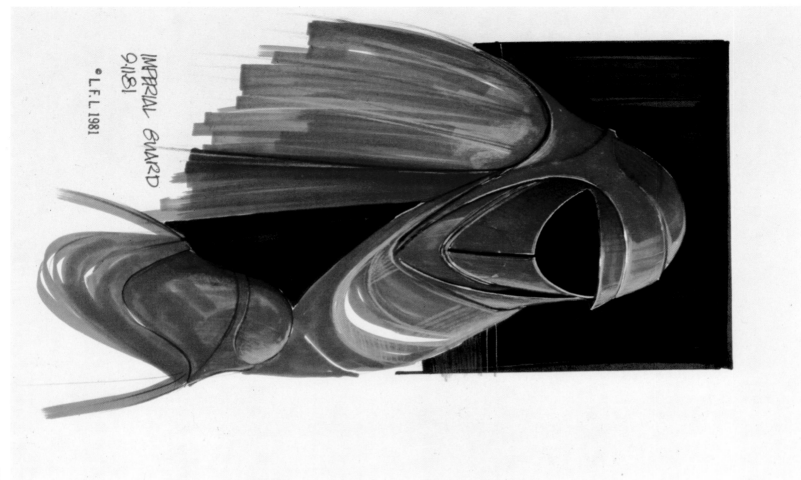

74

Buck Rogers in the Twenty-fifth Century

(Universal, 1979)
Designer: Jean-Pierre Dorléac
(France, born 1943)

Princess Ardala [Pamela Hensley]
Costume sketch
Colored pencil
16 × 12 in.
Collection of Jean-Pierre Dorléac

Draconian Warrior
Costume sketch
Colored pencil
16 × 12 in.
Collection of Jean-Pierre Dorléac

Return of the Jedi

(Twentieth Century-Fox, 1983)
Designers: Aggie Guerard Rodgers
and Nilo Rodis

*Gargan: Multibreasted Dancing Figure
from Jabba the Hutt's Palace*
Costume sketch by Nilo Rodis
Colored pencil, pencil, designer
marker, and watercolor wash
14 × 8½ in.
Lucasfilm Ltd.

74
Imperial Guard
Costume sketch by Nilo Rodis
Colored pencil, designer marker, and
watercolor wash
14 × 8½ in.
Lucasfilm Ltd.

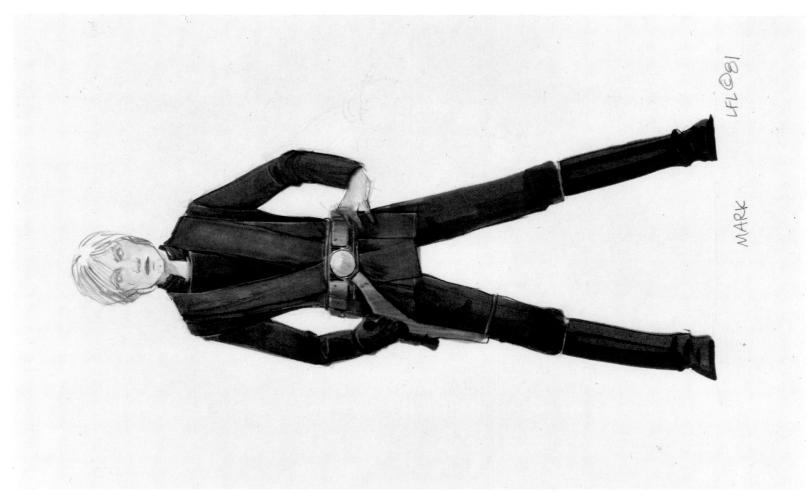

75

75 *Luke Skywalker [Mark Hamill] as Jedi Knight*
Costume sketch by Nilo Rodis
Colored pencil, pencil, designer marker, and watercolor wash
16¼ × 14 in.
Lucasfilm Ltd.

Princess Leia [Carrie Fisher]: Endor Hairstyle
Costume sketch by Paul LeBlanc
(Hair design by Paul LeBlanc)
Colored pencil, pencil, and pastel
16¼ × 14 in.
Lucasfilm Ltd.

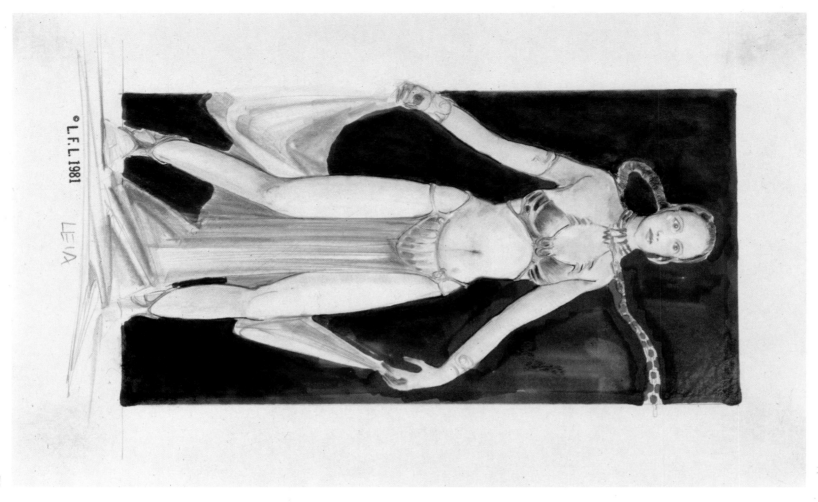

*Princess Leia [Carrie Fisher] Held
Captive by Jabba the Hutt, I*
Costume sketch by Nilo Rodis
Colored pencil and pencil
17 × 11 in.
Lucasfilm Ltd.

76 *Princess Leia [Carrie Fisher] Held
Captive by Jabba the Hutt, II*
Costume sketch by Nilo Rodis
Colored pencil, pencil, designer
marker, and watercolor wash
14 × 8½ in.
Lucasfilm Ltd.

*Princess Leia [Carrie Fisher] Held
Captive by Jabba the Hutt, III*
Costume sketch by Paul LeBlanc
(Designer: Paul LeBlanc)
Colored pencil, pencil, and pastel
16½ × 14 in.
Lucasfilm Ltd.

Filmography

EDWARD MAEDER AND DAVID EHRENSTEIN

This filmography represents a selection of period films arranged chronologically by their time settings. In the accompanying commentary we seek to underscore points of interest pertaining to the films' costume, hairstyle, and makeup and to note their relative degrees of success or failure in achieving historical accuracy. Also included are cross-references to individual essays.

Victor Mature and Carole Landis in *One Million B.C.*

Prehistory

One Million B.C. (*United Artists, 1940*). *Costumes by Harry Black. Starring Victor Mature and Carole Landis (prehistoric cave dwellers). Location not specified.*

Two tribes of prehistoric cave dwellers try to get along with one another while steering clear of man-eating dinosaurs. D. W. Griffith reportedly had a hand in this Hal Roach production.

Carole Landis wears a soft-leather version of a one-piece swimsuit with carefully cut "random" edges. It is precisely seamed and shaped. In another of her costumes the upper part is held in place with spaghetti straps.

One Million Years B.C. (*Twentieth Century-Fox, 1966*). *Costumes by Carl Toms. Starring Raquel Welch and John Richardson (prehistoric cave dwellers). Location not specified.*

This Hammer Films' production is similar in plot to the 1940 release but has more sex and violence.

Welch wears a costume that resembles a fur bikini. The other women are clothed in fur skirts, short like the fashionable minis of the late 1960s. Their hairstyles are typical of 1966 with side partings and teased fullness.

Caveman (*United Artists, 1981*). *Costumes by Robert Fletcher. Starring Ringo Starr (Atouk), Barbara Bach (Lana), and John Matuszak (Tonda). Set in "one zillion BC," location not specified.*

A hilarious send-up of prehistoric-themed films, *Caveman* presents outfits that parody the costumes of earlier films and are intended to be ridiculous. Barbara Bach's fur bikini emphasizes her breasts even more than the garment worn by Welch in *One Million Years B.C.*

Quest for Fire (*Twentieth Century-Fox, 1982*). *Costumes by John Hay and Penny Rose. Starring Everett McGill and Rae Dawn Chong (prehistoric cave dwellers). Set in the Stone Age, location not specified.*

A serious, scientific/historical view of prehistoric times, this drama tells of a riverine tribe passing on the secrets of fire to their more backward cave dwelling cousins. The costumes in this film have a sense of authenticity, but it is still too recent to see the contemporary influence. Anachronisms may become apparent in the next few decades.

Early Egyptian/Biblical

Land of the Pharaohs (*Warner Bros., 1955*). *Costumes by Mayo. Starring Jack Hawkins (Cheops) and Joan Collins (Princess Nellifer). Set in Egypt, about 3000 BC.*

The building of the pyramids and the court intrigues that occurred around it are the basis for this Howard Hawks production. William Faulkner was the chief scriptwriter.

Collins wears a strapless version of a Frederick's of Hollywood cone-shaped bra under a transparent drape of thin, pleated fabric. Her hairstyle is also contemporary.

The Egyptian (*Twentieth Century-Fox, 1954*). *Costumes by Charles LeMaire. Starring Edmund Purdom (Sinuhe), Bella Darvi (Nefer), and Jean Simmons (Merit). Set in Egypt, fourteenth century BC.*

The life and loves of a physician in ancient Egypt are the melodramatic material of this spectacular directed by Michael Curtiz. See Chapter 1.

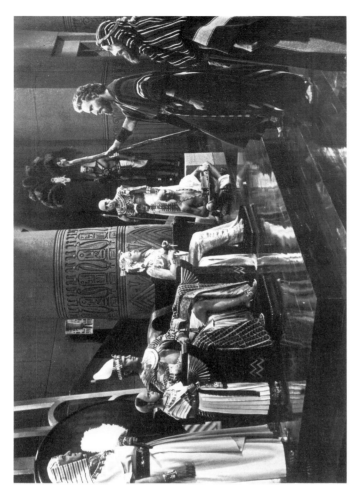

Yul Brynner, Anne Baxter, and Charlton
Heston in *The Ten Commandments* (1956)

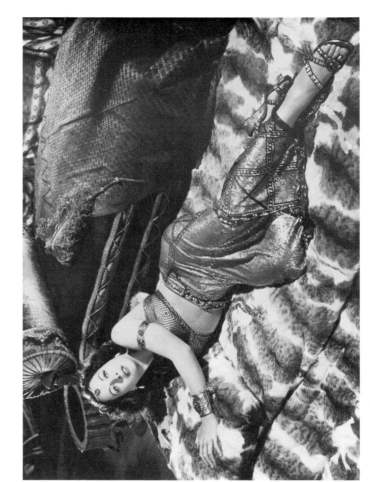

Hedy Lamarr in *Samson and Delilah*

The Ten Commandments (*Paramount,
1923*). *Costumes by Claire West and Howard
Greer. Starring Theodore Robert, Charles de
Roche, Rod LaRoque, and Leatrice Joy (Is-
raelites, Egyptians, and contemporary charac-
ters). Set in Egypt, about 1250 BC, and con-
temporary U.S.A.*

Cecil B. De Mille contrasts the biblical story of
Moses and the Ten Commandments with a
modern tale about some well-to-do citizens
who break several of them. De Mille's
compare-and-contrast type of setting is
clearly derived from Griffith's *Intolerance.*

Estelle Taylor, playing an ancient Egyp-
tian, is dressed like a 1920s vamp, with
beaded fringe and thin chains. The son of
Ramses wears a costume of Egyptian-made
metallic shawls, which were popular with
fashionable women in the 1920s. The
Pharaoh's headdress reflects the cloche look
popular in contemporary ladies' hats. In
keeping with the same aesthetic, foreheads,
even on many of the men, are not to be seen.

The Ten Commandments (*Paramount,
1956*). *Costumes by Edith Head, Ralph Jester,
John Jensen, Dorothy Jeakins, and Arnold
Friberg. Starring Charlton Heston (Moses),
Yul Brynner (Ramses), and Anne Baxter
(Nefertiti). Set in Egypt, about 1250 BC.*

De Mille restricts the action to ancient Egypt
in this remake, one of the most lavish and
spectacular productions of the 1950s.

The men's garments appear remarkably
accurate, but the women's costumes are
strictly in the style of 1956 with pinched-in
waistlines and the ever-present "lifted and
separated" bosoms, carefully draped with
chiffon and other similar materials. The
contemporary bangs in the Queen of Egypt's
hairstyle may be distracting for today's
viewers but did not interfere with the illusion
of historical accuracy that it presented to
moviegoers in 1956.

Samson and Delilah (*Paramount, 1950*).
*Costumes by Edith Head, Gile Steele, Dorothy
Jeakins, Gwen Wakeling, and Elois Jenssen.
Starring Victor Mature (Samson) and Hedy
Lamarr (Delilah). Set in Gaza, about 1000 BC.*

In this costume melodrama the Old Testa-
ment story of Samson and Delilah is given the
lavish De Mille treatment. The spectacular

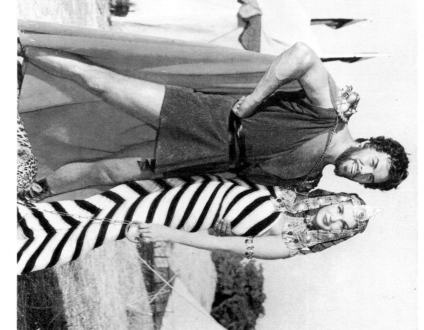

Left: Richard Burton and Claire Bloom in *Alexander the Great*

Right: Howard Keel and Esther Williams in *Jupiter's Darling*

finale in which Samson destroys the temple of his enemies is one of De Mille's finest sequences.

Turkish embroideries, nomadic camel bags, and Indian sari fabrics and jewels create an impression of opulence. Lamarr wears a wide assortment of costumes, including one made from a shawl of metallic fabric. Worn draped over her bosom, the metallic and black-striped fabric resembles a style widely used in the late 1940s in Paris couture.

Intolerance (D. W. Griffith Productions, 1916). Costumes by Claire West. Set in Babylon, 539 BC, starring Constance Talmadge (the mountain girl) and Elmer Clifton (the rhapsode); in Judea, AD 27–33, starring Howard Gaye (the Nazarene) and Lillian Langdon (Mary, the Mother); in France, 1572, starring Marjorie Wilson ("Brown Eyes") and Eugene Pallette (Prosper Latour); and in contemporary U.S.A., starring Mae Marsh (the "Dear One") and Robert Herron (the boy).

Subtitled "A Sun-Play for the Ages," Griffith's massive spectacular remains, after all these years, the most monumental production ever shot in Hollywood and one of the most influential films ever made. Cutting back and forth between four different historical periods, Griffith offers up his vision of "Man's Inhumanity to Man." See Chapter I.

Greek/Early Roman

Ulysses (Paramount/Dino de Laurentiis, 1955). Costumes by Giulio Coltellacci. Starring Kirk Douglas (Ulysses) and Silvana Mangano (Penelope/Circe). Set in mythological Greece.

This American/Italian coproduction, based on Homer's epic *The Odyssey*, follows the mythic saga of Ulysses, presenting it as a straightforward adventure film.

In ancient Greece women's hair was highly stylized, and clothes were made of

wool and linen. The filmmakers here opted for a more glamorous approach with free-flowing locks and costumes of jersey and chiffon.

A Night in Paradise (*Universal, 1946*). *Costumes by Travis Banton. Starring Merle Oberon (Princess Delarai of Persia) and Turhan Bey (Aesop the Storyteller). Set in Samos, Greece, 550 BC.*

The life of Aesop the storyteller is the ostensible subject of this romantic fantasy. The filmmakers, however, appear to have been more interested in highlighting feminine beauty.

The women's costumes—skimpy, bugle-beaded halter tops and robes with yards of flowing chiffon and crepe—could have been worn, with little alteration, to elegant evening dances and parties just after World War II.

Alexander the Great (*United Artists, 1956*). *Costumes by David Ffolkes. Starring Richard Burton (Alexander), Claire Bloom (Barsine), and Fredric March (Philip of Macedonia). Set in Greece, 356–323 BC.*

Alexander the Great, written and directed by Robert Rossen, is one of the more sober and tasteful epics of the 1950s, portraying its legendary protagonist as a man of thought as well as action.

The jeweled trim and the gold thread embroidery with pearls, both seen in the women's costumes, look exactly like the trim and embroidery found on evening wraps in the mid-1950s. Claire Bloom's jewelry was carefully copied from early prototypes, but her makeup and hairstyle are strictly the styles of 1956.

Jupiter's Darling (*M.G.M., 1955*). *Costumes by Helen Rose and Walter Plunkett. Starring Esther Williams (Amytis) and Howard Keel (Hannibal). Set in Rome, 216 BC.*

Hannibal crossing the Alps is an unlikely subject for a musical. It proved to be Williams's last for M.G.M. even though she looked stunning in a costume that left little to the imagination: a form-fitting jersey dress with wide stripes in a chevron pattern.

Spartacus (*Universal, 1960*). *Costumes by Valles, (for Jean Simmons) Bill Thomas, and*

wardrobe by Peruzzi. Technical advisor: Vittorio Nino Novarese. Starring Kirk Douglas (Spartacus), Laurence Olivier (Crassus), and Jean Simmons (Livia). Set in Rome, 73 BC.*

One of the most intelligent and dramatically satisfying spectaculars of the late 1950s, this adaptation of Howard Fast's story of a Roman slave revolt is one of director Stanley Kubrick's finest films.

The women's costumes, late-1950s versions of outfits from ancient Rome, have cinched-in waists and flowing skirts with metallic embroidery and beads. Their hairstyles are full and curled in keeping with the contemporary look; the only item missing from 1950s fashion is the pillbox hat! Even Douglas as Spartacus wears a flat top. See Chapter II.

Late Egyptian/Biblical

The Prodigal (*M.G.M., 1955*). *Costumes by Herschel McCoy. Starring Lana Turner (high priestess of the temple of the goddess Astarte) and Edmund Purdom (the prodigal son). Set in Damascus, 70 BC.*

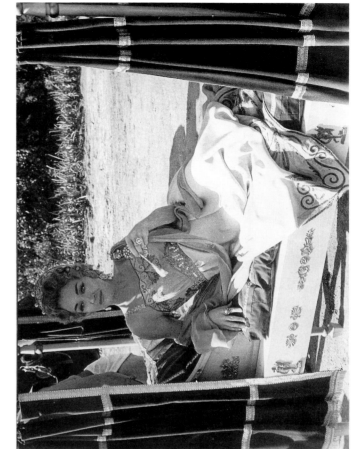

Nina Foch in *Spartacus*

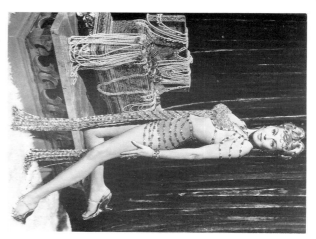

Lana Turner in *The Prodigal*

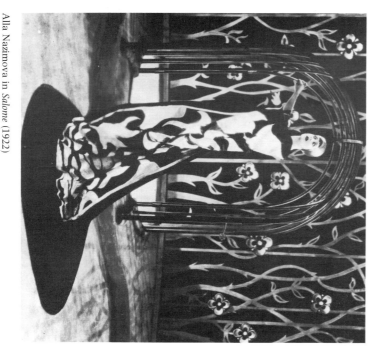

Alla Nazimova in *Salome* (1922)

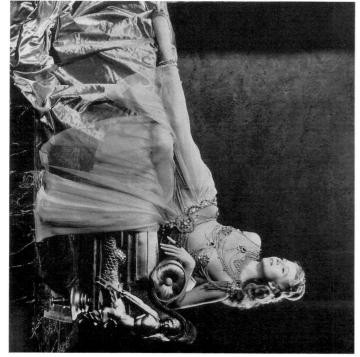

Rita Hayworth in *Salome* (1953)

Ben Hur (*M.G.M., 1926*). *Costumes by Camillo Innocente, Erté, and Harold Grieve. Starring Ramon Novarro (Ben Hur), Francis X. Bushman (Messala), and May McAvoy (Esther). Set in Rome, first century AD.*

The most successful big-screen spectacle of its time, this adaptation of General Lew Wallace's *Tale of Christ* catapulted its star, Ramon Novarro, to international fame.

Most of the clothing was based on forms that were still being worn in the Near East at the time of the film. The costume for Carmel Myers (Flavia) would have been acceptable on stage with the Ballets Russes or in the pages of a 1926 *Vogue*, as the decorative pearl fringes on her dress, designed by Erté, resemble his contemporary designs.

Ben Hur (*M.G.M., 1959*). *Costumes by Elizabeth Haffenden. Starring Charlton Heston (Ben Hur), Stephen Boyd (Messala), and Haya Hararect (Esther). Set in Rome, first century AD.*

William Wyler directed the Academy Award-winning remake of this saga of one man's discovery of Christianity.

In preparing the costumes, Haffenden and

The Bible only makes a brief reference to the road of perdition, traveled by the "prodigal son," but that did not stop the makers of this gaudy spectacle from filling in what the Good Book left out. See Chapter I.

Cleopatra (*Fox Film Corporation, 1917*). *Costume designer unknown. Starring Theda Bara (Cleopatra) and Fritz Leiber (Marc Antony). Set in Egypt and Rome, 48 BC.*

Cleopatra (*Paramount, 1934*). *Costumes by Travis Banton, Ralph Jensen, and Mitchell Leisen. Starring Claudette Colbert (Cleopatra), Warren William (Marc Antony), and Henry Wilcoxon (Julius Caesar). Set in Egypt and Rome, 48 BC.*

Cleopatra (*Twentieth Century-Fox, 1963*). *Costumes by Irene Sharaff, Vittorio Nino Novarese, and Renie Conley. Starring Elizabeth Taylor (Cleopatra), Richard Burton (Marc Antony), Rex Harrison (Julius Caesar). Set in Egypt and Rome, 48 BC.*

For reference to the films' costumes, hair-styles, and makeup see Chapter I and Cleopatra photo essay.

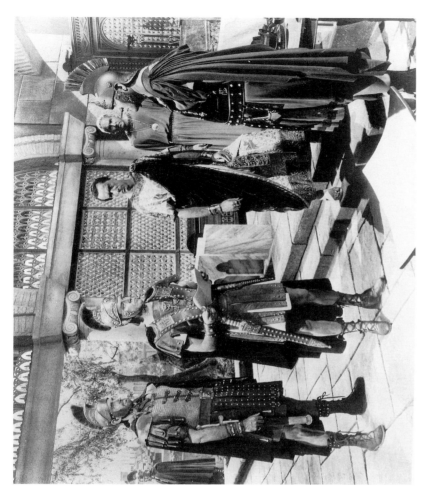

Richard Burton in *The Robe*

the filmmakers did much historical research, studying paintings and sculptures of the period. The colors and materials that they chose, however, reflect modern styles.

Salome (Alla Nazimova Productions, 1922). *Costumes by Natasha Rambova. Starring Alla Nazimova (Salome). Set in Galilee, about 33–34 AD.*

Aubrey Beardsley's art nouveau illustrations were the visual and dramatic inspiration for this independently produced adaptation of Oscar Wilde's play.

Nazimova and Rambova were aiming for a heavily stylized version of the story: historical authenticity was not their intent. One can see a number of nonperiod influences in the outfits, including stylized eighteenth-century wigs for the youthful servants and Japanese samurai-type costumes, with *mons* (family crests) on their shoulders, for the guards.

Salome (Columbia, 1953). *Costumes by Jean Louis and Emile Santiago. Starring Rita Hayworth (Salome) and Stewart Granger (John the Baptist). Set in Galilee, about 33–34 AD.*

The legendary biblical temptress Salome becomes a misunderstood adolescent, a pawn in the schemes of her elders, in this dramatically unconvincing rendition of the ancient tale. Chains and chain fringes are incorporated into Rita Hayworth's attire. Her hair styles are the high-fashion evening wear of 1953.

The Robe (Twentieth Century-Fox, 1953). *Costumes by Charles LeMaire and Emile Santiago. Starring Richard Burton (Marcellus Gallio), Jean Simmons (Diana), and Victor Mature (Demetrius). Set in Galilee, about 33–36 AD.*

Demetrius and the Gladiators (Twentieth Century-Fox, 1954). *Costumes by Charles LeMaire and Adele Balkan. Starring Victor Mature (Demetrius) and Susan Hayward (Messalina). Set in Galilee, about 36 AD.*

A sequel to *The Robe*, this biblical blockbuster offered muscle as well as pious musing in its story of early Christians facing the Roman gladiatorial arena.

Hayward is a model of 1950s styles with her modified ponytail and "cross your heart" bra. See Chapter 1.

The Sign of the Cross (Paramount, 1932). *Costumes by Travis Banton and Mitchell Leisen. Starring Fredric March (Marcus Superbus), Claudette Colbert (Poppaea), and Charles Laughton (Nero). Set in Rome, about 64 AD.*

The struggles of early Christianity get the De Mille treatment in this all-stops-out spectacle.

Bias-cut chevrons on the handmaidens look like early-1930s high-fashion evening

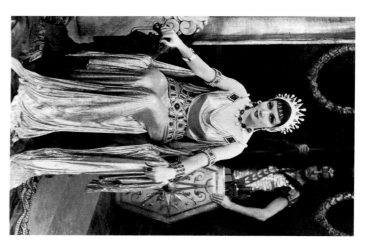

Claudette Colbert in *The Sign of the Cross*

wear. The necklines are gathered into a ring at the center front, similar to the well-known gown worn by Colbert in *Cleopatra* two years later. Breasts are smooth and rounded as was the contemporary style.

Quo Vadis (M.G.M. 1951). *Costumes by Herschel McCoy. Starring Robert Taylor (Marcus Vinicius), Deborah Kerr (Lygia), and Peter Ustinov (Nero). Set in Rome, 64 AD.*

This tale of early Christians at the none-too-tender mercies of the Romans was one of the most popular films of its day.

The use of sequins and beads in Kerr's wardrobe delighted audiences but did little to improve the accuracy of popular conceptions about ancient Rome.

The Big Fisherman (*Buena Vista*, 1959). *Costumes by Renie Conley. Starring Howard Keel (Simon Peter) and Susan Kohner (Princess Fara). Set in Galilee, about 64–68 AD.*

Based on Lloyd C. Douglas's novel about the life of Saint Peter, this Frank Borzage production was decidedly low-key in comparison to the biblical spectaculars of its time.

The designer, Conley, relied heavily on textiles indigenous to the region around Galilee. Her use of coarsely woven fabrics and a layered look made it easy for the moviegoing public to identify the styles as first century AD, even though many of the costumes' forms and surface decorations are of the present century.

Medieval

A Connecticut Yankee in King Arthur's Court (*Paramount, 1949*). *Costumes by Mary Kay Dodson and Gile Steele. Starring Bing Crosby (Hank Martin) and Rhonda Fleming (Alisande de la Carteroise). Set in England, about 830.*

Mark Twain's tale about a modern man transplanted to medieval times is the basis for this Bing Crosby musical.

Fleming, with her flowing locks and swelling bosom, more closely resembles a pin-up girl than ninth-century royalty. A narrow-striped, metallic and black fabric,

which was a high fashion material of the late 1940s, is seen in this film (as well as in *Bride of Vengeance*, another movie released in 1949). The costumes also include asymmetrical drapes of 1940s crêpe, a material unknown in medieval England.

Camelot (*Warner Bros., 1967*). *Costumes by John Truscott. Starring Vanessa Redgrave (Queen Guinevere), Richard Harris (King Arthur), and Franco Nero (Sir Lancelot). Set in mythological England, about 830.*

Alan Jay Lerner and Frederick Loewe's stage musical about King Arthur and the knights of the Round Table was translated into a visually stunning (if dramatically unsatisfying) screen production directed by Joshua Logan.

In designing the memorable costumes for the film, Truscott drew inspiration from the styles of different periods, including the contemporary hippie culture. The aesthetic of the late 1960s is seen clearly in the hairstyles and body movements of the cast. The "Lusty Month of May" number looks like a get together of a group of flower children in

Virginia Field in *A Connecticut Yankee in King Arthur's Court* (1949)

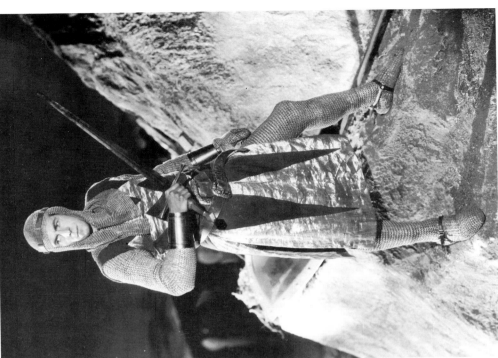

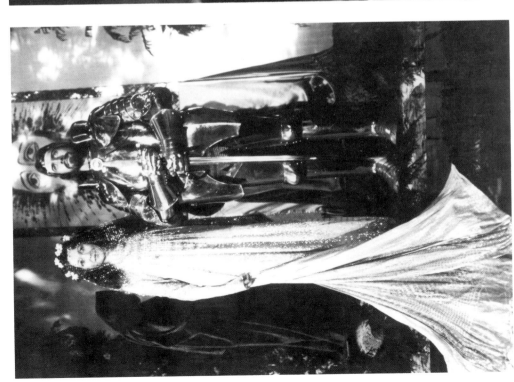

Golden Gate Park. Considering the time when the film was made, that was probably the intent.

Excalibur (*Orion, 1981*). *Costumes by Bob Ringwood. Starring Nigel Terry (King Arthur), Nicol Williamson (Merlin), Cheri Lunghi (Queen Guenevere), Nicholas Clay (Lancelot), and Helen Mirren (Morgan Le Fay). Set in mythological England about 830.*

Writer-director John Boorman's version of the King Arthur legend is an imaginative mixture of Wagnerian opera, Pre-Raphaelite fantasy, and Jungian archetypes.

The men's hairstyles are slightly longer versions of the popular style of 1981. Queen Guenevere wears tresses of a Farrah Fawcett fullness.

The Crusades (*Paramount, 1935*). *Costumes by Travis Banton, Natalie Visart, Al Nickel. Renie Conley, and Ralph Jester. Starring Loretta Young (Berengaria) and Henry Wilcoxon (Richard the Lionheart). Set in England, 1188–92.*

De Mille's version of the adventures of Richard the Lionheart is decoratively diverting, if not dramatically compelling.

Young wears yards of silk chiffon throughout most of the movie. In one scene over her flowing gown she dons a suit of armor. It would have cut her costume to ribbons if it had not been made of heavy knitted cord, painted, and covered with silver leaf. She wore bangs across her forehead and plucked eyebrows, the order of the day in 1935.

Left: Cheri Lunghi and Nigel Terry in *Excalibur*

Right: Colin Tapley in *The Crusades*

Genevieve Page and Sophia Loren in *El Cid*

King Richard and the Crusaders (*Warner Bros.*, 1954). *Costumes by Marjorie Best. Starring Rex Harrison (Emir Ilderim), Virginia Mayo (Lady Edith), and George Sanders (Richard I). Set in England, 1188–92.*

Another foray into the adventurous side of life in the Middle Ages. See Chapter I.

The Adventures of Robin Hood (*Warner Bros.*, 1938). *Costumes by Milo Anderson. Starring Errol Flynn (Robin Hood) and Olivia de Havilland (Maid Marian). Set in England, 1193.*

This film gives a spirited and entertaining rendition of the life of the playful rogue who robbed from the rich and gave to the poor.

Maid Marian wears hammered crêpe and metallic fabrics in her gowns, which would have been acceptable dress for a grand evening affair in 1938. Her crownlike headpieces are set at an angle perfect for the hat of the late 1930s but wrong for the styles of twelfth-century England.

El Cid (*Allied Artists/Samuel Bronston, 1961*). *Costumes by Veniero Colasant and John Moore. Starring Charlton Heston (El Cid) and Sophia Loren (Chimene). Set in Spain, 1197.*

Director Anthony Mann made a stately and richly colored pageant about the life of the legendary Spanish warrior.

A great deal of attention was paid to the costumes of the principal men. Many of the details were taken from primary sources, but strict adherence to the historical period does not appear to have been essential. The women's dress was much more influenced by contemporary fashion, and the seam placements and fabrics used were those one would expect to find in a modern couture house.

The Conqueror (*R.K.O. 1956*). *Costumes by Michael Woulfe Chayward and Yvonne Wood. Starring John Wayne (Temujin-Genghis Khan) and Susan Hayward (Bortai). Set in Mongolia, about 1207–15.*

Wayne would not be the first actor that comes to most people's minds if faced with the prospect of casting the title role for the life story of Genghis Khan. He and his costar make the most of things nonetheless in this

fanciful Howard Hughes production directed by Dick Powell.

Wayne's costumes include a vest with metal grommets and denim shirts with flat-fell seams and turndown collars, items unknown in twelfth-century Mongolia. Hayward's dress and hairstyle were appropriate for everyday wear in 1956 America.

The Court Jester (*Paramount, 1956*). *Costumes by Yvonne Wood and Edith Head. Starring Danny Kaye (Hawkins) and Glynis Johns (Maid Jean). Set in England, about 1215.*

This look at life in the Middle Ages is a wonderful vehicle for Kaye's style of comedy. His costar Johns was made up with 1955 eyebrows and wore off-the-shoulder gowns with form-fitting bodices and center-back closings, dresses not representative of English fashion at the time of the Magna Carta.

Joan of Arc (*R.K.O. 1948*). *Costumes by Karinska, Dorothy Jeakins, and Herschel McCoy. Starring Ingrid Bergman (Joan of Arc) and Jose Ferrer (Charles VII). Set in France, 1428–31.*

The life of the warrior-saint is portrayed here with equal measures of lavish pageantry and hushed reverence. See Chapter II.

John Wayne in *The Conqueror*

Danny Kaye and Glynis Johns in *The Court Jester*

Renaissance

The Vagabond King (*Paramount, 1930*). *Costumes by Travis Banton. Starring Dennis King (François Villon) and Jeanette MacDonald (Katherine). Set in Paris, 1460–70.*

If I Were King (*Paramount, 1938*). *Costumes by Edith Head. Starring Ronald Colman (François Villon), Basil Rathbone (Louis XII), and Ellen Drew (Huguette). Set in Paris, 1460–70.*

The life of medieval rogue and poet François Villon is the basis for these two very different productions. The first is a Rudolf Friml operetta. The second is a straightforward drama, with many ironic touches, written by Preston Sturges.

In *The Vagabond King* the actresses have soft, marcelled hair, done in a late-1920s style. Shoulders were never bared in public in France in the 1460s, but they are in this film. The actresses' dresses were made from beaded and jeweled silk chiffon, a material that did not exist in the Renaissance. The garments in the 1460s had a carefully structured form, which was not adhered to in either production. In the second film the designer, Head, used soft fabrics, cut on the bias, reflecting the aesthetic of 1938.

Bride of Vengeance (*Paramount, 1949*). *Costumes by Mitchell Leisen and Mary Grant. Starring Paulette Goddard (Lucretia Borgia), John Lund (Alfonso d'Este), and MacDonald Carey (Cesare Borgia). Set in Rome, 1480–1500.*

The lives of the conniving Borgia dynasty make for florid melodrama in this colorful production. See Chapter I.

Romeo and Juliet (*M.G.M., 1936*). *Costumes by Oliver Messel and Adrian. Starring Norma Shearer (Juliet), Leslie Howard (Romeo), and John Barrymore (Mercutio). Set in Verona, fifteenth century.*

Shakespeare's romantic tragedy of star-crossed lovers gets the plush M.G.M. treatment in this Irving Thalberg-supervised production directed by George Cukor. Shearer's gowns are vaguely reminiscent

of Renaissance dress, but the costumes' materials, soft satins and chiffons, are fabrics of the 1930s. The men's costumes are strongly theatrical, with exaggerated decoration and ornamentation.

Romeo and Juliet (*Paramount, 1968*). *Costumes by Danilo Donati. Starring Olivia Hussey (Juliet) and Leonard Whiting (Romeo). Set in Verona, about 1460.*

Director Franco Zeffirelli daringly cast actors the same age as Shakespeare's characters in this passionately youth-oriented rendition of the classic tale.

The costumes are probably the most accurate ever produced for a film of this period. The men's shirts, however, have shaped armholes, while shirts in the 1460s would have been made from a series of rectangles. The women's hairstyles are plucked back at the forehead as was popular in the late fifteenth century, but several of the aristocratic women wear enormous, bulbous headpieces that more closely resemble paintings and drawings by Antonio Pisanello done some thirty years earlier than the styles of the 1460s.

The Taming of the Shrew (*United Artists, 1929*). *Costumes by Mitchell Leisen and Adrian. Starring Douglas Fairbanks (Petruchio) and Mary Pickford (Katharine). Set in Padua, fifteenth century.*

Pickford and Fairbanks were at the height of their popularity when they decided to make this version of Shakespeare's comic tale about an unwilling bride and her determined spouse.

Although pearls over satin and Empire dresses are seen in this film, they have little to do with fifteenth-century clothing and are strictly fashions of the late 1920s. Thin silk velvets were also popular at this time and were used in some of the costumes; these materials draped and creased differently from the heavier textiles of the fifteenth century. In accord with the contemporary aesthetic the foreheads of the actresses are generally covered with veils or curls.

The Taming of the Shrew (*Paramount, 1967*). *Costumes by Danilo Donati and Irene Sharaff (for Elizabeth Taylor). Starring Taylor*

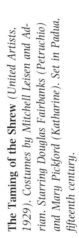

Charlton Heston and Diane Cilento in *The Agony and the Ecstasy*

(*Katharine*) and Richard Burton (*Petruchio*). Set in Padua, about 1500.

Franco Zeffirelli's production of the Shakespeare comedy adds lavish color and enormous physical energy to the comic high-jinks usually associated with this tale of reluctant mating.

The costume designers attempted to reproduce sixteenth-century silk damasks, and the cut of the women's undergarments is historically accurate. For some reason Burton's clothing has a strong German mercenary-soldier influence.

The Agony and the Ecstasy (*Twentieth Century-Fox, 1965*). *Costumes by Vittorio Nino Novarese. Starring Charlton Heston (Michelangelo) and Rex Harrison (Pope Julius II). Set in Rome, 1508.*

Carol Reed's film is based on Irving Wallace's historical novel about how Michelangelo came to paint the ceiling of the Sistine Chapel.

Even though the women's costumes were carefully researched for historical accuracy, they were cut to fit the silhouette of 1965, with its sharply defined figure and "lifted and separated" breasts. The men's shoes feature modern heels.

Captain from Castille (*Twentieth Century-Fox, 1947*). *Costumes by Charles LeMaire. Starring Tyrone Power (Pedro de Vega), Jean Peters (Catana), and Cesar Romero (Cortez). Set in Spain and Mexico, 1518.*

Cortez's conquest of Mexico provides the material for this adventure romance directed by Henry King.

Romero wears a shirt of rayon crêpe with modern set-in sleeves and a turndown collar. The ruffs on the collars and cuffs of the costumes for the Spanish gentlemen are heavy and edged with cord. In the sixteenth century they were made of the finest linen and edged with lace.

The Prince and the Pauper (*Warner Bros., 1937*). *Costumes by Milo Anderson. Starring Errol Flynn (Miles Hendon), Billy Mauch (Tom Canty), and Bobby Mauch (Edward Tudor). Set in London, about 1547.*

William Keighley directed this film version of Mark Twain's tale of a poor youth who changes places with the young prince he closely resembles.

The costumes are typical of the 1930s Hollywood portrayal of Tudor dress. There is not a codpiece in sight, and the men's shoulders are surprisingly narrow given the broad-shouldered look that prevailed in sixteenth-century England.

Diane (*M.G.M., 1956*). *Costumes by Walter Plunkett. Starring Lana Turner (Diane de Poitiers), Roger Moore (Prince Henri), and Pedro Armendariz (François 1). Set in France, about 1572.*

Christopher Isherwood wrote the script of this historical romance. Dialogue, however, took second place to Turner's physical presence. See Chapter II.

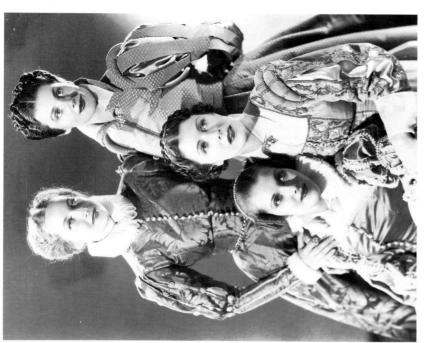

Elizabethan

Young Bess (*M.G.M., 1953*). *Costumes by Walter Plunkett. Starring Jean Simmons (Queen Elizabeth) and Stewart Granger (Thomas Seymour). Set in England, about 1549.*

Court intrigues in the adolescent years of Queen Elizabeth are at the heart of this romantic drama.

The costumes are among Walter Plunkett's best works. Although he somewhat compromised historical authenticity (for example, the shaping over the breasts is not the flattened look of the corseted English lady of the mid-sixteenth century), the colors and types of materials that he used represent the time well.

Mary of Scotland (*R.K.O., 1936*). *Costumes by Walter Plunkett. Starring Katharine Hepburn (Mary, Queen of Scots) and Fredric March (Earl of Bothwell). Set in Scotland and England, 1568–87.*

The life and loves of the Scottish queen, sentenced to death by her rival, Elizabeth, make for melodrama in this John Ford production.

Careful attention to detail, including "blackwork" embroidery, is found on some of Hepburn's costumes. See Chapter III.

The Sea Hawk (*Warner Bros., 1940*). *Costumes by Orry-Kelly. Starring Errol Flynn (Geoffrey Thorpe), Flora Robson (Queen Elizabeth), and Claude Rains (Don José). Set in England, 1580.*

Court intrigue and high-seas adventure make for rousing entertainment in this Michael Curtiz production set in the days of the Spanish Armada.

The shape of Robson's bodice and skirt bears little resemblance to the dress of the real Elizabeth. Robson's costume appears to have relied heavily on the seamstresses who cut the clothing for Bette Davis's portrayal of Elizabeth in *The Private Lives of Elizabeth and Essex*, released the year before. See Chapter II.

Left: *Tyrone Power in* Captain from Castille

Right: Mary of Scotland

205

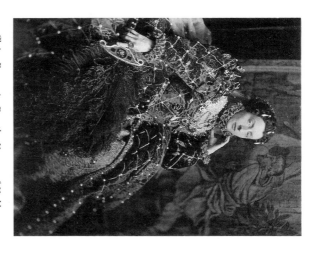

Claire Eames in *Dorothy Vernon of Haddon Hall*

The Virgin Queen (*Twentieth Century-Fox, 1955*). *Costumes by Mary Wills and Charles LeMaire. Starring Bette Davis (Queen Elizabeth), Richard Todd (Sir Walter Raleigh), and Joan Collins (Beth Throckmorton). Set in England, 1595.*

Queen Elizabeth's conflicts with Sir Walter Raleigh provide melodrama in this colorful production, the second time its star, Davis, played the fabled monarch. See Chapters 1 and 11.

Dorothy Vernon of Haddon Hall (*United Artists, 1924*). *Costumes by Mitchell Leisen. Starring Mary Pickford (Dorothy Vernon) and Claire Eames (Queen Elizabeth). Set in England, about 1598.*

Life at court in Queen Elizabeth's time is the setting for this attractive vehicle for "America's Sweetheart," Pickford. See Chapter 1.

The Private Lives of Elizabeth and Essex (*Warner Bros., 1939*). *Costumes by Orry-Kelly. Starring Bette Davis (Queen Elizabeth), Errol Flynn (Robert Devereux), and Olivia de Havilland (Lady Penelope Gray). Set in England, 1599–1601.*

Queen Elizabeth's love/hate for the dashing Lord Essex produces fireworks and melo-drama in this Michael Curtiz production.

The costumes of the monarch were cut over a form-fitting corset, but there are too many curves, and the neck openings do not follow the required horizontal line over the bosom.

Seventeenth Century

The Adventures of Don Juan (*Warner Bros., 1949*). *Costumes by Leah Rhodes and William Travilla. Starring Errol Flynn (Don Juan) and Viveca Lindfors (Queen Margaret). Set in Spain, 1600–20.*

Flynn was the natural choice to play the legendary lover Don Juan.

The men's costumes are historically accurate in both cut and fabrics, featuring diagonal-patterned velvets common in the

period dress. The women's costumes are much less accurate and are closer to modern styles.

The Three Musketeers (*R.K.O., 1935*). *Costumes by Walter Plunkett. Starring Walter Abel (D'Artagnan), Paul Lukas (Athos), Moroni Olson (Porthos), Onslow Stevens (Aramis), Gloria Stuart (Milady de Winter), Lana Turner (Milady de Winter), June Allyson (Constance), and Heather Angel (Constance). Set in France, 1625.*

The Three Musketeers (*M.G.M., 1948*). *Costumes by Walter Plunkett. Starring Gene Kelly (D'Artagnan), Van Heflin (Athos), Gig Young (Porthos), Robert Coote (Aramis), Frank Finlay (Porthos), Richard Chamberlain (Aramis), Faye Dunaway (Milady de Winter), Welch (Constance), and Charlton Heston (Richelieu). Set in France, 1625.*

The Three Musketeers (*Twentieth Century-Fox, 1974*). *Costumes by Yvonne Blake and Ron Talsky (for Raquel Welch). Starring Michael York (D'Artagnan), Oliver Reed (Athos), Frank Finlay (Porthos), Richard Chamberlain (Aramis), Faye Dunaway (Milady de Winter), Welch (Constance), and Vincent Price (Richelieu). Set in France, 1625.*

Alexandre Dumas's story of political skul-duggery, dashing adventure, and breathless romance in seventeenth-century France has had many screen incarnations. All of them have mixed action and suspense with tongue-in-cheek humor.

The 1935 version is noteworthy for Plunkett's introduction of cotton velvetine. It was not historically accurate but made striking costumes, and as a result the material became popular in the fashion industry. In the 1948 version colors and materials were accurate in every way except for Lana Turner's dresses in which her décolletage conformed to modern styles. The costumes in the 1974 version are likewise a triumph of historical accuracy, save for Raquel Welch's upholding the Turner tradition. See Chapter 11.

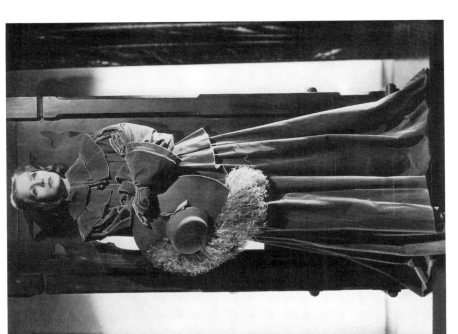

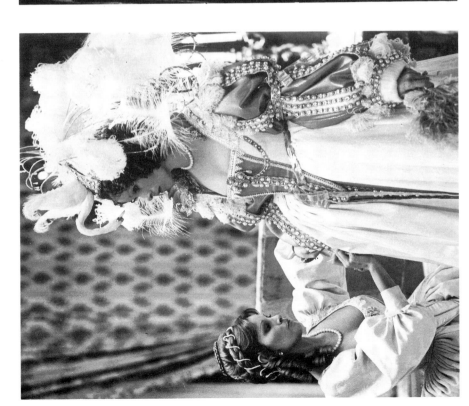

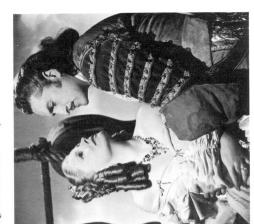

Queen Christina (*M.G.M., 1933*). *Costumes by Adrian. Starring Greta Garbo (Queen Christina) and John Gilbert (Don Antonio). Set in Sweden, 1650–54.*

The solemn beauty of Garbo dominates this Rouben Mamoulian production about an apocryphal romance between the Swedish queen and a handsome Spanish envoy.

Glamorous Garbo as a queen in male attire wears 1934 styles from head to toes—soft marcelled waves in her hair and round-toed satin pumps on her feet. Even her coronation robe has a seam above the waist, exactly like an evening dress of the 1930s. See Chapter III.

Forever Amber (*Twentieth Century-Fox, 1947*). *Costumes by René Hubert and Charles LeMaire. Starring Linda Darnell (Amber), Cornel Wilde (Bruce Carlton), and George Sanders (Charles II). Set in England, 1660.*

This lavish production, based on Kathleen Winsor's novel about seventeenth-century high life, was directed by Otto Preminger. See Chapters I and II.

Frenchman's Creek (*Paramount, 1944*). *Costumes by Raoul Pene du Bois. Starring Joan Fontaine (Dona St. Columb) and Arturo de Cordova (Jean Benoit Aubery). Set in England, 1668.*

A woman of high birth finds herself romantically entangled with a dashing pirate in this fanciful romantic adventure.

Pene du Bois, under the watchful eye of director Mitchell Leisen, created some of the most beautiful and highly authentic costumes ever seen on the screen. Interestingly the wigs on many of the 300 extras are far more authentic than those worn by the stars.

Left: Raquel Welch and Geraldine Chaplin in *The Three Musketeers* (1974)

Right: Greta Garbo in *Queen Christina*

Joan Fontaine and Arturo de Cordova in *Frenchman's Creek*

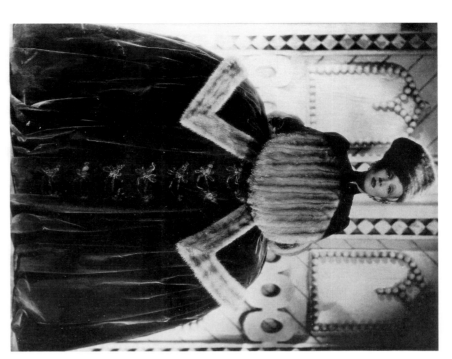

Valentino's "pink powder puff" reputation can be traced to this costume romance, a marked contrast to his more traditionally masculine roles in his earlier melodramas. See Chapters I and II.

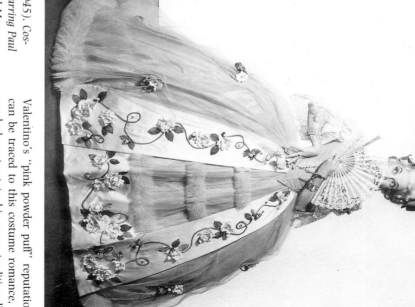

The Spanish Main (R.K.O., 1945). Costumes by Edward Stevenson. Starring Paul Henreid (Laurent van Horn) and Maureen O'Hara (Francesca). Set in Spain, 1680–1700.

In this pirate adventure—as in many others—the chief rogue wins the hand of the fair maiden.

Resembling a fancy-dress ball, the costumes in this epic pale when compared with the work in *Frenchman's Creek* of the previous year. The merry-widow forms of the undergarments worn by O'Hara are perfect for a 1940s pinup photo.

Eighteenth Century

Monsieur Beaucaire (Paramount, 1924). Costumes by Natasha Rambova and George Barbier. Starring Rudolph Valentino (Duke de Charres) and Bebe Daniels (Princess Henriette). Set in France, eighteenth century.

Monsieur Beaucaire (Paramount, 1946). Costumes by Mary Kay Dodson. Starring Bob Hope (Monsieur Beaucaire) and Joan Caulfield (Mimi). Set in France, eighteenth century.

Hope makes no attempt to imitate Valentino's Monsieur Beaucaire, instead creating a period spoof whose mistaken-identity plot bears no resemblance to the earlier silent film.

The film gives only a passing nod to historical prototypes, much like the fancy-dress-ball treatment in *Du Barry Was a Lady*. Bob Hope wears sideburns. See Chapter II.

Tom Jones (*United Artists, 1963*). *Costumes by John McCorry. Starring Albert Finney (Tom Jones) and Susannah York (Sophia Western). Set in England, 1749.*

Henry Fielding's tale was adapted by playwright John Osborne and director Tony Richardson and became one of the key comedy films of the 1960s.

Apart from the hairstyles, with bangs on several of the women, the characters' appearances are generally in keeping with the aesthetic of the eighteenth century. See Chapters I and III.

The Scarlet Empress (*Paramount, 1934*). *Costumes by Travis Banton. Starring Marlene Dietrich (Catherine II), John Lodge (Count Alexei), and Sam Jaffe (Grand Duke Peter). Set in Russia, about 1755–62.*

"A relentless excursion into style," was the way director Josef von Sternberg described his biographical study of Catherine the Great of Russia.

Travis Banton was at his most extravagant in designing the film's costumes for Dietrich, using rows of lace ruffles and an abundance of curled ostrich feathers and mink. She has plucked eyebrows and 1934 hairstyles throughout the film. Period silhouettes were only used when they added to the dramatic effect.

The Glass Slipper (*M.G.M. 1955*). *Costumes by Helen Rose and Walter Plunkett. Starring Leslie Caron (Cinderella) and Michael Wilding (Prince Charming). Set about 1760, location not specified.*

Although this musical adaptation of the fairy tale *Cinderella* is allegedly set in the 1760s, the gowns, made from yards of nylon tulle and tiny velvet flowers with rhinestone centers, bear little resemblance to the styles of the eighteenth century and instead evoke a fairy-tale atmosphere. Caron's hair is a mid-1950s pixie cut.

Barry Lyndon (*Warner Bros., 1976*). *Costumes by Ulla-Britt Sonderland and Milena Canonero. Starring Ryan O'Neal (Redmond Barry) and Marisa Berenson (Lady Lyndon). Set in England, France, and Germany, 1765–70.*

Stanley Kubrick turned William Makepeace Thackeray's satirical novel about a social-climbing young man into a chilly, baroque, visually stunning tour of eighteenth-century European high life.

The makeup appears historically correct in the gambling scenes where the performers wear mouches and white powder. Elsewhere in the film the women's eye makeup is very much in the style of the mid-1970s. The softness of their hairstyles, also a mid-1970s look, is unlike the stiff and formal coiffures worn in the eighteenth century. In a scene set at a music recital Berenson wears a dress that is laced up the back—a method that was not used in European dress of the period.

Du Barry Was a Lady (*M.G.M. 1943*). *Costumes by Irene, Howard Shoup, and Gile Steele. Starring Red Skelton (Louis Blore/King Louis), Lucille Ball (May Daly/Madame du Barry), and Gene Kelly (Alec Howe/Black Arrow). Set in France, 1769, and contemporary U.S.A.*

Cole Porter's satirical musical, juxtaposing modern times with life in the days of the French court, is somewhat diluted in this film

Marisa Berenson in *Barry Lyndon*

209

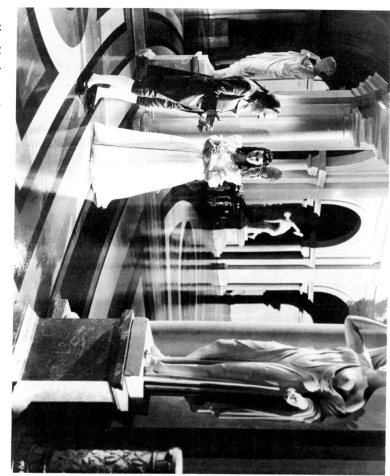

Alan Mowbray and Vivien Leigh in That Hamilton Woman

version. Visually, however, the impact of the period scenes comes across loud and clear.

The fantastic gowns worn by Ball in the eighteenth-century sequences are accompanied by hats that could only have come from Hollywood. Tricorns with dozens of ostrich feathers look almost like a cross between the styles for a Ziegfeld girl and a circus performer. The costume designers were clearly influenced by the wardrobe for Marie Antoinette, released five years earlier.

The Howards of Virginia (Columbia, 1940). Costumes by Irene Saltern. Starring Cary Grant (Matt Howard) and Martha Scott (Jane Peyton Howard). Set in U.S.A., about 1770.

The life of an American family set against the backdrop of the Revolutionary War is the focus of this drama.

Despite much research to determine the exact fabrics used and the shapes of clothing in the 1770s, Saltern's attempt at historical accuracy was lessened by the unauthentic undergarments on the women. Men's and women's hairstyles and makeup in the film conform strictly to the fashions of 1940.

Marie Antoinette (M.G.M., 1938). Costumes by Adrian. Starring Norma Shearer (Marie Antoinette) and Tyrone Power (Count de Fersen). Set in Versailles and Paris, 1770–92.

America was in the grip of the Depression, which, as far as M.G.M. executives were concerned, was all the more reason to offer a sympathetic treatment of the monarch who reportedly said of the starving masses, "Let them eat cake." See Chapters I and II.

Drums along the Mohawk (Twentieth Century-Fox, 1939). Costumes by Gwen Wakeling. Starring Claudette Colbert (Lana Martin) and Henry Fonda (Gil Martin). Set in New York State, 1776.

John Ford's drama deals with the lives of early New York State settlers battling the elements, native Americans, and each other. Although the makeup and hairstyles are modern, the costumes are good period recreations with Colbert well corseted as was common in the period depicted.

1776 (Columbia, 1972). Costumes by Patricia Zipprodt. Starring William Daniels (John Adams), Howard da Silva (Benjamin Franklin), Ken Howard (Thomas Jefferson), and Blythe Danner (Martha Jefferson). Set in Philadelphia, 1776.

The Pulitzer Prize-winning Broadway musical about the signing of the Declaration of Independence was adapted for the screen with most of the original cast members.

Danner's flowing and flimsy gown is suggestive of the wedding dress for a flower child of the late 1960s. The men's costumes, by contrast, are for the most part scrupulously authentic. One exception is the crushed-velvet costume for Franklin; crushed velvet was not worn in the eighteenth century.

Kitty (Paramount, 1944). Costumes by Raoul Pene du Bois. Starring Paulette Goddard (Kitty) and Ray Milland (Sir Hugh Marcy). Set in London, 1780.

A woman of low birth but high spirits rises to the top of the social heap in this light-hearted Mitchell Leisen production.

Nylon broderie anglaise trims the neck and sleeves of Goddard's gown. At several points

Lillian and Dorothy Gish in *Orphans of the Storm*

French Revolution/Directoire

A Tale of Two Cities (M.G.M., 1935). Costumes by Dolly Tree and Valles. Starring Ronald Colman (Sidney Carton) and Elizabeth Allan (Lucie Manette). Set in France, 1789–99.

Charles Dickens's celebrated novel of the French Revolution is brought to the screen in this tasteful M.G.M. adaptation.

The heroine wears a hat with a ribbon bow tied under her left ear—not an eighteenth-century fashion device. Several of the costumes use ruched velvet, a high-fashion treatment of the mid-1930s. The pants have piped seams, a style that was not used extensively until the second quarter of the century.

Désirée (Twentieth Century-Fox, 1954). Costumes by René Hubert and Charles LeMaire. Starring Marlon Brando (Napoleon) and Jean Simmons (Désirée). Set in France, 1794.

A seamstress's love for the Emperor Napoleon is the dramatic thread that holds this costume movie together. See Chapter I.

Orphans of the Storm (D. W. Griffith Productions/United Artists, 1922). Costumes by Hermann Tappe. Starring Lillian Gish

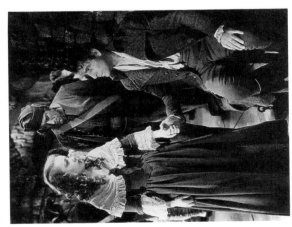

Isabel Jewell and Ronald Colman in *A Tale of Two Cities*

she wears a lace mantilla that makes her look like a Spanish señorita. The men's clothes are beautifully cut, but the shoulders are far too wide to be correct for the period. See Chapter I.

That Hamilton Woman (Alexander Korda Productions, 1941). Costumes by René Hubert. Starring Laurence Olivier (Lord Nelson) and Vivien Leigh (Emma Hamilton). Set in England, 1786–98.

An elaborate "four hankie" love story, this Alexander Korda production was reportedly Sir Winston Churchill's all-time favorite movie.

Long-sleeved boleros, straw hats, and 1940s pompadour hairstyles are featured in the film and clearly reflect modern styles. Leigh's costumes could have come from the pages of a contemporary *Vogue*. See Chapter III.

Mutiny on the Bounty (M.G.M., 1935). Costumes by Walter Plunkett. Starring Clark Gable (Fletcher Christian) and Charles Laughton (Capt. Bligh). Set in Tahiti and England, 1789–91.

Mutiny on the Bounty (M.G.M., 1962). Costumes by Moss Mabry. Starring Marlon Brando (Fletcher Christian) and Trevor Howard (Capt. Bligh). Set in Tahiti and England, 1789–91.

To date there have been three versions of Charles Bernard Nordhoff and James Norman Hall's recounting of the famous British mutiny at sea and its aftermath. (The last version, released in 1984, was called *The Bounty*.) From the dramatic standpoint M.G.M. got it right the first time.

In the first version the breeches and fine linen shirts are cut correctly for the late eighteenth century and are indicative of the careful research that went into the costume design for the entire wardrobe. The shoulders for the men's jackets, however, are too wide for the period and reflect the aesthetic of the mid 1930s. Gable's sideburns seem out of style for the period. See Chapter I.

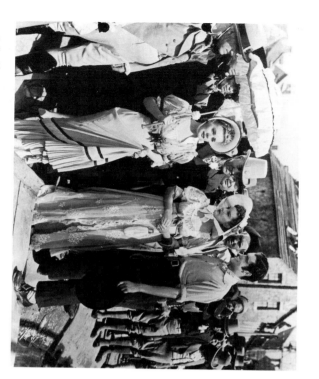

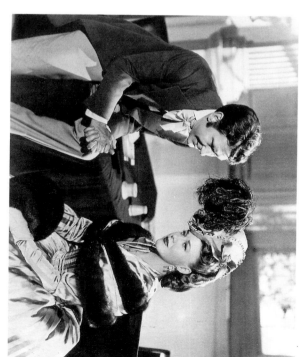

Left: Alice Faye and Richard Todd in *Little Old New York*

Right: Burgess Meredith and Ginger Rogers in *The Magnificent Doll*

(Henriette) and Dorothy Gish *(Louise)*. Set in France about 1799–1800.

Griffith's memorable pairing of the Gish sisters as two innocents tossed about by the "storm" of the French Revolution is one of the greatest melodramas of the silent era. See Chapter I.

1800–1809

The Firefly *(M.G.M., 1937)*. Costumes by Adrian. Starring Jeanette MacDonald *(Nina Azara)* and Allan Jones *(Don Diego/Capt. de Coucort)*. Set in Spain, 1800.

The "Donkey Serenade" is the musical highlight of this popular film operetta.

Having designed *Conquest* earlier that year, Adrian was short of original ideas. His wardrobe for MacDonald, with its soft, draped, silk velvets, and her 1930s marcelled hairstyle fit easily into the fashion picture of the day.

Quality Street *(R.K.O., 1927)*. Costumes by René Hubert. Starring Marion Davies *(Phoebe Throssel)* and Conrad Nagel *(Dr. Valentine Brown)*. Set in England, 1805–15.

Quality Street *(R.K.O., 1937)*. Costumes by Walter Plunkett. Starring Katharine Hepburn *(Phoebe Throssel)* and Franchot Tone *(Dr. Valentine Brown)*. Set in England, 1805–15.

J. M. Barrie's play about a spinster who masquerades as her own niece to win a man's affection has two screen adaptations. Neither of them sent ticket sales soaring. The 1937 version, in fact, went a long way toward establishing Hepburn's reputation in the 1930s as "box-office poison."

In the 1927 version the women wear bandeaux over their foreheads as was common in the 1920s. In the 1937 version Hepburn sports the 1930s fashion rage: printed fabrics with pleated ruffles of silk organza.

Pride and Prejudice *(M.G.M., 1940)*. Costumes by Adrian. Starring Greer Garson *(Elizabeth Bennet)* and Laurence Olivier *(Mr. Darcy)*. Set in England, c. 1807.

Aldous Huxley was the chief scriptwriter for this adaptation of Jane Austen's satire of social climbing and romance. See Chapters I and II.

Conquest *(M.G.M., 1937)*. Costumes by Adrian. Starring Greta Garbo *(Maria Waleska)* and Charles Boyer *(Napoleon)*. Set in Poland and France, 1807.

The romance of Napoleon and Maria Waleska is the centerpiece of this elaborate historical drama, whose main draw is its high-powered stars.

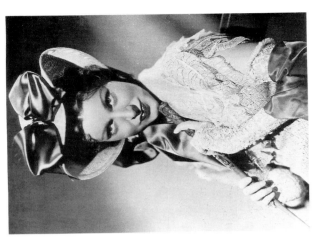

Frances Dee in *Becky Sharp*

Adrian's love of stripes is seen in a bolero that could only have been made and worn in the 1930s. The styles of early nineteenth-century Europe were too severe for Adrian's taste. In the film's costumes his idea of a "full-blown bosom," the style in 1807, was a piece of gathered silk chiffon over the chest to give the illusion of fullness.

Little Old New York *(Twentieth Century-Fox, 1940). Costumes by Royer. Starring Alice Faye (Pat O'Day) and Fred MacMurray (Charles Browne). Set in New York City, 1807.*

This musical about Robert Fulton's invention of the lightweight movies Twentieth Century-Fox concocted as vehicles for Faye, one of the studio's leading stars.

Faye wears a variety of dresses that vaguely relate to the period portrayed but strongly reflect the fashions of the late 1930s. Her hairstyles do not even remotely resemble those worn in 1807.

The Magnificent Doll *(Universal, 1946). Costumes by Travis Banton and Vera West. Starring Ginger Rogers (Dolley Madison) and David Niven (Aaron Burr). Set in Philadelphia, 1809–17.*

Fabled Washington society hostess Dolley Madison is the "doll" in this historical romance directed by Frank Borzage.

Rogers's costumes are stylish and elegant. The waistlines are much lower than they would have been in the days of the War of 1812. Her hairstyles in the film are perfect for evening wear in 1946.

Becky Sharp *(Paramount, 1935). Costumes by Howard Greer and Robert Edmond Jones. Starring Miriam Hopkins (Becky Sharp). Cedric Hardwicke (Marquis of Steyne), and Frances Dee (Amelia Sedly). Set in England, about 1810.*

The first feature film in Technicolor, Rouben Mamoulian's attractive adaptation of William Makepeace Thackeray's *Vanity Fair* is highlighted by Hopkins's spirited performance.

The date of this production is easily identified by the costumes and makeup: large amounts of organdy and lamé, sequined polka-dots with black lace gloves, all over prints on silk crêpe de chine, modified cloche hats, and plucked eyebrows are seen throughout the film.

On a Clear Day You Can See Forever *(Paramount, 1970). Costumes by Cecil Beaton (period) and Arnold Scaasi. Starring Barbra Streisand (Daisy Gamble/Melinda Tentrees) and Yves Montand (Dr. Marc Chabot). Set in England, 1811–22, and contemporary New York City.*

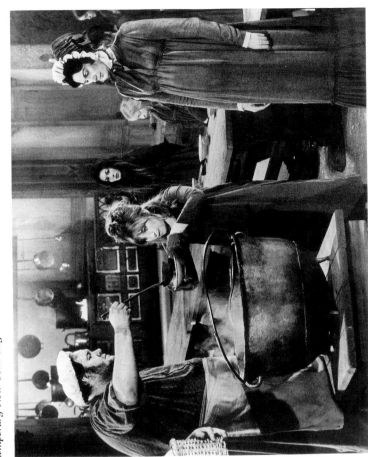

Barbra Streisand in *On a Clear Day You Can See Forever*

1810–19

The President's Lady *(Twentieth Century-Fox, 1953). Costumes by Renie Conley. Starring Charlton Heston (Andrew Jackson) and Susan Hayward (Rachel Donelson Robards). Set in U.S.A., 1790–1826.*

Andrew Jackson's controversial love affair with Rachel Donelson Robards, whom he eventually married, is the subject of this biographical drama. See Chapter I.

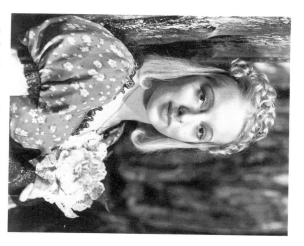

Evelyn Keyes in *The Buccaneer* (1938)

Alan Jay Lerner and Burton Lane's Broadway musical about a shy New Yorker who discovers she had a previous incarnation as a brassy nineteenth-century adventuress is brought to the screen attractively but unevenly by director Vincente Minnelli and his powerhouse star, Streisand.

Beehive hairdos in 1815? One can see them in this portrayal of the early nineteenth century. The mass of hair and its arrangement are clear giveaways that this film was produced at the end of the 1960s.

Anthony Adverse (*Warner Bros., 1936*). *Costumes by Milo Anderson. Starring Fredric March (Anthony Adverse) and Olivia de Havilland (Angela). Set in France, Africa, New Orleans, and Cuba, about 1812.*

Mervyn LeRoy directed this adaptation of Hervey Allen's best-selling epic about the adventures of a nineteenth-century "man of the world."

The results of attempting to re-create period costume are pretty but miss the mark. Anderson's effort to achieve a historical look has many decorative touches, but modern materials are used in modern ways in much of the film's clothing.

The Buccaneer (*Paramount, 1938*). *Costumes by Natalie Visart and Dwight Franklin. Starring Fredric March (Jean Lafitte), Franceska Gaal (Gretchen). Set in U.S.A. 1812.*

The Buccaneer (*Paramount, 1958*). *Costumes by Edith Head, Ralph Jester, and John Jensen. Starring Yul Brynner (Jean Lafitte) and Charlton Heston (Andrew Jackson). Set in U.S.A. 1812.*

This historical adventure yarn is De Mille's version of the War of 1812. He produced but did not direct the 1958 remake.

Women's costumes of this historical period were high-waisted and the bosom was prominently featured. In the 1938 film version the waists are not high enough, and the bosom appears much diminished. In the 1958 version the cut of the costumes is more accurate, but, as was common in the 1950s, seams follow the shape of the bosom. In both versions the performers wear bonnets that fully reveal their faces. The 1812 bonnets would have hidden them.

1820–39

Beau Brummell (*M.G.M., 1954*). *Costumes by Elizabeth Haffenden and Walter Plunkett. Starring Elizabeth Taylor (Lady Patricia) and Stewart Granger (Beau Brummell). Set in England, 1800–40.*

The famous fashion plate and ladies' man, Beau Brummell, is the subject of this costume romance.

In the early nineteenth century men's coats were very narrow in the shoulder. In this film they are broad and padded.

Hawaii (*United Artists, 1966*). *Costumes by Dorothy Jeakins. Starring Julie Andrews (Jerusha), Max Von Sydow (Abner Hale), and Richard Harris (Capt. Foxworth). Set in Hawaii, 1829–41.*

George Roy Hill directed this adaptation of James Michener's bestseller about a well-meaning but misguided missionary, his wife, and their adventures in the Hawaiian Islands.

Andrews is pretty and ladylike in her adaptations of period costume, but the placement of the bosom is not controlled with a corset as would have been the case in the

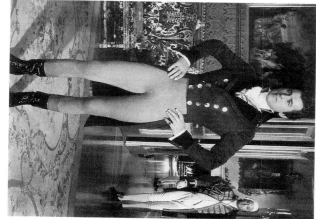

Stewart Granger in *Beau Brummell*

early nineteenth century. Instead the placement and the seams are modern. In the designer's original sketches the period dress is portrayed with great accuracy, but this precision was somewhat lost in the realization of the costumes.

The Pirate (*M.G.M. 1948*). *Costumes by Irene, Tom Keogh, Karinska. Starring Judy Garland (Manuela) and Gene Kelly (Serafin). Set in the West Indies, 1830.*

Cole Porter wrote the score for this most offbeat of M.G.M. musicals. Based on an S. N. Behrman play, it tells of an actor who pretends to be a dashing pirate in order to woo a romance-obsessed maiden.

Even the most meticulous research could not disclose exact information on dress in the West Indies in the 1830s. Consequently the designers opted for a fantasy approach, roughly based on 1830s European fashions. In that regard the cut of the clothing is correct.

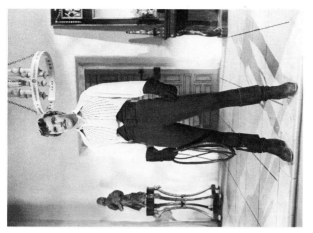

Gene Kelly in *The Pirate*

Plunkett's costumes for this drama. See Chapter II.

The Kissing Bandit (*M.G.M. 1947*). *Costumes by Walter Plunkett. Starring Frank Sinatra (Ricardo) and Kathryn Grayson (Theresa). Set in California, 1840.*

Frank Sinatra would rather forget this rather silly period musical romance. We remember it, however, for Plunkett's marvelous costumes.

Inventive and pretty, the costumes involved careful research and give a flavor of how early Californians may have dressed. The men's costumes were based on surviving examples in the collection of the Los Angeles County Museum of History, Science, and Art.

The Barretts of Wimpole Street (*M.G.M. 1934*). *Costumes by Adrian. Starring Fredric March (Robert Browning), Norma Shearer (Elizabeth Barrett), and Charles Laughton (Edward Moulton-Barrett). Set in London, 1845–46.*

Lovers and poets, husband and wife, the Brownings captured the popular imagi-

1840–49

The Strange Woman (*United Artists, 1946*). *Costumes by Natalie Visart and Elois Jenssen. Starring Hedy Lamarr (Jenny Hager) and George Sanders (John Evered). Set in Bangor, Maine, 1840.*

Edgar G. Ulmer directed this brooding drama about a femme fatale.

The costumes have many period details, including berthas, but generally the clothing in the film creates a 1946 silhouette of the body. The filmmakers attempted seriously to re-create period hairstyles, but these too reflect post-World War II styles.

Green Dolphin Street (*M.G.M. 1947*). *Costumes by Walter Plunkett. Starring Lana Turner (Marianne Patourel) and Van Heflin (Timothy Halsam). Set in New Zealand, 1840.*

Two sisters set their sights on the same man in this lavish costume drama whose title theme has become a standard among jazz musicians.

The gigot (or leg-of-mutton) sleeves popular in the 1830s were carefully re-created in

Cyd Charisse, Ricardo Montalban, and Ann Miller in *The Kissing Bandit*

Left: Bette Davis and George Brent in *The Old Maid*

Right: Robert Taylor in *Camille*

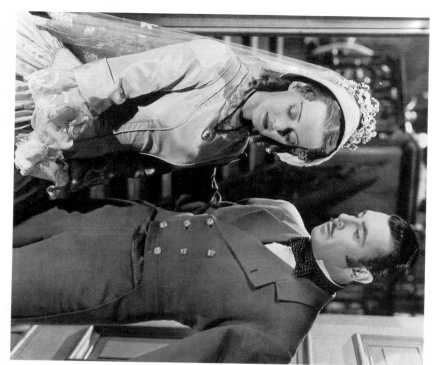

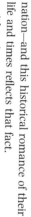

nation—and this historical romance of their life and times reflects that fact.

Adrian's use of contemporary materials such as crêpe-backed satin belie the period in which the film is set. Materials used in the 1840s were lighter and stiffer than the highly draped, almost slinky fabrics popular in the mid-1930s. See Chapter II.

The Old Maid (*Warner Bros., 1939*). *Costumes by Orry-Kelly. Starring Bette Davis (Charlotte Lovell), Miriam Hopkins (Delia Lovell), and George Brent (Lt. Clem Spenser). Set in New York City, 1835–1900.*

Davis and Hopkins create dramatic fireworks in every scene, under Edmund Goulding's direction, in this film of Zoe Atkins's play about an unwed mother who gives up her daughter to her scheming cousin.

This was, perhaps, one of Orry-Kelly's most successful costuming efforts for a period picture. He was able, for the most part, to avoid heavy use of frills and feathers, a common trait in the wardrobes he designed

for other historical films. The results are convincingly nineteenth-century, though some of the dresses are made with a bias cut.

Camille (*M.G.M. 1937*). *Costumes by Adrian. Starring Greta Garbo (Marguerite Gautier) and Robert Taylor (Armand Duvall). Set in Paris, 1847.*

"Oh, I'm just a girl like all the rest," says Garbo as Alexandre Dumas's great, tragic courtesan. But there never was a woman quite like Marguerite, and there never was a Marguerite quite like Garbo's. George Cukor directed this classic love story with flair, imagination, and great taste.

The wardrobe is another Adrian extravaganza. The men's clothes are particularly interesting. One costume worn by Robert Taylor combines a watered silk, striped waistcoat, houndstooth-plaid trousers, a soft-wool check coat, and a most extraordinary abstract-printed silk cravat, gathered almost like a smocked pillow. See Chapter I.

Wuthering Heights (*Samuel Goldwyn Productions, 1939*). *Costumes by Omar Kiam. Starring Laurence Olivier (Heathcliff) and Merle Oberon (Cathy). Set in Yorkshire, 1847.*

William Wyler directed this popular adaptation of Emily Brontë's novel of the Yorkshire moors and the two lovers so in thrall to one another that their romance seems to transcend death itself.

Exotic materials like silver tissue and embroidered net are used for Oberon's costumes in the high-society scenes. The fashionable "long waist" of the 1840s is not seen in any of the costumes.

A Song to Remember (*Columbia, 1945*). *Costumes by Walter Plunkett and Travis Banton (for Merle Oberon). Starring Cornel Wilde (Frédéric Chopin) and Merle Oberon (George Sand). Set in Poland and France, 1848.*

Chopin's love affair with George Sand is the subject of this enormously popular musical biography. (Taking his cue from the candelabra featured on Chopin's piano in this film, Liberace adopted a gimmick that made his career.)

Oberon wears velvet jackets with shoulder pads and a 1940s hairdo. The restricted, long-waisted shape of 1840s female dress is hard to find in the film's clothing except for the dresses of a few extras.

David Copperfield (*M.G.M., 1935*). *Costumes by Dolly Tree. Starring Freddie Bartholomew (David Copperfield), W. C. Fields (Mr. Micawber), and Maureen O'Sullivan (Dora). Set in England, 1850.*

Fields in the part he was born to play—Charles Dickens's Mr. Micawber—is one of the many bright lights in this entertaining rendition of the classic story about a young orphan's life. George Cukor directed.

Ball fringes, "Peter Pan" collars, and 1930s hats abound in this film's wardrobe. The cut of the women's armholes is inconsistent: sometimes they are cut well below the shoulder as would be appropriate for 1850, and at other times they are in the natural position for 1935. The designer, Tree, made attractive use of mixed plaids and stripes in the men's attire.

Jezebel (*Warner Bros., 1938*). *Costumes by Orry-Kelly. Starring Bette Davis (Julie Marston) and Henry Fonda (Preston Dillard). Set in New Orleans, 1850.*

When Davis lost out to Leigh for the role of Scarlett O'Hara in *Gone with the Wind.*

1850–69

How the West Was Won (*M.G.M., 1963*). *Costumes by Walter Plunkett. Starring Henry Fonda (Jethro Stuart), Carroll Baker (Eve Prescott), James Stewart (Linus Rawlings), Debbie Reynolds (Lilith Prescott), and John Wayne (Gen. Sherman). Set in U.S.A., 1839–89.*

John Ford, Henry Hathaway, and George Marshall directed segments of this Cinerama epic about the settling of the American West. Because the film takes place over a fifty-year period, it is difficult to generalize about the costumes. In one scene Reynolds wears a gown that is supposed to suggest an 1840s look but has a 1960s "boat neck."

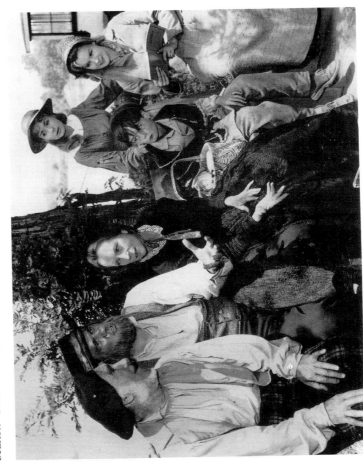

Karl Malden (second from left), Agnes Moorehead, Debbie Reynolds, and Caroll Baker in *How the West Was Won*

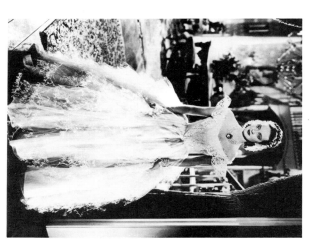

Bette Davis in Jezebel

Loretta Young in Suez

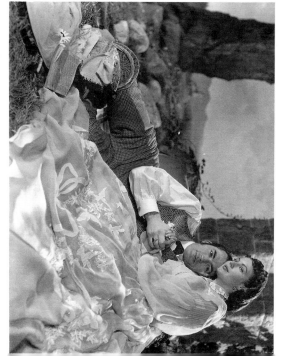

Gregory Peck and Ava Gardner in The Great Sinner

Warner Bros. concocted this Southern-fried extravaganza for its star. Davis won her second Oscar, under William Wyler's direction, for her portrayal of a spoiled Southern belle who wears a red dress to a ball, defying a society that insisted that proper young ladies wear white. Seeing the error of her ways, she adopts correct attire for the grand finale. Rarely has drama so effectively teetered on the edge of fashion.

Davis's two featured dresses are gorgeous but are strictly 1938 in design. The other women's costumes do feature pinched-in waists and boned bodices, but there are no corsets; the hoops are not as full as might be expected; and there are not enough petticoats (this results in the hoops being seen through the dresses). Plucked eyebrows, a 1930s device, can be seen in the makeup for several characters.

Madame Bovary (*M.G.M., 1949*). *Costumes by Walter Plunkett and Valles (for the men). Starring Jennifer Jones (Emma Bovary), Van Heflin (Charles Bovary), and Louis Jourdan (Rodolphe Boulanger). Set in France, about 1850.*

Vincente Minnelli directed this lavish and surprisingly thoughtful adaptation of Gustave Flaubert's masterful study of a provincial woman who lets her romantic fantasies get the better of her.

The film includes some of the most beautiful costumes ever designed by Plunkett. Jones seems a little overdressed in the second scene in which she appears in an all-white confection straight out of a period fashion plate. The most noticeable late-1940s influence is the way that Jones's breasts are separated.

Mississippi Gambler (*Universal, 1953*). *Costumes by Bill Thomas. Starring Tyrone Power (Mark Fallon) and Piper Laurie (Angelique Durox). Set in New Orleans, 1850.*

Rudolph Maté directed this story of a gambler trying to reach the top of his profession. The film's bumper bangs, its 1950s treatment of the bosom, and its makeup with thick eyebrows would not have been seen in 1850 in New Orleans and clearly show the contemporary influence.

The Charge of the Light Brigade (*Warner Bros., 1936*). *Costumes by Milo Anderson. Starring Errol Flynn (Capt. Geoffrey Vickers), Olivia de Havilland (Elsa Campbell). Set in Crimea, 1853–56.*

Michael Curtiz directed this action-oriented historical drama, inspired by Alfred. Lord Tennyson's poem about the calamitous, climactic battle in the Crimean War. Tony Richardson directed a more satirical view of the same story in 1968.

Some of the costumes feature distinctly 1930s materials: hammered silk crêpe and

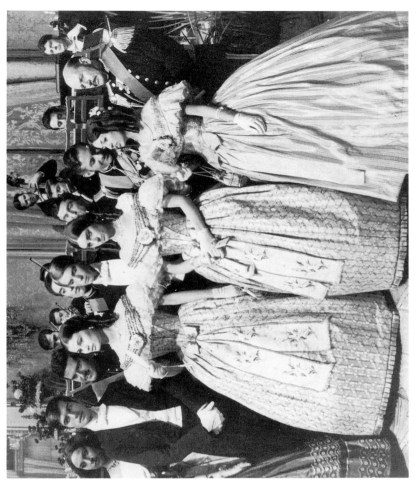

The Leopard

finely crocheted lace doilies are used for sleeve and neck ruffles. Marcelled waves and sausage curls are seen in many of the hairdos.

Suez (*Twentieth Century-Fox, 1938*). *Costumes by Royer. Starring Tyrone Power (Ferdinand de Lesseps), Loretta Young (Countess Eugenie), and Annabella (Toni Pellerin). Set in Europe and the Middle East, 1856–69.*

The construction of the Suez Canal is the backdrop for a costume romance in the grand Hollywood style. Allan Dwan directed.

Overblown, extravagant, and stunning, the costumes capture the period style but also packed a special appeal for audiences who were in the throes of the Depression. Royer used excessive trims with much pleating and thin fabrics. Neither of these devices was in keeping with the period, but they were decorative.

Secrets (*United Artists, 1933*). *Costumes by Adrian. Starring Mary Pickford (Mary Marlow) and Leslie Howard (John Carlton). Set in New England, 1860.*

This film placed Pickford in an uncharacteristic role: she played an adult. This romantic melodrama was her last feature.

Adrian's overblown crinolines with exaggerated trim—yards of pleated silk flounce—had less to do with 1860s dress than with how the contemporary public wished to remember the period.

Bitter Sweet (*M.G.M., 1940*). *Costumes by Adrian. Starring Jeanette MacDonald (Sarah Millick) and Nelson Eddy (Carl Linden). Set in Vienna, 1860.*

Noël Coward's operetta about a singer torn between her career and the man she loves is the basis of this charming MacDonald-Eddy vehicle.

The film's velvet dresses are pleated at the sleeves rather than gathered as was the fashion in the 1860s.

The Men in Her Life (*Columbia, 1941*). *Costumes by Bridgehouse and Charles LeMaire. Starring Loretta Young (Lina Varasavina) and Conrad Veidt (Stanilas Rosing). Set in England and France, 1860.*

Young plays a ballerina. Gregory Ratoff directed this deluxe "women's picture" (see Chapter III).

The costumes create a picture of elegance in contemporary terms, with the 1940s shoulder style and huge "garden party" hats. The fullness of the hair over the temples is a 1940s exaggeration of the style worn in the 1860s.

The Great Sinner (*M.G.M., 1949*). *Costumes by Irene (for the women) and Valles (for the men). Starring Gregory Peck (Fedja) and Ava Gardner (Pauline Ostrovsky). Set in Wiesbaden, Germany, 1860.*

Dostoevsky's great short novel *The Gambler* is the basis for this typical M.G.M. costume drama.

The dresses are made from popular 1940s fabrics, soft and flowing, not resembling the stiff silks and bombazines used for women's formal attire in Germany in 1860.

The Leopard (*Titanus Productions/Twentieth Century-Fox, 1963*). *Costumes by Piero Tosi.*

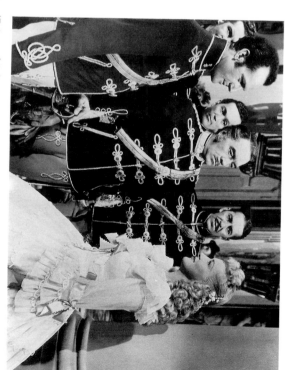

Left: Elizabeth Taylor and Montgomery Clift in *Raintree County*

Right: Betty Grable in *That Lady in Ermine*

Gone with the Wind (*M.G.M./Selznick, 1939*). *Costumes by Walter Plunkett. Starring Vivien Leigh (Scarlett O'Hara) and Clark Gable (Rhett Butler). Set in Georgia, 1860–67.*

Plainly and simply the greatest show ever to come out of Hollywood. This adaptation of Margaret Mitchell's saga of the rise of an antebellum belle dazzled audiences when it made its debut and has been enthralling viewers the world over ever since. See Chapters I, II and III.

Raintree County (*M.G.M., 1958*). *Costumes by Walter Plunkett. Starring Elizabeth Taylor (Susanna Drake) and Montgomery Clift (John Wickliff Shawnessy). Set in Georgia, 1860–67.*

M.G.M. thought it had another *Gone with the Wind* in this Civil War epic, but it failed to stir audiences in the manner of its predecessor. Clearly, a sense of dramatic momentum was lost when Montgomery Clift had a serious automobile accident halfway through the film's shooting.

Walter Plunkett designed costumes that could have appeared in the pages of *Godey's Ladies Book*, a nineteenth-century fashion publication. He used materials masterfully, but as usual the cut of the bodices was modern and similar to that used in *Gone with the Wind*.

Starring Burt Lancaster (Prince of Salina), Alain Delon (Tancredi), and Claudia Cardinale (Angelica). Set in Sicily, 1860–62.

Luchino Visconti masterfully adapted for film Giuseppe di Lampedusa's novel of a Sicilian prince and his family at the time of Italian unification.

This film is arguably the greatest costume drama ever made. Under Visconti's scrupulous direction, every thread—dramatic, visual, and textual—is held in place. Even the corsets are correct in this masterpiece of period re-creation. Only Cardinale's hairstyles and makeup give any indication of modern influence.

The Birth of a Nation (*D. W. Griffith Productions, 1915*). *Costumes by Claire West. Starring Lillian Gish (Elsie Stoneman), Mae Marsh (Flora Cameron), and Henry B. Walthall (Ben Cameron). Set in Piedmont, South Carolina; Washington, D.C.; and Gettysburg, Pennsylvania, 1860–67.*

One of the most elaborate and controversial epics of the silent era, Griffith's adaptation of Thomas W. Dixon's *The Klansman* thrilled viewers with its Civil War drama while reviving the then-fading fortunes of the Ku Klux Klan. Cross burning was not a Klan practice until the appearance of this film in which it was featured.

In the women's costumes high-neck ruffs with hats worn tilted over the right eye are twentieth-century devices. See Chapter I.

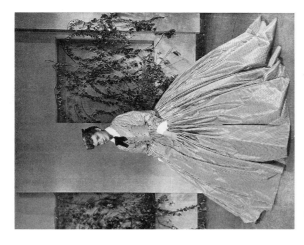

Deborah Kerr in *The King and I*

That Lady in Ermine *(Twentieth Century-Fox, 1948). Costumes by René Hubert. Starring Betty Grable (Francesca/Angelica), Douglas Fairbanks, Jr. (Col. Ladisla Karolyi Teglash/the duke), and Cesar Romero (Mario). Set in Bergamo, Italy, 1861.*

Ernst Lubitsch's last film was this light-hearted operetta spoof, much in the mold of his 1930s musical comedies. When the great director died six days before the end of shooting, Otto Preminger stepped in and completed the picture.

According to a Twentieth Century-Fox press release: "Aside from the two ermine coats she [Grable] wears in the picture, the seven cloud-colored, all-transparent costumes designed for Betty by studio stylist René Hubert each took enough yardage to cover 67 women in one of the 'new look' full-skirted, long hemmed dresses of today, which average five or six yards a piece compared to the 318 yards a piece average of the star's dresses for *That Lady in Ermine*."

Anna and the King of Siam *(Twentieth Century-Fox, 1946). Costumes by Bonnie Cashin. Starring Irene Dunne (Anna Owens) and Rex Harrison (the king). Set in Siam, 1862.*

The King and I *(Twentieth Century-Fox, 1956). Costumes by Irene Sharaff. Starring Deborah Kerr (Anna Owens) and Yul Brynner (the king). Set in Siam, 1862.*

The adventures of an English governess in the court of Siam was first a novel, then a movie, then a Broadway musical, and then a film version of that same musical.

The hoop skirts seen in the 1946 version lack the fullness and dome- or bell-shaped look that was desirable in 1862. In the film's costumes the supporting horizontal crinoline wires do not start at the hips and continue to the floor. Instead they begin at knee level, which results in the fabric of the skirt falling from the waist to the knees, where the hoops can be clearly seen through the dress.

In the second version Kerr's costumes, including dome-shaped hoop skirts, are much more authentic. Her collars, however, are higher-placed and more overblown than the period style. The sleeves do not have the accurate historical shape (a fullness at the elbow) that came from the two-piece construction used in women's dress in the 1860s. The bangs in her hairstyle were fashionable in the 1950s.

Maytime *(M.G.M., 1937). Costumes by Adrian. Starring Jeanette MacDonald (Marcia Mornay), and Nelson Eddy (Paul Allison). Set in Paris, about 1860–70.*

America's singing sweethearts, MacDonald and Eddy, appear in one of their most popular pairings, the story of a penniless singer's love for a famous opera star.

In true Adrian style the dresses have wide chinchilla-fur trims. Such fur was not used in the 1860s but was fashionable in 1937.

The Great Northfield Minnesota Raid *(Universal, 1972). Costumes by Helen Colvig. Starring Robert Duvall (Jesse James) and Cliff Robertson (Cole Younger). Set in Northfield, Minnesota, 1864–82.*

The rise and fall of the bandit Jesse James, whose life became something of a popular legend, has been brought to the screen many times. Other versions of the story include *Jesse James* (1939), directed by Henry King; *The Return of Frank James* (1940), directed by Fritz Lang; *I Shot Jesse James* (1949), directed by Samuel Fuller; *The True Story of Jesse James* (1955), directed by Nicholas Ray; and *The Long Riders* (1980), directed by Walter Hill.

The whores in the "whore-lugging" contest wear their hair parted in the middle, and some of them even wear it layered; such hairstyles did not exist in the late nineteenth century, although they were popular when the film was made. Their eye makeup is strictly early 1970s as is their "no bra" look.

Juarez *(Warner Bros., 1939). Costumes by Orry-Kelly. Starring Paul Muni (Benito Juarez) and Bette Davis (Carlotta). Set in Austria, France, Italy, and Mexico, 1865–67.*

This elaborate biography of the Mexican leader Juarez was directed by William Dieterle.

When designing the costumes for *Juarez*, Orry-Kelly restrained himself from using the lavish decorative effects that he often included in the wardrobes of other period pictures. As wife of the emperor, Davis would have been abreast of all the latest Paris

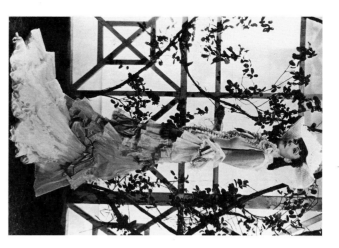

Greta Garbo in Anna Karenina (1935)

fashions, but her sleeves are much too tight for the late 1860s, more like the fashion of the 1840s.

Buffalo Bill (Twentieth Century-Fox, 1944). Costumes by René Hubert. Starring Joel McCrea (Bill Cody) and Maureen O'Hara (Louisa Cody). Set in Wyoming, 1865–90.

William Wellman's production portrays the life of the cowboy hero turned carnival showman in a serious and dramatic fashion. A sharp contrast is provided by Robert Altman's Buffalo Bill and the Indians or Sitting Bull's History Lesson (1976), which views the cowboy demigod from a decidedly satirical perspective.

Nineteen-forties "baby doll" hats and veils are worn by the actresses. Shoulder pads are in all the women's costumes, their eyebrows are arched, and their hair is pulled up to fullness over the temples.

Little Women (R.K.O., 1933). Costumes by Walter Plunkett. Starring Katharine Hepburn (Jo), Frances Dee (Meg), Jean Parker (Beth), and Joan Bennett (Amy). Set in New England, 1869.

Little Women (M.G.M., 1948). Costumes by Walter Plunkett. Starring June Allyson (Jo), Janet Leigh (Meg), Margaret O'Brien (Beth), and Elizabeth Taylor (Amy). Set in New England, 1869.

Louisa May Alcott's beloved story of four close-knit siblings was brought to the screen with great dramatic force under George Cukor's direction in the 1933 version. The 1948 adaptation, though plush, is dramatically diffuse. Walter Plunkett provided the costumes on both occasions. He would have done so another time in the late 1930s had David O. Selznick gone ahead with his plans to make a version starring Jennifer Jones.

Plunkett had trouble finding the appropriate period fabrics when making the wardrobe for the 1933 version. Bennett's pregnancy also created difficulties, forcing Plunkett to adjust her pinafore to new heights. See also Chapters I and III.

In the 1948 version Plunkett had more appropriate fabrics and the benefit of color film. On several of the costumes one can see his designing signature: matched stripes in chevrons.

1870–79

The Age of Innocence (R.K.O., 1934). Costumes by Walter Plunkett. Starring Irene Dunne (Ellen) and John Boles (Newland). Set in New York City, 1870.

An Edith Wharton novel was the basis for this melodrama of marriage and divorce, but the spirit of the production is closer to the tearjerkers written by Fannie Hurst.

The costumes are remarkably close to the period fashions, but Dunne's 1930s-style marcelled hair is a clear indication of when the film was made.

Anna Karenina (M.G.M., 1935). Costumes by Adrian. Starring Greta Garbo (Anna) and Fredric March (Vronsky). Set in Russia, 1870.

Garbo had already played Tolstoy's tragic adulteress in a 1927 silent production called Love. That version had a happy ending. This one stuck to the original downbeat conclusion. Vivien Leigh starred in a 1948 British production of the classic story.

Garbo's low-slung bosom, "garden party" hats, arched eyebrows, and shoulders-forward stance are all elements of 1930s women's fashion. There are no corsets in sight, but there are acres of lace-edged tulle, a favorite Adrian device regardless of period.

Ramona (Twentieth Century-Fox, 1936). Costumes by Gwen Wakeling. Starring Loretta Young (Ramona) and Don Ameche (Alessandro). Set in the San Jacinto Valley, California, about 1860–70.

There is a factual basis to the story of star-crossed lovers in late nineteenth-century California, but this Henry King production is tipped more toward romance than social reality.

Although set in the 1860s, the designer must have thought that early California was at least ten to fifteen years behind the times. Young's costumes are those of the 1840s with 1930s hairstyles and makeup.

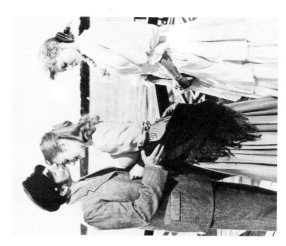

Left: *Seven Brides for Seven Brothers*

Right: *In Old Chicago*

Robert Rounseville, Shirley Jones, and Barbara Ruick in *Carousel*

Seven Brides for Seven Brothers (*M.G.M., 1954*). *Costumes by Walter Plunkett. Starring Jane Powell (Milly) and Howard Keel (Adam). Set in Oregon about 1870.*

The title explains the plot for this M.G.M. release—the surprise hit of the year. The dancing was the main attraction. Choreographer Michael Kidd set his troupers to stomping up a storm in the climactic barn-raising sequence of this Stanley Donen-directed musical.

Plunkett cleverly used quilts and table-cloths for the "brides" clothing, supporting the story-line about their being stranded for months in the mountains and having to improvise their clothing. He designed the dresses in a style of a few years prior to 1870, the film's period, in order to convey the rural nature of the setting—a place where women's styles would be a few years behind the times. The armholes in these dresses are all placed in the position for a modern "shirt waist" dress. The women's hairstyles are all of the mid-1950s with added curls and falls.

The Hawaiians (*United Artists, 1970*). *Costumes by Bill Thomas. Starring Charlton Heston (Whip Hoxworth) and Geraldine Chaplin (Purity Hoxworth). Set in Hawaii, 1870.*

A sequel to *Hawaii*, this historical saga follows the fortunes of the offspring of the first film's characters.

The period costumes for the women are

historically appropriate, but the men all wear shirts and trousers of modern cut.

In Old Chicago (*Twentieth Century-Fox, 1938*). *Costumes by Royer. Starring Tyrone Power (Dion O'Leary) and Alice Faye (Belle Fawcett). Set in Chicago, 1854–71.*

This Henry King production presents the adventures of the O'Leary family, whose discontented cow kicked over a lantern that reportedly started the great Chicago fire, the dramatic climax of the film.

The "baby doll" hat, the latest rage in 1938, is seen throughout the film along with polka-dot net ruffles and other contemporary fashion elements. The prevailing silhouette of the 1850s and 1860s is largely ignored and misunderstood.

Carousel (*Twentieth Century-Fox, 1956*). *Costumes by Dorothy Jeakins. Starring Gordon MacRae (Billy Bigelow), Shirley Jones (Julie Jordan), Barbara Ruick (Carrie). Set in Boothbay, Maine, 1873.*

Henry King directed this carefully mounted version of Rodgers and Hammerstein's musical, based on Ferenc Molnar's *Liliom*, about the ill-fated love of a carnival barker and a country girl.

The charming bustles that appear in the costume sketches were toned down in the finished costumes. The actresses wore simple "shirt waist" dresses rather than the larger period dresses.

223

Betty Grable in *The Shocking Miss Pilgrim*

The Shocking Miss Pilgrim (*Twentieth Century-Fox, 1947*). *Costumes by Orry-Kelly. Starring Betty Grable (Cynthia Pilgrim) and Dick Haymes (John Pritchard). Set in Boston, 1874.*

The "shock" in this story comes from a woman entering the "man's world" of business. George Gershwin songs are featured in this otherwise typical Grable film.

A plaid front on a long bodice, seen in several of Grable's costumes, is a style used in men's casual suits in the mid-1940s. Her hair is done in a 1947 coiffure with an upsweep and pin curls. The ubiquitous "baby doll" hat and shoulder pads are staples of the film's wardrobe, making it one of the most 1940s-looking period films ever made.

Saratoga Trunk (*Warner Bros., 1946*). *Costumes by Leah Rhodes. Starring Ingrid Bergman (Clio Dulaine) and Gary Cooper (Clint Maroon). Set in New Orleans, 1875.*

The stars perform memorably in this adaptation of Edna Ferber's story of an adventurer and an adventuress.

Bergman wore a dress made from the *Strawberry* pattern, popular in the 1940s and 1950s for kitchen curtains and tablecloths. (The pattern was designed by the famous Southern California textile designer Elza of Hollywood.) The hats are perched at precarious angles, and the hairstyles are strictly 1940s fashions.

Centennial Summer (*Twentieth Century-Fox, 1946*). *Costumes by René Hubert. Starring Jeanne Crain (Julia), Linda Darnell (Edith), and Cornel Wilde (Philippe Lascalles). Set in Philadelphia, 1876.*

Clearly hoping to come up with a slice of Americana along the lines of *Meet Me in St. Louis*, this musical, directed by Otto Preminger, manages to be pleasant but not as memorable as its model.

The wardrobe's colors and materials are appropriate for 1870s clothing. The film's broad-shouldered dresses, however, are a Hubert trademark, seen in many of the films he worked on in the 1940s—regardless of period. The hats and hairstyles are also typical 1940s styles. See Chapter 1.

1880–89

Gaslight (*M.G.M., 1944*). *Costumes by Irene. Starring Ingrid Bergman (Paula Alquist) and Charles Boyer (Gregory Anton). Set in London, 1880.*

Bergman and Boyer make for dramatic dynamite in this George Cukor-directed adaptation of the classic Patrick Hamilton thriller about a conniving husband's attempt to drive his wealthy wife out of her mind.

Irene was never really comfortable with designing for period films, but what her costumes lacked in authenticity, they made up in beauty. Her genius for draping thin chiffons and other couture fabrics always gave a richness to her film wardrobes, as can be seen in *Gaslight*. Carefully matched stripes and scallops, two more of her trademarks, are seen on several costumes. She was also fond of asymmetry, as can be seen in several of the evening dresses in the film. Another contemporary influence is her use of horizontal bust darts to fit the bodices; in the nineteenth century the dart was always vertical and originated from the waist seam. Bergman's bangs, fall, and upswept hair over the temples are perfect styles for 1944.

Sea of Grass (*M.G.M., 1947*). *Costumes by Walter Plunkett and Valles (for the men). Starring Katharine Hepburn (Lutie Cameron) and Spencer Tracy (Col. Jim Brewton). Set in New Mexico, about 1880.*

Elia Kazan directed this adaptation of Conrad Richter's novel about feuding ranchers in the New Mexico grasslands.

Plunkett's costumes are elegant and beautiful. The materials—velvets, heavy silks, and white eyelet—are correct for the period. The makeup and hairstyles, by contrast, are just right for 1947.

That Forsyte Woman (*M.G.M., 1950*). *Costumes by Walter Plunkett. Starring Greer Garson (Irene Forsyte) and Errol Flynn (Soames Forsyte). Set in London, about 1880.*

John Galsworthy's *Forsyte Saga* is the basis for this "Class A" melodrama. See Chapter 1.

My Cousin Rachel (*Twentieth Century-Fox, 1952*). *Costumes by Dorothy Jeakins.*

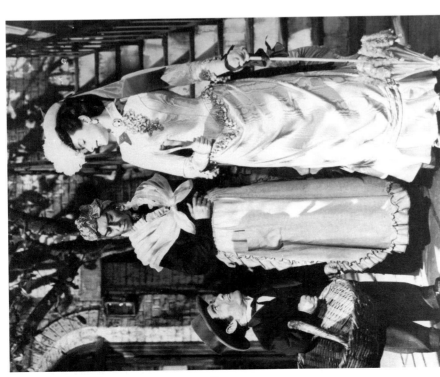

Starring Richard Burton (Philip Ashley) and Olivia de Havilland (Rachel). Set in Cornwall, England, 1880.

Daphne du Maurier's mystery-melodrama of skeletons rattling in family closets is enlivened by the teamwork of its stars.

The film was a strange combination of 1860s and 1950s elements. De Havilland wears an odd assortment of costumes, which reflect several periods, none of which are the 1880s.

The Merry Widow (*M.G.M., 1934*). *Costumes by Adrian. Starring Maurice Chevalier (Capt. Danilo) and Jeanette MacDonald (Sonia). Set in "Marshovia" and Paris, 1885.*

Ernst Lubitsch's film of Franz Lehár's operetta is one of the most delightful and spectacular films of the 1930s. The "Merry Widow Waltz" scene is as technically astonishing as anything created by De Mille or Spielberg.

Adrian liked the fashions of the 1880s, and his costumes for *The Merry Widow* are something special. The yards and yards of sequin-edged tulle and the marcelled hair-styles on all the female stars, however, make it apparent that this film was made in the early 1930s.

Showboat (*Universal, 1936*). *Costumes by Doris Zinkeisen. Starring Irene Dunne (Magnolia), Allan Jones (Gaylord Ravenal), and Helen Morgan (Julie). Set in Mississippi and Chicago, 1885–1901.*

Showboat (*M.G.M. 1951*). *Costumes by Walter Plunkett. Starring Kathryn Grayson (Magnolia), Howard Keel (Gaylord Ravenal), and Ava Gardner (Julie). Set in Mississippi and Chicago, 1885–95.*

One of the most beloved of all American musicals, *Showboat*'s mixture of beautiful songs (by Jerome Kern) and an unusually socially conscious story (touching on re-

Left: Curt Bois, Flora Robson, and Ingrid Bergman in *Saratoga Trunk*

Right: Ava Gardner in *Show Boat* (1951)

225

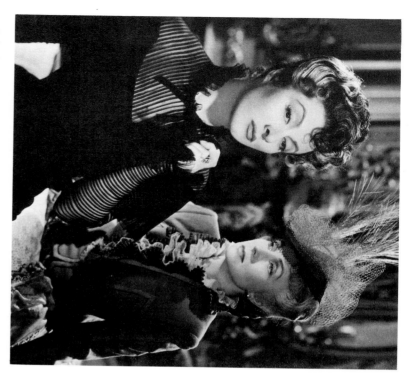

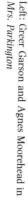

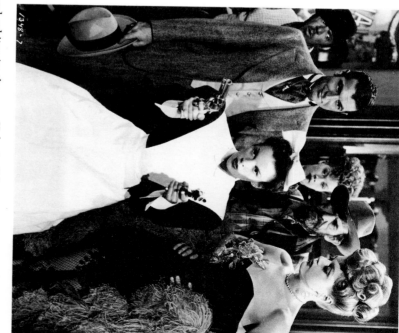

Left: Greer Garson and Agnes Moorehead in *Mrs. Parkington*
Right: Judy Garland and Angela Lansbury in *The Harvey Girls*

Untamed (*Twentieth Century-Fox, 1955*). *Costumes by René Hubert. Starring Susan Hayward (Katie O'Neil) and Tyrone Power (Paul van Riebeck). Set in Ireland and South Africa, 1847–1909.*

Life among the Boers in South Africa is the dramatic focus of this adventure saga. The costumes have much period detail, but

lations between blacks and whites in the post-Civil War South) has thrilled audiences for generations. In addition to the two versions listed there is a silent *Showboat*, released in 1929.

In the 1936 version the costumes are far from historically accurate but have the flavor of the period. Dunne wears shapeless gowns with large bustles.

In the remake fifteen years later the dresses are cut to conform to the shape of the bust; virtually every bosom is "lifted and separated" as was typical of nearly all period films made in the 1950s. Plunkett worked wonders with stripes and plaids, creating exciting costumes, even though he sacrificed authenticity by doing so.

Hubert did not re-create the shoulder placement in dress of the period. The influence of the contemporary silhouette is further reflected in the "lifted and separated" look seen in all of the women's costumes.

Cimarron (*R.K.O., 1931*). *Costumes by Max Ree. Starring Richard Dix (Yancy Cravat) and Irene Dunne (Sabra Cravat). Set in Oklahoma, 1889.*

Wesley Ruggles directed this adaptation of Edna Ferber's story of the Old West, which won Academy Awards for Best Picture and Best Screenplay. Anthony Mann directed a remake of the same story in 1960.

Cimarron probably has more historically accurate clothes than any period film made prior to 1931. Corsets, bustles, necklines, and decorative details are virtually faultless. The only telltale 1930s influences are the marcelled waves and the plucked eyebrows. As titular head of R.K.O.'s wardrobe department, Ree received screen credit for the costumes, but because he was uncomfortable designing period costume, they were executed by Plunkett.

Barbra Streisand in *Hello Dolly!*

1890–99

She Done Him Wrong (*Paramount, 1933*). *Costumes by Edith Head. Starring Mae West (Lady Lou) and Cary Grant (Capt. Cummings). Set in New York City, about 1890.*

Belle of the Nineties (*Paramount, 1934*). *Costumes by Travis Banton. Starring Mae West (Ruby Carter) and John Mack Brown (Brooks Claybourne). Set in New Orleans, about 1890.*

The hourglass figure is unmistakable, the lines (risqué but never vulgar) are unforgettable, and the character ("red-hot mama" with a heart of gold) is overwhelming. To sum it up in two words: Mae West.

The designers for both films conformed to West's specific costume demands. She had created a character with her own idiosyncratic style. Head tried to emphasize West's height by refraining from the use of any break at the waist and by using chevrons and other optical illusions. The makeup in both cases is pure "Mae West 1933," and her hair is always marcelled.

Mrs. Parkington (*M.G.M. 1944*). *Costumes by Irene and Valles. Starring Greer Garson (Susie Parkington) and Walter Pidgeon (Maj. Augustus Parkington). Set in England, 1890.*

A woman with social ambitions marries a wealthy, retiring man only to push both of them into the public spotlight. Tay Garnett directed this class-conscious melodrama.

These costumes are some of Irene's most successful re-creations of period styles. She still had some problems divorcing herself from contemporary fabrics and used 1940s rayon crêpe, but it is likely that her selection of materials was limited by wartime restrictions. In the second part of the film, which takes place about twenty years later, the long, flowing gowns are similar in shape and form to some of the evening dresses of the mid-1940s.

The Harvey Girls (*M.G.M. 1946*). *Costumes by Helen Rose. Starring Judy Garland (Susan Bradley) and John Hodiak (Ned Trent). Set in Sand Rock, New Mexico, 1890.*

"The Atcheson, Topeka, and the Santa Fe" number is the musical highpoint of this Arthur Freed production, directed by George Sidney, about a gaggle of waitresses in the Old West. See Chapter I.

Hello Dolly! (*Twentieth Century-Fox, 1969*). *Costumes by Irene Sharaff. Starring Barbra Streisand (Dolly Gallagher Levi) and Walter Matthau (Horace van der Gelder). Set in Yonkers, New York, and New York City, 1890.*

The biggest Broadway musical of the 1960s and the biggest movie musical star of the same era would appear to be an irresistible combination for a hit movie. But the public proved resistant to this mammoth opus, derived from a Thornton Wilder farce, despite the liveliness of its star, whose brightest moment in the film comes in a memorable title song turn with Louis Armstrong.

The supporting characters all look like they have just stepped out of an 1890s fashion plate, but Streisand wears a 1969 hairstyle: asymmetrical parting and soft wisps of hair pulled across her forehead over her right eye. The problem of achieving authenticity but also maintaining a star's image is clearly demonstrated here.

The Last Remake of Beau Geste (*Universal, 1977*). *Costumes by May Routh. Starring Marty Feldman (Digby), Ann-Margret (Lady Flavia Geste), and Michael York (Beau). Set in England and Morocco, about 1890.*

Poached-egg-eyed British comic Marty Feldman starred in and directed this spoof of North African adventure and heroism.

The overblown hairstyles, the evening eye makeup, and the satin teddies over rounded bosoms are clear indications that the picture was made in the late 1970s. Ann-Margret's costumes are carefully cut from period patterns, and the fabrics are correct for 1890s clothing.

Tess (*Columbia, 1979*). *Costumes by Anthony Powell. Starring Nastassia Kinski (Tess) and Peter Firth (Angel Clare). Set in England, 1890.*

In a complete about-face from his usual cinematic shock tactics, Roman Polanski goes all-out for David Lean-styled craftsmanship in this exquisite adaptation of Thomas

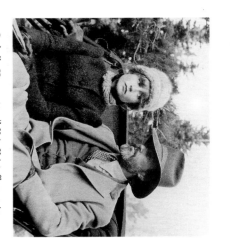

Isabelle Huppert and Kris Kristofferson in *Heaven's Gate*

Hardy's novel of an innocent girl victimized by circumstance.

The costumes in this film still look historically correct eight years after its release, but it may be too soon to see the influence of the 1970s aesthetic. It will be fascinating to see how authentic the costumes appear in a decade.

Butch Cassidy and the Sundance Kid (*Twentieth Century-Fox, 1969*). *Costumes by Edith Head. Starring Paul Newman (Butch), Robert Redford (Sundance), and Katharine Ross (Etta Place). Set in U.S.A. and Bolivia, 1890–1909.*

Comic spoof, lighthearted romance, and fast action mix successfully in this George Roy Hill production about the celebrated outlaw team.

Ross wears a prairie frock of printed calico and a minichemise. Her flowing hairdo looked great in 1969 but now appears very dated. Newman wears corduroy jackets, which are appropriate for the period—except for their plastic buttons. The Oxford cloth shirts worn by both him and Redford are straight out of Brooks Brothers.

Heaven's Gate (*United Artists, 1980*). *Costumes by Allen Highfill. Starring Kris Kristofferson (Averill) and Isabelle Huppert (Ella). Set in Wyoming, 1892.*

Michael Cimino's muddled melodrama about the range wars of the late 1800s was the costliest flop in modern Hollywood history.

Reportedly no expense was spared in re-creating authentic period settings, costumes, and other details. The costumes, however, are not exceptional. Several have a Geoffrey Beene look about them. They consist of jackets made of mohair with asymmetrical fronts and knotted silk scarves about the throat, strictly a 1980s fashion device.

The Importance of Being Earnest (*Rank/Universal, 1953*). *Costumes by Beatrice Dawson. Starring Michael Redgrave (Jack Worthing), Dame Edith Evans (Lady Bracknell), and Joan Greenwood (Gwendolen Fairfax). Set in England, 1893.*

Oscar Wilde's peerless comedy of manners is beautifully served in this attractive screen adaptation.

Masses of applied decoration in the form of flowers and other motifs had recently been introduced into the fashion world by the British designer Norman Hartnell. In this film they appear with a theatrical flair.

The Belle of New York (*M.G.M., 1952*). *Costumes by Helen Rose and Gile Steele. Starring Fred Astaire (Charlie Hill) and Vera-Ellen (Agnes Collins). Set in New York City, 1898.*

Fred Astaire dancing in the clouds is one of the high points of this M.G.M. musical, directed by Charles Walters, about a playboy and a mission worker.

Vera-Ellen wears strapless dresses, a style that did not exist in the 1890s. Strong 1950s influences can be seen in the film's hairstyles and makeup.

Heaven Can Wait (*Twentieth Century-Fox, 1943*). *Costumes by René Hubert. Starring Don Ameche (Horace van Cleve) and Gene Tierney (Martha). Set in New York City, 1872–1942.*

One of Ernst Lubitsch's most beautiful productions, this episodic feature recounts the life of a middle-class playboy who's more of a romantic than the suspects.

Tierney's saucily placed Persian lamb hat matches the collar on her suit, which features sizable 1940s-styled shoulder pads. This suit is worn over a silk crêpe blouse with a band at the neck tied in a bow, another contemporary touch.

1900–1909

Back Street (*Universal, 1941*). *Costumes by Vera West and Muriel King. Starring Charles Boyer (Walter Saxen) and Margaret Sullavan (Ray Smith). Set in New York City, Cincinnati, and Paris, 1900–32.*

Fannie Hurst's all-time tearjerker is given first-class treatment by this fine cast. A 1961 version of this tale of the woes of a married man's mistress is set in contemporary times.

Sullavan wears a fox fur draped asymmetrically over one shoulder, strictly a style of the early 1940s. Some of the "at home" wear, made of soft silk crêpe with a layered

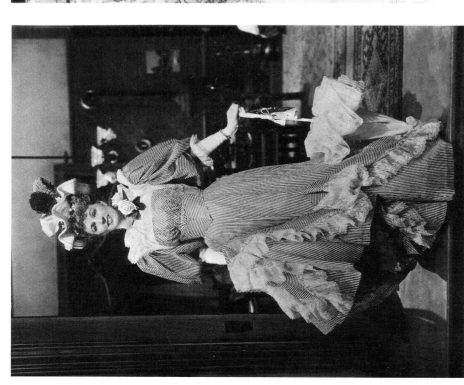

Left: Margaret Sullavan in *Back Street*

Right: Bette Davis in *The Little Foxes*

look of the late 1930s, seems inappropriate for the time portrayed in the film, but for the most part the costumes are very good.

The Little Foxes (*Samuel Goldwyn Productions, 1941*). *Costumes by Orry-Kelly. Starring Bette Davis (Regina Giddens) and Herbert Marshall (Horace Giddens). Set in a small town in Georgia, 1900.*

Lillian Hellman's melodrama of a scheming, money-hungry Southern family is brought effectively to the screen by director William Wyler, cinematographer Gregg Toland, and the incandescent brilliance of Davis and Marshall.

The film's costumes and coiffures—soft crêpe blouses and finger waves (added to Gibson Girl hairstyles)—reflect the prevalent fashions in 1941. In one scene Davis wears a strapless evening gown that looks as if it is held in place by the hat veiling that is draped

over her shoulders. Strapless evening gowns did not exist until the fourth decade of the twentieth century.

Hello Frisco Hello (*Twentieth Century-Fox, 1942*). *Costumes by Helen Rose. Starring Alice Faye (Trudy Evans), John Payne (Johnnie Cornell), and Jack Oakie (Dan Daley). Set in San Francisco, 1900.*

This Fox vehicle for Alice Faye sends the singing star on the road to show-business stardom with its predictable dramatic ups and downs.

Faye's Gibson Girl hairstyle includes the fashionable upswept look of 1940s hairdos. See Chapter I.

Mrs. Mike (*United Artists, 1950*). *Costumes by Elois Jenssen. Starring Dick Powell (Sgt. Mike Flannigan) and Evelyn Keyes (Kathy O'Fallon). Set in Canada, 1900.*

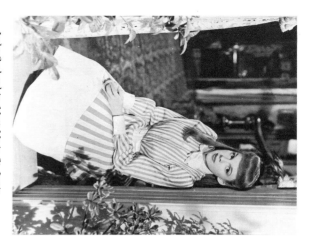

Judy Garland in *Meet Me in St. Louis.*

55 Days at Peking (Allied Artists/Samuel Bronston, 1963). Costumes by Orry-Kelly. Starring Charlton Heston (*Maj. Matthew Lewis*), Ava Gardner (*Baroness Natalie Ivanoff*), and David Niven (*Sir Arthur Robinson*). Set in Peking, 1900.

An impressive cast did their best in this rather diffuse retelling of the Boxer Rebellion. It was director Nicholas Ray's last Hollywood film.

The costumes of the military men and the Chinese appear to be accurate to the last detail, but Gardner's hairstyles are strictly in the fashion of 1963.

Gigi (M.G.M., 1958). Costumes by Cecil Beaton. Starring Leslie Caron (*Gigi*), Louis Jourdan (*Gaston Lachaille*), and Maurice Chevalier (*Honoré Lachaille*). Set in Paris, 1900.

Colette's saucy tale of the training and education of a Parisian courtesan was transformed into a big-screen musical that is almost wholesome but by no means less delightful for it. Alan Jay Lerner and Frederick Loewe's songs ("Thank Heaven for Little Girls," "The Night They Invented Champagne"), a perfect cast, and Vincente Minnelli's superb direction all contributed to make this an Oscar winner. A large part of the film's success is due of course to the work of Beaton.

Many of the costumes have a theatrical flair associated with Beaton, but it is Caron's bangs and hair pulled back with a barrette as well as her 1950s makeup that date the film.

Two Weeks with Love (M.G.M., 1950). Costumes by Helen Rose. Starring Jane Powell (*Patti Robinson*) and Ricardo Montalban (*Demi Armendez*). Set in "Kissamee," the Catskills, New York, 1900.

This typical "nostalgia" musical from the 1950s is chiefly remembered for Debbie Reynolds and Carlton Carpenter's duet "Abadaba Honeymoon."

The costumes are less the style of 1900 than the style of Helen Rose—lots of silk, satin, and pleated "soufflé."

Lady L (M.G.M., 1966). Costumes by Marcel Escoffier. Starring Sophia Loren (*Lady L*), Paul Newman (*Armand*) and David Niven (*Dickey*). Set in Paris and Switzerland, 1900.

This adaptation of Romain Gary's darkly comic novel of the life and loves of a "woman of the world" was originally set to go before the cameras in 1961 with Gina Lollabrigida and Tony Curtis in the principal roles under George Cukor's direction. Script problems and Cukor's illness forced the cancellation of shooting. The project was taken up again some years later with Loren and Newman in the principal roles under Peter Ustinov's direction.

The Orry-Kelly costumes and designs for Lady L shown in the exhibition *Hollywood and History* (1987) represent work produced for the first, unfinished version of the project. Marcel Escoffier designed the costumes for the film that was eventually released in 1966. His costumes for Loren were excellent. It is only in the scenes of casual dress or even partial undress that the aesthetic of the 1960s is apparent. Again, it is the hair and makeup that remain the most noticeable modern elements.

The Merry Widow (M.G.M., 1952). Costumes by Helen Rose and Gile Steele. Starring Lana Turner (*Crystal Radek*) and Fernando Lamas (*Count Danilo*). Set in Vienna and Paris about 1900–10.

Turn-of-the-century Europe seems to have adopted the strapless look in evening gowns. Turner's hairstyles are holdovers from the late 1940s.

The bodies belong to the stars, but their singing voices come from other sources in the lavish (and somewhat lugubrious) version of the ever-popular Viennese musical.

Mrs. Soffel (M.G.M., 1984). Costumes by Shay Cunliffe. Starring Diane Keaton (*Mrs. Soffel*) and Mel Gibson (*Ed Biddle*). Set in Pittsburgh, 1901.

A jailer's wife finds herself drawn to a pair of outlaw brothers put under her husband's care and decides to help them make an escape.

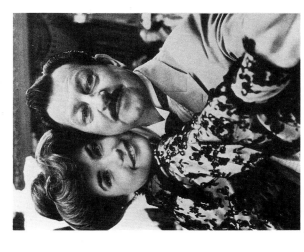

Clark Gable and Jeanette MacDonald in *San Francisco*

Elizabeth McGovern and Donald O'Connor in *Ragtime*

The gowns, hairstyles, and even the makeup appear to be perfect re-creations of the period look, but with the passage of more time it may be possible to see a contemporary influence.

Meet Me in St. Louis (*M.G.M., 1944*). *Costumes by Irene and Irene Sharaff. Starring Judy Garland (Esther Smith), Lucille Bremer (Rose Smith), and Margaret O'Brien ("Tootie" Smith). Set in St. Louis, 1903–04.*

The Smith family makes plans to leave St. Louis and move to New York; then they change their minds. That is about all the plot that exists in this musical treasure, superbly directed by Vincente Minnelli. A musical mood piece, it is a unique example of cinematic Americana.

Irene and Sharaff made the costumes using large amounts of rayon crêpe, one of the few fabrics readily available during World War II. Some of the waltz-length skirts in the film would have been perfect for afternoon wear in 1944. The 1940s fascination with stripes can be seen in the dress Judy Garland wears in "The Boy Next Door" number. The attention given to this dress (Judy is shown primping in front of the mirror) suggests that the film-makers were making a fashion pitch (see Chapter III).

The Reivers (*National General, 1969*). *Costumes by Theadora van Runkle. Starring Steve McQueen (Boon Hogganbeck) and Rupert Crosse (Ned McCaslin). Set in Jefferson, Missouri, 1905.*

Based on William Faulkner's last novel, this picaresque comedy tells of a young boy's adventurous auto trip with a pair of rascally elders.

The costumes appear to be carefully researched, right down to the calico shirts worn by McQueen. The women's costumes are historically correct except for the late-1960s eye makeup and lipstick.

Ah, Wilderness! (*M.G.M., 1935*). *Costumes by Dolly Tree. Starring Mickey Rooney (Tommy), Wallace Beery (Sid), Cecilia Parker (Muriel), and Lionel Barrymore (Nat Miller). Set in New England, 1906.*

Eugene O'Neill's only comedy, this study of small-town life, translated well to the screen.

and the principal performers are well suited to their characters.

Parker carries a 1930s "betsy bag," and her coiffure reflects the Mary Pickford influence with marcelled hair and a mass of sausage curls. The broad shoulder-cut of the men's suits is straight out of the 1935 high-fashion magazines.

San Francisco (*M.G.M., 1936*). *Costumes by Adrian. Starring Clark Gable (Blackie Norton), Jeanette MacDonald (Mary Blake), and Spencer Tracy (Father Mullin). Set in San Francisco, 1905–06.*

Romance, music, and mayhem mix surprisingly well in this film about the San Francisco earthquake, the granddaddy of all "disaster" flicks.

The women's costumes are made in the style of the 1930s. Chorus girls have sequined bows over their crotches and butterflies over their bosoms. An all-sequined dress with a pattern of black bursts and neck ruffles of pleated and sequined tulle could only have been made by Adrian in the 1930s. There is a soft, draping look in all of the dresses, which comes from the bias cut of the 1930s.

Ragtime (*Paramount, 1981*). *Costumes by Anna Hill Johnstone. Starring James Cagney (Police Commissioner Rheinlander Waldo), Elizabeth McGovern (Evelyn Nesbit), Howard E. Rollins, Jr. (Coalhouse Walker, Jr.), and James Olson (Father). Set in New York City, 1906.*

Novelist E. L. Doctorow's paraphrase of Heinrich von Kleist's *Michael Kohlhaas* comes to the screen as a vignette-styled panorama of the period in which it is set. Society figures, vaudeville performers, would-be revolutionaries, and a "typical" middle-class family intermingle in a network of dramatic blackout sketches.

Virtually all of the costume elements in this film look historically correct to fashion historians in the 1980s. In a few more years the makeup will probably appear dated.

Oklahoma! (*Rodgers and Hammerstein Productions, 1955*). *Costumes by Orry-Kelly and Motley. Starring Gordon MacRae (Curly) and Shirley Jones (Laurie). Set in Oklahoma, 1907.*

Left: Helena Bonham-Carter and Daniel Day-Lewis in *A Room with a View*

Right: Grace Kelly and Alec Guinness in *The Swan*

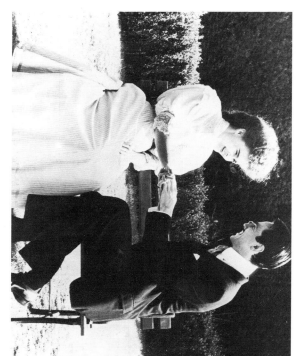

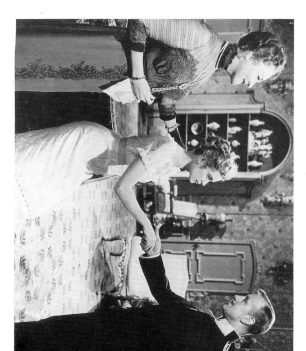

Rodgers and Hammerstein's ground-breaking stage musical comes to the screen in an eye-popping production in Todd-AO.

A range of contemporary hairstyles—from ponytails to pixie cuts—is seen on the women in this film. Many of the dresses appear to have been strongly influenced by the popular "shirt waist" dress of the mid-1950s.

A Room with a View (*Merchant-Ivory/Goldcrest/Cinecom International, 1986*). *Costumes by Jenny Beavan and John Bright. Starring Maggie Smith (Charlotte Bartlett), Helena Bonham-Carter (Lucy Honeychurch), Daniel Day Lewis (Cecil Vyse), and Julian Sands (George Emerson). Set in Italy and England, 1907.*

E. M. Forster's short novel about uptight Britons letting their hair down in Italy was transformed by the Merchant-Ivory film-making team into a delicate, hilarious comedy of manners. It is the most recent example of a period film creating a trend in contemporary fashion.

Heralded as a masterpiece of period construction and awarded an Oscar for its costumes, it is difficult to see any flaws in the interpretation of period dress at this time. In the future the 1980s fashion influence may become apparent.

1910–19

The Swan (*M.G.M., 1956*). *Costumes by Helen Rose. Starring Grace Kelly (Princess Alexandra), Alec Guinness (Prince Albert), and Van Dyke Parks (George). Set in Hungary, 1910.*

Grace Kelly's last screen appearance, prior to leaving Hollywood to become Princess of Monaco, was in this adaptation of Ferenc Molnár's play. A comedy of manners set in aristocratic circles, the story had already been filmed in 1925 and 1930.

This is one of designer Rose's most successful period film wardrobes. All of the costumes follow the same as her look in films set in modern times.

Mary Poppins (*Buena Vista, 1965*). *Costumes by Bill Thomas and Tony Walton. Starring Julie Andrews (Mary Poppins) and Dick Van Dyke (Bert). Set in London, 1910.*

P. L. Travers's story of a "practically perfect" nanny with magical powers was the basis for this Walt Disney musical. Andrews won an Oscar for her work.

The women's dress in this film shows only slight reference to 1910. Their costumes are a mixture of all-purpose, generic old-fashioned shapes and forms. Andrews's hairstyle, when

Ruth Nelson in *Wilson*

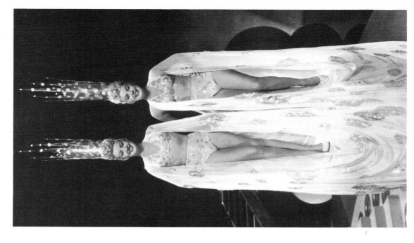

Betty Grable and June Haver in *The Dolly Sisters*

not flattened by her straw hat, is full, bulbous, and teased as was the style in 1965.

Wilson (*Twentieth Century-Fox, 1944*). *Costumes by René Hubert. Starring Alexander Knox (Woodrow Wilson) and Geraldine Fitzgerald (Edith Wilson). Set in Washington, D.C., 1909–21.*

This story of Wilson and his decision to bring America into World War I was produced during World War II.

Fitzgerald wore rayon velvet wraps, which may have been the result of wartime restrictions—more authentic materials were scarce. Asymmetrical and bizarre hats of the 1940s are perched precariously on the side of the First Lady's head in a most startling manner.

Death in Venice (*Warner Bros., 1971*). *Costumes by Piero Tosi. Starring Dirk Bogarde (Gustav Aschenbach), Silvana Mangano (the mother), and Bjorn Anderson (Tadzio). Set in Venice, 1911.*

Like his work in *The Leopard*, Luchino Visconti paid scrupulous attention to period detail in this adaptation of Thomas Mann's novella about a dying man's romantic obsession with a youth to whom he speaks not a word.

From hats to hosiery, this film's wardrobe is a practically perfect re-creation of the styles in 1911. Even period movements and gestures were carefully studied and observed. The scene of the hotel patrons in the lobby could have been a period photograph come to life. The only hint of the early 1970s is the women's eye makeup.

The Magnificent Ambersons (*R.K.O., 1942*). *Costumes by Edward Stevenson. Starring Tim Holt (George Amberson Minafer), Joseph Cotton (Eugene Morgan), and Dolores Costello (Isabel Amberson). Set in the Midwest, 1885–1913.*

Orson Welles's film of Booth Tarkington's novel about the fading fortunes of a once-powerful Midwestern family is perhaps the most beautiful evocation of the past ever created by an American filmmaker. In one of the opening sequences Joseph Cotton is shown modeling men's fashions of the day, as Welles, the narrator, notes the changes

they went through: coat lengths going up and down, shoes varying from pointed to square toes, pants widening from slender to baggy, and hats changing from stovepipe to bowler.

The women's costumes are charming, but Costello's sequin-dotted tulle ruffles and her World War II hairstyle (with added sausage curls) date this film firmly in the early 1940s.

The Dolly Sisters (*Twentieth Century-Fox, 1946*). *Costumes by Orry-Kelly. Starring Betty Grable (Jeannie), June Haver (Rosie), and John Payne (Harry Fox). Set in New York City, London, and Paris, 1904–12.*

There may be a real-life biographical basis to this story of singing siblings, but the look, feel, and plot of this Twentieth Century-Fox musical is pure (albeit enjoyable) Hollywood hokum.

The costumes do not show a hint of the period styles. The film's clothes are strictly in the fashions of the postwar 1940s.

Easter Parade (*M.G.M., 1948*). *Costumes by Irene. Starring Fred Astaire (Don Hewes), Judy Garland (Hannah Brown), and Ann Miller (Nadine Hale). Set in New York City, 1912.*

Two musical comedy legends and a clutch of Irving Berlin standards turned this story, a familiar showbiz saga, into memorable entertainment. Charles Walters directed this Arthur Freed production.

The film's "garden party" hats, 1940s stripes, and crêpe drapes were all part of designer Irene's fashion picture. Never really comfortable with designing period styles, she made the women's costumes chic and beautiful from the point of view of her contemporary aesthetic.

Titanic (*Twentieth Century-Fox, 1953*). *Costumes by Charles LeMaire and Dorothy Jeakins. Starring Clifton Webb (Richard Sturgess) and Barbara Stanwyck (Mrs. Sturgess). Set in the North Atlantic, 1912.*

The sinking of the luxury ocean liner S.S. *Titanic* provides the backdrop for this typical melodrama. Webb and Stanwyck give outstanding performances.

Women's styles in 1912 did not include dresses like the strapless evening gowns seen

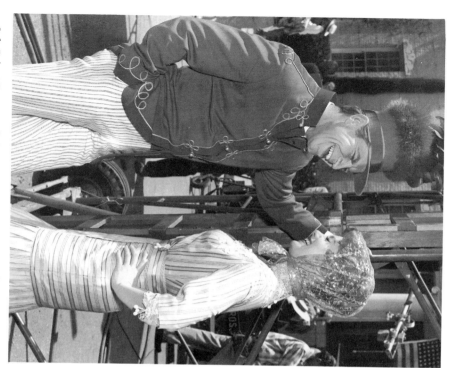

Left: Robert Preston and Shirley Jones in *The Music Man*

Right: Audrey Hepburn and Rex Harrison in *My Fair Lady*

in this film, trimmed with pearlized leaves and encrusted with pearls and rhinestones over "lifted and separated" breasts. Thick, clumpy jewelry and 1950s hairstyles are additional examples of the contemporary influence.

The Music Man (*Warner Bros., 1962*). *Costumes by Dorothy Jeakins. Starring Robert Preston (Harold Hill) and Shirley Jones (Marian Paroo). Set in "River City," Iowa, 1912.*

Meredith Wilson's rousing Broadway musical about the romance of a brash con-man and a suspicious librarian was brought to the screen with great vigor.

Hermione Gingold as the mayor's wife wears modified hobble skirts, but her hats could have been purchased over the counter at Bonwit Teller. The choice of fabrics and decorations for the formal wear is true to the period. The careful attention to the children's costumes is also noteworthy.

My Fair Lady (*Warner Bros., 1964*). *Costumes by Cecil Beaton. Starring Rex Harrison (Henry Higgins) and Audrey Hepburn (Eliza Doolittle). Set in London, 1912.*

George Cukor directed this sumptuous production of Alan Jay Lerner and Frederick Loewe's world-famous musical version of George Bernard Shaw's *Pygmalion*.

A key ingredient of the sumptuousness is the costumes, which won an Academy Award for Beaton. The hats and gowns have a period feeling but are somewhat exaggerated. Many of the strange hairdos are from the high fashions of the 1960s.

The Story of Vernon and Irene Castle (*R.K.O., 1939*). *Costumes by Irene Castle and Walter Plunkett. Starring Fred Astaire (Vernon Castle) and Ginger Rogers (Irene Castle). Set in New York City and Paris, 1912–19.*

Astaire and Rogers, the most famous dance team of the 1930s, portray the most famous dance team of an earlier era. A drama with music, this performance stands in sharp contrast to other entries in the Astaire-Rogers series.

Irene Castle would only permit the film to be made if she was allowed to design the costumes. Disquiet ensued, and Rogers refused to wear what she considered "unflattering" gowns designed by Castle. Every evening after filming Rogers would meet with Plunkett, and they would redo the costumes for the next day's shooting. Once they were on film they could not be changed. The results bear only a nodding resemblance to the fashions seen in the 1910s.

The "I Don't Care" Girl (Twentieth Century-Fox, 1953). Costumes by Renie Conley and Charles LeMaire. Starring Mitzi Gaynor (Eva Tanguay) and George Jessel (himself). Set in Paris, New York City, and Hollywood, 1912–18 and contemporary.

This fanciful musical about legendary cabaret performer Eva Tanguay features a forgettable movie-within-a-movie plot and some spectacular dance routines choreographed by the great Jack Cole.

The costume designers made no attempt to achieve the restricted look of the period, but the costumes are show stopping.

Somewhere in Time (Universal, 1980). Costumes by Jean-Pierre Dorleac. Starring Christopher Reeve (Richard Collier) and Jane Seymour (Elise McKenna). Set in Michigan, 1912 and contemporary.

A playwright falls in love with the photograph of a woman who lived seventy years earlier. Gradually he finds a way of projecting himself into the past.

From our point of view, only seven years after Somewhere in Time was filmed, this picture appears to be historically correct in every costume detail. Only with the passage of time will we be able to observe the 1980s aesthetic.

Dishonored (Paramount, 1931). Costumes by Travis Banton. Starring Marlene Dietrich (Agent X27) and Victor McLaglen (Lt. Kranau). Set in Austria, during World War I, 1914–18.

As a Mata Hari-style spy, Marlene Dietrich decodes secret messages by playing a piano sonata in this delightfully outrageous Josef von Sternberg production.

Banton was at his most creative in his designs for this film, using monkey fur, feathers, and tulle. Bias-cut lamé and huge fox-fur collars were flattering to Dietrich even if they were not typical of styles during World War I. Dietrich's very soft, marcelled, curled hair enhanced her face as did her pencil-thin eyebrows.

Mata Hari (M.G.M. 1932). Costumes by Adrian. Starring Greta Garbo (Mata Hari) and Ramon Novarro (Lt. Alexis Rosanoff). Set in Paris and Russia, during World War I, 1914–18.

Garbo plays the celebrated World War I spy. Adrian was "ahead of his time," creating costumes for this film that are exotic and excessive. His version of World War I styles includes suede boots worn under silk velvet; asymmetrically beaded gowns with matching velvet, modified cloches; and solidly beaded, form-fitting long pants for women.

Christopher Reeve and Jane Seymour in Somewhere in Time

235

Barbra Streisand in *Funny Girl*

Darling Lili (*Paramount, 1970*). *Costumes by Jack Bear and Donald Brooks. Starring Julie Andrews (Lili Smith) and Rock Hudson (Maj. William Larabee). Set in France and England, during World War I, 1914–18.*

A Mata Hari-esque spy doubles as a musical comedy performer in this elaborate musical romance.

Many aspects of the film's costumes—beaded and spangled paisley dresses with spaghetti straps, wide "Tom Jones" cuffs, and turtleneck blouses—are perfect for 1970.

Doctor Zhivago (*M.G.M. 1965*). *Costumes by Phyllis Dalton. Starring Omar Sharif (Yuri), Julie Christie (Lara), Geraldine Chaplin (Tonya), Tom Courtenay (Pasha), Rod Steiger (Komarovsky), Alec Guinness (Yevgraf), and Rita Tushingham (the girl). Set in Russia, about 1914–20.*

Critics were divided as to the extent of director David Lean's success in adapting (with screenwriter Robert Bolt's collaboration) Boris Pasternak's epic novel to the screen. The public, however, was unanimous in its support of the film as an old-fashioned movie romance set against the tumultuous backdrop of the Russian Revolution.

Carefully researched for historical accuracy, Dalton's designs strongly influenced 1960s fashion, particularly overcoats for men. Julie Christie's hair, asymmetrically parted and swept over the forehead, is a typical 1960s style. See Chapter III.

The Happiest Millionaire (*Buena Vista/Walt Disney Productions, 1967*). *Costumes by Bill Thomas. Starring Fred MacMurray (Anthony J. Drexel Biddle), Tommy Steele (John Lawless), and Greer Garson (Mrs. Cornelia Biddle). Set in Philadelphia, 1916.*

An eccentric Philadelphia millionaire and his family are the subject of this Walt Disney musical.

Garson is in stylish attire, and the costumes in general have been well thought out in terms of the period. As is usual with period films from the 1960s, the hair and makeup of the women date it rather precisely.

Rasputin and the Empress (*M.G.M. 1932*). *Costumes by Adrian. Starring John Barrymore (Prince Chegodieff), Ethel Barrymore (the Czarina), Lionel Barrymore (Rasputin). Set in Russia, 1904–18.*

The entire Barrymore clan ham it up with entertaining results in this melodramatic tale of the fall of the Romanov dynasty.

Ethel Barrymore's hair is heavily marcelled. The children wear 1930s-style dresses. The gowns worn in the court scenes bear no resemblance to the real court dress of the period.

Nicholas and Alexandra (*Columbia, 1971*). *Costumes by Yvonne Blake, Antonio Castillo (for Janet Suzman and Irene Worth), and John Mollo (military costumes). Starring Michael Jayston (Nicholas), Janet Suzman (Alexandra), and Irene Worth (Marie Federova). Set in Russia, 1904–18.*

The film covers the same events as *Rasputin and the Empress* but with less dramatic effect. Franklin Schaffner directed.

The designers did a masterful job on the costumes. The only noticeable error is the placement of the hats on the royal children, which is awkward and nonperiod. According to reliable sources the children pushed the hats back away from their faces just before the cameras rolled. The hairstyles are strongly influenced by the 1970s styles.

Funny Girl (*Columbia, 1968*). *Costumes by Irene Sharaff, Howard Shoup. Starring Barbra Streisand (Fanny Brice) and Omar Sharif (Nick Arnstein). Set in New York City, about 1918–29.*

Barbra Streisand plays Ziegfeld star Fanny Brice, the role that made her a Broadway star. This film version, directed by William Wyler, won Streisand an Oscar. (In 1975 she played the part again in a less effective sequel, *Funny Lady*, directed by Herbert Ross.)

Even though Streisand wears an original Fortuny gown, her hairstyle undercuts the attempt to establish an air of authenticity. Many of the women in the film wear beehive hairdos.

By the Light of the Silvery Moon (*Warner Bros., 1953*). *Costumes by Leah Rhodes.*

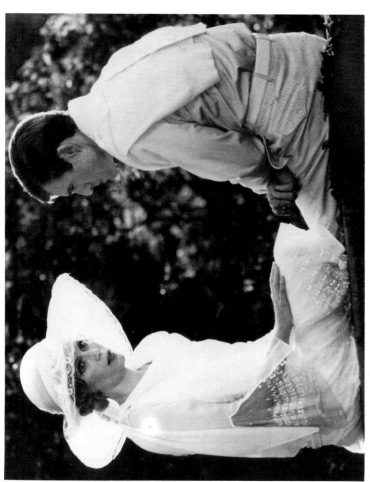

Mia Farrow and Robert Redford in *The Great Gatsby* (1974)

Starring Doris Day (Marjorie Winfield) and Gordon MacRae (William Sherman). Set in Indiana, 1919.

Loosely based on Booth Tarkington stories, this bit of musical nostalgia concerns a couple in the period just following World War I. This film was a sequel to *On Moonlight Bay* (Warner Bros., 1952), a film with the same cast and characters set in an earlier time frame.

The costumes are only vaguely related to the dress of 1919, and most of the outfits worn by Day would have looked perfectly normal on any American street in 1953.

1920–29

The Great Gatsby (*Paramount, 1974*). *Costumes by Theoni V. Aldredge. Starring Robert Redford (Jay Gatsby) and Mia Farrow (Daisy Buchanan). Set in "West Egg," Long Island, 1920–25.*

F. Scott Fitzgerald's classic love story of a shady businessman in thrall to a flighty society girl was transformed into a monumental production, directed by Jack Clayton. One of the most aggressively marketed features ever to come out of Hollywood, this Robert Evans production sported tie-ins with everything from liquor to Teflon cookware. Twenties clothing, however, was the major point of sales focus. An earlier version of *Gatsby*, with considerably less attention paid to detail, was made in 1949. Alan Ladd and Betty Field played the leading roles. Elliott Nugent directed.

The costumes on both men and women appear to be historically correct, even down to the men's shoelaces, tied in a ladder fashion across from hole to hole rather than alternating holes in a chevron pattern. The soft, full hairstyles are the most outstanding 1970s feature in the film, bearing no resemblance to the close, tight, formalized styles of the 1920s, which would have covered the foreheads.

Love Me or Leave Me (*M.G.M., 1955*). *Costumes by Helen Rose. Starring Doris Day (Ruth Etting) and James Cagney (Moe Snyder). Set in New York City, Chicago, and Hollywood, 1920–30s.*

The love story of singer Ruth Etting and her brutish manager/husband, Moe Snyder, is the subject of this powerful musical melodrama directed by Charles Vidor.

The filmmakers did not really attempt period re-creation. There are "garden party" hats, 1950s lace gowns, sequined spaghetti straps, and "shirt waist" dresses, none of which bear any resemblance to the styles of the period. Day's 1920s-styled bandeau is not horizontal, as it would have been in the 1920s. Instead it is tilted higher in the front than in the back and is covered by the soft curls of her 1950s "poodle" haircut.

Gypsy (*Warner Bros., 1962*). *Costumes by Orry-Kelly. Starring Rosalind Russell (Rose) and Natalie Wood (Louise). Set in New York City, Chicago, Seattle, and the Midwest, 1920–30s.*

The ground-breaking Jules Styne-Stephen Sondheim musical about the early vaudeville career of stripper Gypsy Rose Lee is given a visually brassy but dramatically muted treatment in this film version directed by Mervyn LeRoy.

The costumes are, for the most part, styled only vaguely in 1920s and 1930s modes. A

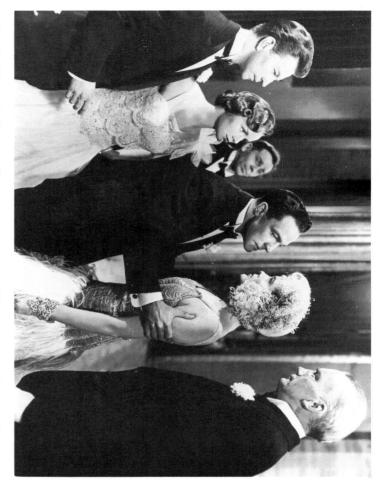

Donald O'Connor, Debbie Reynolds, King Donovan, Gene Kelly, Jean Hagen, and Millard Mitchell in *Singin' in the Rain.*

successful attempt at authenticity, however, was made in reproducing Baby June's white ensemble and Louise's velvet suit, both of which are based on the outfits the real Mama Rose designed for the real June and Louise. Later in the film Wood wears a hat that appears to be exactly the same as one Orry-Kelly made for Marilyn Monroe in *Some Like It Hot* only three years earlier. In keeping with the styles of the early 1960s, the actresses have well-developed beehive hairdos, and their breasts are "lifted and separated."

Cheaper by the Dozen (*Twentieth Century-Fox, 1950*). *Costumes by Edward Stevenson and Charles LeMaire. Starring Clifton Webb (Frank Bunker Gilbreth), Myrna Loy (Lillian Gilbreth), and Jeanne Crain (Ann Gilbreth). Set in Montclair, New Jersey, 1921.*

An unconventional father with an overwhelmingly large brood is the subject of this light family comedy, based on the book by Frank Gilbreth and Ernestine Gilbreth Carey.

Loy wears a variety of fairly authentic 1920s dresses. The hairstyles of the children, with bangs and forms of ponytails, strongly reflect the 1950s influence.

Thoroughly Modern Millie (*Universal, 1966*). *Costumes by Jean Louis. Starring Julie Andrews (Millie), Mary Tyler Moore (Dorothy), James Fox (Jimmy), and Carol Channing (Missy). Set in New York City, 1922.*

George Roy Hill directed this good-natured spoof on the fads and fashions of the 1920s.

The dresses in the film are fitted and display the women's curves rather than hiding them; they lack the 1920s verticality. Cloche hats, an important part of the period look, are included in the wardrobe, but they are always worn too high, never correctly at eyebrow level. Beatrice Lillie as the operator of the hotel for women wears an enormous beehive and 1960s makeup.

The Roaring Twenties (*Warner Bros., 1939*). *Costumes by Milo Anderson. Starring James Cagney (Eddie Bartlett), Humphrey Bogart (George Hally), and Priscilla Lane (Jean Whelan). Set in New York City, about 1917-27.*

This fast and entertaining Cagney vehicle, directed by Raoul Walsh, tells of the rise and fall of a mobster with a heart of gold.

The costumes pass as accurate period renditions, but the hairstyles do not. No period film has correctly portrayed the 1920s hairstyles, which required hair over the forehead. Moviemakers apparently believed that audiences would find such a look too distracting.

Elmer Gantry (*United Artists, 1960*). *Costumes by Dorothy Jeakins. Starring Burt Lancaster (Elmer Gantry), Jean Simmons (Sister Sharon Falconer). Set in the Midwest, 1927.*

Richard Brooks's spirited adaptation of Sinclair Lewis's novel about a phony evangelist proved as controversial on the screen as it did in print.

Jeakins's costumes evoke an unadorned 1920s look without specific period details.

Chariots of Fire (*Ladd Company, 1981*). *Costumes by Milena Canonero. Starring Ben Cross (Harold Abrahms) and Ian Charleson (Eric Liddell). Set in Cambridge, London, and Paris, 1927-28.*

Britain's track and field victories at the 1928

Rosalind Russell in *Auntie Mame*

Olympics and the stories of the men who ran the races are the basis for this patriotic panorama, the Oscar winner for Best Picture of 1981.

Renowned for its excellent Oscar-winning costumes, this film may have anachronisms, but more time must pass before any become apparent.

Tender Is the Night (*Twentieth Century-Fox, 1962). Costumes by Pierre Balmain and Marjorie Best. Starring Jennifer Jones (Nicole Diver) and Jason Robards, Jr. (Dick Diver). Set in Paris, Rome, and Switzerland, about 1928–29.*

F. Scott Fitzgerald's story of a beautiful, mentally disturbed young woman is given a reserved treatment in this film. Mental breakdown was never more genteel.

There is a strong undercurrent of late-1950s aesthetics in the costumes for this film. The sketches, in particular, illustrate the influence of the current stance on all costumes. In one case the model stands with her pelvis jutting forward, a position completely unrelated to the stance of the 1920s.

Singin' in the Rain (*M.G.M., 1952). Costumes by Walter Plunkett. Starring Gene Kelly (Don Lockwood), Donald O'Connor (Cosmo Brown), Debbie Reynolds (Kathy Selden), and Jean Hagen (Lina Lamont). Set in Hollywood, 1929.*

Often cited as the greatest of all M.G.M. musicals, this spoof of the troubles faced by the movie community when sound came in boasts great songs by Arthur Freed and Nacio Herb Brown, a terrific screenplay by Betty Comden and Adolph Green, and superb direction by Gene Kelly and Stanley Donen.

Some of the less elaborate dresses are straight out of the fashion journals of the 1920s. The more elaborate ones seen in the night-club scenes are strongly influenced by 1950s styles. The hairstyles and hats are of modern form, leaving foreheads exposed.

Some Like It Hot (*United Artists, 1959). Costumes by Orry-Kelly and Bert Henrikson. Starring Marilyn Monroe (Sugar Kane), Jack Lemmon (Jerry/Daphne), and Tony Curtis (Joe/Josephine). Set in Chicago and Miami, 1929.*

One of the funniest comedies ever made, this

Billy Wilder film centers on two musicians, Lemmon and Curtis, who witness the St. Valentine's Day massacre and then escape the wrath of Chicago's gangland by disguising themselves as musicians and joining an all-girl band. Complications ensue when they meet the band's chief asset: Monroe.

The "no bust" look of the 1920s was completely lost on Monroe, but the flapper dresses worn by Lemmon and Curtis are much more convincing.

Auntie Mame (*Warner Bros., 1958). Costumes by Orry-Kelly. Starring Rosalind Russell (Auntie Mame), Forrest Tucker (Beauregard Burnside), and Coral Browne (Vera Charles). Set in New York City, Connecticut, Georgia, and Switzerland, 1928–58.*

Patrick Dennis's tale of a sophisticated New Yorker whose motto was "Live, live, live!" was first a bestseller, next a hit play, then this hit movie, later a hit musical, and finally a nonhit film of that musical (with Lucille Ball in the title role).

The film has wild, exotic costumes, which were based on the ones in the Broadway play. They evoke a period feeling but are not exact re-creations of period styles. From beginning to end the hairstyles are from 1958.

Giant (*Warner Bros., 1956). Costumes by Moss Mabry and Marjorie Best. Starring Rock Hudson (Bick Benedict), Elizabeth Taylor (Leslie Benedict), and James Dean (Jett Rink). Set in Texas and Virginia, 1929–56.*

Edna Ferber's sprawling saga of a Texas oil family is transported to the screen in grand style by director George Stevens.

Only modest concessions were made in the costumes to reflect the period represented. With her 1920s suit Taylor wore a cloche, but her entire forehead was exposed. Throughout the film, which covers twenty-six years, she wears the same 1956-styled makeup.

Star! (*Twentieth Century-Fox, 1968). Costumes by Donald Brooks. Starring Julie Andrews (Gertrude Lawrence) and Daniel Massey (Noël Coward). Set in London and New York City, 1906–30s.*

The life of British stage star Gertrude Lawrence makes for a somewhat stolid musical drama. Robert Wise directed.

Left: Liza Minnelli in *Cabaret*
Right: Susannah York in *They Shoot Horses Don't They?*

Brooks, a New York fashion designer, created a wardrobe with a "retro" look, which was very beautiful but had no relation to the period dress. Authenticity was probably not an important factor in making costume decisions.

1930–39

The Boy Friend (*M.G.M.*, *1971*). *Costumes by Shirley Russell. Starring Twiggy (Polly), Christopher Gable (Tony), and Tommy Tune (Tommy). Set in the English provinces, 1930.* Sandy Wilson's musical spoof of the 1920s was transformed by director Ken Russell into a spoof/*hommage* to movie musicals.

There are many 1920s elements in the costumes, such as the elongated waistlines and the flapper look. The eye-makeup is reminiscent of the type used in the early silent films, in which large, dark, expressive eyes were used to convey emotion.

The Sound of Music (*Twentieth Century-Fox, 1965*). *Costumes by Dorothy Jeakins. Starring Julie Andrews (Maria) and Christopher Plummer (Capt. von Trapp). Set in Salzburg, Austria, about 1930–34.* Under the direction of Robert Wise, Rodgers and Hammerstein's musical about the singing von Trapp family became one of the most popular films ever made.

Andrews wears both hair and makeup styles of the mid-1960s. The rustic clothing of the family is of no particular period style. In the dance sequence the oldest daughter wears a dress that looks exactly like a modern prom dress.

The Damned (*Warner Bros., 1969*). *Costumes by Piero Tosi. Starring Dirk Bogarde (Frederich Bruckmann), Ingrid Thulin*

(Baroness Sophie), and Helmut Berger (Martin). Set in Germany, about 1930–34.

Tosi created a masterpiece of period atmosphere. His costumes, including genuine 1930s bias-cut dresses, helped revive an interest in 1930s fashions. The film also popularized plucked eyebrows and close-cut hairdos.

Bonnie and Clyde (Warner Bros., 1967). *Costumes by Theadora van Runkle. Starring Warren Beatty (Clyde Barrow) and Faye Dunaway (Bonnie Parker). Set in the Midwest, 1930–39.*

One of the most popular and controversial films of the 1960s, this tale of the two infamous bandits sparked a revival of 1930s styles.

The men's clothes were very authentic-looking with period fabrics and details. Dunaway's clothes were also made from correct period fabrics, but the length of the skirt was compromised. The miniskirt was in style in the late 1960s, and the nearly ankle-length skirts of the period would have seemed too awkward and unflattering to the contemporary audience. Dunaway's hairdo resembles Raquel Welch's in *One Million Years* BC. See Chapter III.

Lady Sings the Blues (Paramount, 1972). *Costumes by Bob Mackie, Ray Aghayan (for Diana Ross), and Norma Koch. Starring Diana Ross (Billie Holiday) and Billy Dee Williams (Louis McKay). Set in Baltimore and New York City, 1930–59.*

The lady here is the peerless jazz songstress, Billie Holiday.

Ross wore a 1930s "Letty Lynton" style dress during the 1930s sequence, but the cut and construction are misunderstood, and the dress is somewhat shapeless. Both hair and makeup are basically modern.

Cabaret (Allied Artists, 1972). *Costumes by Charlotte Fleming. Starring Liza Minnelli (Sally Bowles), Michael York (Brian Roberts), and Joel Grey (master of ceremonies). Set in Berlin, 1931.*

Liza Minnelli won an Oscar for her portrayal of a night-club singer in Berlin during the Nazis' rise to power. Bob Fosse directed and choreographed the movie, based on Christopher Isherwood's *Berlin Stories* and John van Druten's *I Am a Camera.*

The evocation of the period was much less successful than *The Damned,* released three years earlier. As is usual in 1970s films set in the 1930s, the men's clothes are more historically accurate than those of the women. The cut of a suit is more easily reproduced than the cut of a dress.

They Shoot Horses Don't They? (*Cinerama Releasing, 1969). Costumes by Donfeld. Starring Jane Fonda (Gloria Beatty), Michael Sarrazin (Robert Syverton), and Gig Young (master of ceremonies). Set in Los Angeles, 1932.*

Horace McCoy's tragic tale of Hollywood in the days of the dance marathons was brought to the screen with dramatic flair by Sydney Pollack.

Most of the clothes worn by the women have a wonderful homemade look about them, which is appropriate for costumes from the Depression years. The makeup artists attempted to re-create 1930s eye makeup but were only partially successful.

Ship of Fools (*Columbia, 1965). Costumes by Bill Thomas. Starring Vivien Leigh (Mary Treadwell), Simone Signoret (La Condesa), Oskar Werner (Dr. Schumann), Lee Marvin (Tenny). Set on an ocean liner traveling from Vera Cruz to Bremerhaven, 1933.*

Stanley Kramer turns Katharine Anne Porter's celebrated novel about an ocean voyage into a political and philosophical debate about the causes of World War II.

Thomas was striving to create a timeless look and was not concerned with rigorous authenticity. The wardrobe's chiffon dresses and fitted bodices resemble more closely the dress of the 1950s than the clothing of the 1930s (the film's period setting).

Murder on the Orient Express (*Paramount, 1974). Costumes by Tony Walton. Starring Albert Finney (Hercule Poirot), Lauren Bacall (Mrs. Hubbard), Ingrid Bergman (Greta), Sean Connery (Col. Arbuthnot), and Vanessa Redgrave (Mary Debenham). Set on the Orient Express, 1934.*

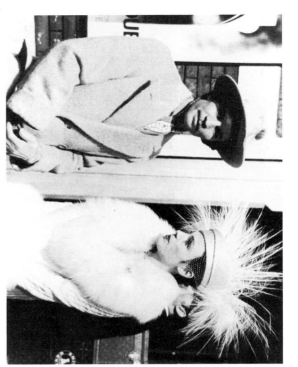

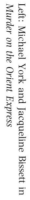

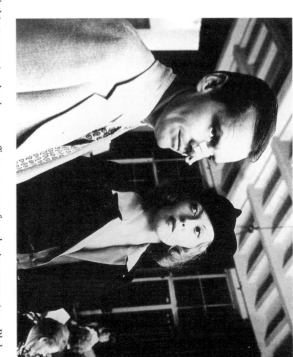

Left: Michael York and Jacqueline Bissett in *Murder on the Orient Express*
Right: Jack Nicholson and Faye Dunaway in *Chinatown*

Sidney Lumet directed this tongue-in-cheek version of Agatha Christie's classic murder mystery, using an all-star cast. There is a strong emphasis on fashion.

The men's clothing is much more convincing than that of the women. The makeup and hairstyles are contemporary.

Pennies from Heaven (*M.G.M., 1981*). *Costumes by Bob Mackie. Starring Steve Martin (Arthur Parker) and Bernadette Peters (Eileen). Set in Chicago, 1934.*

A sheet-music salesman, trying to make ends meet during the Depression, finds release in the songs he sells. Adapted from a British television series of the same name, the film is a mixture of stark drama sequences and musical numbers. Herbert Ross directed.

Mackie made masterful use of plaids and prints on both the men's and women's clothing. The eye makeup appears to be historically correct, but it may be a little exaggerated. It has only been six years since the film's release, and the exaggeration may become clearer with the passing of time.

Victor/Victoria (*M.G.M., 1982*). *Costumes by Patricia Norris. Starring Julie Andrews (Victoria/Victor), Robert Preston (Toddy), and James Garner (King Marchan). Set in Paris, 1934.*

A penniless British singer becomes an overnight sensation when she passes herself

off as a gay female impersonator. Blake Edwards directed this musical farce.

The costumes look virtually perfect to us today. As with other films of the 1980s, it will be at least ten years before we can see the contemporary influence.

The Sting (*Universal, 1973*). *Costumes by Edith Head. Starring Paul Newman (Henry Gondorff) and Robert Redford (Johnny Hooker). Set in Chicago and Joliet, Illinois, 1936.*

Topping their runaway hit *Butch Cassidy and the Sundance Kid*, Newman and Redford reteamed as big-time con men in this George Roy Hill production.

The stars' costumes strongly influenced the cut of men's clothes in the mid-1970s, returning broad lapels and pin-striped Al Capone suits to the fashion forefront.

Chinatown (*Paramount, 1974*). *Costumes by Anthea Sylbert. Starring Jack Nicholson (J. J. Gittes) and Faye Dunaway (Evelyn Mulwray). Set in Los Angeles, 1937.*

Roman Polanski directed this loving re-creation of the Raymond Chandler-style thriller. It is a story about big-city corruption, based on an original script by Robert Towne.

Dunaway wears convincing clothing and makeup. Nicholson is appropriately attired for the period and wears his hair parted and slicked in the style of the 1930s.

Robert Redford in *The Sting*

Robert Redford and Barbra Streisand in *The Way We Were*

Beloved Infidel (*Twentieth Century-Fox, 1959*). *Costumes by Bill Thomas. Starring Gregory Peck (F. Scott Fitzgerald) and Deborah Kerr (Sheilah Graham). Set in New York City and Hollywood, 1937–40.*

Hollywood columnist Sheilah Graham's love affair with doomed alcoholic novelist F. Scott Fitzgerald is transformed into melodrama in this Twentieth Century-Fox production.

Even though the film was made only about twenty years after the period setting, the women's clothing is not historically accurate and has the shape popular in 1959.

The Way We Were (*Columbia, 1973*). *Costumes by Dorothy Jeakins and Moss Mabry. Starring Barbra Streisand (Katie Morosky), Robert Redford (Hubbell Gardiner). Set in New York City and Hollywood, 1937–57.*

The unlikely pairing of two of Hollywood's biggest stars matched perfectly with the story of a pair of unlikely lovers. Arthur Laurents wrote the script about a campus radical in love with an apolitical "golden boy." Sydney Pollack directed.

The costumes were carefully researched and constructed. Streisand's hair, however, is an obvious clue that the film was not shot during the period but is in the style of the 1970s.

1940–49

1941 (*Universal, 1979*). *Costumes by Deborah Nadoolman. Starring Bobby di Cicco (Wally), John Belushi (Wild Bill Kelso), Ned Beatty (Ward Douglas), Treat Williams (Sitarski), Dianne Kay (Betty), and Wendy Jo Sperber (Maxine). Set in Los Angeles, December 13, 1941.*

Steven Spielberg's wildly overscaled, live-action cartoon about war hysteria in Los Angeles makes a Three Stooges programmer look like Ernst Lubitsch.

Both the tailoring of the women's suits and the casualness of their hairstyles create a look that is perfect for 1979. The slick perfection of 1941 fashion is not evident. Nadoolman's costumes fit right into the film's cartoonish style.

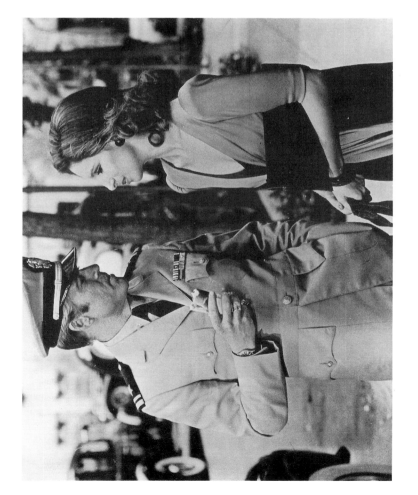

Liza Minnelli and Robert de Niro in *New York, New York*

The Diary of Anne Frank (*Twentieth Century-Fox, 1959*). *Costumes by Charles LeMaire. Starring Millie Perkins (Anne), Richard Beymer (Peter), and Shelley Winters (Mrs. van Daan). Set in Amsterdam, 1942–45.*

George Stevens directed this moving film based on the diaries of a young Jewish girl who hid with her family from the Nazis in an attic in Amsterdam. It was adapted from a Broadway play.

It would be difficult to tell what period the film is portraying, if one were to look only at the costumes. Winters wore a late-1950s hairstyle: an oversized hairdo with a modified French twist.

South Pacific (*Twentieth Century-Fox, 1958*). *Costumes by Dorothy Jeakins. Starring Rossano Brazzi (Emile de Beque) and Mitzi Gaynor (Nellie Forbush). Set in the South Pacific during World War II, 1942–45.*

Under Joshua Logan's direction Rodgers and Hammerstein's great musical drama of World War II was turned into a placid but pictorially stunning adaptation.

Gaynor appears in all manner of late-1950s attire. From strapless sundresses to paramilitary shirts with the sleeves rolled up, virtually all of her costumes, except for her uniform, are contemporary.

New York, New York (*United Artists, 1977*). *Costumes by Theadora van Runkle. Starring Robert de Niro (Jimmy Doyle) and Liza Minnelli (Francine Evans). Set in New York City and South Carolina, 1945–55.*

Martin Scorsese's wildly experimental musical drama about the troubled love affair of a band singer and a jazz musician. Shot in a stylized manner—the enormous sets are meant to be seen and appreciated as sets—this production was "ahead of its time."

Upon first and even second glance the costumes in this film look perfect for the period. After careful scrutiny, however, one can see a certain exaggeration in all of the clothing, hair, and makeup. Everything seems a little overstated. This is most noticeable in the women's hairstyles: for example, Minnelli wears an elaborate snood.

Cathy Moriarty in *Raging Bull*

Raging Bull (*United Artists, 1980*). *Costumes by Richard Bruno and John Boxer. Starring Robert de Niro (Jake La Motta), Cathy Moriarty (Vickie La Motta), and Joe Pesci (Joey). Set in New York City and Miami, 1941–64.*

Robert de Niro's astonishing Oscar-winning performance dominates this Martin Scorsese biography of boxer Jake La Motta.

While the story is set largely in the same period as that covered by *New York, New York*, costume and makeup treatment are considerably more restrained. The filmmakers based their research on photographs and home movies provided by the actual subjects of the story. The white turban and sunsuit that Jake gives Vickie as a present in one scene are an exact copy of the ensemble worn by Lana Turner in *The Postman Always Rings Twice* (*M.G.M. 1945*).

1950–59

Heartbeat (*Orion, 1980*). *Costumes by Patricia Norris. Starring Nick Nolte (Neal Cassady), Sissy Spacek (Carolyn Cassady), and John Heard (Jack Kerouac). Set in San José, San Francisco, and New York City, 1950–56.*

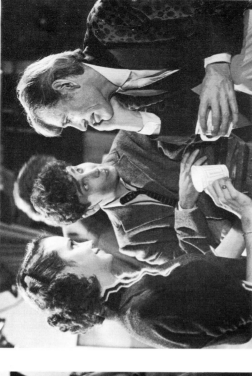

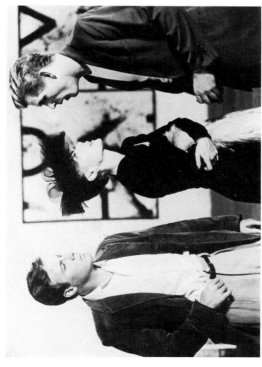

This tale of the Beat Generation chronicles the friendship of Kerouac and Cassady.

There is much fashion emphasis as a result of the costumes for Cassady's style-conscious wife, portrayed by Spacek. The costumes generally appear to be authentic. The men's hairstyles, however, are too long for this period.

My Favorite Year (*M.G.M., 1982*). *Costumes by May Routh. Starring Peter O'Toole (Alan Swann), Mark Linn-Baker (Benjy Stone), and Jessica Harper (K. C. Downing). Set in New York City, 1954.*

A loving re-creation of the atmosphere of early television in general and Sid Caesar's legendary *Your Show of Shows* in particular. Many of the distinctive fashion elements of 1954, such as full skirts, are in the costumes. With the passage of time the contemporary influence may become more apparent.

Grease (*Paramount, 1978*). *Costumes by Albert Wolsky. Starring John Travolta (Danny) and Olivia Newton-John (Sandy). Set at "Rydell High School," about 1958–62.*

The Broadway musical about teenagers in the 1950s that was transformed into a successful stylized movie with costumes that evoke the 1950s without offending the public of 1978. Many of the most fondly re-membered aspects of those innocent years come to life on the screen.

The Idolmaker (*United Artists, 1980*). *Costumes by Rita Riggs. Starring Ray Sharkey (Vincent Vacarri), Tovah Feldshuh (Brenda Roberts), and Peter Gallagher (Caesare). Set in New York City and New Jersey, 1959–62.*

The rise of Frankie Avalon and Fabian, two teen heartthrobs of the early 1960s, provides the basis for this story of a firebrand business manager and his two budding pop stars.

Left: John Heard, Sissy Spacek, and Nick Nolte in *Heartbeat*

Right: Jessica Harper, Mark Linn-Baker, and Peter O'Toole in *My Favorite Year*

Sid Caesar and Eve Arden in *Grease*

Left: Paul Land in *The Idolmaker*

Right: Julie Christie, Goldie Hawn, Tony Bill, and Warren Beatty in *Shampoo*

This movie features men's period fashion from its opening shot (Sharkey pulling up his black nylon sock) to the last scene. The flamboyant costumes devised for teen idols of the period, such as jackets without lapels and silver lamé jumpsuits, are included in the wardrobe.

1960–69

American Graffiti (*Universal, 1973*). Costumes by Aggie Guerard Rodgers. Starring Richard Dreyfuss (*Curt*), Ron Howard (*Steve*), Paul Le Mat (*John*), and Cindy Williams (*Laurie*). Set in Modesto, California, 1962.

The lives and loves of small-town teenagers in Modesto, California, are treated with seriousness and humor in this George Lucas production.

Flip hairdos on the girls, "shawl collars" on the guys, sweaters, and polished cotton pants all give an air of authenticity to this film.

Shampoo (*Columbia, 1975*). Costumes by Anthea Sylbert. Starring Warren Beatty (*George*), Julie Christie (*Jackie*), and Goldie Hawn (*Jill*). Set in Los Angeles, November 4 (*election eve*), 1968.

Beatty is a Beverly Hills hairdresser who cannot keep his hands off his beautiful

clientèle. Set at the close of the 1960s, there are political undertones to this satirical romp directed by Hal Ashby from a script by Robert Towne and star/producer Warren Beatty.

Mini skirts and *Star Trek* hairdos for the women, modified Beatle haircuts for the men, and late-hippie jewelry and neck scarves send the viewer back to 1968.

1970s

Sid and Nancy (*Samuel Goldwyn Productions, 1986*). Costumes by Cathy Cook and Theda deRamus. Starring Gary Oldman (*Sid Vicious*) and Chloe Webb (*Nancy Spungen*). Set in New York City and London, 1977–78.

More time is needed to get a grip on the total fashion picture for the late 1970s; but undoubtedly when the history of this era is written, punk will emerge as a major fashion style. This tale of the comic/tragic love affair of the guitarist for the Sex Pistols and his groupie girlfriend is the *Romeo and Juliet* of punk.

The main fashion feature that stands out in this glimpse at the 1970s is the tenacity of the punk movement. The clothes worn in the film could be seen any night of the week on Melrose Avenue in Los Angeles in 1987.

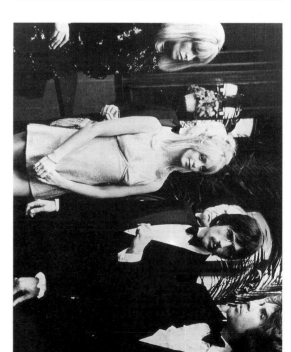

Kier Dullea in *2001: A Space Odyssey*

The Future

Tron (*Buena Vista*, 1982). *Costumes by Elois Jenssen and Rosanna Norton. Starring Jeff Bridges (Kevin Flynn/Clu), Bruce Boxleitner (Alan Bradley/Tron), and David Warner (Ed Dillinger/Sark). Set in an unspecified location sometime in the future.*

Video-game players find themselves propelled into a futuristic computer world in this visually challenging science-fiction adventure. See *Visions of the Future photo-essay.*

2001: A Space Odyssey (*M.G.M.*, 1968). *Costumes by Hardy Amies. Starring Kier Dullea (David Bowman) and Gary Lockwood (Frank Poole). Set on Earth, the Moon, and outer space, prehistory and 2001.*

Stanley Kubrick's metaphysical spectacular caught critics by surprise in the year of its release; many were expecting a conventional science-fiction film and were annoyed to find something quite different. But audiences warmed to its minimalist narrative (the first half-hour passes without dialogue) and its maximum impact visionary finale. See *Visions of the Future photo essay.*

Blade Runner (*Ladd Company/Run Run Shaw*, 1982). *Costumes by Charles Knode and Michael Kaplan. Starring Harrison Ford (Rick Deckard), Rutger Hauer (Roy Batty), and Sean Young (Rachel). Set in Los Angeles, 2019.*

Based on Philip K. Dick's comic novel *Do Androids Dream of Electric Sheep?*, this very serious look at the future combines the atmosphere of the 1940s film noir with a vision of a future Los Angeles straight out of Hieronymus Bosch. See *Visions of the Future photo essay.*

Logan's Run (*M.G.M.*, 1976). *Costumes by Bill Thomas. Starring Michael York (Logan), Jenny Agutter (Jessica), and Farrah Fawcett-Majors (Holly). Set in what once was Washington D.C., twenty-third century.*

The film shows a society given to hedonistic pleasure. The only catch is that death awaits those over thirty. See *Visions of the Future photo essay.*

Star Trek: The Motion Picture (*Paramount, 1979*). *Costumes by Robert Fletcher. Starring William Shatner (Capt. Kirk), Leonard Nimoy (Spock), and DeForest Kelly (Dr. McCoy). Set in outer space, twenty-third century.*

Star Trek II: The Wrath of Khan (*Paramount, 1982*). *Costumes by Robert Fletcher. Starring William Shatner (Commander Kirk), Leonard Nimoy (Spock), and Ricardo Montalban (Khan). Set in outer space, twenty-third century.*

Star Trek III: The Search for Spock (*Paramount, 1984*). *Costumes by Robert Fletcher. Starring William Shatner (Commander Kirk), Leonard Nimoy (Spock), and Christopher Lloyd (Kruge). Set in outer space, twenty-third century.*

Star Trek IV: The Voyage Home (*Paramount, 1986*). *Costumes by Robert Fletcher. Starring William Shatner (Commander Kirk), Leonard Nimoy (Spock), and Catherine Hicks (Gillian). Set in San Francisco, 1986, and outer space, twenty-third century.*

The television series that went "where no man has gone before" went where no one expected it to go: into the movies. See *Visions of the Future photo essay.*

Battlestar Galactica (*Universal, 1979*). *Costumes by Jean-Pierre Dorleac. Starring Richard Hatch (Capt. Apollo), Dirk Benedict*

Max von Sydow in *Flash Gordon* (1980)

(Lt. Starbuck), Lorne Greene (Cmdr. Adama), and Jane Seymour (Serina). Set in outer space, the unspecified future.

Just as *Star Trek* made a successful transition from television to the big screen, it was hoped that this science-fiction series would do likewise. Audiences, however, proved unwilling to go to the theaters and pay for a story they could get free at home. Many costumes had oriental and medieval motifs.

Buck Rogers in the Twenty-fifth Century (Universal, 1979). *Costumes by Jean-Pierre Dorleac. Starring Gil Gerard (Buck Rogers), Pamela Hensley (Princess Ardala), and Erin Gray (Wilma Deering). Set in outer space, twenty-fifth century.*

Dorleac's costumes were featured in this movie, yet another television series regeared for the big screen. Buster Crabbe played the original Buck Rogers in the 1930s serial. See *Visions of the Future* photo essay.

Star Wars (Twentieth Century-Fox, 1977). *Costumes by John Mollo. Starring Mark Hamill (Luke Skywalker), Harrison Ford (Han Solo), Carrie Fisher (Princess Leia Organa), Alec Guinness (Obi-Wan Kenobi), Anthony Daniels (C3PO), Kenny Baker (R2D2), Peter Mayhew (Chewbacca), and David Prowse (Darth Vader). Set "a long time ago in a galaxy far far away."*

The Empire Strikes Back (Twentieth Century-Fox, 1983). *Costumes by John Mollo. Starring Mark Hamill (Luke Skywalker), Harrison Ford (Han Solo), Carrie Fisher (Princess Leia Organa), Alec Guinness (Obi-Wan Kenobi), Anthony Daniels (C3PO), Kenny Baker (R2D2), Peter Mayhew (Chewbacca), David Prowse (Darth Vader), Billy Dee Williams (Lando Calrissian). Set "a long time ago in a galaxy far far away."*

Return of the Jedi (Twentieth Century-Fox, 1983). *Costumes by Aggie Guerard Rodgers and Nilo Rodis. Starring Mark Hamill (Luke Skywalker), Harrison Ford (Han Solo), Carrie Fisher (Princess Leia Organa), Alec Guinness (Obi-Wan Kenobi), Anthony Daniels (C3PO),*

Kenny Baker (R2D2), Peter Mayhew (Chewbacca), David Prowse (Darth Vader), Billy Dee Williams (Lando Calrissian). Set "a long time ago in a galaxy far far away."

From the moment it hit the screen, George Lucas's outer space adventure saga—a compendium of pop-culture artifacts, ranging from comic strips to Saturday matinee serials: Hermann Hesse's *Steppenwolf*; and a touch of Richard Wagner's *Ring* cycle thrown in for good measure—wended its way into the hearts of the moviegoing public. See *Visions of the Future* photo essay.

Flash Gordon (Universal, 1936). *Costumes uncredited. Starring Buster Crabbe (Flash Gordon), Jean Rogers (Dale Arden), and Charles Middleton (Ming the Merciless). Set on Earth and the planet "Mongo," sometime in the future.*

Flash Gordon (Universal/Dino de Laurentiis, 1980). *Costumes by Danilo Donati. Starring Sam J. Jones (Flash Gordon), Melody Anderson (Dale Arden), Max Von Sydow (Ming the Merciless), and Ornella Muti (Princess Aura). Set on Earth and the planet "Mongo," sometime in the future.*

The great 1936 comic-strip adventure serial has delighted generations with its tawdry energy and melodramatic spirit. While the original movie was played straight with hilarious results, the 1980 version was done for laughs and is almost as much fun. See *Visions of the Future* photo essay.

Barbarella (Paramount/Dino de Laurentiis, 1968). *Costumes by Jacques Fonteray. Starring Jane Fonda (Barbarella), John Philip Law (Pygar), and Anita Pallenberg (The Black Queen). Set on the planet "Sogo," sometime in the future.*

Jean-Claude Forest's naughty comic strip for adults was brought to the screen by the only director possible for such material. Roger (*And God Created Woman*) Vadim. Fonda is delightfully funny and sexy as the astronaut-adventurer-heroine. See *Visions of the Future* photo essay.

Notes to the Text

Index of Designers · Index of Movie Titles

Notes to the Text

Notes to Chapter I. The Celluloid Image: *Historical Dress in Film*

1. Geoffrey Squire, *Dress and Society* (London, 1972), 17–18.

2. For further discussion of the wedding gown, see Chapter III.

3. M.G.M. press release, 1940, *Pride and Prejudice* clipping file, Academy of Motion Picture Arts and Sciences Library, Beverly Hills, CA.

4. David Chierichetti, *Hollywood Director: The Career of Mitchell Leisen* (New York, 1973).

5. I thank my colleague Satch LaValley for providing me with information on the history of costume design in the 1910s and 1920s.

6. Twentieth Century-Fox press release by Harry Brand, 1947, 5–6, *Forever Amber* clipping file, Academy of Motion Picture Arts and Sciences Library, Beverly Hills, CA.

7. "Over Four Thousand Costumes in *The Prodigal*," *Los Angeles Mirror News*, 2 May 1955, *The Prodigal* clipping file, Academy of Motion Picture Arts and Sciences Library, Beverly Hills, CA.

8. "The Prodigal Arrives at Capitol," *New York Post*, 14 May 1955, *The Prodigal* clipping file, Academy of Motion Picture Arts and Sciences Library, Beverly Hills, CA.

9. Ibid.

10. Madeleine Vionnet, a Parisian couturière, was renowned for her achievements in this form; one of the techniques she developed was to hang lengths of fabric by one corner for several weeks, allowing the textile to stretch in the direction of the bias.

11. The widespread popularity and acceptance of the suit for ladies, a somewhat masculine garment, may lie in the uniforms worn by military women during World War II.

12. Twentieth Century-Fox press release, 1943, 1, *Hello Frisco Hello* clipping file, Academy of Motion Picture Arts and Sciences Library, Beverly Hills, CA.

13. "Details Nudge Past into Focus in Making Films," *Los Angeles Times*, 15 March 1954, sec. 2.

14. This information came from Walter Plunkett in a personal conversation with Satch LaValley.

15. Chierichetti, *Hollywood Director*, 37.

16. "Lurex, Miracle in Metallics," *American Fabrics* 2 (Spring 1947), 60.

17. Chierichetti, *Hollywood Director*, 275.

18. Twentieth Century-Fox press release by Harry Brand, 19 November 1952, 3–4, *President's Lady* clipping file, Academy of Motion Picture Arts and Sciences Library, Beverly Hills, CA.

19. Ibid.

20. "Désirée," *Time*, 29 November 1954, 75.

21. Evelyn Harvey, "Napoleon Brando," *Collier's*, 29 October 1954, 108.

22. *De re vestiaria* (Paris, 1536) by Lazari Bayfius.

Notes to Chapter II. The Photogenic Formula: *Hairstyles and Makeup in Historical Films*

1. W. Robert LaVine, *In a Glamorous Fashion* (New York, 1980), 27.

2. Margaret J. Bailey, *Those Glorious Glamour Years* (Secaucus, N.J., 1982), 7.

3. Serge Strenkovsky, *The Art of Make-up*, ed. Elizabeth S. Taber (New York, 1937), 257–58.

4. Adele Whitely Fletcher, "Miracle Men at Work to Make You Lovelier," *Photoplay* 53 (July 1939): 26.

5. John J. Baird, *Make-Up: A Manual for the Use of Actors, Amateur and Professional* (New York, 1930), 101.

6. Information on Max Factor obtained from archival and display material at the Max Factor Museum, Hollywood, CA, and interviews with its director, Bob Salvatore, May 1986.

7. Pete Martin, "Mister Wigs," *Saturday Evening Post* 217 (19 May 1945): 34.

8. Ibid., 28.

9. Advertisement displayed at the Max Factor Museum, Hollywood, CA.

10. Martin, "Mister Wigs," 39.

11. Bailey, *Those Glorious Glamour Years*, 330.

12. Whitney Stine and Bette Davis, *Mother Goddam: The Story of the Career of Bette Davis* (New York, 1974), 125.

13. Ibid., 273.

14. Wall text displayed at the Max Factor Museum, Hollywood, CA.

15. Advertisement displayed at the Max Factor Museum, Hollywood, CA.

Notes to Chapter III. Hollywood and Seventh Avenue: *The Impact of Period Films on Fashion*

1. Lillian Churchill. "Modes à la Movies." *New York Times Magazine*, 7 January 1940, 8.

2. Cecilia Ager, "Mae West Reveals the Foundations of the 1900 Mode," *Vogue*, 1 September 1933, 86.

3. Elsa Schiaparelli, *Shocking Life* (London, 1954), 95–96. Also Churchill. "Modes à la Movies," 8.

4. Marie Beynon Ray, "Curves Ahead," *Colliers*, 7 October 1933, 40.

5. Laura Blayney, "Do Movies Influence the Paris Designers?" *Movie Classic* 8 (June 1935): 34.

6. Ibid, 58.

7. Ibid.

8. Gwen Walters, "Fashion Letter," *Photoplay* 52 (November 1938): 72.

9. Ibid.

10. *M.G.M. Studio News*, 16 April 1940.

11. Hattie Carnegie, "Even a Queen's Fads Aren't Fashion," *Pictorial Review* 39 (September 1938): 64.

12. Lisa Harrington, "From Rags to Riches," *California Monthly* 91 (June–July 1981): 15.

13. "Forecasting the Fashion Influence of *Mary of Scotland*," *Photoplay* 49 (June 1936): 64–65.

14. Churchill. "Modes à la Movies." 8.

15. Ibid.

16. Christina Probert, *Brides in Vogue since 1910* (New York, 1981), 28–29.

17. Ibid.

18. Churchill. "Modes à la Movies." 8.

19. Kay Hardy, *Costume Design* (New York, 1948), 66.

20. Lillian Howard. "Beverly Bayne: A Living Van Dyke." *Photoplay* 11 (March 1917): 107–8.

21. Elizabeth Ewing, *History of Twentieth Century Fashion* (London, 1974), 97.

22. "Gowns Designed in the Period of Sixteenth Century," *Screen News* 1 (4 March 1922): 11.

23. Paul Michael, *The American Movies: Pictorial Encyclopedia* (New York, 1969), 11.

24. Julian Robinson, *Fashion in the Thirties* (London, 1978), 19.

25. "Cinema Fashions," *Fortune*, January 1937, 38, 44.

26. Margaret Farrand Thorp, *America at the Movies* (New Haven, 1939), 119.

27. Robert Gustafson, "The Power of the Screen," *The Velvet Light Trap*, no. 19 (1982), 8.

28. "The Miracle of Mauve," *California Stylist* 9 (February 1945): 123.

29. Editorial, *Harper's Bazaar*, October 1947, 180.

30. Cecil Beaton, *Memoirs of the 40s* (New York, 1972), 154.

31. Cecil Beaton, ". . . in Making *Gigi*," *Vogue*, June 1958, 88.

32. Jane Dorner, *Fashion in the Forties and Fifties* (New York, 1975), 94.

33. Editorial captions for photograph, *Vogue*, 1 March 1964, 140–41.

34. Katie Kelly, *The Wonderful World of Women's Wear Daily* (New York, 1972), 60.

35. "Theadora Van Runkle's Sketch Book of the Thirties," *Show* 1 (23 July 1970): 16–17.

36. Alberto Arbasino, "The Fantastic Tosi," *Vogue*, 1 September 1970, 385.

Index of Costume Designers

Index of Historical Movies

(Page numbers in italic print refer to illustrations)